PORTABLE EDITION | BOOK 5 | FOURTH EDITION

# ART HISTORY

## A View of the World
## Part Two: Asian, African, and Oceanic Art and Art of the Americas

## MARILYN STOKSTAD

Judith Harris Murphy Distinguished Professor of Art History Emerita
The University of Kansas

## MICHAEL W. COTHREN

Scheuer Family Professor of Humanities
Department of Art, Swarthmore College

### CONTRIBUTORS

Frederick M. Asher, David A. Binkley, Claudia L. Brittenham, Claudia Brown,

Patricia J. Darish, Patricia J. Graham, and Carol S. Ivory

**Prentice Hall**

Boston   Columbus   Indianapolis   New York   San Francisco   Upper Saddle River
Amsterdam   Cape Town   Dubai   London   Madrid   Milan   Munich   Paris   Montréal   Toronto
Delhi   Mexico City   São Paulo   Sydney   Hong Kong   Seoul   Singapore   Taipei   Tokyo

**Editorial Director:** Craig Campanella
**Editor-in-Chief:** Sarah Touborg
**Senior Sponsoring Editor:** Helen Ronan
**Editorial Project Manager:** David Nitti
**Editorial Assistant:** Carla Worner
**Editor-in-Chief, Development:** Rochelle Diogenes
**Development Editors:** Margaret Manos and Cynthia Ward
**Media Director:** Brian Hyland
**Media Editor:** Alison Lorber
**Media Project Manager:** Rich Barnes
**Director of Marketing:** Brandy Dawson
**Senior Marketing Manager:** Kate Mitchell
**Marketing Assistant:** Craig Deming
**Senior Managing Editor:** Ann Marie McCarthy
**Assistant Managing Editor:** Melissa Feimer
**Production Project Managers:** Barbara Cappuccio and Marlene Gassler
**Senior Operations and Manufacturing Manager:** Nick Sklitsis
**Senior Operations Specialist:** Brian Mackey
**Manager of Design Development:** John Christiana
**Art Director and Interior Design:** Kathy Mrozek
**Cover Design:** Kathy Mrozek
**Site Supervisor, Pearson Imaging Center:** Joe Conti
**Pearson Imaging Center:** Corin Skidds, Robert Uibelhoer, and Ron Walko
**Cover Printer:** Lehigh-Phoenix Color
**Printer/Binder:** Courier/Kendallville

This book was designed by
Laurence King Publishing Ltd, London
www.laurenceking.com

**Commissioning Editor:** Kara Hattersley-Smith
**Senior Editors:** Melissa Danny/Sophie Page
**Production Manager:** Simon Walsh
**Page Design:** Nick Newton/Randell Harris
**Photo Researcher:** Emma Brown
**Copy Editors:** Tessa Clark/Jenny Knight/Robert Shore/
    Johanna Stephenson
**Proofreader:** Jennifer Speake
**Indexer:** Sue Farr

*Cover photo:* Panel from a box (detail). From Tamil Nadu, south India. Nayak dynasty, late 17th–18th century. Ivory backed with gilded paper, 6 × 12⅜ × ⅛″ (15.2 × 31.4 × 0.3 cm). Virginia Museum of Fine Arts. The Arthur and Margaret Glasgow Fund. 80.171. Katherine Wetzel/Virginia Museum of Fine Arts.

Credits and acknowledgments borrowed from other sources and reproduced, with permission, in this textbook appear on the appropriate page within text or on the credit pages in the back of this book.

**Library of Congress Cataloging-in-Publication Data**
Stokstad, Marilyn
    Art History / Marilyn Stokstad, Michael W. Cothren; contributors,
    Frederick M. Asher … [eg al.]. —4th ed.
        p. cm.
    Includes bibliographical references and index.
    ISBN-13: 978-0-205-74422-0 (hardcover : alk. paper)
    ISBN-10: 0205-74422-2 (hardcover : alk. paper)
    1. Art—History. I. Cothren, Michael Watt. II. Asher, Frederick M. III
Title.
N5300.S923 2011
709—dc22                                    2010001489

10 9 8 7 6 5 4 3 2 1

**Prentice Hall**
is an imprint of

www.pearsonhighered.com

ISBN 10: 0-205-79095-X
ISBN 13: 978-0-205-79095-1

# CONTENTS

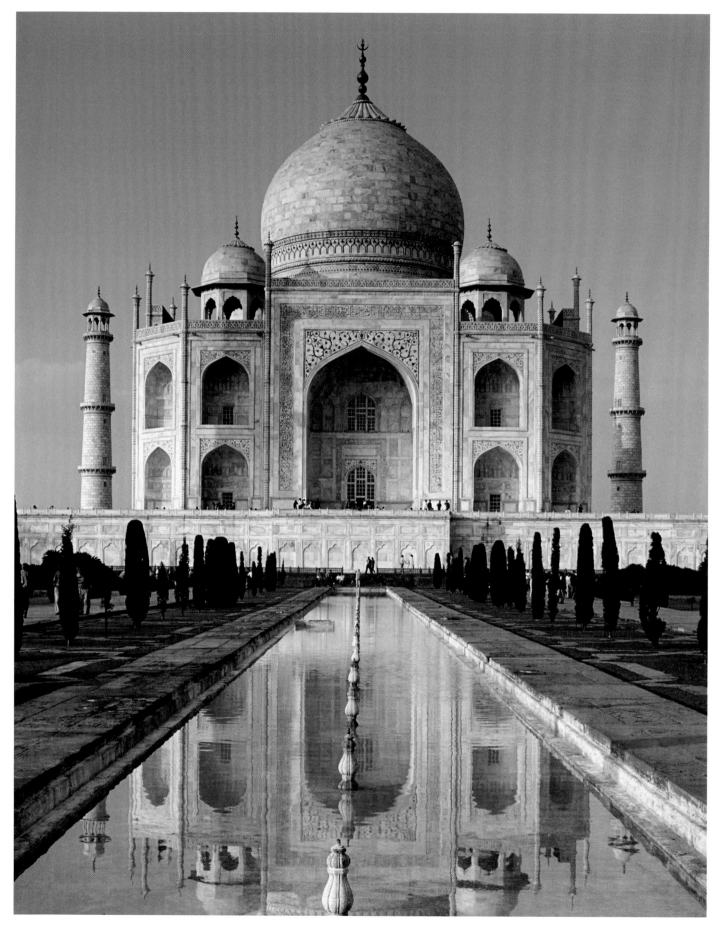

**23-1 • TAJ MAHAL**  Agra, India. Mughal period, reign of Shah Jahan, c. 1631–1648.

# ART OF SOUTH AND SOUTHEAST ASIA AFTER 1200

Upon entering the gateway that today serves as the entrance to the great Taj Mahal complex, the visitor beholds the majestic white marble structure that is one of the world's best-known monuments. Its reflection shimmers in the pools of the garden meant to evoke a vision of paradise as described in the Qur'an, the holy book of Islam. The building's façades are delicately inlaid with inscriptions designed by India's foremost calligrapher of the time, Amanat Khan, and floral arabesques in semiprecious stones—carnelian, agate, coral, turquoise, garnet, lapis, and jasper. Above, its luminous, white marble dome reflects each shift in light, flushing rose at dawn, dissolving in its own brilliance in the noonday sun. This extraordinary building, originally and appropriately called the Illuminated Tomb and only from the nineteenth century known as the **TAJ MAHAL** (**FIG. 23–1**), was built between 1632 and 1648 by the Mughal ruler Shah Jahan as a mausoleum for his favorite wife, Mumtaz Mahal, who died in childbirth, and likely as a tomb for himself.

Inside, the Taj Mahal invokes the *hasht behisht* ("eight paradises"), a plan named for the eight small chambers that ring the interior—one at each corner and one behind each *iwan*, a vaulted opening with an arched portal, that is a typical feature of eastern Islamic architecture. In two stories (for a total of 16 chambers), the rooms ring the octagonal central area, which rises the full two stories to a domed ceiling that is lower than the outer dome. In this central chamber, surrounded by a finely carved octagonal openwork marble screen, are the exquisite inlaid **cenotaphs** (funerary monuments) of Shah Jahan and his wife, whose actual tombs lie in the crypt below.

The Taj Mahal includes much more than the white marble tomb. On one side is a mosque, while opposite and very similar in appearance is a building that may have served as a rest house. The enormous garden, both in front of the building and in its continuation on the opposite side of the Jamuna River, lends a lush setting consistent with Islamic notions of paradise. Both the side buildings and the two parts of the garden provide a sense of perfect symmetry to the entire complex.

A dynasty of central Asian origin, the Mughals were the most successful of the many Islamic groups that established themselves in India beginning in the twelfth century. Under their patronage, Persian and central Asian influences mingled with older traditions of the South Asian subcontinent, adding yet another dimension to the already ancient and complex artistic heritage of India.

## LEARN ABOUT IT

**23.1** Understand the impact of Islam on the art of India and Southeast Asia.

**23.2** Understand how exogenous influences affect the form of a nation's arts.

**23.3** Recognize how nationalism can be expressed in art.

**23.4** Understand the way global styles can address indigenous themes.

**23.5** Recognize the ways in which art of diverse religions is produced simultaneously in the same nation.

**HEAR MORE:** Listen to an audio file of your chapter **www.myartslab.com**

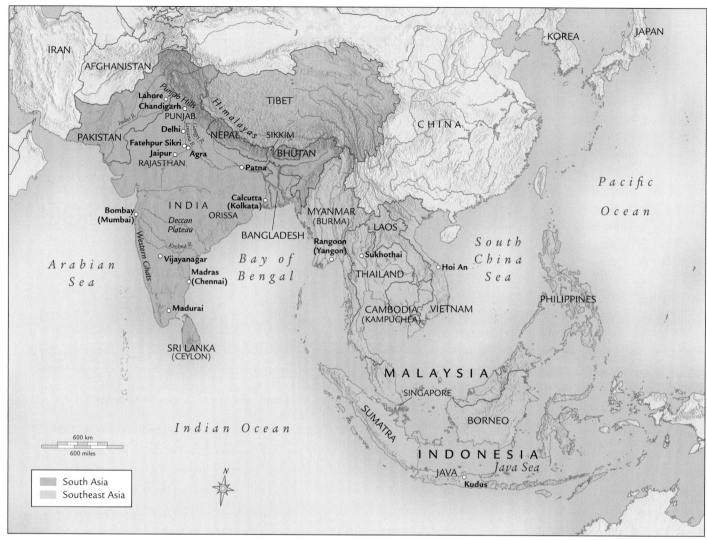

**MAP 23-1 • SOUTH AND SOUTHEAST ASIA**

Throughout its history, the kingdoms comprising the Indian subcontinent engaged—sometimes peacefully, sometimes militarily—with neighboring and more distant people, contributing significantly to the development of its art.

# INDIA AFTER 1200

By 1200 India was already among the world's oldest civilizations (see "Foundations of Indian Culture," page 774). The art that survives from its earlier periods is almost exclusively sacred, most of it inspired by the three principal religions: Buddhism, Hinduism, and Jainism. These three religions remained a primary focus for Indian art, even as dynasties arriving from the northwest began to establish the new religious culture of Islam.

## BUDDHIST ART

After many centuries of prominence, Buddhism had been in decline as a cultural force in India since the seventh or eighth century. By 1200, the principal Buddhist centers were concentrated in the northeast, in the region that had been ruled by the Pala dynasty (c. 750–1199). There, in great monastic universities that attracted monks from as far away as China, Korea, and Japan, was cultivated a form of Buddhism known as Tantric (Vajrayana) Mahayana.

ICONOGRAPHY OF A TANTRIC BODHISATTVA. The practices of Tantric Buddhism, which include techniques for visualizing deities, encourage the development of images with precise iconographic details such as the twelfth-century gilt-bronze sculpture of **THE BODHISATTVA AVALOKITESHVARA** in FIGURE 23–2 from the site of Kurkihar in eastern India. Bodhisattvas are beings who are well advanced on the path to buddhahood (enlightenment), the goal of Mahayana Buddhists, and who have vowed out of compassion to help others achieve enlightenment. Avalokiteshvara, the bodhisattva of greatest compassion, whose vow is to forgo buddhahood until all others become buddhas, became the most popular of these saintly beings in India and in East Asia.

Characteristic of bodhisattvas, Avalokiteshvara is distinguished in art by his princely garments, unlike a buddha, who wears a monk's robes. Avalokiteshvara is specifically recognized by the lotus flower he holds and by the presence in his crown of his "parent" Buddha, in this case Amitabha, the Buddha of the Western Pure

Land (the Buddhist paradise). Other marks of Avalokiteshvara's extraordinary status are the third eye (symbolizing the ability to see in miraculous ways) and the wheel on his palm (signifying the ability to teach the Buddhist truth).

Avalokiteshvara is shown here in the relaxed pose known as the posture of royal ease. One leg angles down; the other is drawn up onto the lotus seat, itself considered an emblem of spiritual purity. His body bends gracefully, if a bit stiffly, to one side. The chest scarf and lower garment cling to his body, fully revealing its shape. Delicate floral patterns enliven the textiles, and closely set parallel folds provide a wiry, linear tension that contrasts with the hard but silken surfaces of the body. Linear energy continues in the sweep of the tightly pleated hem emerging from under the right thigh, in the sinuous lotus stalks on each side, and in the fluttering ribbons of the elaborate crown. A profusion of details and varied textures creates an ornate effect—the lavish jewelry, the looped hair piled high and cascading over the shoulders, the ripe blossoms, the rich layers of the lotus seat. Though still friendly and human, the image is somewhat formalized. The features of the face, where we instinctively look for a human echo, are treated abstractly, and despite its reassuring smile the statue's expression remains remote. Through richness of ornament and tension of line, this style expresses the heightened power of a perfected being.

With the fall of the Pala dynasty in the late twelfth century, the last centers of Buddhism in northern India collapsed, and most

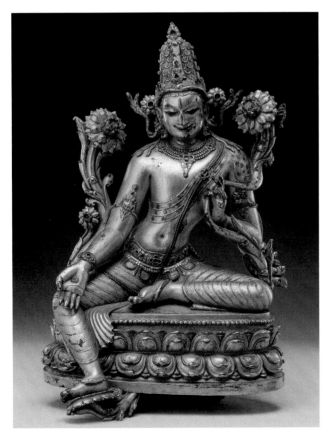

**23-2 • THE BODHISATTVA AVALOKITESHVARA**
From Kurkihar, Bihar. Pala dynasty, 12th century. Gilt-bronze, height 10″ (25.5 cm). Patna Museum, Patna.

**23-3 • DETAIL OF A LEAF WITH THE BIRTH OF MAHAVIRA**
*Kalpa Sutra*, western Indian school (probably Gujarat). c. 1375–1400. Gouache on paper, 3⅜ × 3″ (8.5 × 7.6 cm). Prince of Wales Museum, Bombay.

of the monks dispersed, mainly into Nepal and Tibet **(SEE MAP 23–1)**. From that time, Tibet has remained the principal stronghold of Tantric Buddhist practice and its arts (see "Tantric Influence in the Art of Nepal and Tibet," page 776). The artistic style perfected under the Palas, however, became an influential international style throughout East and Southeast Asia.

## JAIN ART

The Jain religion traces its roots to a spiritual leader called Mahavira (c. 599–527 BCE), whom it regards as the final in a series of 24 saviors known as pathfinders (*tirthankaras*). Devotees seek through purification to become worthy of rebirth in the heaven of the pathfinders, a zone of pure existence at the zenith of the universe. Jain monks live a life of austerity, and even laypersons avoid killing any living creature.

A MANUSCRIPT LEAF FROM THE *KALPA SUTRA*. Muslim dynasties brought with them a rich tradition of book illustration, and non-Islamic religions began to write and illustrate their own sacred books, previously intended largely for memorization. The Jains of western India, primarily in the region of Gujarat, created many illustrated manuscripts, such as this *Kalpa Sutra*, which explicates the lives of the pathfinders **(FIG. 23–3)**. Produced during the late fourteenth century, it is one of the first Jain manuscripts on

## Foundations of Indian Culture

The earliest civilization on the Indian subcontinent flourished toward the end of the third millennium BCE along the Indus River in present-day Pakistan. Remains of its expertly engineered brick cities have been uncovered, together with works of art that intriguingly suggest spiritual practices and reveal artistic traits known in later Indian culture.

The decline of the Indus civilization during the mid second millennium BCE coincides with (and may be related to) the arrival from the northwest of a seminomadic people who spoke an Indo-European language and referred to themselves as Aryans. Over the next millennium they were influential in formulating the new civilization that gradually emerged. The most important Aryan contributions to this new civilization included the Sanskrit language and the sacred texts called the Vedas. The evolution of Vedic thought under the influence of indigenous Indian beliefs culminated in the mystical, philosophical texts called the Upanishads, which took shape sometime after 800 BCE.

The Upanishads teach that the material world is illusory; only Brahman, the universal soul, is real and eternal. We—that is, our individual souls—are trapped in this illusion in a relentless cycle of birth, death, and rebirth. The ultimate goal of religious life is to liberate ourselves from this cycle and to unite our individual soul with Brahman.

Buddhism and Jainism are two of the many religions that developed in the climate of Upanishadic thought. Buddhism (see "Buddhism" page 297) is based on the teachings of Shakyamuni Buddha, who lived in central India about 500 BCE; Jainism was shaped about the same time by the followers of the spiritual leader Mahavira. Both religions acknowledged the cyclical nature of existence and taught a means of liberation from it, but they rejected the authority,

rituals, and social strictures of Vedic religion. Whereas the Vedic religion was in the hands of a hereditary priestly class, Buddhist and Jain communities welcomed all members of society, which gave them great appeal. The Vedic tradition eventually evolved into the many sects now collectively known as Hinduism (see "Hinduism" page 298).

Through most of its history India was a mosaic of regional dynastic kingdoms, but from time to time empires emerged that unified large parts of the subcontinent. The first was that of the Maurya dynasty (c. 322–185 BCE), whose great king Ashoka patronized Buddhism. From this time Buddhist doctrines spread widely and its artistic traditions were established.

In the first century CE the Kushans, a central Asian people, created an empire extending from present-day Afghanistan down into central India. Buddhism prospered under Kanishka, the most powerful Kushan king, and spread into central Asia and to east Asia. At this time, under the evolving thought of Mahayana Buddhism, traditions first evolved for depicting the image of the Buddha in art.

Later, under the Gupta dynasty (c. 320–550 CE) in northern India, Buddhist art and culture reached their high point. However, Gupta monarchs also patronized Hindu art, and from this time Hinduism grew to become the dominant Indian religious tradition, with its emphasis on the great gods Vishnu, Shiva, and the Goddess—all with multiple forms.

After the tenth century, numerous regional dynasties prevailed, some quite powerful and long-lasting. Hindu temples, in particular, developed monumental and complex forms that were rich in symbolism and ritual function, with each region of India producing its own variation.

paper rather than palm leaf, the material that had previously been used for written documents.

With great economy, the illustration, inserted between blocks of Sanskrit text, depicts the birth of Mahavira. He is shown cradled in his mother's arms as she reclines in her bed under a canopy | connoting royalty, attended by three ladies-in-waiting. Decorative pavilions and a shrine with peacocks on the roof suggest a luxurious palace setting. Everything appears two-dimensional against the brilliant red or blue ground. Vibrant colors and crisp outlines impart an energy to the painting that suggests the arrival of the divine in the mundane world. Transparent garments with variegated designs reveal the swelling curves of the figures, whose alert postures and gestures convey a sense of the importance and excitement of the event. Strangely exaggerated features, such as the protruding eyes, contribute to the air of the extraordinary. With its angles and tense curves, the drawing is closely linked to the aesthetics of Sanskrit calligraphy, and the effect is as if the words themselves had suddenly flared into color and image.

### HINDU ART

With the increasing popularity of Hindu sects came the rapid development of Hindu temples. Spurred by the ambitious building programs of wealthy rulers, well-formulated regional styles had evolved by about 900 CE. The most spectacular structures of the era were monumental, with a complexity and grandeur of proportion rarely equaled even in later Indian art.

Emphasis on monumental individual temples gave way to the building of vast temple complexes and more moderately scaled, yet more richly ornamented, individual temples. These developments took place largely in the south of India, although some of the largest temples are in the north, for example, the Sun Temple at Konarak, built in the thirteenth century, and the Govind Deva Temple in Brindavan, built in the sixteenth century under the patronage of the Mughal emperor Akbar. The mightiest of the southern Indian kingdoms was Vijayanagar (c. 1336–1565), whose rulers successfully countered the potential incursions of neighboring dynasties, both Hindu and Muslim, for more than 200

years. Under the patronage of the Vijayanagar kings and their successors, the Nayaks, some of India's most spectacular Hindu architecture was created.

TEMPLE AT MADURAI. The enormous temple complex at Madurai, one of the capitals of the Nayaks, is an example of this fervent expression of Hindu faith. Founded around the thirteenth century, it is dedicated to the goddess Minakshi (the local name for Parvati, the consort of the god Shiva) and to Sundareshvara (the local name for Shiva himself). The temple complex stands in the center of the city and is the focus of Madurai life. At its heart are the two oldest shrines, one to Minakshi and the other to Sundareshvara. Successive additions over the centuries gradually expanded the complex around these small shrines and came to dominate the visual landscape of the city. The most dramatic features of this and similar "temple cities" of the south were the thousand-pillar halls, large ritual-bathing pools, and especially the entrance gateways, **gopuras** in Sanskrit, that tower above the temple site and the surrounding city like modern skyscrapers (**FIG. 23–4**).

*Gopuras* proliferated as a temple city grew, necessitating new and bigger enclosing walls, and thus new gateways. Successive rulers, often seeking to outdo their predecessors, donated taller and taller *gopuras*. As a result, the tallest structures in temple cities are often at the periphery, rather than at the central temples, which are sometimes totally overwhelmed by the height of the surrounding structures. The temple complex at Madurai has 11 *gopuras*, the largest over 160 feet tall.

Formally, the *gopura* has its roots in the pyramidal tower characteristic of the seventh-century southern temple style. As the *gopura* evolved, it took on the graceful concave silhouette shown here. The exterior is embellished with thousands of sculpted figures, evoking a teeming world of gods and goddesses. Inside, stairs lead to the top for an extraordinary view.

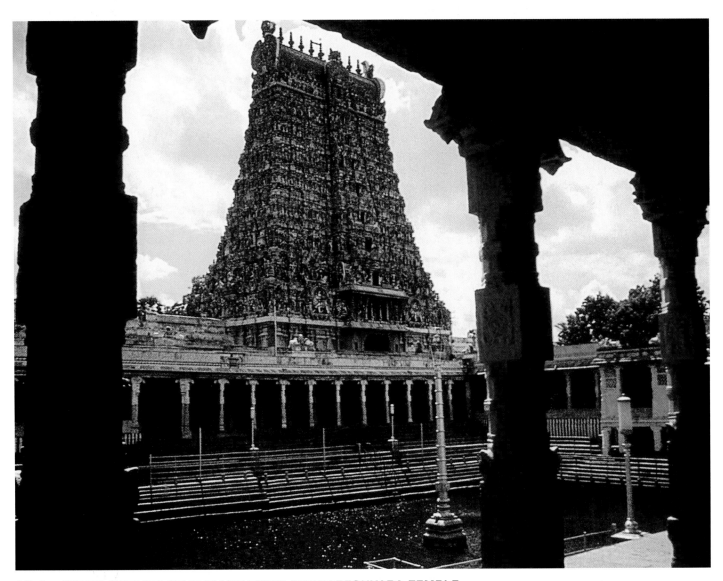

**23-4 • OUTER GOPURA OF THE MINAKSHI-SUNDARESHVARA TEMPLE**
Madurai, Tamil Nadu, south India. Nayak dynasty, mostly 13th to mid 17th century, with modern renovations.

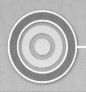

# Tantric Influence in the Art of Nepal and Tibet

The legacy of India's Tantric Buddhist art can be traced in the regions of Nepal and Tibet. Artistic expression of Esoteric Buddhist ideals reached a high point in the seventeenth and eighteenth centuries. Indeed, even today, artists worldwide continue to explore aspects of this tradition.

**Inlaid Devotional Sculpture.** In Nepal, where Hinduism intermingled with Buddhism, sculptors developed a metalwork style in which a traditional artistic use of polished stones became prevalent in devotional sculptures as well. Inlaid gems and semiprecious stones often enlivened their copper or bronze sculptures, which were almost always brightly gilded. Complex representations of deities, often multiarmed and adorned with celestial attributes, predominated, but some themes from early Buddhism were revived. In one particularly fine eighteenth-century example (FIG. A), Maya, the Mother of the Buddha, holds the legendary tree branch while the Buddha emerges from her side. The cast and **chased** (ornamented by hammering or incising the metal surface) details of the regal costume of Queen Maya, including fluttering scarves, elaborate jewelry, and a large crown, are studded with real jewels, pearls, and semiprecious stones. The tree, also, is richly inlaid, symbolizing the auspicious nature of the event. Both the tree and the figure rise from a pedestal shaped to suggest the blossoming lotus, a reference to the appearance of the Buddha's purity in the muddy pond of the material world.

***Tangka* Painting.** Buddhism was established relatively late in Tibet, but the region has since become almost wholly identified with the religion. With the rule of a lineage of Dalai Lamas established in the seventeenth century and continuing through to the twentieth century, and a related expansion of monasteries, the arts associated with Tantric Buddhism flourished. Wrathful manifestations of powerful deities were evoked in sculpted and painted forms, with the scroll-like *tangka* emerging as a major format. A nineteenth-century painting of Achala (FIG. B), one of a group of wrathful deities associated with truth, resolve, and the overcoming of obstacles, exemplifies this major aspect of Tibetan art. The deity exudes brilliant red flames while brandishing a sword and posing as if to strike. Following traditional practice, the artist—or artists, as such paintings may have employed highly specialized craftsmen—positions the terrifying figure on a lotus pedestal, establishing his ethereal nature. The background suggests the green hills and blue sky of the material world as well as the cosmic geometry envisioned in Tantric Buddhism. Repeated representations of the deity emphasize the efficacious function and conspicuous power of the image.

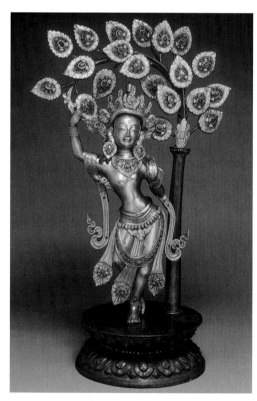

**A. MAYA, MOTHER OF BUDDHA, HOLDING A TREE BRANCH**
From Nepal. 18th century. Gilt bronze with inlaid precious stones, height 22″ (56 cm). Musée Guimet, Paris.

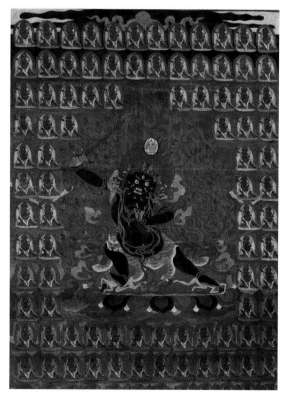

**B. ACHALA**
From Tibet. 19th century. Gouache on cotton, 33½ × 23⅔″ (85 × 60 cm). Musée Guimet, Paris.

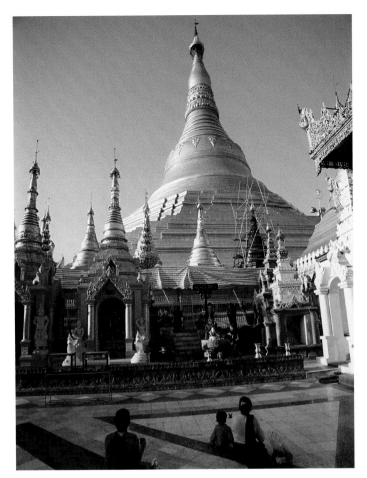

**23-5 • SHWE-DAGON STUPA (PAGODA)**
Yangon.15th century. Construction at the site dates from at least the 14th century, with continuous replastering and redecoration to the present.

# THE BUDDHIST AND HINDU INHERITANCE IN SOUTHEAST ASIA

India's Buddhist and Hindu traditions influenced Southeast Asia (discussed in Chapter 9), where they were absorbed by newly rising kingdoms in the regions now comprising Burma (Myanmar), Thailand, Cambodia, Vietnam, and Indonesia.

### THERAVADA BUDDHISM IN BURMA AND THAILAND

In northern Burma, from the eleventh to the thirteenth century, rulers raised innumerable religious monuments—temples, monasteries, and stupas—in the Pagan Plain, following the Scriptures of Theravada Buddhism (also called Hinayana Buddhism, see Chapter 9). To the south arose the port city of Yangon (formerly known as Rangoon, called Dagon in antiquity), the nation's present-day capital. Established by Mon rulers (SEE FIG. 9–29) at least by the eleventh century, Yangon is site of the **SHWE-DAGON STUPA (FIG. 23–5)**, which enshrines relics of the Buddha. The modern structures of Shwe-dagon ("Golden Dagon") rise from an ancient core—fourteenth century or earlier—and reflect centuries of continual restoration and enhancement. The site

continues to be a center of Theravada devotion amid symbolic ornamentation—especially lotus elements symbolic of the Buddha's purity—and splendid decoration in gilding and precious stones supplied by pious contributions. Images of the Buddha, and sometimes his footprints alone, provide focal points for devotion.

In Thailand, the Sukhothai kingdom (mid thirteenth to late fourteenth century) also embraced Theravada Buddhism, although Hindu shrines were constructed as well in its capital city, Sukhothai (ancient name Sukhodaya). Artisans working under royal patrons developed a classic statement of Theravada ideals in bronze sculptures of the Buddha. Notable was their development of a free-standing walking Buddha. Especially evocative of the ascetic simplicity of Theravada Buddhism, however, are their many renditions of the Buddha Calling the Earth to Witness (**FIG. 23–6**). Inspired by devotional texts and poetry, and further refined through reference to models from Sri Lanka, the iconographic and stylistic elements became notably formalized. The Buddha's cranial protuberance is interpreted as a flame of divine knowledge, as it was in southern India and Sri Lanka, and details of his ecclesiastical garb are reduced to a few elegant lines. The *mudras* (see page 304), or hand gestures, are quietly eloquent.

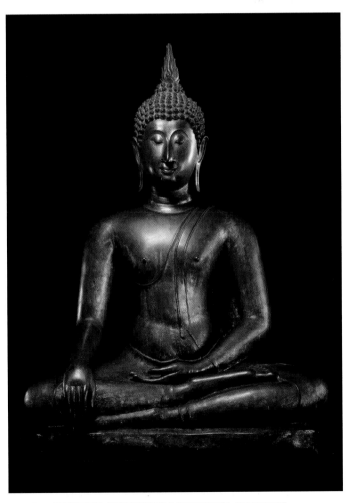

**23-6 • SEATED SUKHOTAI BRONZE BUDDHA**
Leaded bronze, height 35⅜″ (90 cm). The Walters Art Museum, Baltimore. Bequest of A.B. Griswold, 1992. 54.2775

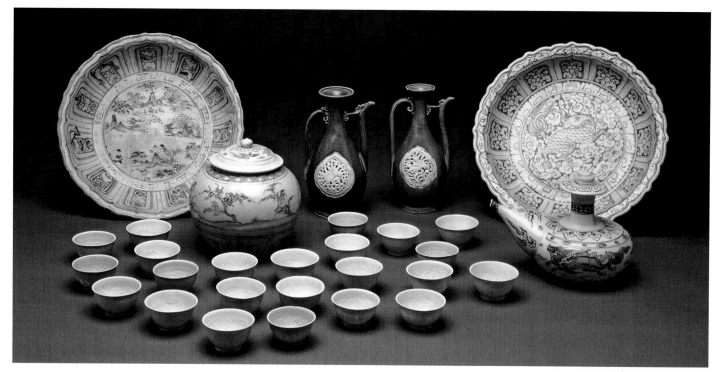

**23-7 • GROUP OF VIETNAMESE CERAMICS FROM THE HOI AN HOARD**
Late 15th to early 16th century, porcelain with underglaze blue decoration; barbed-rim dishes: (left) diameter 14″ (35.1 cm); (right) diameter 13¼″ (34.7 cm). Phoenix Art Museum. (2000.105–109)

More than 150,000 blue-and-white ceramic items were found in the hold of a sunken ship excavated in the late 1990s under commission from the Vietnamese government, which later sent many of the retrieved items for public auction. The 23 small cups among the works shown here were found packed inside the jar.

## VIETNAMESE CERAMICS

Both the Burmese and Thai kingdoms produced ceramics, often inspired by stonewares and porcelains from China. Sukhothai potters, for example, made green-glazed and brown-glazed wares, called Sawankhalok wares. Even more widespread were the wares of Vietnamese potters. For example, excavation of the Hoi An "hoard" **(FIG. 23–7)**, actually the contents of a sunken ship laden with ceramics for export, brought to light an impressive variety of ceramic forms made by Vietnamese potters of the late fifteenth to early sixteenth century. Painted in underglaze cobalt blue and further embellished with overglaze enamels, these wares were shipped throughout Southeast Asia and beyond, as far east as Japan and as far west as England and the Netherlands.

## INDONESIAN TRADITIONS

Indonesia, now the world's most populous Muslim country, experienced a Hindu revival in the centuries following its Buddhist period, which came to a close in the eighth or ninth century (see Chapter 9). As a consequence, it has maintained unique traditions that build upon the Hindu epics, especially the *Ramayana*. Islamic monuments in Indonesia, like the Hindu and Buddhist ones, draw from a rich and diverse repertoire of styles and motifs. The **MINARET MOSQUE** of Kudus in central Java **(FIG. 23–8)** was built in 1549. The minaret serves as the tower from which Muslims are

called to worship five times daily, but the minaret's red brick, general shape, and the niches that adorn its façade all recall Hindu temples built in east Java about two centuries earlier. As in India, Javanese artists worked in a consistent style, independent of the religion of the patron. Their architecture did, of course, accommodate the specific ritual functions of the building.

# MUGHAL PERIOD

Islam first touched the South Asian subcontinent in the eighth century, when Arab armies captured a small territory near the Indus River. Later, beginning around 1000, Turkic factions from central Asia, relatively recent converts to Islam, began military campaigns into north India, at first purely for plunder, then seeking territorial control. From 1193, various Turkic and Afghan dynasties ruled portions of the subcontinent from the northern city of Delhi. These sultanates, as they are known, constructed forts, mausoleums, monuments, and mosques. Although these early dynasties left their mark, it was the Mughal dynasty that made the most inspired and lasting contribution to the art of India.

The Mughals, too, came from central Asia. Muhammad Zahir-ud-Din, known as Babur ("Lion" or "Panther"), was the first Mughal emperor of India (r. 1526–30). He emphasized his Turkic

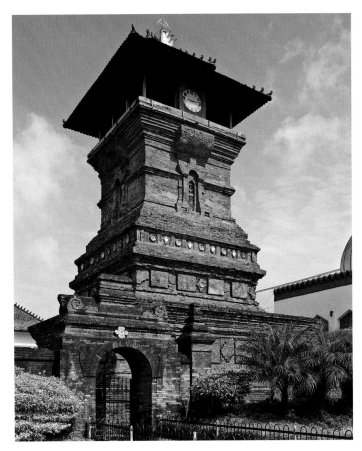

**23-8 • MINARET MOSQUE**
1549. Kudus, Java.

heritage, though he had equally impressive Mongol ancestry. After some initial conquests in central Asia, he amassed an empire stretching from Afghanistan to Delhi, which he conquered in 1526. Akbar (r. 1556–1605), the third ruler, extended Mughal control over most of north India, and under his two successors, Jahangir and Shah Jahan, northern India was generally unified by 1658. The Mughal Empire lasted until 1858, when the last Mughal emperor was deposed and exiled to Burma by the British.

## MUGHAL ARCHITECTURE

Mughal architects were heir to a 300-year-old tradition of Islamic building in India. The Delhi sultans who preceded them had great forts housing government and court buildings. Their architects had introduced two fundamental Islamic structures, the mosque and the tomb, along with construction based on the arch and the dome. (Earlier Indian architecture had been based primarily on post-and-lintel construction.) They had also drawn freely on Indian architecture, borrowing both decorative and structural elements to create a variety of hybrid styles, and had especially benefited from the centuries-old Indian virtuosity in stonecarving and masonry. The Mughals followed in this tradition, synthesizing Indian, Persian, and central Asian elements for their forts, palaces, mosques, tombs, and cenotaphs (tombs or monuments to someone whose remains are actually somewhere else).

Akbar, an ambitious patron of architecture and city planning, constructed a new capital at a place he named Fatehpur Sikri ("City of Victory at Sikri"), celebrating his military conquests and the birth of his son Salim, who subsequently took on the throne name of Jahangir. The palatial and civic buildings, built primarily during Akbar's residence there from about 1572 to 1585, have drawn much admiration. There are two major components to Fatehpur Sikri: a religious section including the Jami Mosque and the administrative and residential section. Among the most extraordinary buildings in the administrative and residential section is the private audience hall (Diwan-i Khas) (see "A Closer Look," page 780). In the center of the hall is a tall pillar supporting a circular platform on which Akbar could sit as he received his nobles and dispensed justice. The structure recalls, perhaps consciously, the pillars erected by Ashoka (see Chapter 9) to promulgate his law.

**THE TAJ MAHAL.** Perhaps the most famous of all Indian Islamic structures, the Taj Mahal is sited on the bank of the Jamuna River at Agra, in northern India. Built between 1631 and 1648, it was commissioned as a mausoleum for his wife by the emperor Shah Jahan (r. 1628–58), who is believed to have taken a major part in overseeing its design and construction.

Visually, the Taj Mahal never fails to impress (SEE FIG. 23–1). As visitors enter through a monumental, hall-like gate, the tomb rises before them across a spacious garden set with long reflecting pools. Measuring some 1,000 by 1,900 feet, the enclosure is unobtrusively divided into quadrants planted with trees and flowers, and framed by broad walkways and stone inlaid in geometric patterns. In Shah Jahan's time, fruit trees and cypresses—symbolic of life and death, respectively—lined the walkways, and fountains played in the shallow pools. Truly, the senses were beguiled in this earthly evocation of paradise.

The garden in which the mausoleum is set is comprised of two parts divided by the Jamuna River. Thus while the structure appears to visitors to be set at the end of a garden, it is in fact in the center of a four-part garden, a traditional Mughal tomb setting used for earlier Mughal tombs. The tomb is flanked by two smaller structures not visible here, one a mosque and the other a hall designed in mirror image. They share a broad base with the tomb and serve visually as stabilizing elements. Like the entrance hall, they are made mostly of red sandstone, rendering even more startling the full glory of the tomb's white marble, a material previously reserved for the tombs of saints and so here implying an elevated religious stature for Shah Jahan and Mumtaz Mahal. The tomb is raised higher than these structures on its own marble platform. At each corner of the platform, a minaret defines the surrounding space. The minarets' three levels correspond to those of the tomb, creating a bond between them. Crowning each minaret is a **chattri** (pavilion). Traditional embellishments of Indian palaces, *chattris* quickly passed into the vocabulary of Indian Islamic architecture, where they appear prominently. Minarets occur in architecture throughout the Islamic world; from their heights, the faithful are called to prayer.

## Private Audience Hall, Fatehpur Sikri › c.1570, north-central India.

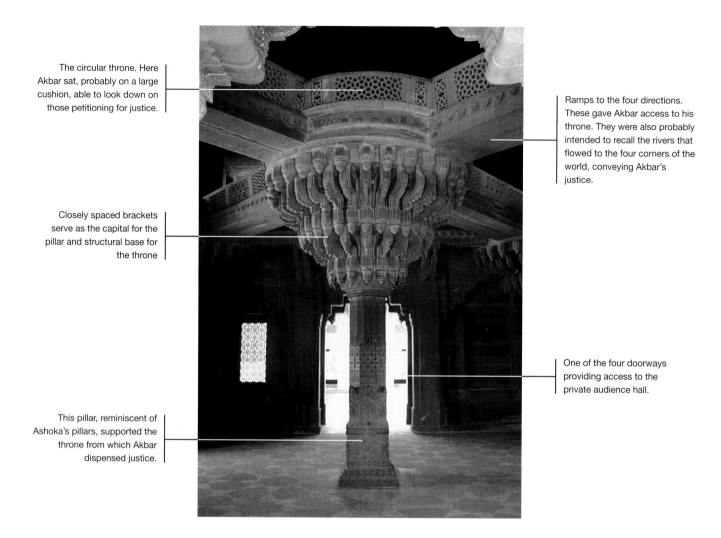

The circular throne. Here Akbar sat, probably on a large cushion, able to look down on those petitioning for justice.

Ramps to the four directions. These gave Akbar access to his throne. They were also probably intended to recall the rivers that flowed to the four corners of the world, conveying Akbar's justice.

Closely spaced brackets serve as the capital for the pillar and structural base for the throne

One of the four doorways providing access to the private audience hall.

This pillar, reminiscent of Ashoka's pillars, supported the throne from which Akbar dispensed justice.

SEE MORE: View the Closer Look feature for the Private Audience Hall at Fatehpur Sikri www.myartslab.com

A lucid geometric symmetry pervades the tomb. It is basically square, but its **chamfered** (sliced-off) corners create a subtle octagon. Measured to the base of the **finial** (the spire at the top), the tomb is almost exactly as tall as it is wide. Each façade is identical, with a central *iwan* flanked by two stories of smaller *iwans*. By creating voids in the façades, these *iwans* contribute markedly to the building's sense of weightlessness. On the roof, four octagonal *chattris*, one at each corner, create a visual transition to the lofty, bulbous dome, the crowning element that lends special power to this structure. Framed but not obscured by the *chattris*, the dome rises more gracefully and is lifted higher by its drum than in earlier Mughal tombs, allowing the swelling curves and elegant lines of its beautifully proportioned, surprisingly large form to emerge with perfect clarity.

By the seventeenth century, India was well known for exquisite craftsmanship and luxurious decorative arts (see "Luxury Arts," page 782). The pristine surfaces of the Taj Mahal are embellished with utmost subtlety (**FIG. 23–9**). Even the sides of the platform on which the Taj Mahal stands are carved in relief with a **blind arcade** (decorative arches set into a wall) motif and carved relief panels of flowers. The portals are framed with verses from the Qur'an and inlaid in black marble, while the spandrels are

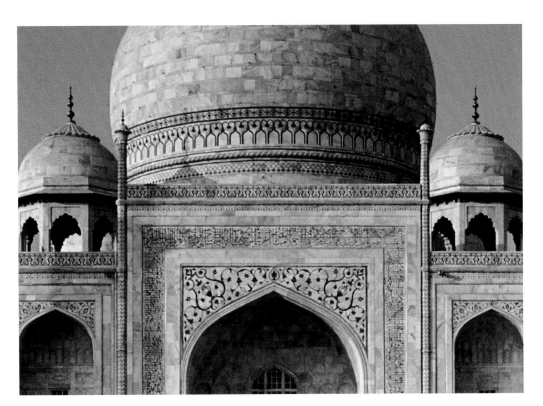

**23-10 • AKBAR INSPECTING THE CONSTRUCTION OF FATEHPUR SIKRI**
*Akbarnama*. c. 1590. Opaque watercolor on paper, 14¾ × 10″ (37.5 × 25 cm). Victoria & Albert Museum, London. (I.S.2-1896 91/117)

Many of the painters in the Mughal imperial workshops are recorded in texts of the period. Based on those records and on signatures that occur on some paintings, the design of this work has been attributed to Tulsi Kalan (Tulsi the Elder), the painting to Bandi, and the portraits to Madhu Kalan (Madhu the Elder) or Madhu Khurd (Madhu the Younger).

decorated with floral arabesques inlaid in colored semiprecious stones, a technique known by its Italian name **pietra dura**. Not strong enough to detract from the overall purity of the white marble, the embellishments enliven the surfaces of this impressive yet delicate masterpiece.

## MUGHAL PAINTING

Probably no one had more control over the solidification of the Mughal Empire and the creation of Mughal art than the emperor Akbar. A dynamic, humane, and just leader, Akbar enjoyed religious discourse and loved the arts, especially painting. He created an imperial atelier (workshop) of painters, which he placed under the direction of two artists from the Persian court. Learning from these two masters, the Indian painters of the atelier soon transformed Persian styles into the more vigorous, naturalistic styles that mark Mughal painting (see "Indian Painting on Paper," page 784). At Akbar's cosmopolitan court, pictorial sources from Europe also became inspiration for Mughal artists.

PAINTING AT THE COURT OF AKBAR. Akbar's court artists also produced paintings documenting Akbar's own life and accomplishments recorded in the *Akbarnama*, a text written by Akbar's court biographer, Abul Fazl. Among the most fascinating in this imperial manuscript are those that record Akbar's supervision of the construction of Fatehpur Sikri. One painting (FIG. 23–10) documents his inspection of the stonemasons and other craftsmen.

PAINTING IN THE COURTS OF JAHANGIR AND SHAH JAHAN. Jahangir (r. 1605–1627), Akbar's son and successor, was a connoisseur of painting; he had his own workshop, which he

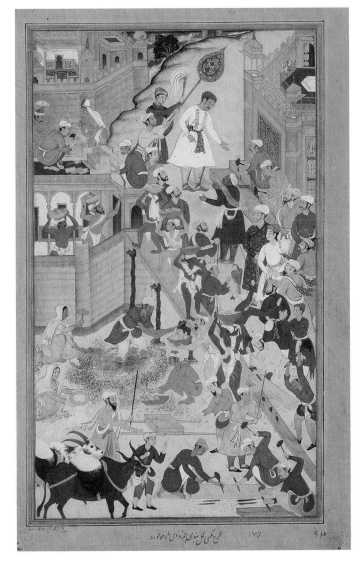

# Luxury Arts

The decorative arts of India have been widely appreciated since the first century CE. An Indian ivory carving was found at Pompeii, while other Indian works of the time have been found along the Silk Route connecting China with Rome. For centuries Indian textiles have been made for export and copied in Europe for domestic consumption. Technically superb and crafted from precious materials, tableware, jewelry, furniture, and containers enhance the prestige of their owners and give visual pleasure as well. Metalwork and work in rock crystal, agate, and jade, carving in ivory, and intricate jewelry are all characteristic Indian arts. Because of the intrinsic value of their materials, however, pieces have been disassembled, melted down, and reworked, making the study of Indian luxury arts very difficult. Many pieces, like the carved ivory panel illustrated here, have no date or records of manufacture or ownership. And, like it, many such panels have been removed from a larger container or piece of furniture.

Carved in ivory against a golden ground, where openwork, stylized vines with spiky leaves weave an elegant arabesque, loving couples dally under the arcades of a palace courtyard, whose thin columns and cusped arches resemble the arcades of the palace of Tirumala Nayak (r. 1623–1659) in Madurai (present-day Tamil Nadu). Their huge eyes under heavy brows suggest the intensity of their gaze, and the artist's choice of the profile view shows off their long noses and sensuously thick lips. Their hair is tightly controlled; the men have huge buns, and the women long braids hanging down their backs. Are they divine lovers? After all, Krishna lived and loved on earth among the cowherd maidens. Or are we observing scenes of courtly romance?

The rich jewelry and well-fed look of the couples indicate a high station in life. Men as well as women have voluptuous figures— rounded buttocks and thighs, abdomens hanging over jeweled belts, and sharply indented slim waists that emphasize seductive breasts. Their smooth flesh contrasts with the diaphanous fabrics that swath their plump legs, and their long arms and elegant gestures seem designed to show off their rich jewelry—bracelets, armbands, necklaces, huge earrings, and ribbons. Such amorous couples symbolize harmony as well as fertility.

The erotic imagery suggests that the panel illustrated here might have adorned a container for personal belongings such as jewelry, perfume, or cosmetics. In any event, the ivory relief is a brilliant example of south Indian secular arts.

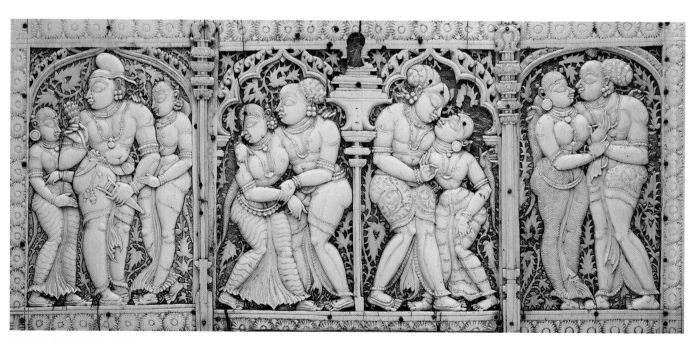

**PANEL FROM A BOX**
From Tamil Nadu, south India. Nayak dynasty, late 17th–18th century. Ivory backed with gilded paper, 6 × 12⅜ × ⅛″ (15.2 × 31.4 × 0.3 cm). Virginia Museum of Fine Arts.
The Arthur and Margaret Glasgow Fund. 80.171

established even before he became emperor. His focus on detail was much greater than that of his father. In his memoirs, he claimed:

> My liking for painting and my practice in judging it have arrived at such a point that when any work is brought before me, either of deceased artists or of those of the present day, without their names being told me I say on the spur of the moment that it is the work of such and such a man, and if there be a picture containing many portraits, and each face be the work of a different master, I can discover which face is the work of each of them. And if any other person has put in the eye and eyebrow of a face, I can perceive whose work the original face is and who has painted the eye and eyebrows.

Portraits become a major art under Jahangir. The portrait Jahangir commissioned of himself with the Safavid-dynasty Persian emperor Shah Abbas **(FIG. 23–11)** demonstrates his sense of his superiority: Jahangir is depicted much larger than Shah Abbas, who appears to bow deferentially to the Mughal emperor; Jahangir's head is centered in the halo; and he stands on the lion, whose body

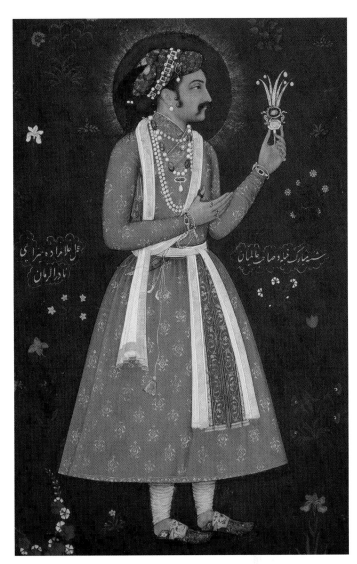

**23-12 • Nadir al-Zaman (Abu'l Hasan) PRINCE KHURRAM, THE FUTURE SHAH JAHAN AT AGE 25**
From the Minto Album. Mughal period, c. 1616–1617. Opaque watercolor, gold and ink on paper, 18⅛ × 4½" (20.6 × 11.5 cm); page 15¼ × 10½" (39 × 26.7 cm). Victoria & Albert Museum, London

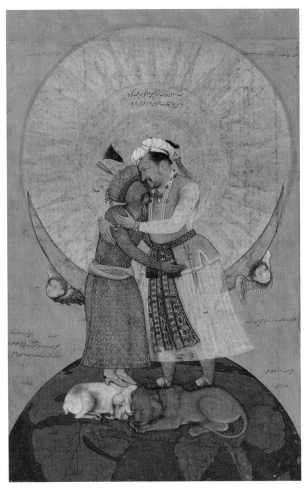

**23-11 • Nadir al-Zaman (Abu'l Hasan) JAHANGIR AND SHAH ABBAS**
From the St. Petersburg Album. Mughal period, c. 1618. Opaque watercolor, gold and ink on paper, 9⅜ × 6" (23.8 × 15.4 cm). Freer Museum of Art, Smithsonian Institution, Washington, DC. Purchase, F1945.9. Freer Gallery, Washington

spans a vast territory, including Shah Abbas's own Persia. We can only speculate on the target audience for this painting. Because it is small, it certainly would not be intended for Jahangir's subjects; a painting of this size could not be publicly displayed. But because we know that paintings were commonly sent by embassies from one kingdom to another, it may have been intended as a gift for Shah Abbas, one with a message of clear strength and superiority cloaked in the diplomatic language of cordiality.

Jahangir was succeeded by his son, Prince Khurram, who took the title Shah Jahan. Although Shah Jahan's greatest artistic achievements were in architecture, painting continued to flourish during his reign. A portrait of Prince Khurram bears an inscription indicating that he considered it "a very good likeness of me at age 25" **(FIG. 23–12)**. Like all portraits of Shah Jahan, this one depicts him in profile, the view that has least likelihood of distortion. Holding an exquisite turban ornament, the prince stands quite

Before the fourteenth century most painting in India had been on walls or palm leaves. With the introduction of paper, about the same time in India as in Europe, Indian artists adapted painting techniques from Persia and over the ensuing centuries produced jewel-toned works on paper.

Painters usually began their training early. As young apprentices, they learned to make brushes and grind pigments. Brushes were made from the curved hairs of a squirrel's tail, arranged to taper from a thick base to a single hair at the tip. Paint came from pigments of vegetables and minerals—lapis lazuli to make blue, malachite for pale green—that were ground to a paste with water, then bound with a solution of gum from the acacia plant. Paper was made by crushing fibers of cotton and jute to a pulp, pouring the mixture onto a woven mat, drying it, and then burnishing with a smooth piece of agate, often achieving a glossy finish.

Artists frequently worked from a collection of sketches belonging to a master painter's atelier. Sometimes, to transfer the drawing to a blank sheet beneath, sketches were pricked with small, closely spaced holes that were then daubed with wet color. The resulting dots were connected into outlines, and the process of painting began.

First, the painter applied a thin wash of a chalk-based white, which sealed the surface of the paper while allowing the underlying sketch to show through. Next, outlines were filled with thick washes of brilliant, opaque, unmodulated color. When the colors were dry, the painting was laid face down on a smooth marble surface and burnished with a rounded agate stone, rubbing first up and down, then side to side. The indirect pressure against the marble polished the pigments to a high luster. Then outlines, details, and modeling—depending on the style—were added with a fine brush.

Sometimes certain details were purposely left for last, such as the eyes, which were said to bring the painting to life. Gold and raised details were applied when the painting was nearly finished. Gold paint, made from pulverized, 24-carat gold leaf bound with acacia gum, was applied with a brush and burnished to a high shine. Raised details such as the pearls of a necklace were made with thick, white, chalk-based paint, with each pearl a single droplet hardened into a tiny raised mound.

---

formally against a dark background, allowing nothing in the painting to compete for the viewer's attention.

## RAJPUT PAINTING

Outside of the Mughal strongholds at Delhi and Agra, much of northern India was governed regionally by local Hindu princes, descendants of the so-called Rajput warrior clans, who were allowed to keep their lands in return for allegiance to the Mughals. Like the Mughals, Rajput princes frequently supported painters at their courts, and in these settings a variety of strong, indigenous Indian painting styles were perpetuated. Rajput painting, more abstract than the Mughal style, included subjects like those treated by Mughal painters, royal portraits and court scenes, as well as indigenous subjects such as Hindu myths, love poetry, and Ragamala illustrations (illustrations of musical modes).

The Hindu devotional movement known as *bhakti*, which had done much to spread the faith in the south from around the seventh century, now experienced a revival in the north. As it had earlier in the south, *bhakti* inspired an outpouring of poetic literature, this time devoted especially to Krishna, the popular human incarnation of the god Vishnu. Most renowned is the *Gita Govinda*, a cycle of rhapsodic poems about the love between God and humans expressed metaphorically through the love between the young Krishna and the cowherd Radha.

The illustration here (**FIG. 23–13**) is from a manuscript of the *Gita Govinda* probably produced in present-day Rajasthan about 1525–50. The blue god Krishna sits in dalliance with a group of cowherd women. Standing with her maid and consumed with love for Krishna, Radha peers through the trees, overcome by jealousy. Her feelings are indicated by the cool blue color behind her, while the crimson red behind the Krishna grouping suggests passion. The curving stalks and bold patterns of the flowering vines and trees express not only the exuberance of springtime, when the story unfolds, but also the heightened emotional tensions of the scene. Birds, trees, and flowers are as brilliant as fireworks against the black, hilly landscape edged in an undulating white line. As in the Jain manuscript earlier (SEE FIG. 23–3), all the figures are of a single type, with plump faces in profile and oversized eyes. Yet the resilient line of the drawing gives them life, and the variety of textile patterns provides some individuality. The intensity and resolute flatness of the scene seem to thrust all of its energy outward, irrevocably engaging the viewer in the drama.

Quite a different mood pervades **HOUR OF COWDUST**, a work from the Kangra School in the Punjab Hills, foothills of the Himalayas north of Delhi (**FIG. 23–14**). Painted around 1790, some 250 years later than the *Gita Govinda* illustration, it shows the influence of Mughal naturalism on the later schools of Indian painting. The theme is again Krishna. Wearing his peacock crown, garland of flowers, and yellow garment—all traditional iconography of Krishna-Vishnu—he returns to the village with his fellow cowherds and their cattle. All eyes are upon him as he plays his flute, said to enchant all who hear it. Women with water jugs on their heads turn to look; others lean from windows to watch and call out to him. We are drawn into this charming village scene by the diagonal movements of the cows as they surge through the gate and into the courtyard beyond. Pastel houses and walls create a sense of space, and in the distance we glimpse other villagers going about their work or peacefully sitting in their houses. A rim of dark trees softens the horizon, and an atmospheric sky completes the aura of enchanted naturalism. Again, all the figures are similar in

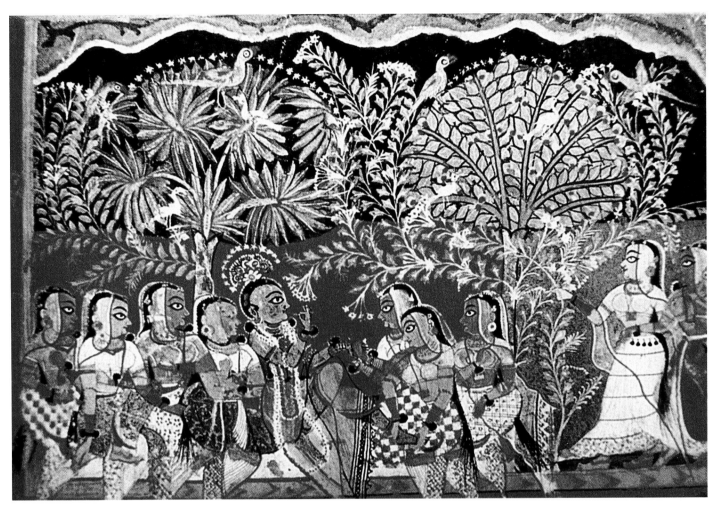

**23-13 • KRISHNA AND THE *GOPIS***

From the *Gita Govinda*, Rajasthan, India. Mughal period,
c. 1525–1550. Gouache on paper, 4⅞ × 7½″ (12.3 × 19 cm). Prince of
Wales Museum, Bombay.

---

The lyrical poem *Gita Govinda*, by the poet-saint Jayadeva, was
probably written in eastern India during the latter half of the twelfth
century. The episode illustrated here occurs early in the relationship
of Radha and Krishna, which in the poem is a metaphor for the
connection between humans and God. The poem traces the progress
of their love through separation, reconciliation, and fulfillment.
Intensely sensuous imagery characterizes the entire poem, as in the
final song, when Krishna welcomes Radha to his bed. (Narayana is the
name of Vishnu in his role as cosmic creator.)

> Leave lotus footprints on my bed of tender shoots, loving Radha!
> Let my place be ravaged by your tender feet!
> Narayana is faithful now. Love me Radhika!
> I stroke your feet with my lotus hand—you have come far.
> Set your golden anklet on my bed like the sun.
> Narayana is faithful now. Love me Radhika!
> Consent to my love. Let elixir pour from your face!
> To end our separation I bare my chest of the silk that bars your breast.
> Narayana is faithful now. Love me Radhika!

(Translated by Barbara Stoler Miller)

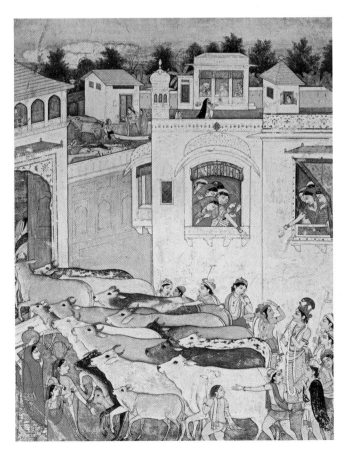

**23-14 • HOUR OF COWDUST**

From Punjab Hills, India. Mughal period, Kangra School,
c. 1790. Gouache on paper, 14¹⁵⁄₁₆ × 12⁹⁄₁₆″ (36 × 31.9 cm). Museum
of Fine Arts, Boston. Denman W. Ross Collection (22.683)

type, this time with a perfection of proportion and a gentle, lyrical movement that complement the idealism of the setting. The scene embodies the sublime purity and grace of the divine, which, as in so much Indian art, is evoked into our human world to coexist with us as one.

# INDIA'S ENGAGEMENT WITH THE WEST

By the time *Hour of Cowdust* was painted, India's regional rulers, both Hindu and Muslim, had reasserted themselves, and the vast Mughal Empire had shrunk to a small area around Delhi. At the same time, however, a new power, Britain, was making itself felt, inaugurating a markedly different period in Indian history.

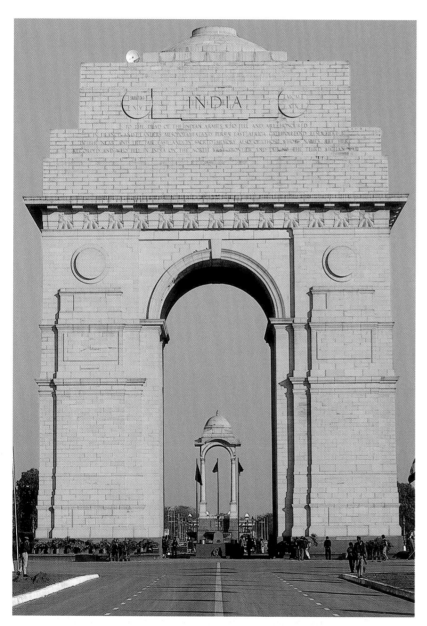

**23-15 • Sir Edwin Lutyens INDIA GATE**
Originally the All India War Memorial. New Delhi. British colonial period, 20th century.

## BRITISH COLONIAL PERIOD

First under the mercantile interests of the British East India Company in the seventeenth and eighteenth centuries, and then under the direct control of the British government as a part of the British Empire in the nineteenth century, India was brought forcefully into contact with the West and its culture, a very different situation from its long-standing role in a world system that had included trade in both commodities and culture. The political concerns of the British Empire extended even to the arts, especially architecture. Over the course of the nineteenth century, the great cities of India, such as Calcutta (present-day Kolkata), Madras (Chennai), and Bombay (Mumbai), took on a European aspect as British architects built in the revivalist styles favored in England.

NEW DELHI. In 1911, the British announced its intention to move the seat of government from Calcutta to a newly constructed Western-style capital city to be built at New Delhi, a move intended to capitalize on the long-standing association of Delhi with powerful rulers such as the Mughals. Two years later, Sir Edwin Lutyens (1869–1944) was appointed joint architect for New Delhi (with Herbert Baker), and was charged with laying out the new city and designing the Viceroy's House, the present-day Rashtrapati Bhavan (President's House). Drawing inspiration from Classical antiquity—as well as from more recent urban models, such as Paris and Washington, D.C.—Lutyens sited the Viceroy's House as a focal point along with the triumphal arch that he designed as the All India War Memorial, now called the **INDIA GATE (FIG. 23–15)**. In these works Lutyens sought to maintain the tradition of Classical architecture—he developed a "Delhi order" based on the Roman Doric—while incorporating massing, detail, and ornamentation derived from Indian architecture as well. The new capital was inaugurated in 1931.

MOTHER INDIA. Far prior to Britain's consolidation of imperial power in New Delhi a new spirit asserting Indian independence and pan-Asiatic solidarity was awakening. For example, working near Calcutta, the painter Abanindranath Tagore (1871–1951)—nephew of the poet Rabindranath Tagore (1861–1941), who went on to win the Nobel Prize for Literature in 1913—deliberately rejected the medium of oil painting and the academic realism of Western art. Like the Nihonga artists of Japan (SEE FIG. 25–15) with whom he was in contact, Tagore strove to create a style that reflected his ethnic origins. In **BHARAT MATA** (Mother India) he invents a nationalistic icon by using Hindu symbols while

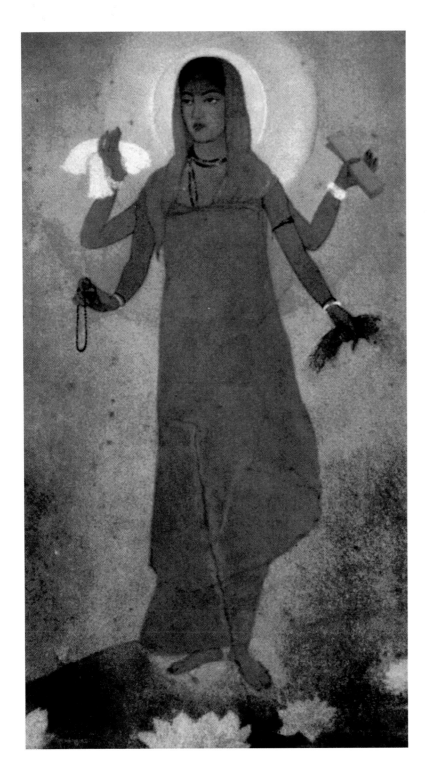

23-16 • Abanindranath Tagore
**BHARAT MATA (MOTHER INDIA)**
1905. Watercolor on paper, 10½ × 6″
(26.7 × 15.3 cm). Rabindra Bharati Society,
Calcutta.

also drawing upon the format and techniques of Mughal and Rajput painting (FIG. 23–16).

## THE MODERN PERIOD

In the wake of World War II, the imperial powers of Europe began to shed their colonial domains. The attainment of self-rule had been five long decades in the making, when finally—chastened by the nonviolent example of Mahatma Gandhi (1869–1948)—the British Empire relinquished its "Jewel in the Crown," which was partitioned to form two modern nations: India and Pakistan. After independence in 1947, the exuberant young nation welcomed a modern, internationalist approach to art and architecture.

JAWAHAR KALA KENDRA. Architect Charles Correa often draws on traditional Indian architectural forms. One example is his impressive **JAWAHAR KALA KENDRA**, a center for the visual and performing arts in Jaipur that was completed in 1992 (FIG. 23–17). Like the original design of Jaipur, the building's design is based on a nine-square plan, and its elevation makes visual reference to the city's historic buildings. Correa's work is not confined to India, but

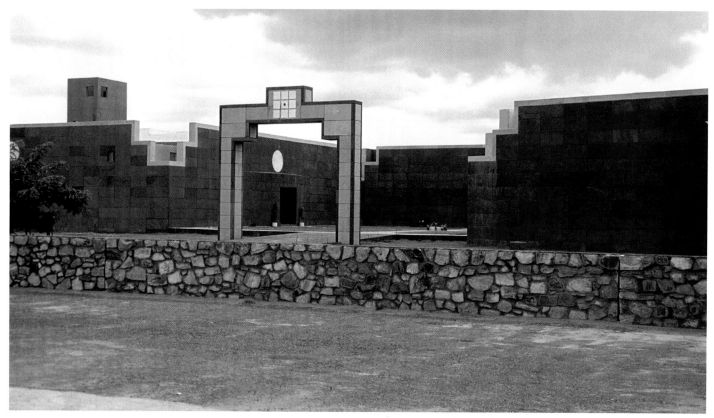

**23–17 • Charles Correa JAWAHAR KALA KENDRA**
1992. Jaipur. Like many of Correa's buildings, this arts center draws upon traditional Indian motifs and forms. Its many open spaces provide a feeling of connected space rather than individual rooms.

includes buildings in Europe and the United States, for example the Cognitive Sciences Complex at MIT completed in 2005.

TWO MODERN ARTISTS. Artists working after Indian independence have continued to study and work abroad, but often draw upon India's distinctive literary and religious traditions as well as regional and folk art traditions. One example is Manjit Bawa (b. 1941), who worked in Britain as a silkscreen artist before returning to India to settle in New Delhi. His distinctive canvases, painted meticulously in oil, juxtapose illusionistically modeled figures and animals against brilliantly colored backgrounds of flat, unmodulated color. The composite result, for example in **DHARMA AND THE GOD (FIG. 23–18)**, brings a strikingly new interpretation to the heroic figures of Indian tradition.

With Anish Kapoor (b. 1954), as with so many artists living abroad, we must consider issues of identity. Although some of his work draws inspiration from his Indian origins, for example, his 1981 composition **AS IF TO CELEBRATE, I DISCOVERED A MOUNTAIN BLOOMING WITH RED FLOWERS (23–19)**, whose red and ocher mounds recall the vermilion and other pigments beautifully piled for sale outside Indian temples, other works make no reference to India. Kapoor represented Britain, where he now lives and works, at the Venice Biennale in 1990, further complicating the issue of his identity.

**23–18 • Manjit Bawa DHARMA AND THE GOD**
1984. Oil on canvas, 85 × 72¹⁵⁄₁₆″ (216 × 185.4 cm). Peabody Essex Museum, Salem, Massachusetts. The Davida and Chester Herwitz Collection

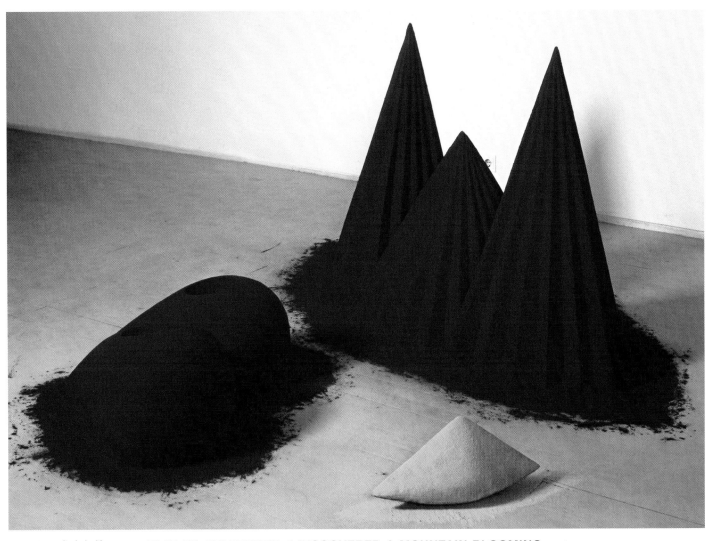

**23–19 • Anish Kapoor  AS IF TO CELEBRATE, I DISCOVERED A MOUNTAIN BLOOMING WITH RED FLOWERS**
1981. Wood, cement, polystyrene and pigment, 3 elements, 38¼ (highest point) × 30 (widest point) × 63″ (97 × 76.2 × 160 cm); 13 × 28 × 32″ (33 × 71.1 × 81.3 cm); 8¼ × 6 × 18½″ (21 × 15.3 × 47 cm), overall dimensions variable. Arts Council Collection, South Bank Centre, London.

## THINK ABOUT IT

**23.1** Explain some of the ways that Islamic art and culture impacted that of the Indian subcontinent. Explain how the Taj Mahal demonstrates influence from building styles studied in Chapter 8, and indicate how it departs from prior styles on the Indian subcontinent.

**23.2** Analyze the Shwe-Dagon Stupa (Pagoda) in Yangon, and determine how the structure incorporates influence from Indian buildings. In your answer, compare the stupa to at least one Indian building.

**23.3** Analyze the form of the India Gate (SEE FIG. 23–15) and explain how the ancient Roman form of the triumphal arch (see, for example, the Arch of Titus (SEE FIG. 6–32) is used within a new Indian context.

**23.4** Explain how the artist Anish Kapoor utilizes Indian themes in his work *As if to Celebrate, I Discovered a Mountain Blooming with Red Flowers* (SEE FIG. 23–19). What other ideas can you infer from this work?

**23.5** From the works discussed in this chapter, select a two-dimensional religious artwork from each of two religions practiced in India. Compare and contrast both directly, determining similarities in regional style and technique as well as differences due to their varying religious contexts.

**PRACTICE MORE:** Compose answers to these questions, get flashcards for images and terms, and review chapter material with quizzes
**www.myartslab.com**

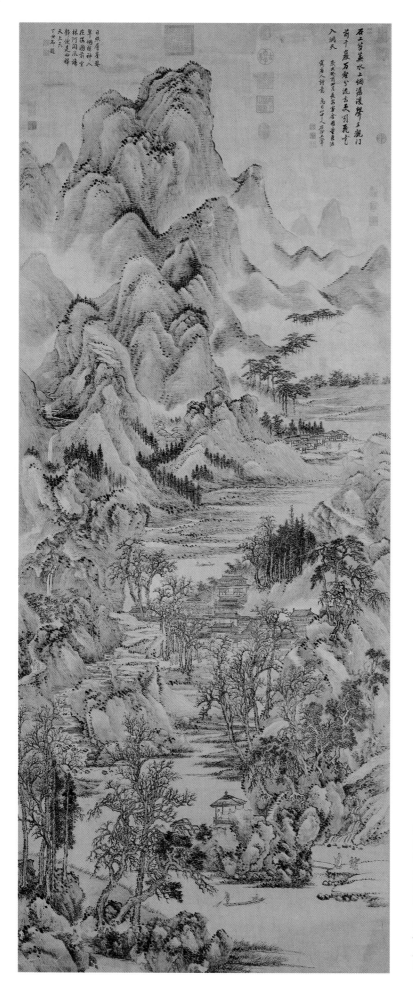

石上苔草水上桐滉瀁摩王視門
荷干歲石聲分流古吳引花竹
入洞天
萬歲晚晴日員長松石南香田重崖法
高木人時蒼為百十八臣宋望筆

日歲辛年秋
年物桂神人
在時國喬堂
林門洞水塘
秋侯是四轉
天上六丁
丁卯高題

**24–1 • Wang Hui  A THOUSAND PEAKS AND MYRIAD RAVINES**
Qing dynasty, 1693. Hanging scroll, ink on paper, 8'2½" × 3'4½" (2.54 × 1.03 m). National Palace Museum, Taibei, Taiwan, Republic of China.

**EXPLORE MORE: Gain insight from a primary source related to *A Thousand Peaks and Myriad Ravines* www.myartslab.com**

# CHINESE AND KOREAN ART AFTER 1279

**A THOUSAND PEAKS AND MYRIAD RAVINES (FIG. 24–1)**, painted by Wang Hui (1632–1717) in 1693, exemplifies the subjects of Chinese landscape painting: mountains, rivers, waterfalls, trees, rocks, temples, pavilions, houses, bridges, boats, wandering scholars, fishers—familiar motifs from a tradition now many centuries old. On it, the artist has written:

> Moss and weeds cover the rocks and mist hovers over the water.
> The sound of dripping water is heard in front of the temple gate.
> Through a thousand peaks and myriad ravines the spring flows,
> And brings the flying flowers into the sacred caves.
>
> In the fourth month of the year 1693, in an inn in the capital, I
> painted this based on a Tang-dynasty poem in the manner of
> [the painters] Dong [Yuan] and Ju[ran].
>
> (Translation by Chu-tsing Li)

The inscription refers to the artist's inspiration found in the lines of a Tang-dynasty poem, which offered the subject, and in the paintings of tenth-century painters Dong Yuan and Juran, on which he based his style. Wang Hui's art reflects ideals of the scholar in imperial China.

China's scholar class was unique, the product of an examination system designed to recruit the finest minds in the country for government service. Instituted during the Tang dynasty (618–907) and based on even earlier traditions, the civil service examinations were excruciatingly difficult, but for the tiny percentage who passed at the highest level, the rewards were prestige, position, power, and wealth. Steeped in philosophy, literature, and history, China's scholars—often called *wenren* (literati)—shared a common outlook. Following Confucianism, they became officials to fulfill their obligation to the world; pulled by Daoism, they retreated from society in order to come to terms with nature and the universe: to create a garden, to write poetry, to paint.

During the Song dynasty (960–1279) the examinations were expanded and regularized. More than half of all government positions came to be filled by scholars. In the subsequent Yuan and Ming periods, the tradition of **literati painting** (a style that reflected the taste of the educated class) further developed. When the Yuan period of foreign rule came to an end, the new Ming ruling house revived the court traditions of the Song. The Ming became the model for the rulers of Korea's Joseon dynasty, under whose patronage these styles achieved a distinctive and austere beauty.

In the Qing era, China was again ruled by an outside group, this time the Manchus. While maintaining their traditional connections to Tibet and inner Asia through their patronage of Tibetan Buddhism, the Manchu rulers also embraced Chinese ideals, especially those of the literati. Practicing painting and calligraphy, composing poetry in Chinese, and collecting esteemed Chinese works of art, these rulers amassed the great palace collections that can now be seen in Beijing and Taibei.

## LEARN ABOUT IT

**24.1** Analyze the continued importance of the three ways of thought (Daoism, Confucianism, and Buddhism) in Chinese art of the thirteenth century to the present.

**24.2** Assess the influence of court life and patronage on art in China and Korea.

**24.3** Examine the continuing relationship of calligraphy and painting in Chinese art.

**24.4** Discuss literati values and the scholarly life in art in later China and Korea.

**24.5** Assess the emergence of expression as a value of importance beyond representation in China and Korea, from the thirteenth century to the present.

**HEAR MORE:** Listen to an audio file of your chapter **www.myartslab.com**

# THE MONGOL INVASIONS

At the beginning of the thirteenth century the Mongols, a nomadic people from the steppes north of China, began to amass an empire. Led first by Genghiz Khan (c. 1162–1227), then by his sons and grandsons, they swept westward into central Europe and overran Islamic lands from Central Asia through present-day Iraq. To the east, they quickly captured northern China, and in 1279, led by Kublai Khan, they conquered southern China as well. Grandson of the mighty Genghiz, Kublai proclaimed himself emperor of China and founder of the Yuan dynasty (1279–1368).

The Mongol invasions were traumatic, and their effect on China was long-lasting. During the Song dynasty, China had grown increasingly introspective. Rejecting foreign ideas and influences, intellectuals had focused on defining the qualities that constituted true "Chinese-ness." They drew a clear distinction between their own people, whom they characterized as gentle, erudite, and sophisticated, and the "barbarians" outside China's borders, whom they regarded as crude, wild, and uncivilized. Now, faced with the reality of barbarian occupation, China's inward gaze intensified in spiritual resistance. For centuries to come, long after the Mongols had gone, leading scholars continued to seek intellectually more challenging, philosophically more profound, and artistically more subtle expressions of all that could be identified as authentically Chinese (see "Foundations of Chinese Culture," opposite).

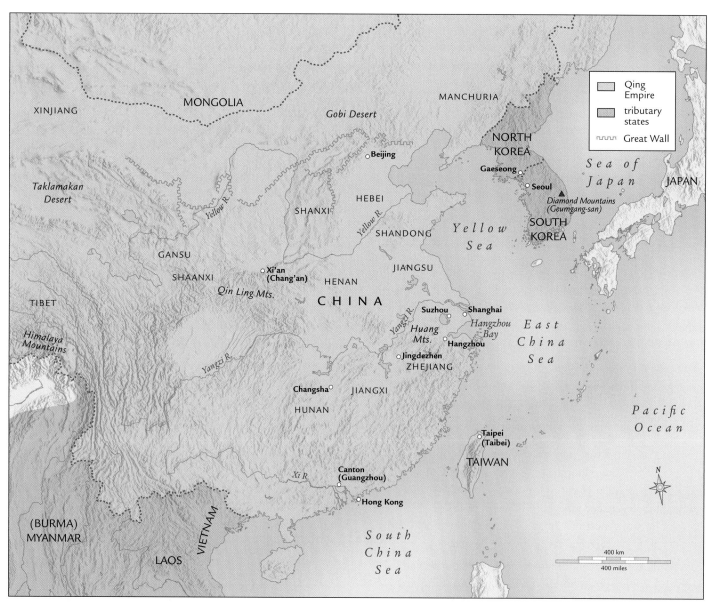

**MAP 24-1 • CHINA AND KOREA**

The map shows the borders of both contemporary China and Korea. The colored areas indicate the historical extent of the Qing dynasty empire (1644–1911) including its tributary states.

## Foundations of Chinese Culture

Chinese culture is distinguished by its long and continuous development. Between 6000 and 2000 BCE a variety of Neolithic cultures flourished across China. Through long interaction these cultures became increasingly similar and they eventually gave rise to the three Bronze Age dynastic states with which Chinese history traditionally begins: the Xia, the Shang (c. 1700–1100 BCE), and the Zhou (1100–221 BCE).

The Shang developed traditions of casting ritual vessels in bronze, working jade in ceremonial shapes, and writing consistently in scripts that directly evolved into the modern Chinese written language. Society was stratified, and the ruling group maintained its authority in part by claiming power as intermediaries between the human and spirit worlds. Under the Zhou a feudal society developed, with nobles related to the king ruling over numerous small states.

During the latter part of the Zhou dynasty, states began to vie for supremacy through intrigue and increasingly ruthless warfare. The collapse of social order profoundly influenced China's first philosophers, who largely concerned themselves with the pragmatic question of how to bring about a stable society.

In 221 BCE, rulers of the state of Qin triumphed over the remaining states, unifying China as an empire for the first time. The Qin created the mechanisms of China's centralized bureaucracy, but their rule was harsh and the dynasty was quickly overthrown. During the ensuing Han dynasty (206 BCE–220 CE), China at last knew peace and prosperity. Confucianism was made the official state ideology, in the process assuming the form and force of a religion. Developed from the thought of Confucius (551–479 BCE), one of the many philosophers of the Zhou, Confucianism is an ethical system for the management of society based on establishing correct relationships among people. Providing a counterweight was Daoism, which also came into its own during the Han dynasty. Based on the thought of Laozi, a possibly legendary contemporary of Confucius, and the philosopher Zhuangzi (369–286 BCE), Daoism is a view of life that seeks to harmonize the individual with the Dao, or Way, the process of the universe. Confucianism and Daoism have remained central to Chinese thought—the one addressing the public realm of duty and conformity, the other the private world of individualism and creativity.

Following the collapse of the Han dynasty, China experienced a centuries-long period of disunity (220–589 CE). Invaders from the north and west established numerous kingdoms and dynasties, while a series of six precarious Chinese dynasties held sway in the south. Buddhism, which had begun to spread over trade routes from India during the Han era, now flourished. The period also witnessed the economic and cultural development of the south (previous dynasties had ruled from the north).

China was reunited under the Sui dynasty (581–618 CE), which quickly fell to the Tang (618–907), one of the most successful dynasties in Chinese history. Strong and confident, Tang China fascinated and, in turn, was fascinated by the cultures around it. Caravans streamed across central Asia to the capital, Chang'an, then the largest city in the world. Japan and Korea sent thousands of students to study Chinese culture, and Buddhism reached the height of its influence before a period of persecution signaled the start of its decline.

The mood of the Song dynasty (960–1279) was quite different. The martial vigor of the Tang gave way to a culture of increasing refinement and sophistication, and Tang openness to foreign influences was replaced by a conscious cultivation of China's own traditions. In art, landscape painting emerged as the most esteemed genre, capable of expressing both philosophical and personal concerns. With the fall of the north to invaders in 1126, the Song court set up a new capital in the south, which became the cultural and economic center of the country.

## YUAN DYNASTY

The Mongols established their capital in the northern city now known as Beijing (MAP 24–1). The cultural centers of China, however, remained the great cities of the south, where the Song court had been located for the previous 150 years. Combined with the tensions of Yuan rule, this separation of China's political and cultural centers created a new dynamic in the arts.

Throughout most of Chinese history, the imperial court had set the tone for artistic taste: Artisans attached to the court produced architecture, paintings, gardens, and objects of jade, lacquer, ceramics, and silk especially for imperial use. Over the centuries, painters and calligraphers gradually moved higher up the social scale, for these "arts of the brush" were often practiced by scholars and even emperors, whose high status reflected positively on whatever interested them. With the establishment of an imperial painting academy during the Song dynasty, painters finally achieved a status equal to that of court officials. For the literati, painting came to be grouped with calligraphy and poetry as the trio of accomplishments suited to members of the cultural elite.

But while the literati elevated the status of painting by virtue of practicing it, they also began to develop their own ideas of what painting should be. Not needing to earn an income from their art, they cultivated an amateur ideal in which personal expression counted for more than "mere" professional skill. They created for themselves a status as artists totally separate from and superior to professional painters, whose art they felt was inherently compromised, since it was done to please others, and impure, since it was tainted by money.

The conditions of Yuan rule now encouraged a clear distinction between court taste, ministered to by professional

## Marco Polo

China under Kublai Khan was one of four Mongol khanates that together extended west into present-day Iraq and through Russia to the borders of Poland and Hungary. For roughly a century, travelers moved freely across this vast expanse, making the era one of unprecedented cross-cultural exchange. Diplomats, missionaries, merchants, and adventurers flocked to the Yuan court, and Chinese envoys were dispatched to the West. The most celebrated European traveler of the time was a Venetian named Marco Polo (c. 1254–1324), whose descriptions of his travels were for several centuries the only firsthand account of China available in Europe.

Marco Polo was still in his teens when he set out for China in 1271. He traveled with his uncle and father, both merchants, bearing letters for Kublai Khan from Pope Gregory X. After a four-year journey the

Polos arrived at last in Beijing. Marco became a favorite of the emperor and spent the next 17 years in his service, during which time he traveled extensively throughout China. He eventually returned home in 1295.

Imprisoned later during a war between Venice and Genoa, rival Italian city-states, Marco Polo passed the time by dictating an account of his experiences to a fellow prisoner. The resulting book, *A Description of the World*, has fascinated generations of readers with its depiction of prosperous and sophisticated lands in the East. Translated into many European languages, it was an important influence in stimulating further exploration. When Columbus set sail across the Atlantic in 1492, one of the places he hoped to find was a country Marco Polo called Zipangu—Japan.

---

artists and artisans, and literati taste. The Yuan dynasty continued the imperial role as patron of the arts, commissioning buildings, murals, gardens, paintings, and decorative arts. Western visitors such as the Italian Marco Polo were impressed by the magnificence of the Yuan court (see "Marco Polo," above). But scholars, profoundly alienated from the new government, took little notice of these accomplishments. Nor did Yuan rulers have much use for scholars, especially those from the south. The civil service examinations were abolished, and the highest government positions were bestowed, instead, on Mongols and their foreign allies. Scholars now tended to turn inward, to search for solutions of their own and to try to express themselves in personal and symbolic terms.

ZHAO MENGFU. Zhao Mengfu (1254–1322) was a descendant of the imperial line of Song. Unlike many scholars of his time, he eventually chose to serve the Yuan government and was made a high official. A painter, calligrapher, and poet, all of the first rank,

Zhao was especially known for his carefully rendered paintings of horses. But he also cultivated another manner, most famous in his landmark painting **AUTUMN COLORS ON THE QIAO AND HUA MOUNTAINS (FIG. 24–2)**.

Zhao painted this work for a friend whose ancestors came from Jinan, the present-day capital of Shandong Province, and the painting supposedly depicts the landscape there. Yet the mountains and trees are not painted in the accomplished naturalism of Zhao's own time but rather in the archaic yet oddly elegant manner of the earlier Tang dynasty (618–907). The Tang dynasty was a great era in Chinese history, when the country was both militarily strong and culturally vibrant. Through his painting Zhao evoked a nostalgia not only for his friend's distant homeland but also for China's past.

This educated taste for the "spirit of antiquity" became an important aspect of literati painting in later periods. Also typical of literati taste are the unassuming brushwork, the subtle colors sparingly used (many literati paintings forgo color altogether), the use of landscape to convey personal meaning, and even the

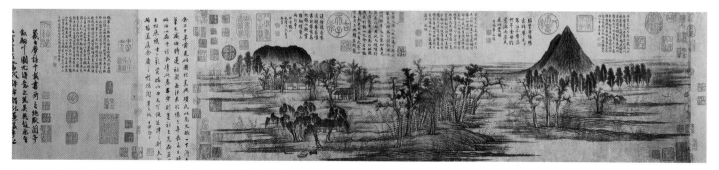

**24-2 • Zhao Mengfu AUTUMN COLORS ON THE QIAO AND HUA MOUNTAINS**
Yuan dynasty, 1296. Handscroll, ink and color on paper, 11¼ × 36¾" (28.6 × 9.3 cm). National Palace Museum, Taibei, Taiwan, Republic of China.

intended audience—a close friend. The literati did not paint for public display but for each other. They favored small formats such as **handscrolls**, **hanging scrolls**, or **album leaves** (book pages), which could easily be shown to friends or shared at small gatherings (see "Formats of Chinese Painting," page 797).

NI ZAN. Of the considerable number of Yuan painters who took up Zhao's ideas, several became models for later generations. One such was Ni Zan (1301–74), whose most famous surviving painting is **THE RONGXI STUDIO** (FIG. 24–3). Done entirely in ink, the painting depicts the lake region in Ni's home district. Mountains, rocks, trees, and a pavilion are sketched with a minimum of detail using a dry brush technique—a technique in which the brush is not fully loaded with ink but rather is about to run out, so that white paper "breathes" through the ragged strokes. The result is a painting with a light touch and a sense of simplicity and purity. Literati styles were believed to reflect the painter's personality. Ni's spare, dry style became associated with a noble spirit, and many later painters adopted it or paid homage to it.

Ni Zan was one of those eccentrics whose behavior has become legendary in the history of Chinese art. In his early years he was one of the richest men in the region, the owner of a large estate. His pride and his aloofness from daily affairs often got him into trouble with the authorities. His cleanliness was notorious. In addition to washing himself several times daily, he also ordered his servants to wash the trees in his garden and to clean the furniture after his guests had left. He was said to be so unworldly that late in life he gave away most of his possessions and lived as a hermit in a boat, wandering on rivers and lakes.

Whether these stories are true or not, they were important elements of Ni's legacy to later painters, for Ni's life as well as his art served as a model. The painting of the literati was bound up with certain views about what constituted an appropriate life. The ideal, as embodied by Ni Zan and others, was of a brilliantly gifted scholar whose spirit was too refined for the dusty world of government service and who thus preferred to live as a recluse, or as one who had retired after having become frustrated by a brief stint as an official.

## MING DYNASTY

The founder of the next dynasty, the Ming (1368–1644), came from a family of poor uneducated peasants. As he rose through the ranks in the army, he enlisted the help of scholars to gain power and solidify his following. Once he had driven the Mongols from Beijing and firmly established himself as emperor, however, he grew to distrust intellectuals. His rule was despotic, even ruthless. Throughout the nearly 300 years of Ming rule most emperors shared his attitude, so although the civil service examinations were reinstated, scholars remained alienated from the government they were trained to serve.

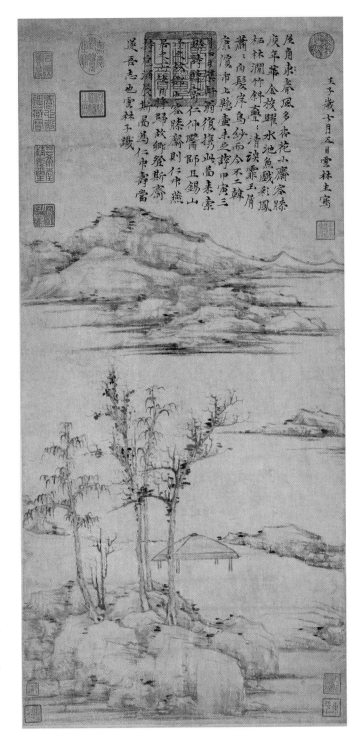

**24-3 • Ni Zan THE RONGXI STUDIO**
Yuan dynasty, 1372. Hanging scroll, ink on paper, height 29⅜"
(74.6 cm). National Palace Museum, Taibei, Taiwan, Republic of China.

The idea that a painting is not done to capture a likeness or to satisfy others but is executed freely and carelessly for the artist's own amusement is at the heart of the literati aesthetic. Ni Zan once wrote this comment on a painting: "What I call painting does not exceed the joy of careless sketching with a brush. I do not seek formal likeness but do it simply for my own amusement. Recently I was rambling about and came to a town. The people asked for my pictures, but wanted them exactly according to their own desires and to represent a specific occasion. [When I could not satisfy them,] they went away insulting, scolding, and cursing in every possible way. What a shame! But how can one scold a eunuch for not growing a beard?" (translated in Bush and Shih, p. 266).

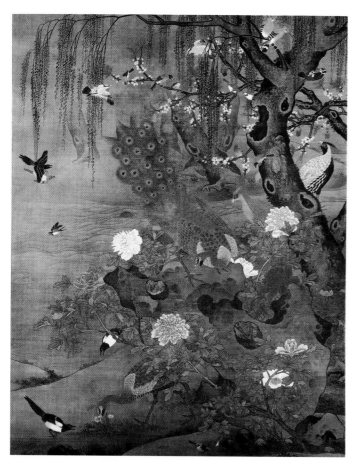

**24-4 • Yin Hong  HUNDREDS OF BIRDS ADMIRING THE PEACOCKS**
Ming dynasty, late 15th–early 16th century. Hanging scroll, ink and color on silk, 7'10½" × 6'5" (2.4 × 1.96 m). Cleveland Museum of Art. Purchase from the J. H. Wade Fund, 74.31

**24-5 • Dai Jin  RETURNING HOME LATE FROM A SPRING OUTING**
Ming dynasty. Hanging scroll, ink on silk, 5½' × 2'8¾" (1.68 × 0.83 m). National Palace Museum, Taibei, Taiwan, Republic of China.

## COURT AND PROFESSIONAL PAINTING

The contrast between the luxurious world of the court and the austere ideals of the literati continued through the Ming dynasty.

A typical example of Ming court taste is **HUNDREDS OF BIRDS ADMIRING THE PEACOCKS**, a large painting on silk by Yin Hong, an artist active during the late fifteenth and early sixteenth centuries (**FIG. 24–4**). A pupil of well-known courtiers, Yin most probably served in the court at Beijing. The painting is an example of the birds-and-flowers genre, which had been popular with artists

of the Song academy. Here the subject takes on symbolic meaning, with the homage of the birds to the peacocks representing the homage of court officials to the imperial state. The style goes back to Song academy models, although the large format and multiplication of details are traits of the Ming.

A related, yet bolder and less constrained, landscape style was also popular during this period. Sometimes called the Zhe style since its roots were in Hangzhou, Zhejiang Province, where the Southern Song court had been located, this manner especially influenced

**24-6 • Qiu Ying  SECTION OF SPRING DAWN IN THE HAN PALACE**
Ming dynasty, 1500–1550. Handscroll, ink and color on silk, 1' × 18'13⁄16" (0.30 × 5.7 m). National Palace Museum, Taibei, Taiwan, Republic of China.

# TECHNIQUE | Formats of Chinese Painting

With the exception of large wall paintings that typically decorated palaces, temples, and tombs, most Chinese paintings were done in ink and water-based colors on silk or paper. Finished works were generally mounted as **handscrolls**, **hanging scrolls**, or leaves in an album.

An album comprises a set of paintings of identical size mounted in a book. (A single painting from an album is called an **album leaf**.) The paintings in an album are usually related in subject, such as various views of a famous site or a series of scenes glimpsed on one trip.

Album-sized paintings might also be mounted as a handscroll, a horizontal format generally about 12 inches high and anywhere from a few feet to dozens of feet long. More typically, however, a handscroll would be a single continuous painting. Handscrolls were not meant to be displayed all at once, the way they are commonly presented today in museums. Rather, they were unrolled only occasionally, to be savored in much the same spirit as we might view a favorite film. Placing the scroll on a flat surface such as a table, a viewer would unroll it a foot or two at a time, moving gradually through the entire scroll from right to left, lingering over favorite details. The scroll was then rolled up and returned to its box until the next viewing.

Like handscrolls, hanging scrolls were not displayed permanently but were taken out for a limited time: a day, a week, a season. Unlike a handscroll, however, the painting on a hanging scroll was viewed as a whole—unrolled and put up on a wall, with the roller at the lower end acting as a weight to help the scroll hang flat. Although some hanging scrolls are quite large, they are still fundamentally intimate works, not intended for display in a public place.

Creating a scroll was a time-consuming and exacting process accomplished by a professional mounter. The painting was first backed with paper to strengthen it. Next, strips of paper-backed silk were pasted to the top, bottom, and sides, framing the painting on all four sides. Additional silk pieces were added to extend the scroll horizontally or vertically, depending on the format. The assembled scroll was then backed again with paper and fitted with a half-round dowel, or wooden rod, at the top of a hanging scroll or on the right end of a handscroll, with ribbons for hanging and tying, and with a wooden roller at the other end. Hanging scrolls were often fashioned from several patterns of silk, and a variety of piecing formats were developed and codified. On a handscroll, a painting was generally preceded by a panel giving the work's title and often followed by a long panel bearing **colophons**—inscriptions related to the work, such as poems in its praise or comments by its owners over the centuries. A scroll would be remounted periodically to better preserve it, and colophons and inscriptions would be preserved in each remounting. **Seals** added another layer of interest. A treasured scroll often bears not only the seal of its maker but also those of collectors and admirers through the centuries.

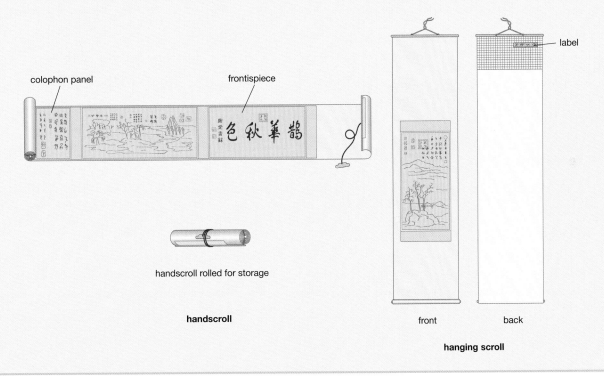

colophon panel

frontispiece

handscroll rolled for storage

**handscroll**

label

front      back

**hanging scroll**

painters in Korea and Japan. A major example is **RETURNING HOME LATE FROM A SPRING OUTING (FIG. 24–5)**, unsigned but attributed to Dai Jin (1388–1462). This work reflects the Chinese sources for such artists as An Gyeon (SEE FIG. 24–17) and Sesshu (SEE FIG. 25–3).

**QIU YING.** A preeminent professional painter in the Ming period was Qiu Ying (1494–1552), who lived in Suzhou, a prosperous southern city. He inspired generations of imitators with exceptional works, such as a long handscroll known as **SPRING DAWN IN THE HAN PALACE (FIG. 24–6)**. The painting is based on Tang-dynasty depictions of women in the court of the Han dynasty (206 BCE–220 CE). While in the service of a well-known collector, Qiu Ying had the opportunity to study many Tang paintings, whose artists usually concentrated on the figures, leaving out the

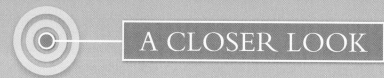
*Spring Dawn in the Han Palace* ▶  Ming dynasty, 1500–1550. Section of a handscroll, ink and color on silk, 1' × 18¹³⁄₁₆" (0.30 × 5.7 m). National Palace Museum, Taibei, Taiwan, Republic of China.

Two ladies unwrap a *qin*, the zither or lute that was the most respected of musical instruments.

A seated lady plays the *pipa*, an instrument introduced from Central Asia during the Tang dynasty.

Antique vessels of bronze, lacquer, and porcelain adorn the room and suggest the ladies' refined taste.

A tray landscape featuring an eroded rock provides a sculptural counterpart to landscape (mountain-and-water) painting and suggests a place where immortals might dwell.

Two ladies dance together letting their sleeves and sashes swirl.

SEE MORE: View the Closer Look feature for the detail of *Spring Dawn in the Han Palace* **www.myartslab.com**

background entirely. Qiu's graceful and elegant figures—although modeled after those in Tang works—are portrayed in a setting of palace buildings, engaging in such pastimes as chess, music, calligraphy, and painting. With its antique subject matter, refined technique, and flawless taste in color and composition, *Spring Dawn in the Han Palace* brought professional painting to a new high point (see "A Closer Look," above).

### DECORATIVE ARTS

Qiu Ying painted to satisfy his patrons in Suzhou. The cities of the south were becoming wealthy, and newly rich merchants collected

paintings, antiques, and art objects. The court, too, was prosperous and patronized the arts on a lavish scale. In such a setting, the decorative arts thrived.

MING BLUE-AND-WHITE WARES.  The Ming became famous the world over for its exquisite ceramics, especially **porcelain** (see "The Secret of Porcelain," opposite). The imperial kilns in Jingdezhen, in Jiangxi Province, became the most renowned center for porcelain not only in all of China, but in all the world. Particularly noteworthy are the blue-and-white wares produced there during the ten-year reign of the ruler known as the Xuande

Marco Polo, it is said, was the one who named a new type of ceramic he found in China. Its translucent purity reminded him of the smooth whiteness of the cowry shell, *porcellana* in Italian. **Porcelain** is made from kaolin, an extremely refined white clay, and petuntse, a variety of the mineral feldspar. When properly combined and fired at a sufficiently high temperature, the two materials fuse into a glasslike, translucent ceramic that is far stronger than it looks.

Porcelaneous stoneware, fired at lower temperatures, was known in China by the seventh century, but true porcelain was perfected during the Song dynasty. To create blue-and-white porcelain such as the flask in FIGURE 24–7, blue pigment was made from cobalt oxide, finely

ground and mixed with water. The decoration was painted directly onto the unfired porcelain vessel, then a layer of clear glaze was applied over it. (In this technique, known as **underglaze** painting, the pattern is painted beneath the glaze.) After firing, the piece emerged from the kiln with a clear blue design set sharply against a snowy white background.

Entranced with the exquisite properties of porcelain, European potters tried for centuries to duplicate it. The technique was finally discovered in 1709 by Johann Friedrich Böttger in Dresden, Germany, who tried—but failed—to keep it a secret.

**24-7 • FLASK**
Ming dynasty, 1426–1435. Porcelain with decoration painted in underglaze cobalt blue. Collection of the Palace Museum, Beijing.

Dragons have featured prominently in Chinese folklore from earliest times—Neolithic examples have been found painted on pottery and carved in jade. In Bronze Age China, dragons came to be associated with powerful and sudden manifestations of nature, such as wind, thunder, and lightning. At the same time, dragons became associated with superior beings such as virtuous rulers and sages. With the emergence of China's first firmly established empire during the Han dynasty, the dragon was appropriated as an imperial symbol, and it remained so throughout Chinese history. Dragon sightings were duly recorded and considered auspicious. Yet even the Son of Heaven could not monopolize the dragon. During the Tang and Song dynasties the practice arose of painting pictures of dragons to pray for rain, and for Chan (Zen) Buddhists, the dragon was a symbol of sudden enlightenment.

Emperor (ruled 1426–1435), such as the **FLASK** in **FIGURE** 24–7. The subtle shape, the refined yet vigorous decoration of dragons posturing above the sea, and the flawless glazing embody the high achievement of Ming artisans.

## ARCHITECTURE AND CITY PLANNING

Centuries of warfare and destruction have left very few Chinese architectural monuments intact. The most important remaining example of traditional Chinese architecture is **THE FORBIDDEN CITY**, the imperial palace compound in Beijing, whose principal buildings were constructed during the Ming dynasty (**FIG. 24–8**).

THE FORBIDDEN CITY.    The basic plan of Beijing was the work of the Mongols, who laid out their capital city according to traditional Chinese principles. City planning began early in China—in the seventh century, in the case of Chang'an (present-day Xi'an), the capital of the Sui and Tang emperors. The walled city of Chang'an was laid out on a rectangular grid, with evenly spaced streets that ran north–south and east–west. At the northern end stood a walled imperial complex.

Beijing, too, was developed as a walled, rectangular city with streets laid out in a grid. The palace enclosure occupied the center of the northern part of the city, which was reserved for the Mongols. Chinese lived in the southern third of the city. Later, Ming and Qing emperors preserved this division, with officials living in the northern or Inner City and commoners living in the southern or Outer City. Under the third Ming emperor, Yongle (ruled 1403–1424), the Forbidden City was rebuilt as we see it today.

The approach to the Forbidden City was impressive. Visitors entered through the Meridian Gate, a monumental gate with side wings (SEE FIG. 24–8). Inside the Meridian Gate a broad courtyard is crossed by a bow-shaped waterway that is spanned by five arched marble bridges. At the opposite end of the courtyard is the Gate of Supreme Harmony, opening onto an even larger courtyard that houses three ceremonial halls raised on a broad platform. First is the Hall of Supreme Harmony, where, on the most important state occasions, the emperor was seated on his throne,

**24-8 • THE FORBIDDEN CITY**
Now the Palace Museum, Beijing. Mostly Ming dynasty.
View from the southwest.

**SEE MORE:** View a simulation about the Forbidden City
www.myartslab.com

facing south. Beyond is the smaller Hall of Central Harmony, then the Hall of Protecting Harmony. Behind these vast ceremonial spaces, still on the central axis, is the inner court, again with a progression of three buildings, this time more intimate in scale. In its balance and symmetry the plan of the Forbidden City reflects ancient Chinese beliefs about the harmony of the universe, and it emphasizes the emperor's role as the Son of Heaven, whose duty was to maintain the cosmic order from his throne in the middle of the world.

## THE LITERATI AESTHETIC

In the south, particularly in the district of Suzhou, literati painting, associated with the educated men who served the court as government officials, remained the dominant trend. One of the major literati figures from the Ming period is Shen Zhou (1427–1509), who had no desire to enter government service and spent most of his life in Suzhou. He studied the Yuan painters avidly and tried to recapture their spirit in such works as *Poet on a Mountaintop* (see "*Poet on a Mountaintop*," page 802). Although the style of the painting recalls the freedom and simplicity of Ni Zan (SEE FIG. 24–3), the motif of a poet surveying the landscape from a mountain plateau is Shen's creation.

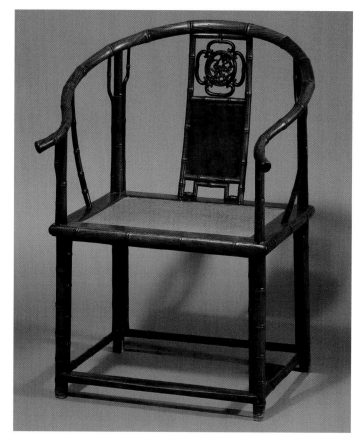

**24-9 • ARMCHAIR**
Ming dynasty, 16th–17th century. Huanghuali wood (hardwood), 39⅜ × 27¼ × 20″ (100 × 69.2 × 50.8 cm). The Nelson-Atkins Museum of Art, Kansas City, Missouri. Purchase, Nelson Trust (46-78/1)

**24-10 • GARDEN OF THE CESSATION OF OFFICIAL LIFE (ALSO KNOWN AS THE HUMBLE ADMINISTRATOR'S GARDEN)**
Suzhou, Jiangsu. Ming dynasty, early 16th century.

Early in the sixteenth century, an official in Beijing, frustrated after serving in the capital for many years without promotion, returned home. Taking an ancient poem, "The Song of Leisurely Living," for his model, he began to build a garden. He called his retreat the Garden of the Cessation of Official Life to indicate that he had exchanged his career as a bureaucrat for a life of leisure. By leisure, he meant that he could now dedicate himself to calligraphy, poetry, and painting, the three arts dear to scholars in China.

LITERATI INFLUENCE ON FURNITURE, ARCHITECTURE, AND GARDEN DESIGN. The taste of the literati came to influence furniture and architecture, and especially the design of gardens. Chinese furniture made for domestic use reached the height of its development in the sixteenth and seventeenth centuries. Characteristic of Chinese furniture, the chair in **FIGURE 24–9** is constructed without the use of glue or nails. Instead, pieces fit together based on the principle of the **mortise-and-tenon** joint, in which a projecting element (tenon) on one piece fits snugly into a cavity (mortise) on another. Each piece of the chair is carved, as opposed to being bent or twisted, and the joints are crafted with great precision. The patterns of the wood grain provide subtle interest unmarred by any

painting or other embellishment. The style, like that of Chinese architecture, is one of simplicity, clarity, symmetry, and balance. The effect is formal and dignified but natural and simple—virtues central to the Chinese view of proper human conduct as well.

The art of landscape gardening also reached a high point during the Ming dynasty, as many literati surrounded their homes with gardens. The most famous gardens were created in the southern cities of the Yangzi Delta, especially in Suzhou. The largest surviving garden of the era is the **GARDEN OF THE CESSATION OF OFFICIAL LIFE (FIG. 24–10)**. Although modified and reconstructed many times through the centuries, it still reflects many of the basic ideas of the original Ming owner. About a third of the garden is

## Poet on a Mountaintop

In earlier landscape paintings, human figures were typically shown dwarfed by the grandeur of nature. Travelers might be seen scuttling along a narrow path by a stream, while overhead towered mountains whose peaks conversed with the clouds and whose heights were inaccessible. Here, the poet has climbed the mountain and dominates the landscape. Even the clouds are beneath him. Before his gaze, a poem hangs in the air, as though he were projecting his thoughts.

The poem, composed by Shen Zhou himself, and written in his distinctive hand, reads:

White clouds like a scarf enfold the mountain's waist;
Stone steps hang in space—a long, narrow path.
Alone, leaning on my cane, I gaze intently at the scene,
And feel like answering the murmuring brook with the music of my flute.

(Translation by Jonathan Chaves, *The Chinese Painter as Poet*, New York, 2000, p. 46.)

Shen Zhou composed the poem and wrote the inscription at the time he painted the album. The style of the calligraphy, like the style of the painting, is informal, relaxed, and straightforward—qualities that were believed to reflect the artist's character and personality.

The painting reflects Ming philosophy, which held that the mind, not the physical world, was the basis for reality. With its perfect synthesis of poetry, calligraphy, and painting, and with its harmony of mind and landscape, *Poet on a Mountaintop* represents the essence of Ming literati painting.

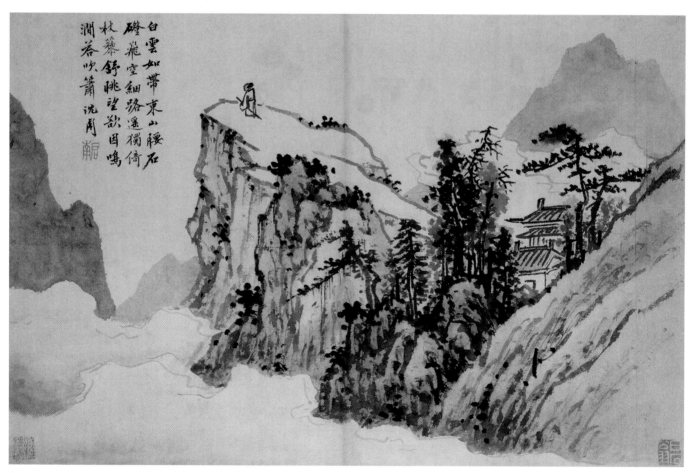

**Shen Zhou  POET ON A MOUNTAINTOP**
Leaf from an album of landscapes; painting mounted as part of a handscroll. Ming dynasty, c. 1500. Ink and color on paper, 15¼ × 23¾″ (40 × 60.2 cm). Nelson-Atkins Museum of Art, Kansas City, Missouri. Purchase, Nelson Trust (46-51/2)

devoted to water through artificially created brooks and ponds. The landscape is dotted with pavilions, kiosks, libraries, studios, and corridors. Many of the buildings have poetic names, such as Rain Listening Pavilion and Bridge of the Small Flying Rainbow.

**DONG QICHANG, LITERATI THEORIST.** The ideas underlying literati painting found their most influential expression in the writings of Dong Qichang (1555–1636). A high official in the late Ming period, Dong Qichang embodied the literati tradition as poet, calligrapher, and painter. He developed a view of Chinese art history that divided painters into two opposing schools, northern and southern. The names have nothing to do with geography— a painter from the south might well be classed as northern—but reflect a parallel Dong drew with the northern and southern schools of Chan (Zen) Buddhism in China. The southern school of Chan, founded by the eccentric monk Huineng (638–713), was unorthodox, radical, and innovative; the northern school was traditional and conservative. Similarly, Dong's two schools of painters represented progressive and conservative traditions. In Dong's view the conservative northern school was dominated by professional painters whose academic, often decorative, style emphasized technical skill. In contrast, the progressive southern school preferred ink to color and free brushwork to meticulous detail. Its painters aimed for poetry and personal expression. In promoting this theory, Dong gave his unlimited sanction to literati painting, which he positioned as the culmination of the southern school, and he fundamentally influenced the way the Chinese viewed their own tradition.

Dong Qichang summarized his views on the proper training for literati painters in the famous statement "Read ten thousand books and walk ten thousand miles." By this he meant that one must first study the works of the great masters, then follow "heaven and earth," the world of nature. These studies prepared the way for greater self-expression through brush and ink, the goal of literati painting. Dong's views rested on an awareness that a painting of scenery and the actual scenery are two very different things. The excellence of a painting does not lie in its degree of resemblance to reality—that gap can never be bridged—but in its expressive power. The expressive language of painting is inherently abstract and lies in its nature as a construction of brushstrokes. For example, in a painting of a rock, the rock itself is not expressive; rather, the brushstrokes that suggest a rock are expressive.

With such thinking Dong brought painting close to the realm of calligraphy, which had long been considered the highest form of artistic expression in China. More than a thousand years before Dong's time, a body of critical terms and theories had evolved to discuss calligraphy in light of the formal and expressive properties of brushwork and composition. Dong introduced some of these terms—ideas such as opening and closing, rising and falling, and void and solid—to the criticism of painting.

Dong's theories are fully embodied in his painting **THE QING-BIAN MOUNTAINS (FIG. 24–11)**. According to his own inscription,

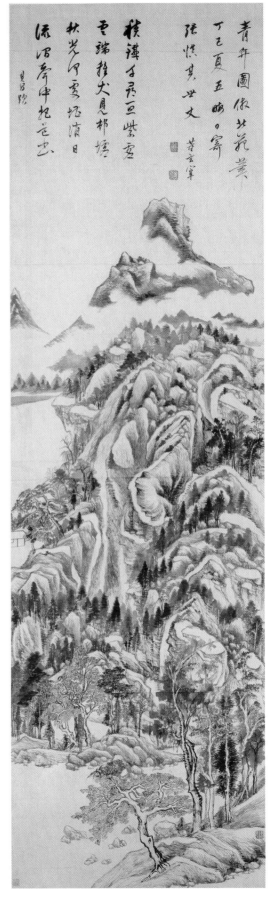

**24-11 • Dong Qichang THE QINGBIAN MOUNTAINS**
Ming dynasty, 1617. Hanging scroll, ink on paper, 21′8″ × 7′4⅜″ (6.72 × 2.25 m). Cleveland Museum of Art. Leonard C. Hanna, Jr., Fund

the painting was based on a work by the tenth-century artist Dong Yuan. Dong Qichang's style, however, is quite different from the styles of the masters he admired. Although there is some indication of foreground, middle ground, and distant mountains, the space is ambiguous, as if all the elements were compressed to the surface of the picture. With this flattening of space, the trees, rocks, and mountains become more readily legible in a second way, as semi-abstract forms made of brushstrokes.

Six trees arranged diagonally define the extreme foreground and announce themes that the rest of the painting repeats, varies, and develops. The tree on the left, with its outstretched branches and full foliage, is echoed first in the shape of another tree just across the river and again in a tree farther up and toward the left. The tallest tree of the foreground grouping anticipates the high peak that towers in the distance almost directly above it. The forms of the smaller foreground trees, especially the one with dark leaves,

are repeated in numerous variations across the painting. At the same time, the simple and ordinary-looking boulder in the foreground is transformed in the conglomeration of rocks, ridges, hills, and mountains above. This double reading, both abstract and representational, parallels the work's double nature as a painting of a landscape and an interpretation of a traditional landscape painting.

The influence of Dong Qichang on the development of Chinese painting of later periods cannot be overstated. Indeed, nearly all Chinese painters since the early seventeenth century have reflected his ideas in one way or another.

## QING DYNASTY

In 1644, when the armies of the Manchu people to the northeast of China marched into Beijing, many Chinese reacted as though their civilization had come to an end. Yet, the Manchus had already

**24-12 • Yun Shouping AMARANTH**
Leaf from an album of flowers, bamboo, fruits, and vegetables. 1633–1690. Album of 10 leaves; ink and color on paper; each leaf 10 × 13″ (25.3 × 33.5 cm). Collection of Phoenix Art Museum. Gift of Marilyn and Roy Papp

The leaf is inscribed by the artist: "Autumn garden abounds in beauty, playfully painted by Ouxiangguan (Yun Shouping)." Translation by Momoko Soma Welch.

24–13 • Shitao
**LANDSCAPE**
Leaf from *An Album of Landscapes*. Qing dynasty, c. 1700. Ink and color on paper, 9½ × 11″ (24.1 × 28 cm). Collection C. C. Wang family

adopted many Chinese customs and institutions before their conquest. After gaining control of all of China, a process that took decades, they showed great respect for Chinese tradition. In art, all the major trends of the late Ming dynasty eventually continued into the Manchu, or Qing, dynasty (1644–1911).

## ORTHODOX PAINTING

Literati painting had been established as the dominant tradition; it now became orthodox. Scholars followed Dong Qichang's recommendation and based their approach on the study of past masters, and they painted large numbers of works in the manner of Song and Yuan artists as a way of expressing their learning, technique, and taste.

The Qing emperors of the late seventeenth and eighteenth centuries were painters themselves. They collected literati painting, and their taste was shaped mainly by artists such as Wang Hui (SEE FIG. 24–1). Thus literati painting, long associated with reclusive scholars, ultimately became an academic style practiced at court. Imbued with values associated with scholarship and virtue, these paintings constituted the highest art form of the Qing court. The emperors also esteemed a style of bird-and-flower painting developed by Yun Shouping (1633–1690). Like the orthodox style of landscape painting, it was embraced by literati painters—many of them court officials themselves. The style, most often seen in

albums or fans, recalled aspects of Song- and Yuan-dynasty bird-and-flower painting, and artists cited their ancient models as a way to enrich both the meaning and the beauty of these small-format works. In a leaf from an album of flowers, bamboo, fruits and vegetables, which employs a variety of brush techniques (FIG. 24–12), Yun Shouping represents flowers of the autumn season.

## INDIVIDUALIST PAINTING

The first few decades of Qing rule had been both traumatic and dangerous for those who were loyal—or worse, related—to the Ming. Some committed suicide, while others sought refuge in monasteries or wandered the countryside. Among them were several painters who expressed their anger, defiance, frustration, and melancholy in their art. They took Dong Qichang's idea of painting as an expression of the artist's personal feelings very seriously and cultivated highly original styles. These painters have become known as the individualists.

SHITAO. One of the individualists was Shitao (1642–1707), who was descended from the first Ming emperor and who took refuge in Buddhist temples when the dynasty fell. In his later life he brought his painting to the brink of abstraction in such works as **LANDSCAPE** (FIG. 24–13). A monk sits in a small hut, looking out onto mountains that seem to be in turmoil. Dots, used for

centuries to indicate vegetation on rocks, here seem to have taken on a life of their own. The rocks also seem alive—about to swallow up the monk and his hut. Throughout his life Shitao continued to identify himself with the fallen Ming, and he felt that his secure world had turned to chaos with the Manchu conquest.

## THE MODERN PERIOD

In the mid and late nineteenth century, China was shaken from centuries of complacency by a series of humiliating military defeats at the hands of Western powers and Japan. Only then did the government finally realize that these new rivals were not like the Mongols of the thirteenth century. China was no longer at the center of the world, a civilized country surrounded by "barbarians." Spiritual resistance was no longer sufficient to solve the problems brought on by change. New ideas from Japan and the West began to filter in, and the demand arose for political and cultural reforms. In 1911 the Qing dynasty was overthrown, ending 2,000 years of imperial rule, and China was reconceived as a republic.

During the first decades of the twentieth century Chinese artists traveled to Japan and Europe to study Western art. Returning to China, many sought to introduce the ideas and techniques they had learned, and they explored ways to synthesize the Chinese and the Western traditions. After the establishment of the present-day Communist government in 1949, individual artistic freedom was curtailed as the arts were pressed into the service of the state and its vision of a new social order. After 1979, however, cultural attitudes began to relax, and Chinese painters again pursued their own paths.

WU GUANZHONG.    One artist who emerged during the 1980s as a leader in Chinese painting is Wu Guanzhong (b. 1919). Combining his French artistic training and Chinese background, Wu Guanzhong developed a semiabstract style to depict scenes from the Chinese landscape. He made preliminary sketches on site, then, back in his studio, he developed these sketches into free interpretations based on his feeling and vision. An example of his work, **PINE SPIRIT**, depicts a scene in the Huang (Yellow) Mountains **(FIG. 24–14)**. The technique, with its sweeping gestures of paint, is clearly linked to Abstract Expressionism, an influential Western movement of the post–World War II years (Chapter 32); yet the painting also claims a place in the long tradition of Chinese landscape as exemplified by such masters as Shitao.

Like all aspects of Chinese society, Chinese art has felt the strong impact of Western influence, and the question remains whether Chinese artists will absorb Western ideas without losing their traditional identity. Interestingly, landscape remains an important subject, as it has been for more than a thousand years, and calligraphy continues to play a vital role. Using the techniques and methods of the West, some of China's artists have joined an international avant-garde (see, for example, Wenda Gu in Chapter 32), while other painters still seek communion with nature through their ink brushstrokes as a means to come to terms with human life and the world.

**24–14 • Wu Guanzhong PINE SPIRIT**
1984. Ink and color on paper, 2′3⅝″ × 5′3½″ (0.70 × 1.61 m). Spencer Museum of Art, The University of Kansas, Lawrence. Gift of the E. Rhodes and Leonard B. Carpenter Foundation

# ARTS OF KOREA: THE JOSEON DYNASTY TO THE MODERN ERA

In 1392, General Yi Seonggye (1335–1408) overthrew the Goryeo dynasty (918–1392), establishing the Joseon dynasty (1392–1910), sometimes called the Yi dynasty. He first maintained his capital at Gaeseong, the old Goryeo capital, but moved it to Seoul in 1394, where it remained through the end of the dynasty. The Joseon regime rejected Buddhism, espousing Neo-Confucianism as the state philosophy. Taking Ming-dynasty China as its model, the new government patterned its bureaucracy on that of the Ming emperors, even adopting as its own such outward symbols of Ming imperial authority as blue-and-white porcelain. The early Joseon era was a period of cultural refinement and scientific achievement, during which Koreans invented Han'geul (the Korean alphabet) and movable type, not to mention the rain gauge, astrolabe, celestial globe, sundial, and water clock.

## JOSEON CERAMICS

Like their Silla and Goryeo forebears (see Chapter 10), Joseon potters excelled in the manufacture of ceramics, taking their cue from contemporaneous Chinese wares, but seldom copying them directly.

BUNCHEONG CERAMICS. Descended from Goryeo celadons, Joseon-dynasty stonewares, known as *buncheong* wares, enjoyed widespread usage throughout the peninsula. Their decorative effect relies on the use of white slip that makes the humble stoneware resemble more expensive white porcelain. In fifteenth-century examples, the slip is often seen inlaid into repeating design elements stamped into the body.

Sixteenth-century *buncheong* wares are characteristically embellished with wonderfully fluid, calligraphic brushwork painted in iron-brown slip on a white slip ground. Most painted *buncheong* wares have stylized floral décor, but rare pieces, such as the charming wine bottle in **FIGURE 24–15**, feature pictorial decoration. In fresh, lively brushstrokes, a bird with outstretched wings grasps a fish that it has just caught in its talons; waves roll below, while two giant lotus blossoms frame the scene.

Japanese armies repeatedly invaded the Korean peninsula between 1592 and 1597, destroying many of the *buncheong* kilns, and essentially bringing the ware's production to a halt. Tradition holds that the Japanese took many *buncheong* potters home with them to produce *buncheong*-style wares, which were greatly admired by connoisseurs of the tea ceremony. In fact, the spontaneity of Korean *buncheong* pottery has inspired Japanese ceramics to this day.

PAINTED PORCELAIN. Korean potters produced porcelains with designs painted in underglaze cobalt blue as early as the fifteenth century, inspired by Chinese porcelains of the early Ming period (SEE FIG. 24–7). The Korean court dispatched artists from the royal painting academy to the porcelain kilns—located some 30 miles southeast of Seoul—to train porcelain decorators. As a result, from the fifteenth century onward, the painting on the best Korean porcelains closely approximated that on paper and silk, unlike in China, where ceramic decoration followed a path of its own with but scant reference to painting traditions.

In another unique development, Korean porcelains from the sixteenth and seventeenth centuries often feature designs painted in underglaze iron-brown rather than the cobalt blue customary in Ming porcelain. Also uniquely Korean are porcelain jars with bulging shoulders, slender bases, and short, vertical necks, which

**24-15 • HORIZONTAL WINE BOTTLE WITH DECORATION OF A BIRD CARRYING A NEWLY CAUGHT FISH**

Korea. Joseon dynasty, 16th century. *Buncheong* ware: light gray stoneware with decoration painted in iron-brown slip on a white slip ground, 6¹⁄₁₀ × 9½″ (15.5 × 24.1 cm). Museum of Oriental Ceramics, Osaka, Japan. Gift of the Sumitomo Group (20773)

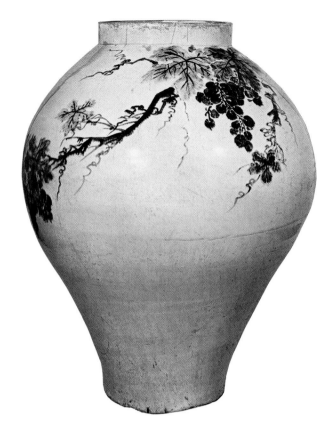

appeared by the seventeenth century and came to be the most characteristic ceramic shapes in the later Joseon period. Painted in underglaze iron-brown, the seventeenth-century jar shown in **FIGURE 24–16** depicts a fruiting grape branch around its shoulder. In typical Korean fashion, the design spreads over a surface unconstrained by borders, resulting in a balanced but asymmetrical design that incorporates the Korean taste for unornamented spaces.

**24-16 • BROAD-SHOULDERED JAR WITH DECORATION OF A FRUITING GRAPEVINE**
Korea. Joseon dynasty, 17th century. Porcelain with decoration painted in underglaze iron-brown slip, height 22⅛″ (53.8 cm). Ewha Women's University Museum, Seoul, Republic of Korea.

Chinese potters invented porcelain during the Tang dynasty, probably in the eighth century. Generally fired in the range of 1300° to 1400° C, porcelain is a high-fired, white-bodied ceramic ware. Its unique feature is its translucency. Korean potters learned to make porcelain during the Goryeo dynasty, probably as early as the eleventh or twelfth century, though few Goryeo examples remain today. For many centuries, only the Chinese and Koreans were able to produce porcelains.

## JOSEON PAINTING

Korean secular painting came into its own during the Joseon dynasty. Continuing Goryeo traditions, early Joseon examples employ Chinese styles and formats, their range of subjects expanding from botanical motifs to include landscapes, figures, and a variety of animals.

Painted in 1447 by An Gyeon (b. 1418), **DREAM JOURNEY TO THE PEACH BLOSSOM LAND (FIG. 24–17)** is the earliest extant and dated Joseon secular painting. It illustrates a fanciful tale by China's revered nature poet Tao Qian (365–427), and recounts a dream about chancing upon a utopia secluded from the world for centuries while meandering among the peach blossoms of spring.

As with their Goryeo forebears, the monumental mountains and vast, panoramic vistas of such fifteenth-century Korean paintings, echo Northern Song painting styles. Chinese paintings of the Southern Song (1127–1279) and Ming periods (1368–1644) also influenced Korean painting of the fifteenth, sixteenth, and seventeenth centuries, though these styles never completely supplanted the imprint of the Northern Song masters.

THE SILHAK MOVEMENT. In the eighteenth century, a truly Korean style emerged, inspired by the *silhak* ("practical learning") movement, which emphasized the study of things Korean in addition to the Chinese classics. The impact of the movement is

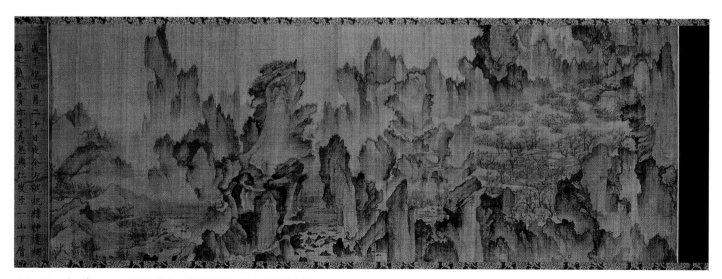

**24-17 • An Gyeon DREAM JOURNEY TO THE PEACH BLOSSOM LAND**
Korea. Joseon dynasty, 1447. Handscroll, ink and light colors on silk, 15¼ × 41¾″ (38.7 × 106.1 cm). Central Library, Tenri University, Tenri (near Nara), Japan.

萬二千峯皆骨山何人用
意寫真頰衆香浮
飛騰勢雄蟠
東扶赤外
世界
間
歲寒
芙蓉之素
壽半林松
柏隱玄聞從令脚
端須今遍事似枕邊者不慳

金剛全圖
謙齋

**24-18** • Jeong Seon
**PANORAMIC VIEW OF THE
DIAMOND MOUNTAINS
(GEUMGANG-SAN)**
Korean. Joseon Dynasty, 1734. Hanging
scroll, ink and colors on paper,
40⅝ × 37″ (130.1 × 94 cm). Lee'um,
Samsung Museum, Seoul, Republic
of Korea.

exemplified by the painter Jeong Seon (1676–1759), who chose well-known Korean vistas as the subjects of his paintings, rather than the Chinese themes favored by earlier artists. Among Jeong Seon's paintings are numerous representations of the Diamond Mountains (Geumgang-san), a celebrated range of craggy peaks along Korea's east coast. Painted in 1734, the scroll reproduced in **FIGURE 24–18** aptly captures the Diamond Mountains' needlelike peaks. The subject is Korean, and so is the energetic spirit and the intensely personal style, with its crystalline mountains, distant clouds of delicate ink wash, and individualistic brushwork.

Among figure painters, Sin Yunbok (b. 1758) is an important exemplar of the *silhak* attitude. Active in the late eighteenth and early nineteenth centuries, Sin typically depicted aristocratic figures in native Korean garb. The album leaf entitled **PICNIC AT THE LOTUS POND (FIG. 24–19)** represents a group of Korean gentlemen enjoying themselves in the countryside on an autumn day in the company of several *gisaeng* (female entertainers). The figures are recognizably Korean—the women with their full coiffures, short jackets, and generous skirts, and the men with their beards, white robes, and wide-brimmed hats woven of horsehair and coated with black lacquer. The stringed instrument played by

**24-19 • Sin Yunbok PICNIC AT THE LOTUS POND**
Leaf from an album of genre scenes. Korea. Joseon dynasty, late 18th century. Album of 30 leaves;
ink and colors on paper, 11⅛ × 13⅞″ (28.3 × 35.2 cm). Kansong Museum of Art, Seoul, Republic of Korea.

the gentleman seated at lower right is a *gayageum* (Korean zither), the most hallowed of all Korean musical instruments.

## MODERN KOREA

Long known as "the Hermit Kingdom," the Joseon dynasty pursued a policy of isolationism, closing its borders to most of the world, except China, until 1876. Japan's annexation of Korea in 1910 brought the Joseon dynasty to a close, but effectively prolonged the country's seclusion from the outside world. The legacy of self-imposed isolation compounded by colonial occupation (1910–1945)—not to mention the harsh circumstances imposed by World War II (1939–1945), followed by the even worse conditions of the Korean War (1950–1953)—impeded Korea's artistic and cultural development during the first half of the twentieth century.

A MODERNIST PAINTER FROM KOREA.   Despite these privations, some modern influences did reach Korea indirectly via China and

Japan, and beginning in the 1920s and 1930s a few Korean artists experimented with contemporary Western styles, typically painting in the manner of Cézanne or Gauguin, but sometimes trying abstract, nonrepresentational styles. Among these, Gim Hwangi (1913–1974) was influenced by Constructivism and geometric abstraction and would become one of twentieth-century Korea's influential painters. Like many Korean artists after the Korean War, Gim wanted to examine Western modernism at its source. He visited Paris in 1956 and then, from 1964 to 1974, lived and worked in New York, where he produced his best-known works. His painting **5-IV-71** presents a large pair of circular radiating patterns composed of small dots and squares in tones of blue, black, and gray **(FIG. 24–20)**. While appearing wholly Western in style, medium, concept, and even title—Gim Hwangi typically adopted the date of a work's creation as its title—*5-IV-71* also seems related to Asia's venerable tradition of monochrome **ink painting**, while suggesting a transcendence that seems Daoist or

24–20 • Gim Hwangi 5-IV-71 Korea. 1971. Oil on canvas, 39½ × 39½" (100 × 100 cm). Whanki Museum, Seoul, Republic of Korea.

Buddhist in feeling. Given that the artist was Korean, that he learned the Chinese classics in his youth, that he studied art in Paris, and that he then worked in New York, it is possible that his painting embodies all of the above. Gim's painting illustrates the paradox that the modern artist faces while finding a distinctive, personal style: whether to paint in an updated version of a traditional style, in a wholly international style, in an international style with a distinctive local twist, or in an eclectic, hybrid style that incorporates both native and naturalized elements from diverse traditions. By addressing these questions, Gim Hwangi blazed a trail for subsequent Korean-born artists, such as the renowned video artist Nam June Paik (1932–2006), whose work can be seen in FIGURE 32–57.

## THINK ABOUT IT

**24.1** Explain the role played by one of the following three ways of thought prevalent in Chinese society—Daoism, Confucianism, and Buddhism—and discuss the implications that it had for the visual arts. Make specific reference to works from this chapter.

**24.2** Examine a work commissioned by the court at Beijing and distinguish which of its features are typical of court art.

**24.3** Discuss the place that calligraphy held within Chinese society and in relation to other arts. Then, explain why Dong Qichang's *The Qingbian Mountains* (SEE FIG. 24–11) has elicited comparison with the art of calligraphy.

**24.4** Discuss the culture of the literati, including their values and their system of art patronage, and distinguish the formats of painting that they used.

**24.5** Theorize reasons for the emergence of individualist painting in China, using works such as Shitao's *Landscape* (SEE FIG. 24–13) to support your argument.

**PRACTICE MORE:** Compose answers to these questions, get flashcards for images and terms, and review chapter material with quizzes www.myartslab.com

**25-1 • Suzuki Harunobu THE FLOWERS OF BEAUTY IN THE FLOATING WORLD: MOTOURA AND YAEZAKURA OF THE MINAMI YAMASAKIYA** Edo period, 1769.
Polychrome woodblock print on paper, 11⅜ × 8½″ (28.9 × 21.8 cm). Chicago Art Institute.
Clarence Buckingham Collection (1925.2116)

# JAPANESE ART AFTER 1333

Lounging at a window seat, a young woman pauses from smoking her pipe while the young girl at her side peers intently through a telescope at boats in a bay below (FIG. 25–1). The scene takes place in the city of Edo (now Tokyo) in the 1760s, during an era of peace and prosperity that started some 150 years earlier when the Tokugawa shoguns unified the nation. Edo was then the largest city in the world, with over 1 million inhabitants: samurai-bureaucrats and working-class townspeople. The commoners possessed a vibrant culture centered in urban entertainment districts, where geisha and courtesans (licenced prostitutes), such as the lady and her young trainee portrayed in this woodblock print, worked.

In the 1630s, the Tokugawa shogunate banned Japanese citizens from traveling abroad and restricted foreign access to the country. Nagasaki became Japan's sole international port, which only Koreans, Chinese, and Dutch could enter (and they could not travel freely around the country). The government did this to deter Christian missionaries and to assert authority over foreign powers. Not until 1853, when Commodore Matthew Perry of the United States forced Japan to open additional ports, did these policies change. Even so, foreign influences could not be prevented, as the tobacco pipe and telescope in this print testify.

The Japanese had first encountered Westerners—Portuguese traders—in the mid sixteenth century. The Dutch reached Japan by 1600 and brought tobacco and, soon after that, the telescope and other exotic optical devices, including spectacles, microscopes, other curious objects, and books, many illustrated. The Japanese people eagerly welcomed these foreign goods and imitated foreign customs, which conferred an air of sophistication on the user. Looking through the telescopes like the one in this print was a popular amusement of prostitutes and their customers. It also conveyed sexual overtones, because of its phallic shape, and suggests the ribald humor then in vogue. Novel optical devices, all readily available by the mid eighteenth century, offered a new way of seeing, and impacted the appearance of Japanese pictorial art. Yet Chinese influences in the arts still remained strong and spread throughout the population as never before, due to new efforts to educate the broader populace in Chinese studies. In varying degrees, the intermingling of diverse native and foreign artistic traditions has continued to shape the arts of Japan up to the present.

## LEARN ABOUT IT

**25.1** Evaluate the importance of Zen Buddhism to Japan's visual arts.

**25.2** Compare art created in Kyoto to art made in the city of Edo during the Edo period.

**25.3** Appraise the role and significance of crafts in Japanese artistic culture.

**25.4** Recognize foreign influences on Japanese art in the Muromachi and Edo periods.

**25.5** Understand the changing role of patronage in the development of Japanese art.

**HEAR MORE:** Listen to an audio file of your chapter **www.myartslab.com**

# MUROMACHI PERIOD

By the year 1333, Japanese art had already developed a long and rich history (see "Foundations of Japanese Culture," page 817). Very early, a particularly Japanese sensitivity to artistic production had emerged, including a love of natural materials, fondness for representing elements of the natural world, and an overriding attention to fine craftsmanship. Aesthetically, Japanese arts had come to feature a taste for asymmetry, abstraction, brevity or boldness of expression, and humor—characteristics that continue to distinguish Japanese art, appearing and reappearing in ever-changing guises.

Late in the twelfth century, the authority of the emperor had been supplanted by rule by powerful and ambitious warriors (samurai) under the leadership of the shogun, the general-in-chief. But in 1333, Emperor Go-Daigo attempted to retake power. He failed and was forced into hiding in the mountains south of Kyoto where he set up a "southern court." Meanwhile, the shogunal family then in power, the Minamoto, was overthrown by warriors of the Ashikaga clan, who placed a rival to the upstart emperor on the throne in Kyoto, in a "northern court," and had him declare their clan head as shogun. They ruled the country from the Muromachi district in Kyoto, and finally vanquished the southern court emperors in 1392. The Muromachi period, also known as the Ashikaga era (1392–1573), formally began with this event.

The Muromachi period is marked by the ascendance of Zen Buddhism, introduced into Japan in the late twelfth century, whose austere ideals particularly appealed to the highly disciplined samurai. While Pure Land Buddhism, which had spread widely during the latter part of the Heian period (794–1185), remained popular, Zen (which means meditation) became the dominant cultural force in Japan among the ruling elite.

## ZEN INK PAINTING

During the Muromachi period, brightly colored narrative handscrolls depicting native themes continued to be produced, but monochrome ink painting in black ink and its diluted grays—which had just been introduced to Japan from the continent at the end of the Kamakura period (1185–1333)—reigned supreme. Muromachi ink painting was heavily influenced by the aesthetics of Zen, but unlike earlier Zen paintings that had concentrated on depictions of important individuals associated with the Zen monastic tradition, many artists also began painting Chinese-style ink landscapes. Traditionally, the monk-artist Shubun (active c. 1418–1463) is regarded as Japan's first great master of the ink landscape. Unfortunately, no works survive that can be proven to be his. Two landscapes by Shubun's pupil Bunsei (active c. 1450–1460) have survived, however. The one shown in FIGURE **25–2** is closely modeled on Korean ink landscape paintings that themselves copied Chinese Ming period models (such as FIG. 24–5). It contains a foreground consisting of a spit of rocky land with an overlapping series of motifs—a spiky pine tree, a craggy rock, a poet seated in a hermitage, and a brushwood fence

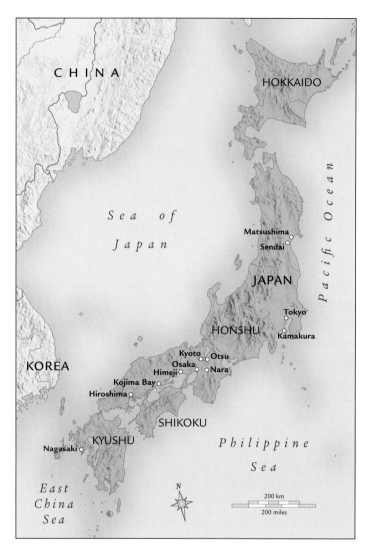

**MAP 25-1 • JAPAN**

Japan's wholehearted emulation of myriad aspects of Chinese culture began in the fifth century and was challenged by new influences from the West only in the mid nineteenth century after Western powers forced Japan to open its treaty ports to international trade.

surrounding a small garden of trees and bamboo. In the middle ground is space—emptiness, the void. We are expected to "read" the empty paper as representing water. Beyond the blank space, subtle tones of gray ink delineate a distant shore where fishing boats, a small hut, and two people stand. The two parts of the painting seem to echo each other across a vast expanse. The painting illustrates well the pure, lonely, and ultimately serene spirit of the Zen-influenced poetic landscape tradition.

SESSHU. Another of Shubun's pupils, Sesshu (1420–1506), out-shone his master, and has come to be regarded as one of the greatest Japanese painters of all time. Although they completed training to become Zen monks, at the monastery, Shubun and his followers specialized in art rather than in religious ritual or teaching, unlike earlier Zen monk-painters for whom art production was just one facet of their lives. By Shubun's day, temples had formed their own

to head a small provincial Zen temple in western Japan, in his quest to concentrate on painting unencumbered by monastic duties and entanglements with the political elite. His new temple was patronized by a private and wealthy warrior clan that was engaged in trade with China. With funding from them, he had the opportunity to visit China in 1467 on a diplomatic mission. He traveled extensively there for three years, viewing the scenery, stopping at Zen (Chan in Chinese) monasteries, and studying Chinese paintings by professional artists rather than those by contemporary literati masters. When he returned from China, he remained in the provinces to avoid the turmoil in Kyoto, which was being devastated by civil warfare that would last for the next hundred years. Only a few paintings from Sesshu's years prior to his sojourn in China have recently come to light. These he painted in a style closer to Shubun and he signed them with another name. His paintings after his return demonstrate he consciously broke artistically with the refined landscape style of his teacher. These masterful paintings by Sesshu exhibit a bold, new spirit, evident in his **WINTER LANDSCAPE** (**FIG. 25–3**). A cliff descending from the mist seems to cut the composition in two. Sharp, jagged brushstrokes delineate a series of

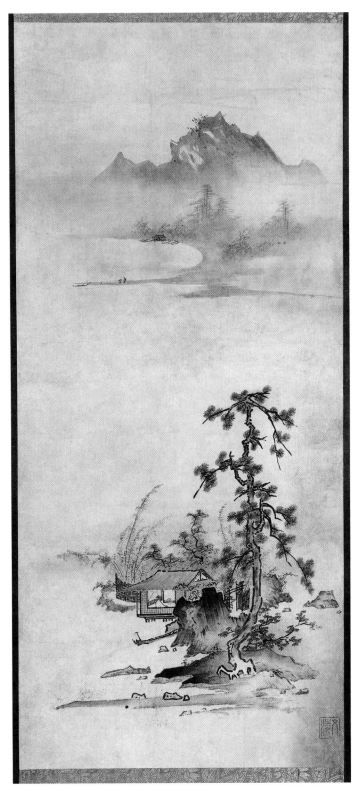

**25-2 • Bunsei LANDSCAPE**
Muromachi period, mid 15th century. Hanging scroll, ink and light colors on paper, 28¾ × 13″ (73.2 × 33 cm). Museum of Fine Arts, Boston. Special Chinese and Japanese Fund (05.203)

professional painting ateliers in order to meet demands for large numbers of paintings from warrior patrons. Sesshu trained as a Zen monk at Shokokuji, where Shubun had his studio. There, he worked in the painting atelier under Shubun for 20 years, but then left Kyoto

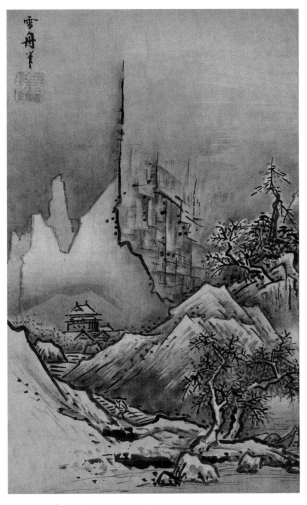

**25-3 • Sesshu WINTER LANDSCAPE**
Muromachi period, c. 1470s. Hanging scroll, ink on paper, 18¼ × 11½″ (46.3 × 29.3 cm). Collection of the Tokyo National Museum. National Treasure.

rocky hills, where a lone figure makes his way to a Zen monastery. Instead of a gradual recession into space, flat overlapping planes fracture the composition into crystalline facets. The white of the paper is left to indicate snow, while the sky is suggested by tones of gray. A few trees cling desperately to the rocky land, and the harsh chill of winter is boldly expressed.

## THE ZEN DRY GARDEN

Zen monks led austere monastic lives in their quest for the attainment of enlightenment. In addition to daily meditation, they engaged in manual labor to provide for themselves and maintain their temple properties. Many Zen temples constructed dry land-scape courtyard gardens, not for strolling in but for contemplative viewing. Cleaning and maintaining these gardens—pulling weeds, tweaking unruly shoots, and raking the gravel—was a kind of active meditation. It helped to keep their minds grounded.

The dry landscape gardens of Japan, *karesansui* ("dried-up mountains and water"), exist in perfect harmony with Zen Buddhism. The dry garden in front of the abbot's quarters in the Zen temple at Ryoanji is one of the most renowned Zen creations in Japan **(FIG. 25–4)**. A flat rectangle of raked gravel, about 29 by 70 feet, surrounds 15 stones of different sizes in islands of moss. The stones are set in asymmetrical groups of two, three, and five. Low, plaster-covered walls establish the garden's boundaries, but beyond the perimeter wall maple, pine, and cherry trees add color and texture to the scene. Called "borrowed scenery," these elements are a considered part of the design even though they grow outside the garden. The garden is celebrated for its severity and emptiness.

Dry gardens began to be built in the fifteenth and sixteenth centuries in Japan. By the sixteenth century, Chinese landscape painting influenced the gardens' composition, and miniature clipped plants and beautiful stones were arranged to resemble famous paintings. Especially fine and unusual stones were coveted and even carried off as war booty, such was the cultural value of these seemingly mundane objects.

The Ryoanji garden's design, as we see it today, probably dates from the mid seventeenth century. By the time the garden was created, such stone and gravel gardens had become highly intellectualized, abstract reflections of nature. This garden has been interpreted as representing islands in the sea, or mountain peaks rising above the clouds, perhaps even a swimming tigress with her cubs, or constellations of stars and planets. All or none of these interpretations may be equally satisfying—or irrelevant—to a monk seeking clarity of mind through contemplation.

**25-4 • ROCK GARDEN, RYOANJI, KYOTO**
Muromachi period, c. 1480. Photographed spring 1993. Photograph by Michael S. Yamashita. UNESCO World Heritage Site, National Treasure.

The American composer John Cage once exclaimed that every stone at Ryoanji was in just the right place. He then said, "And every other place would also be just right." His remark is thoroughly Zen in spirit. There are many ways to experience Ryoanji. For example, we can imagine the rocks as having different visual "pulls" that relate them to one another. Yet there is also enough space between them to give each one a sense of self-sufficiency and permanence.

## Foundations of Japanese Culture

With the end of the last Ice Age roughly 15,000 years ago, rising sea levels submerged the lowlands connecting Japan to the Asian landmass, creating the chain of islands we know today as Japan (MAP 25–1). Not long afterward, early Paleolithic cultures gave way to a Neolithic culture known as Jomon (c. 11,000–400 BCE) after its characteristic cord-marked pottery. During the Jomon period, a sophisticated hunter-gatherer culture developed. Agriculture supplemented hunting and gathering by around 5000 BCE, and rice cultivation began some 4,000 years later.

A fully settled agricultural society emerged during the Yayoi period (c. 400 BCE–300 CE), accompanied by hierarchical social organization and more centralized forms of government. As people learned to manufacture bronze and iron, use of those metals became widespread. Yayoi architecture, with its unpainted wood and thatched roofs, already showed the Japanese affinity for natural materials and clean lines, and the style of Yayoi granaries in particular persisted in the design of shrines in later centuries. The trend toward centralization continued during the Kofun period (c. 300–552 CE), an era characterized by the construction of large royal tombs, following the Korean practice. Veneration of leaders grew into the beginnings of the imperial system that has lasted to the present day.

The Asuka era (552–645 CE) began with a century of profound change as elements of Chinese civilization flooded into Japan, initially through the intermediary of Korea. The three most significant Chinese contributions to the developing Japanese culture were Buddhism (with its attendant art and architecture), a system of writing, and the structures of a centralized bureaucracy. The earliest extant Buddhist temple compound in Japan, Horyuji, which contains the oldest currently existing wooden buildings in the world, dates from this period.

The arrival of Buddhism also prompted some formalization of Shinto, the loose collection of indigenous Japanese beliefs and practices. Shinto is a religion that connects people to nature. Its rites are shamanistic and emphasize ceremonial purification. These include the invocation and appeasement of spirits, including those of the recently dead. Many Shinto deities are thought to inhabit various aspects of nature, such as particularly magnificent trees, rocks, and waterfalls, and living creatures such as deer. Shinto and Buddhism have in common an intense awareness of the transience of life, and as their goals are complementary—purification in the case of Shinto, enlightenment in the case of Buddhism—they have generally existed comfortably alongside each other to the present day.

The Nara period (645–794) takes its name from Japan's first permanently established imperial capital. During this time the founding works of Japanese literature were compiled and Buddhism became the most important force in Japanese culture. Its influence at court grew so great that in 794 the emperor moved the capital from Nara to Heian-kyo (present-day Kyoto), far from powerful monasteries.

During the Heian period (794–1185) an extremely refined court culture thrived, embodied today in an exquisite legacy of poetry, calligraphy, and painting. An efficient method for writing the Japanese language was developed, and with it a woman at the court wrote Japan's most celebrated fictional story, which some describe as the world's first novel: *The Tale of Genji*. Esoteric Buddhism, as hierarchical and intricate as the aristocratic world of the court, became popular.

The end of the Heian period was marked by civil warfare as regional warrior (samurai) clans were drawn into the factional conflicts at court. Pure Land Buddhism, with its simple message of salvation, offered consolation to many in troubled times. In 1185 the Minamoto clan defeated their arch rivals, the Taira, and their leader, Minamoto Yoritomo, assumed the position of shogun (general-in-chief). While paying respects to the emperor, Minamoto Yoritomo kept actual military and political power to himself, setting up his own capital in Kamakura. The Kamakura era (1185–1333) began a tradition of rule by shogun that lasted in various forms until 1868. It was also the time in which renewed contacts with China created the opportunity for Zen Buddhism, which was then flourishing in China (known there as Chan), to be introduced to Japan. By the end of the Kamakura period, numerous Zen monasteries had been founded in Kyoto and Kamakura, and Chinese and Japanese Chan/Zen monks were regularly visiting each others' countries.

## MOMOYAMA PERIOD

The civil wars sweeping Japan laid bare the basic flaw in the Ashikaga system, which was that samurai were primarily loyal to their own feudal lord (*daimyo*), rather than to the central government. Battles between feudal clans grew more frequent, and it became clear that only a warrior powerful and bold enough to unite the entire country could control Japan. As the Muromachi period drew to a close, three leaders emerged who would change the course of Japanese history.

The first of these leaders was Oda Nobunaga (1534–1582), who marched his army into Kyoto in 1568 and overthrew the reigning Ashikaga shogun in 1573, initiating a new age of Japanese politics. A ruthless warrior, Nobunaga went so far as to destroy a Buddhist monastery because the monks refused to join his forces. Yet he was also a patron of the most rarefied and refined arts. Assassinated in the midst of one of his military campaigns, Nobunaga was succeeded by one of his generals, Toyotomi Hideyoshi (1537–1598), who soon gained complete power in Japan. He, too, patronized the arts when not leading his army, and he considered culture a vital adjunct to his rule. Hideyoshi, however, was overly ambitious. He believed that he could conquer both Korea and China, and he wasted much of his resources on two ill-fated invasions. A stable and long-lasting military regime

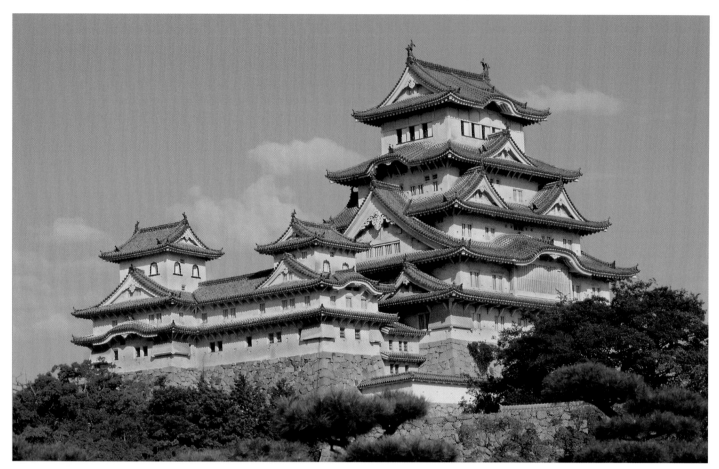

**25-5 • HIMEJI CASTLE, HYOGO, NEAR OSAKA**
Momoyama period, 1601–1609. Unesco World Heritage Site, National Treasure.

finally emerged soon after 1600 with the triumph of a third leader, Tokugawa Ieyasu (1543–1616), a former ally of Nobunaga who served as a senior retainer to Hideyoshi, and only asserted his power after Hideyoshi's death. But despite its turbulence, the era of Nobunaga and Hideyoshi, known as the Momoyama period (1573–1615), was one of the most creative eras in Japanese history.

Today the very word Momoyama conjures up images of bold warriors, luxurious palaces, screens shimmering with gold leaf, and, in contrast, rustic tea-ceremony ceramics. Europeans first made an impact in Japan at this time. After the arrival of a few wayward Portuguese explorers in 1543, traders and missionaries soon followed. It was only with the rise of Nobunaga, however, that Westerners were able to extend their activities beyond the ports of Kyushu, Japan's southernmost island. Nobunaga welcomed foreign traders, who brought him various products, the most influential of which were firearms.

## ARCHITECTURE

European muskets and cannons quickly changed the nature of Japanese warfare and Japanese castle architecture. To protect castles from these new weapons, in the late sixteenth century they became heavily fortified garrisons. Some were eventually lost to warfare or torn down by victorious enemies, and others have been extensively altered over the years. One of the most beautiful of the few that have survived intact is Himeji, not far from the city of Osaka (FIG. 25–5). Rising high on a hill above the plains, Himeji has been given the name White Heron. To reach the upper fortress, visitors must follow angular paths beneath steep walls, climbing from one area to the next past stone ramparts and through narrow fortified gates, all the while feeling as though lost in a maze, with no sense of direction or progress. At the main building, a further climb up a series of narrow ladders leads to the uppermost chamber. There, the footsore visitor is rewarded with a stunning 360-degree view of the surrounding countryside.

## DECORATIVE PAINTINGS FOR *SHOIN* ROOMS

Castles such as Himeji were sumptuously decorated, offering artists unprecedented opportunities to work on a grand scale. Interiors were divided into rooms by paper-covered sliding doors (**fusuma**), perfect canvases for large-scale murals. Free-standing folding screens (*byobu*) were also popular. Some had gold-leaf backgrounds, whose glistening surfaces not only conveyed light within the castle rooms but also displayed the wealth of the warrior leaders. Temples, too, commissioned large-scale paintings in these formats for grand reception rooms where the monks met with their wealthy warrior patrons (see "*Shoin* Design," opposite).

The Japanese tea ceremony and *shoin*-style interior residential architecture are undoubtedly the most significant and most enduring expressions of Japanese taste to emerge during the Momoyama period. **Shoin** combine a number of interior features in more-or-less standard ways, though no two rooms are ever the same. These features include wide verandas, walls divided by wood posts, floors covered with woven straw *tatami* mats, recessed panels in ceilings, sometimes painted and sometimes covered with reed matting, several shallow alcoves for prescribed purposes, *fusuma* (paper-covered sliding doors), and **shoji** screens—wood frames covered with translucent rice paper. The *shoin* illustrated here was built in 1601 as a guest hall, called Kojoin, at the Buddhist temple of Onjoji near Kyoto.

The *shoin* is a formal room for receiving important upper-class guests. With some variations due to differences in status, these rooms were designed for buildings used by samurai, aristocrats, and even well-to-do commoners. They are found in various types of buildings including private residences, living quarters at religious complexes (both Shinto shrines and Buddhist temples) and guesthouses or

reception rooms at these places for use by high-ranking patrons, and at the finest houses of entertainment (such as seen in fig. 25–1) where geisha and courtesans entertained important guests. The owner of the building or the most important guest would be seated in front of the main alcove (*tokonoma*), which would contain a hanging scroll, an arrangement of flowers, or a large painted screen. Alongside that alcove was another that featured staggered shelves, often for displaying writing instruments. The veranda side of the room also contained a writing space fitted with a low writing desk.

The architectural harmony of a *shoin* is derived from standardization of its basic units, or modules. In Japanese carpentry, the common module of design and construction is the **bay**, reckoned as the distance from the center of one post to the center of another, which is governed in turn by the standard size of **tatami** floor mats. Although varying slightly from region to region, the size of a single *tatami* is about 3 by 6 feet. Room area in Japan is still expressed in terms of the number of *tatami* mats; for example, a room may be described as an eight-mat room.

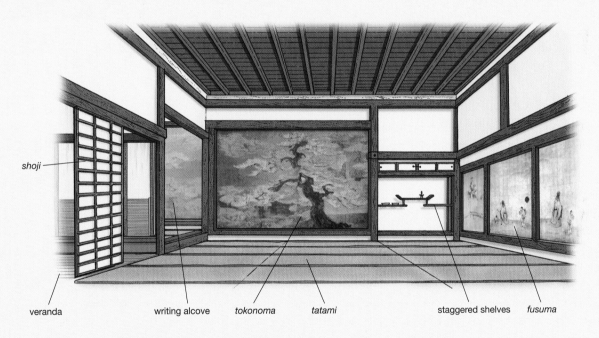

shoji · veranda · writing alcove · *tokonoma* · *tatami* · staggered shelves · *fusuma*

**ARTIST'S RENDERING OF THE KOJOIN GUEST HOUSE AT ONJOJI**
Otsu, Shiga prefecture. Momoyama period, 1601. National Treasure.

SEE MORE: View a simulation of *Shoin* Design **www.myartslab.com**

Daitokuji, a celebrated Zen monastery in Kyoto, has a number of subtemples for which Momoyama artists painted magnificent *fusuma*. One, the Jukoin, possesses *fusuma* by Kano Eitoku (1543–1590), one of the most brilliant painters from the hereditary lineage of professional artists known as the Kano school. Eitoku headed this school, which was founded by his grandfather. The Kano school painted for the highest ranking warriors from the sixteenth century through 1868. They perfected a new style that combined the

Muromachi ink-painting tradition with brightly colored decorative subjects. **FIGURE 25–6** shows two of the three walls of **FUSUMA** panels at Jukoin painted by Eitoku when was in his mid twenties. To the left, the subject is the familiar Kano school theme of cranes and pines, both symbols of long life; to the right is a great gnarled plum tree, symbol of spring. The trees are so massive they seem to extend far beyond the panels. An island rounding both walls of the far corner provides a focus for the outreaching trees. Ingeniously, it

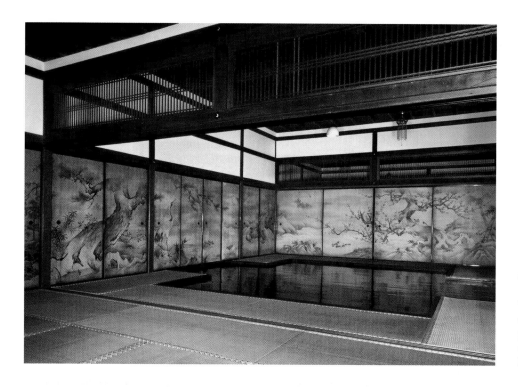

**25-6 • Kano Eitoku FUSUMA**
Depicting pine and cranes (left) and plum tree (right) from the central room of the Jukoin, Daitokuji, Kyoto. Momoyama period, c. 1563–1573. *Fusuma* (sliding door panels), ink and gold on paper, height 5′9⅛″ (1.76 m). National Treasure.

belongs to both compositions at the same time, thus uniting them into an organic whole. Eitoku's vigorous use of brush and ink, his powerfully jagged outlines, and his dramatic compositions recall the style of Sesshu, but the bold new sense of scale in his works is a defining characteristic of the Momoyama period.

## THE TEA CEREMONY

Japanese art is never one-sided. Along with castles and their opulent interior decoration, there was an equal interest during the Momoyama period in the quiet, the restrained, and the natural. This was expressed primarily through the tea ceremony.

The term "tea ceremony," a phrase now in common use, does not convey the full meaning of *chanoyu*, the Japanese ritual drinking of tea, which has no counterpart in Western culture. Tea had been introduced to Japan in the ninth century. Then, it was molded into cakes and boiled. However, the advent of Zen brought to Japan a different way of preparing tea, with the leaves crushed into powder and then whisked in bowls with hot water. Zen monks used such tea as a mild stimulant to aid meditation. Others found it had medicinal properties.

SEN NO RIKYU. The most famous tea master in Japanese history was Sen no Rikyu (1522–1591). He conceived of the tea ceremony as an intimate gathering in which a few people would enter a small rustic room, drink tea carefully prepared in front of them by their host, and quietly discuss the tea utensils or a Zen scroll hanging on the wall. He largely established the aesthetic of modesty, refinement, and rusticity that permitted the tearoom to serve as a respite from the busy and sometimes violent world outside. A traditional tearoom combines simple elegance and rusticity. It is made of natural materials such as bamboo and wood,

with mud walls, paper windows, and a floor covered with *tatami*. One tearoom that preserves Rikyu's design is named Taian **(FIG. 25–7)**. Built in 1582, it has a tiny door (guests must crawl to enter)

**25-7 • Sen no Rikyu TAIAN TEAROOM**
Myokian Temple, Kyoto. Momoyama period, 1582. National Treasure.

and miniature *tokonoma* for displaying a Zen scroll or a simple flower arrangement. At first glance, the room seems symmetrical. But a longer look reveals the disposition of the *tatami* does not match the spacing of the *tokonoma*, providing a subtle undercurrent of irregularity. The walls seem scratched and worn with age, but the *tatami* are replaced frequently to keep them clean and fresh. The mood is quiet; the light is muted and diffused through three small paper windows. Above all, there is a sense of spatial clarity. Nonessentials have been eliminated, so there is nothing to distract from focused attention. This tearoom aesthetic became an important element in Japanese culture.

THE TEA BOWL.  Every utensil connected with tea, including the water pot, the kettle, the bamboo spoon, the whisk, the tea caddy, and, above all, the tea bowl, came to be appreciated for its aesthetic quality, and many works of art were created for use in *chanoyu*.

The age-old Japanese admiration for the natural and the asymmetrical found full expression in tea ceramics. Korean-style rice bowls made for peasants were suddenly considered the epitome of refined taste, and tea masters urged potters to mimic their imperfect shapes. But not every misshapen bowl would be admired. A rarified appreciation of beauty developed that took into consideration such factors as how well a tea bowl fitted into the hands, how subtly the shape and texture of the bowl appealed to the eye, and who had previously used and admired it. For this purpose, the inscribed storage box became almost as important as the ceramic that fitted within it, and if a bowl had been given a name by a leading tea master, it was especially treasured by later generations.

One of the finest tea bowls extant is named Mount Fuji after Japan's most sacred peak **(FIG. 25–8)**. (Mount Fuji is depicted in FIGURE 25–12.) An example of **raku** ware—a hand-built, low-fired ceramic developed for use in the tea ceremony—the bowl was crafted by Hon'ami Koetsu (1558–1637), a leading cultural figure of his day. Koetsu was most famous as a calligrapher, but he was also a painter, poet, lacquer designer, sword connoisseur, and potter. With its small foot, straight sides, irregular shape, and crackled texture, this bowl exemplifies tea taste.

# EDO PERIOD

When Tokugawa Ieyasu gained control of Japan, he forced the emperor to proclaim him shogun, a title neither Nobunaga nor Hideyoshi had held. His reign initiated the Edo period (1615–1868), named after the city that he founded (present-day Tokyo) as his capital. This period is alternatively known as the Tokugawa era. Under the rule of the Tokugawa family, peace and prosperity came at the price of a rigid and repressive bureaucracy. The problem of a potentially rebellious *daimyo* was solved by ordering all feudal lords to spend either half of each year, or every other year, in Edo, where their families were required to live. Zen Buddhism was supplanted as the prevailing intellectual force by a

**25-8 • Hon'ami Koetsu  TEA BOWL, CALLED MOUNT FUJI**
Momoyama-Edo period, early 17th century. *Raku* ware, height 3⅜″ (8.5 cm). Sakai Collection, Tokyo. National Treasure.

Connoisseurs developed a subtle vocabulary to discuss the aesthetics of tea. A favorite term was *sabi* ("loneliness"), which refers to the tranquility found when feeling alone. Other virtues were *wabi* ("poverty"), which suggests the artlessness of humble simplicity, and *shibui* ("bitter" or "astringent"), meaning elegant restraint. Tea bowls, such as this example, embody these aesthetics.

form of Neo-Confucianism, a philosophy formulated in Song-dynasty China that emphasized loyalty to the state, although the popularity of Buddhism among the commoner population surged at this time.

The shogunate officially divided Edo society into four classes. Samurai officials constituted the highest class, followed by farmers, artisans, and finally merchants. As time went on, however, merchants began to control the money supply, and in Japan's increasingly mercantile economy their accumulation of wealth soon exceeded that of the samurai, which helped, unofficially, to elevate their status. Reading and writing became widespread at all levels of society, and with literacy came intellectual curiosity and interest in the arts. All segments of the population—including samurai, merchants, townspeople, and rural peasants—were able to patronize artists. A rich cultural atmosphere developed unlike anything Japan had experienced before, in which artists worked in a wide variety of styles that appealed to these different groups of consumers.

## RINPA SCHOOL PAINTING

During the Edo period, Edo was the shogun's city while life in Kyoto took its cues from the emperor and his court who resided there. Kyoto was also home to wealthy merchants, artists, and craftsmakers who served the needs of the courtiers and shared their interest in refined pursuits, such as the tea ceremony, and also their appreciation of art styles that recalled those perfected by aristocratic

# Lacquer Box for Writing Implements

This lacquer box reflects the collaborative nature of Japanese artistic production and the fluidity with which artists worked in various media. It was designed by the Rinpa school painter Ogata Korin (1658–1716), who oversaw its execution, although he left the actual work to trained crafts specialists. He also frequently collaborated with his brother Kenzan, a celebrated potter. The upper tray housed writing implements, the larger bottom section stored paper (see "Inside a Writing Box," page 824). Korin's design sets a motif of irises and a plank bridge in a dramatic asymmetrical combination of mother-of-pearl, silver, lead, and gold lacquer. The subject was one he frequently also represented in painting because it was immensely popular with the educated Japanese of his day. They immediately recognized the imagery as an allusion to a famous passage from the tenth-century *Tales of Ise*, a classic of Japanese literature. A nobleman poet, having left his wife in the capital, pauses at a place called Eight Bridges, where a river branches into eight streams, each covered

with a plank bridge. Irises are in full bloom, and his traveling companions urge the poet to write a *waka*—a five-line, 31-syllable poem—beginning each line with a syllable from the word for "iris": *Kakitsubata* (*ka-ki-tsu-ba-ta*). The poet responds (substituting *ha* for *ba*):

> **K**aragoromo
> **ki**tsutsu narenishi
> **tsu**ma shi areba
> **ha**rubaru kinuru
> **ta**bi o shi zo omou.
> When I remember
> my wife, fond and familiar
> as my courtly robe,
> I feel how far and distant
> my travels have taken me.
> (Translated by Stephen Addiss)

The poem in association with the scene became so famous that any image of a group of irises, with or without a plank bridge, immediately calls the episode to mind.

**Lacquer** is derived in Asia from the sap of the lacquer tree, *Rhus verniciflua*,

indigenous to China but very early in history also grown commercially throughout east Asia. It is gathered by tapping into a tree and letting the sap flow into a container. It can be colored with vegetable or mineral dyes. Applied in thin coats to a surface of wood or leather, lacquer hardens into a glasslike protective coating that is waterproof, heat- and acid-resistant, and airtight. Its practical qualities made it ideal for storage containers, and vessels for food and drink. The creation of a piece of lacquer can take several years. First, the item is fashioned of wood and sanded smooth. Next, up to 30 layers of lacquer are thinly applied, each dried and polished before the next is brushed on.

Japanese craftsmakers exploited the decorative potential of lacquer to create expensive luxury items, such as this box, which was created when lacquer arts had been perfected. It features inlays of mother-of-pearl and precious metals in a style known as *makie* ("sprinkled design"), in which flaked or powdered gold or silver was embedded in a still-damp coat of lacquer.

Ogata Korin **LACQUER BOX FOR WRITING IMPLEMENTS**
Edo period, late 17th–early 18th century. Lacquer, lead, silver, and mother-of-pearl, 5⅝ × 10¾ × 7¾" (14.2 × 27.4 × 19.7 cm). Tokyo National Museum, Tokyo. National Treasure.

**DETAILS OF BOX INTERIOR AND LID**
Left: interior of lid; center: top tray with ink stone and waterpot; right: exterior view of box lid.

**25-9 • Tawaraya Sotatsu  WAVES AT MATSUSHIMA**
Edo period, 17th century. Pair of six-panel folding screens, ink, mineral colors, and gold leaf on paper; each screen 4′9⅞″ × 11′8½″ (1.52 × 3.56 m). Freer Gallery of Art, Smithsonian Institution, Washington, D.C. Gift of Charles Lang Freer (F1906.231 & 232)

The six-panel screen format was a triumph of scale and practicality. Each panel consisted of a light wood frame surrounding a latticework interior covered with several layers of paper. Over this foundation was pasted a high-quality paper, silk, or gold-leaf ground, ready to be painted by the finest artists. Held together with ingenious paper hinges, a screen could be folded for storage or transportation, resulting in a mural-size painting light enough to be carried by a single person, ready to be displayed as needed.

artists in the Heian period. The most famous and original Kyoto painter who worked for this group of patrons was Tawaraya Sotatsu (active c. 1600–40), who occasionally collaborated with the potter Koetsu (SEE FIG. 25–8). Sotatsu is considered the first great painter of the Rinpa school, the modern name given to a group of artists whose art reinterpreted ancient courtly-style arts. These artists are grouped together because of their shared interests and art styles,

and did not constitute a formal school, such as the Kano. Rinpa masters were not just painters, however: They sometimes collaborated with craftsmakers (see "Lacquer Box for Writing Implements," opposite).

One of Sotatsu's most famous pairs of screens depict the islands of Matsushima near the northern city of Sendai (**FIG. 25–9**). On the right screen (shown here on top), mountainous islands echo

Writing boxes hold tools basic for both writing and painting: ink stick, ink stone, brushes, and paper, which are beautiful objects in their own right.

Ink sticks are basically soot from burning wood or oil that is bound into a paste with resin, and pressed into small stick-shaped or cake-shaped molds to harden.

Fresh ink is made for each writing or painting session by grinding the hard, dry ink stick in water against a fine-grained stone. A typical ink stone has a shallow well at one end sloping up to a grinding surface at the other. The artist fills the well with water from a waterpot. The ink stick, held vertically, is dipped into the well to pick up a small amount of water, then is rubbed in a circular motion firmly on the grinding surface. Grinding ink is viewed as a meditative task, time for collecting one's thoughts and concentrating on the painting or calligraphy ahead.

Brushes are made from animal hair set in simple bamboo or hollow-reed handles. Brushes taper to a fine point that responds

sensitively to any shift in pressure. Although great painters and calligraphers do eventually develop their own styles of holding and using the brush, all begin by learning the basic position for writing. The brush is held vertically, grasped firmly between the thumb and first two fingers, with the fourth and fifth fingers often resting against the handle for more subtle control.

**writing implements**

the swing and sweep of the waves, with stylized gold clouds in the upper left. The left screen continues the gold clouds until they become a sand spit from which twisted pines grow. Their branches seem to lean toward a strange island in the lower left, composed of an organic, amoebalike form in gold surrounded by mottled ink. This mottled effect was a specialty of Rinpa school painters.

As one of the "three famous beautiful views of Japan," Matsushima was often depicted in art. Most painters showed the pine-covered islands that make the area famous from above. Sotatsu's genius was to portray them in an abbreviated manner and from a fresh vantage point, as though the viewer were passing the islands in a boat on the roiling waters. The artist's asymmetrical composition and use of thick mineral colors in combination with soft, playful brushwork and sparkling gold leaf create the boldly decorative effect that is the hallmark of the Rinpa tradition.

## NATURALISTIC PAINTING

NAGASAWA ROSETSU. By the middle of the eighteenth century, the taste of wealthy Kyoto merchants had shifted, influencing the styles of artists who competed for their patronage. The public was enthralled with novel imagery captured in magnifying glasses, telescopes, and an optical device that enhanced the three-

**25–10 • Nagasawa Rosetsu BULL AND PUPPY**
Edo period, late 18th century. Left of a pair of six-panel screens, ink and gold wash on paper, 5′7¼″ × 12′3″ (1.70 × 3.75 m). Los Angeles County Museum of Art, California. Joe and Etsuko Price Collection (L.83.45.3a)

dimensional effects of Western-style perspective pictures. Schools of independent artists emerged in Kyoto to satisfy demands for naturalistic-style paintings that reflected this fascination. The most influential was founded by Maruyama Okyo, who had perfected methods to incorporate Western shading and perspective into a more native Japanese decorative style, creating a sense of volume new to east Asian painting, while still retaining a sense of familiarity.

Okyo's most famous pupil was Nagasawa Rosetsu (1754–1799), a painter of great natural talent who added his own boldness and humor to his master's tradition. Rosetsu delighted in surprising his viewers with odd juxtapositions and unusual compositions. One of his finest works is a pair of screens, the left one depicting a bull and a puppy (FIG. 25–10). The bull is so immense that his mammoth body exceeds the borders of the screen, undoubtedly influenced by new optical devices. The puppy, white against the dark gray of the bull, helps to emphasize the huge size of the bull by its own smallness. The puppy's relaxed and informal pose, looking happily right out at the viewer, gives this powerful painting a humorous touch that increases its charm. In the hands of a master such as Rosetsu, plebeian subject matter became simultaneously delightful and monumental.

### LITERATI PAINTING

Because the city of Kyoto was far from the watchful eyes of the government in Edo, and the emperor resided there with his court, it enjoyed a degree of privilege and independence not found in any other Japanese city. These conditions allowed for the creation of art in the new Rinpa and naturalistic styles. They also encouraged the emergence of new schools of philosophy based on interpretations of Chinese Confucianism that disagreed with those taught at schools sponsored by Tokugawa shoguns. These new interpretations incorporated ideas from Chinese Daoism, which promoted cultivation of a person's uniqueness, thus encouraging artistic creativity. Kyoto's intellectuals, who admired Chinese culture, even created a new, more informal tea ceremony of their own, featuring steeped tea called *sencha* because it was the tea drunk by Ming-dynasty Chinese literati. They did this as political protest—by then *chanoyu* had become encumbered by rules and was closely associated with the repressive shogunate. Influenced by the new ideas, a Chinese manner of painting arose in the mid eighteenth century in emulation of Chinese literati painting. Artists who embraced this style, both professionals who painted for paying clients and amateurs who painted for their own enjoyment, quickly grew to number hundreds as its popularity spread throughout Japan alongside increased interest in drinking *sencha*, as well as in other aspects of Chinese culture. They learned about Chinese literati painting from paintings and woodblock-printed painting manuals imported from China, and also from Chinese emigrant monks and merchants who lived in Japan.

The best and most successful of these artists took Chinese literati painting models as starting points for their original interpretations of literati themes. One of them was Ike Taiga (1723–1776),

admired as much for his magnetic personality as for his art. He was born into a poor farming family near Kyoto and showed innate talent for painting at a young age. Moving to Kyoto in his teens, he became friends with Chinese scholars there, including those who promoted drinking *sencha*. Taiga became a leader in this group, attracting admirers who were enamored of both his quasi-amateurish painting style and his quest for spiritual self-cultivation. His character and personal style are seen in the scintillating, rhythmic layering of strokes used to define the mountains in his **TRUE VIEW OF KOJIMA BAY** (FIG. 25–11) which blends Chinese

**25-11 • Ike Taiga TRUE VIEW OF KOJIMA BAY**
Edo period, third quarter of 18th century. Hanging scroll, ink and color on silk. 39¼ × 14⅝″ (99.7 × 37.6 cm). Hosomi Museum, Kyoto.

The production of woodblock prints combined the expertise of three people: the artist, the carver, and the printer. Coordinating and funding the endeavor was a publisher, who commissioned the project and distributed the prints to stores or itinerant peddlers, who would sell them.

The artist supplied the master drawing for the print, executing its outlines with brush and ink on tissue paper. Colors might be indicated, but more often they were understood or decided on later. The drawing was passed on to the carver, who pasted it face down on a hardwood block, preferably cherrywood, so that the outlines showed through the paper in reverse. A light coating of oil might be brushed on to make the paper more transparent, allowing the drawing to stand out clearly. The carver then cut around the lines of the drawing with a sharp knife, always working in the same direction as the original brushstrokes. The rest of the block was chiseled away, leaving the outlines in relief. This block, which reproduced the master drawing, was called the **key block**. If the print was to be **polychrome**, having multiple colors, prints made from the key block were in turn pasted face down on blocks that would be used as guides for the carver of the color blocks. Each color generally required a separate block, although both sides of a block might be used for economy.

Once the blocks were completed, the printer took over. Paper for printing was covered lightly with animal glue (gelatin). Before printing, the paper was lightly moistened so that it would take ink and color well. Water-based ink or color was brushed over the block, and the paper placed on top and rubbed with a smooth, padded device called a *baren*, until the design was completely transferred. The key block was printed first, then the colors one by one. Each block was carved with two small marks called **registration marks**, in exactly the same place in the margins, outside of the image area—an L in one corner, and a straight line in another. By aligning the paper with these marks before letting it fall over the block, the printer ensured that the colors would be placed correctly within the outlines. One of the most characteristic effects of later Japanese prints is a grading of color from dark to pale. This was achieved by wiping some of the color from the block before printing, or by moistening the block and then applying the color gradually with an unevenly loaded brush—a brush loaded on one side with full-strength color and on the other with diluted color.

**Toshusai Sharaku ONOE MATSUSUKE AS MATSUSHITA MIKINOSHIN**
Edo period, 1794–95. Polychrome woodblock print, ink and colors on mica ground paper, 14¾₁₆ × 9¹¹⁄₁₆″ (36.1 × 24.6 cm). British Museum, London. (1909,0618,0.42)

Much as people today buy posters of their favorite sports, music, or movie stars, so, too, in the Edo period people clamored for images of their idols, actors of the popular form of drama known as Kabuki. The artist of this print was renowned for capturing the personality of his subjects. The actor has his eyes crossed, in what was a frozen, tension-filled moment in an action-packed play. The print has a shiny mica background, made of crushed shells, painstakingly applied by printers.

**SEE MORE:** View a video about the printmaking process of woodcut **www.myartslab.com**

models, Japanese aesthetics, and personal brushwork. The gentle rounded forms of the mountains intentionally recall the work of famous Chinese literati painters, and Taiga utilizes a stock landscape composition that separates foreground and background mountains with a watery expanse (SEE FIG. 25–2). However, he did not paint an imaginary Chinese scene but a personal vision of an actual Japanese place that he had visited—Kojima Bay—as a document accompanying the painting explains. Still, in deference to his admiration for Chinese literati, Taiga places two figures clad in Chinese robes on the right, midway up the mountain.

## UKIYO-E: PICTURES OF THE FLOATING WORLD

Edo served as the shogun's capital as well as the center of a flourishing popular culture associated with tradespeople. Deeply Buddhist, commoners were acutely aware of the transience of life, symbolized, for example, by the cherry tree which blossoms so briefly. Putting a positive spin on this harsh realization, they sought to live by the mantra: Let's enjoy it to the full as long as it lasts. This they did to excess in the restaurants, theaters, bathhouses, and brothels of the city's pleasure quarters, named after the Buddhist phrase *ukiyo* ("floating world"). Every major city in Japan had these

**25-12 • Katsushika Hokusai THE GREAT WAVE**
From *Thirty-Six Views of Mt. Fuji*. Edo period, c. 1831. Polychrome woodblock print on paper, 9⅞ × 14⅝″
(25 × 37.1 cm). Honolulu Academy of Arts, Honolulu, Hawaii. James A. Michener Collection (HAA 13, 695)

**EXPLORE MORE:** Gain insight from a primary source related to *The Great Wave* **www.myartslab.com**

quarters, and most were licensed by the government. But those of Edo were the largest and most famous. The heroes of the floating world were not famous samurai or aristocratic poets. Instead, swashbuckling Kabuki actors and beautiful courtesans were admired. These paragons of pleasure soon became immortalized in paintings and—because paintings were too expensive for common people—in woodblock prints known as *ukiyo-e* ("pictures of the floating world"; see "Japanese Woodblock Prints," opposite). Most prints were inexpensively produced by the hundreds and not considered serious fine art. Yet when first imported to Europe and America, they were immediately acclaimed and strongly influenced late nineteenth- and early twentieth-century Western art (see Chapter 30).

HARUNOBU. The first woodblock prints had no color, only black outlines. Soon artists added colors by hand to make them more resemble paintings. But to produce colored prints more rapidly they gradually devised a system to print colors using multiple blocks. The first artist to design prints that took advantage of this new technique,

known as **nishiki-e** ("brocade pictures"), was Suzuki Harunobu (1724–1770), famous for his images of courtesans (SEE FIG. 25–1).

HOKUSAI. During the first half of the nineteenth century, the heyday of popular travel, pictures of famous sights of Japan grew immensely popular. The two most famous *ukiyo-e* printmakers, Utagawa Hiroshige (1797–1858) and Katsushika Hokusai (1760–1849), specialized in this genre. Hiroshige's *Fifty-Three Stations of the Tokaido* and Hokusai's *Thirty-Six Views of Mt. Fuji* became the most successful sets of graphic art the world has known. The woodblocks were printed, and printed again, until they wore out. They were then recarved, and still more copies were printed. This process continued for decades, and thousands of prints from the two series are still extant.

THE GREAT WAVE (FIG. 25–12) is the most famous of the scenes from *Thirty-Six Views of Mt. Fuji*. The great wave rears up like a dragon with claws of foam, ready to crash down on the figures huddled in the boats below. Exactly at the point of

imminent disaster, but far in the distance, rises Japan's most sacred peak, Mount Fuji, whose slopes, we suddenly realize, swing up like waves and whose snowy crown is like foam—comparisons the artist makes clear in the wave nearest us, caught just at the moment of greatest resemblance. In the late nineteenth century when Japonisme, or *japonism*, became the vogue in the West, Hokusai's art was greatly appreciated, even more so than it had been in Japan: The first book on the artist was published in France.

## ZEN PAINTING: BUDDHIST ART FOR RURAL COMMONERS

Outside Japan's urban centers, art for commoners also flourished, much of it tied to their devotion to Buddhism. Deprived of the support of the samurai officials who now favored Confucianism, Buddhism nevertheless thrived during the Edo period through patronage from private individuals, many of them rural peasants. In the early eighteenth century, one of the great monks who preached in the countryside was the Zen master Hakuin Ekaku (1685–1769), born in a small village near Mount Fuji. After hearing a fire-and-brimstone sermon in his youth he resolved to become a monk and for years he traveled around Japan seeking out the strictest Zen teachers. He became the most important Zen master of the last 500 years, and invented many *koan* (questions posed to novices by Zen masters to guide their progression towards enlightenment during meditation), including the famous "What is the sound of one hand clapping?" He was also, in his later years, a self-taught painter and calligrapher, who freely gave away his scrolls to admirers (who included not only farmers but also artisans, merchants, and even samurai) as a way of spreading his religious message.

Hakuin's art differed from that of Muromachi period monk-painters like Bunsei and Sesshu (SEE FIGS. 25–2, 25–3). His work featured everyday Japanese subjects or Zen themes that conveyed his ideas in ways his humble followers could easily understand. He often painted Daruma (Bodhidharma in Sanskrit) **(FIG. 25–13)**, the semilegendary Indian monk who founded Zen (see Chapter 11). Hundreds of Zen monks of the Edo period and later created simply brushed Zen ink paintings. Hakuin largely set the standards that subsequent Zen artists followed.

## CRAFTS

The ingenuity and technical proficiency that contributed to the development of *ukiyo*-prints came about because of Japan's long history of fine crafts production. Textiles, ceramics, lacquer, woodwork, and metalwork were among the many crafts in which Japanese artisans excelled. In pre-modern Japan, unlike the West, no separate words distinguished fine arts (painting and sculpture) from crafts. (The Japanese word for fine art and corresponding modern Japanese language words for various types of craft were not coined until 1872.) This was largely because professional Japanese artist and crafts studios basically followed the same hereditary, hierarchical structure. A master artist directed all

activity in a workshop of trainees, who gradually gained seniority through years of apprenticeship and innate talent. Sometimes, such as when a pupil was not chosen to succeed the master, he would go off and start his own studio. This teamwork approach to artistic production is characteristic of the way most traditional Japanese arts were created.

**25-13 • Hakuin Ekaku GIANT DARUMA**
Edo period, mid 18th century. Hanging scroll, ink on paper 4′3½″ × 1′9¾″ (130.8 × 55.2 cm). Manyo'an Collection, New Orleans 1973.2

As a self-taught amateur painter, Hakuin's painting style is the very antithesis of that of consummate professionals, such as painters of the Kano or Rinpa schools. The appeal of his art lies in its artless charm, humor, and astonishing force. Here Hakuin has portrayed the wide-eyed Daruma during his nine years of meditation in front of a temple wall in China. Intensity, concentration, and spiritual depth are conveyed by a minimal number of broad, forceful brushstrokes. The inscription is the ultimate Zen message, attributed to Daruma himself: "Pointing directly to the human heart, see your own nature and become Buddha."

## *Kosode* Robe ›

With design of waves and floral bouquets. Edo period, second half of 18th century to early 19th century. White figured satin ground with silk and metallic thread embroidery, stencil tie-dyeing, brush painting; indigo blue dyed silk lining, height 64¾″ (163 cm), width 24½″ (61.5 cm) below sleeve, 50″ (127 cm) sleeve top. The Nelson-Atkins Museum of Art, Kansas City, Missouri. Gift of Mrs. Harold J. Owens (57-45)

The white silk background is woven with a key-fret textured pattern.

Ink drawing was used to define the vines, leaves, ribbons, and flower petals.

Embroidery with gold and brightly colored thread embellishes the flowers and leaves.

Stencil dyeing makes up some of the leaf, flower, and wave patterns.

SEE MORE: View the Closer Look feature for *Kosode* Robe **www.myartslab.com**

**KOSODE ROBES.**   The kimono is as much a symbol of Japanese culture as is the tea ceremony. Before the late nineteenth century, it was known as *kosode*. These loose, unstructured garments that wrap around the body and are cinched with a sash were the principal outer article of clothing of both men and women, beginning in the Muromachi period. *Kosode* ("small sleeves") refers to the vertical length of the sleeves (in contrast, young, unmarried women wore robes with long, flowing sleeves). Because of their fragility, few *kosode* prior to the Edo period

survive. But those from the eighteenth century reveal the opulent tastes of affluent merchant-class women of the day (see "A Closer Look," page 830). In the example shown, ribbons and flower bouquets float above abstract waves and scalloped-edged clouds in a playful, asymmetrical composition. Artisans used many techniques to create the rich interplay of textures and designs on this gorgeous robe, made in the country's premier textile center of Kyoto. Its design elements resemble those found in paintings of the period.

**25-14 • LARGE PLATE WITH LEAF DESIGN**
Edo period, early 18th century. Arita ware, *Ko*-Imari type. Porcelain with underglaze blue decoration, diameter 15⅜″ (39.1 cm). Nelson-Atkins Museum of Art, Kansas City. Purchase: Nelson Trust (63-4)

JAPANESE PORCELAIN.    While the history of ceramic production dates to the earliest days of Japanese civilization, production of glazed, high-fired stoneware ceramics proliferated in Japan only from the sixteenth century, encouraged largely by the tea ceremony. The industry thrived in southern Japan, where, around 1600, influxes of more highly skilled Korean potters helped native artisans to learn new continental technologies that allowed them to manufacture porcelain for the first time. One town, Arita, became the center for the production of porcelain, created for export to the West and for domestic use. While tea ceremony aesthetics still favored rustic wares such as Koetsu's tea bowl (SEE FIG. 25–8), porcelain was more widely adopted for everyday use in response to a growing fashion for Chinese arts. Porcelains made in Arita are known by various names according to their dating and decorative schemes. Those ornamented exclusively with underglaze cobalt blue, the first porcelains made in Japan, are generally known as Imari, the name for the port city from which some of them were exported to Europe. However, the piece shown in FIGURE 25–14 must have been made for domestic use, as the audaciously abstracted design would not have appealed to Europeans, who preferred more recognizable natural forms. Complementing the strong, vertical stylized leaves are small, half-round forms resembling chestnuts.

## THE MODERN PERIOD

The tensions that resulted from Commodore Matthew Perry's forced opening of trade ports in Japan in 1853 precipitated the downfall of the Tokugawa shogunate. In 1868 the emperor was formally restored to power, an event known as the Meiji Restoration. The court soon moved from Kyoto to Edo, which was renamed Tokyo ("Eastern Capital"). After a period of intense industrialization in the first two decades after the Meiji Restoration, influential private individuals and government officials, sometimes working cooperatively, created new arts institutions including juried exhibitions, artists' associations, arts universities, and cultural heritage laws. These rekindled appreciation for the art of the past, encouraged

**25-15 • Yokoyama Taikan FLOATING LIGHTS**
Meiji period, 1909. One of a pair of hanging scrolls, ink, colors, and gold on silk, 56½ × 20½″ (143 × 52 cm). The Museum of Modern Art, Ibaraki.

perpetuation of artistic techniques threatened by adoption of Western ways, and stimulated new artistic production. Many of these arts institutions still exist today.

## MEIJI-PERIOD NATIONALIST PAINTING

The Meiji period (1868–1912) marked a major change for Japan. Japanese society adapted various aspects of Western education, governmental systems, clothing, medicine, industrialization, and technology in efforts to modernize the nation. Teachers of sculpture and oil painting came from Italy, while adventurous Japanese artists traveled to Europe and America to study.

**A MEIJI PAINTER.** Ernest Fenollosa (1853–1908), an American who had recently graduated from Harvard, traveled to Japan in 1878 to teach philosophy and political economy at Tokyo University. Within a few years, he and a former student, Okakura Kakuzo (1862–1913), began urging artists to study traditional Japanese arts rather than to focus exclusively on Western art styles and media, but infuse them with a modern sensibility. Yokoyama Taikan (1868–1958) subsequently developed his personal style within the Nihonga (modern Japanese painting) genre promoted by Okakura. Encouraged by Okakura, who had gone there before him, Taikan visited India in 1903. He embraced Okakura's ideals of pan-Asian cultural nationalism, expressed in the first line of Okakura's book, *Ideals of the East* (1903), with the words "Asia is One." This outlook later contributed to fueling Japan's imperialist ambitions. Taikan's **FLOATING LIGHTS (FIG. 25–15)** was inspired by a visit to Calcutta, where he observed women engaged in divination on the banks of the Ganges. The naturalism of their semitransparent robes and the flowing water reveal his indebtedness to Western art. In contrast, the lightly applied colors, and graceful branches with delicate, mottled brushwork defining the leaves, recall techniques of Rinpa-school artists.

## JAPAN AFTER WORLD WAR II

In the aftermath of World War II (1941–1945), Japan was a shambles, her great cities ruined. Nevertheless, under the U.S.-led Allied Occupation (1946–1952), the Japanese people immediately began rebuilding, unified by a sense of national purpose. Within ten years, Japan established nascent automobile, electronics, and consumer goods industries. Rail travel, begun in 1872, expanded and improved significantly after the war and by the time of the Tokyo Olympics in 1964 the capital had an extensive commuter rail system, and Japan was the world leader in city-to-city high-speed rail transit with its new Shinkansen (bullet train). As the rest of the world came to know Japan, foreign interest in its arts focused especially on the country's still thriving crafts traditions. Not only were these a source of national pride and identity, the skills and attitudes they fostered also served as the basis for Japan's national revival.

**POSTWAR ARCHITECTURE.** The Hiroshima Peace Memorial Museum and Park **(FIG. 25–16)** was one of the first monuments constructed after World War II. A memorial to those who perished on August 6, 1945, and an expression of prayers for world peace, it attests to the spirit of the Japanese people at this difficult juncture in history. Tange Kenzo (1913–2005), who would eventually become one of the masters of Modernist architecture, designed the complex after winning an open competition as a young, up-and-coming architect.

The building's design befits the solemnity of its function. Concrete piers raise its stripped concrete form 20 feet off the ground. The wood formwork of the concrete recalls the wooden forms of traditional Japanese architecture. But the use of concrete is also inspired by Le Corbusier's 1920s Modernist villas. Evenly spaced vertical concrete fins lining the façade afford light shade. They suggest both the regular spacing of elements present in modular *shoin* architecture (see "*Shoin* Design," page 819) and the values of Modernist architects who advocated that structure should

**25–16 • Tange Kenzo HIROSHIMA PEACE MEMORIAL MUSEUM**
Showa period, 1955. Main building (center) repaired in Heisei period, 1991. East building (right), the former Peace Memorial Hall, which first opened in 1955, was rebuilt in June 1994 and attached to the main building. Designated UNESCO World Heritage site in 1996.

This exquisite wooden box was crafted by Eri Sayoko (1945–2007). In 2002, the government designated her a Living National Treasure for her accomplishment in the art of cut-gold leaf (*kirikane*), traditionally used to decorate Buddhist sculpture and paintings (as in FIG. 11–15). The National Treasure designation originated in Japanese laws of 1897 that were intended to safeguard the nation's artistic heritage at a time when art was being bought by Western collectors but suffering neglect at home. In 1955 the government added provisions to honor living individuals who excel in traditional craft techniques with the title Living National Treasure. This historic preservation system is the most complex of its type in the world.

Eri was the third person awarded the title for cut-gold-leaf decoration and the first woman. In its encouragement of traditional crafts, the Living National Treasure system has greatly assisted women in gaining much-deserved recognition. In pre-modern Japan (encompassing the prehistoric era up to the start of the Meiji period in 1868), women mostly operated in the private sphere of the home where they created crafts for their own enjoyment or for devotional purposes. By the eighteenth century, this situation had begun to change, so that women could be poets, calligraphers, and painters;

the wives or daughters of famous male artists gained the most recognition. Among the most famous was Gyokuran, wife of the literati painter Ike Taiga (SEE FIG. 25–11). However, the conservative nature of traditional Japanese crafts workshops meant women could not hold leadership positions in them, and until the postwar period they were seldom recognized for their achievements in crafts. Eri Sayoko flourished in the new climate, as one of the first women to work in the medium of cut-gold, which she took up via an unorthodox route.

Eri specialized in Japanese painting in high school and in design-dyeing in junior college. After marriage to a traditional Buddhist sculptor she started producing Buddhist paintings and began an apprenticeship with a master *kirikane* craftsman. She was so talented that after only three years she was able to exhibit her work professionally. Her art is informed by her deep study of the history of the technique, and her marvelous sensitivity for color betrays her training in dyeing. Eri's elegant, functional objects, typified by this box, are infused with modern sensibilities, although her designs have a basis in traditional *kirikane* patterns. Her art reveals that adherence to a craft tradition can still result in artistic originality.

**Eri Sayoko  ORNAMENTAL BOX: DANCING IN THE COSMOS**
Heisei period, 2006. Wood with polychrome and cut gold, height 33⅞" (86 cm), width 6½" (16.5 cm), depth 6½" (16.5 cm). Collection of Eri Kokei

dictate form. In this commission Tange infuses Modernist tendencies and materials with a Japanese sense of interval and refinement, characteristics also seen in the work of most younger contemporary Japanese architects active today.

**POSTWAR CRAFTS.** Throughout their history, the Japanese have displayed a heightened sensitivity toward the surface quality of things, for polish, for line, for exquisiteness and stylishness. Their appreciation of craft has continued to the present (see "Craftsmakers as Living National Treasures," above). Some crafts are made for use

in the tea ceremony, which remains popular today. Others are produced as functional objects for use in the home, as high-fashion apparel, or simply as decoration. Many combine diverse influences, native and foreign, that the maker integrates uniquely, often using novel techniques invented to achieve the desired results. In this way, the traditions of fine crafts in Japan, among the signature achievements of Japanese culture, continue to be enriched.

**A MODERN CERAMICIST.** Perhaps because the arts of tea ceremony and flower arrangement both require ceramic vessels,

**25–17 • Fukami Sueharu  SKY II**
Heisei period, c. 1990. Celadon-glazed porcelain with wood base 3 × 44⅛ × 9½" (7.7 × 112.1 × 24.2 cm).
Helen Foresman Spencer Museum of Art, University of Kansas, Lawrence, Kansas.
Museum purchase: R. Charles and Mary Margaret Clevenger Fund (1992.0072)

the Japanese have a particular love for pottery. While some ceramicists continue to create *raku* tea bowls and other traditional wares, others experiment with new styles and innovative techniques.

Fukami Sueharu (b. 1947) is among the most innovative clay artists in Japan today. Yet his art has roots in the past—in his case, in Chinese porcelains with pale bluish-green glazes (*seihakuji*). Even so, his forms and fabrication methods, typified by his **SKY II**, are ultramodern **(FIG. 25–17)**. He created the piece using a slip casting technique, in which he injected liquid clay into a mold using a high-pressure compressor. Although he sometimes makes functional pieces, mainly cylinders that could hold flower arrangements, *Sky II* shows his mastery of pure form. The title suggests sources of his abstract sculptural form: a wing or a blade of an aircraft slicing through the heavens. The pale blue sky-colored glaze enhances this allusion.

A plurality of artistic styles and media reflects Japan's long history and idiosyncratic worldview. While maintaining a strong sense of national identity, it has been able to absorb techniques and ideas from other lands, improve them, polish and refine them, and paradoxically make them its own. Deeply influenced by the Shinto and Buddhist religions, benefiting from a rich topography and mild climate, with citizens' lives revolving around a complex and hierarchical social structure, and reflecting a well-educated population curious about the rest of the world yet self-consciously different from it, the arts of Japan share common aesthetic principles that make them distinctively Japanese.

## THINK ABOUT IT

**25.1** Discuss the unique characteristics of Japanese Zen gardens, and explain how the rock garden at Ryoanji embodies the ideals of Zen Buddhism.

**25.2** Explain how differences between pictorial styles of artists from the cities of Kyoto and Edo reflect the variations in the social status, and cultural and intellectual interests of the residents. Build your discussion upon a comparison of a painting or lacquer box by a Rinpa-school artist from Kyoto with a woodblock print that was made in Edo.

**25.3** Discuss how the Japanese tea ceremony works and observe the role that craft arts play within it. Explore the unique aesthetics of the tearoom and craft arts associated with the ceremony, making reference to at least one work from this chapter.

**25.4** Discuss Chinese influences on Japanese art styles and techniques in the Muromachi and Edo periods; for your answer, look back to Chapter 24 and draw specific comparisons between two works from each chapter.

**25.5** Distinguish at least three different patron groups for Japanese arts and architecture in the Muromachi, Momoyama, and Edo periods. Discuss the kinds of arts and architecture each group preferred and how they were used by these patrons.

**PRACTICE MORE:** Compose answers to these questions, get flashcards for images and terms, and review chapter material with quizzes
**www.myartslab.com**

**26–1 • Julia Jumbo  TWO GREY HILLS TAPESTRY WEAVING**    Navajo, 2003.
Handspun wool, 36 × 24½″ (91.2 × 62.1 cm). Wheelwright Museum of the American Indian,
Santa Fe, New Mexico.

# ART OF THE AMERICAS AFTER 1300

According to Navajo mythology, the universe itself is a weaving, its fibers spun by Spider Woman out of sacred cosmic materials. Spider Woman taught the art of weaving to Changing Woman (a Mother Earth figure), and she in turn taught it to Navajo women, who continue to keep this art vital, seeing its continuation as a sacred responsibility. Early Navajo blankets were composed of simple horizontal stripes, but over time weavers have introduced more intricate patterns, and today Navajo rugs are woven in numerous distinctive styles.

The tapestry weaving in FIGURE 26–1 is designed in the Two Grey Hills style that developed during the early twentieth century around a trading post of that name in northwest New Mexico. Weavers who work in this style use the natural colors of undyed sheep's wool (only the black wool is sometimes dyed) to create dazzling geometric patterns. The artist Julia Jumbo (1928–2007), who learned to weave as a child, used her weavings to support her family. She raised her own sheep, and carded and spun her wool by hand before incorporating it into painstakingly made textiles. Jumbo is renowned for the clarity of her designs and the technical perfection of her fine weave. This outstanding work, created in 2003, attests to the vital and dynamic nature of Native American arts today.

When the first Europeans arrived, the Western Hemisphere was already inhabited from the Arctic Circle to Tierra del Fuego by peoples with long histories and rich cultural traditions (MAP 26–1). After 1492, when Christopher Columbus and his companions first sailed to the New World, the arrival of Europeans completely altered the destiny of the Americas. In Mesoamerica and South America the break with the past was sudden and violent: two great empires—the Aztec in Mexico and the Inca in South America—that had risen to prominence in the fifteenth century were rapidly destroyed. In North America the change took place more gradually, but the outcome was much the same. In both North and South America, natives succumbed to European diseases to which they had no immunity, especially smallpox, leading to massive population loss and social disruption. Over the next 400 years, many Native Americans were displaced from their ancestral homelands, and many present-day Native American ethnic groupings were formed by combinations of various survivor groups.

Despite all the disruption, during the past century the indigenous arts of the Americas have undergone a re-evaluation that has renewed the conception of what constitutes "American art." Native artists like Julia Jumbo continue to revive and reimagine indigenous traditions, revisit traditional outlooks, and restate their ancient customs and ideas in new ways. After being pushed to the brink of extinction, Native American cultures are experiencing a revival in both North and South America, as Native Americans assert themselves politically and insist on the connections between their history and the land.

## LEARN ABOUT IT

**26.1** Distinguish the styles, symbols, and techniques characteristic of Native American arts and crafts.

**26.2** Explore the cultural developments and achievements of the Aztec and Inca empires.

**26.3** Assess the role of portable and ephemeral media in the arts of the Americas.

**26.4** Observe how indigenous arts have changed in the centuries since contact with Europe.

**26.5** Explore the gender divisions in the production of the arts of the Americas.

**HEAR MORE:** Listen to an audio file of your chapter **www.myartslab.com**

# THE AZTEC EMPIRE

In November 1519, the army of the Spanish soldier Hernán Cortés beheld for the first time the great Aztec capital of Tenochtitlan. The shimmering city, which seemed to be floating on the water, was built on an island in the middle of Lake Texcoco in the Valley of Mexico, and linked by broad causeways to the mainland. One of Cortés's companions later recalled the wonder the Spanish felt at that moment: "When we saw so many cities and villages built on the water and other great towns on dry land and that straight and level causeway going towards [Tenochtitlan], we were amazed … on account of the great towers and temples and buildings rising from the water, and all built of masonry. And some of our soldiers even asked whether the things that we saw were not a dream." (Bernal Díaz del Castillo, cited in Coe and Koontz 2005, p. 190.)

The Mexica people who lived in the remarkable city that Cortés found were then rulers of much of the land that later took their name, Mexico. Their rise to power had been recent and swift. Only 400 years earlier, according to their own legends, they had been a nomadic people living far north of the Valley of Mexico in a distant place called Aztlan. The term Aztec derives from the word Aztlan, and refers to all those living in Central Mexico who came from this mythical homeland, not just to the Mexica of Tenochtitlan.

The Mexica arrived in the Valley of Mexico in the thirteenth century. They eventually settled on an island in Lake Texcoco where they had seen an eagle perching on a prickly pear cactus (*nochtli*) growing out of a stone (*tetl*), a sign that their god Huitzilopochtli told them would mark the end of their wandering. They called the place Tenochtitlan. The city on the island was gradually expanded by reclaiming land from the lake, and serviced by a grid of artificial canals. In the fifteenth century, the Mexica—joined by allies in a triple alliance—began an aggressive campaign of expansion. The tribute they exacted from all over Mexico transformed Tenochtitlan into a glittering capital.

Aztec religion was based on a complex pantheon that combined Aztec deities with more ancient ones that had long been worshiped in central Mexico. According to Aztec belief, the gods had created the current era, or sun, at the ancient city of Teotihuacan in the Valley of Mexico (see Chapter 12). The continued existence of the world depended on human actions, including rituals of bloodletting and human sacrifice. Many Mesoamerican peoples believed that the world had been created multiple times before the present era. But while most Mesoamericans believed that they were living in the fourth era, or sun, the Mexica asserted that they lived in the fifth sun, a new era that coincided with the Aztec Empire. The Calendar Stone (see "A Closer Look," page 839) boldly makes this claim, using the dates of the destructions of the four previous eras to form the glyph that names the fifth sun, 4 Motion. The end of each period of 52 years in the Mesoamerican calendar was a particularly dangerous time that required a special fire-lighting ritual.

## TENOCHTITLAN

An Aztec scribe drew an idealized representation of the city of Tenochtitlan and its sacred ceremonial precinct (FIG. 26–2) for the Spanish viceroy in 1545. It forms the first page of the *Codex Mendoza*. An eagle perched on a prickly pear cactus growing out of a stone—the symbol of the city—fills the center of the page. Waterways divide the city into four quarters, and indicate the lake surrounding the city. Early leaders of Tenochtitlan are shown sitting in the four quadrants. The victorious warriors at the bottom of the page represent Aztec conquests, and a count of years surrounds the entire scene. This image combines historical narration with idealized cartography, showing the city in the middle of the lake at the moment of its founding.

At the center of Tenochtitlan was the sacred precinct, a walled enclosure that contained dozens of temples and other buildings. The focal point of the sacred precinct was the Great Pyramid, a twin pyramid with paired temples on top: the one on the north dedicated to Tlaloc, an ancient rain god with a history extending

**26-2 • THE FOUNDING OF TENOCHTITLAN**
Page from *Codex Mendoza*. Mexico. Aztec, 1545. Ink and color on paper, 12⅜ × 8⁷⁄₁₆″ (21.5 × 31.5 cm). Bodleian Library, University of Oxford, England. MS. Arch Selden. A.1.fol. 2r

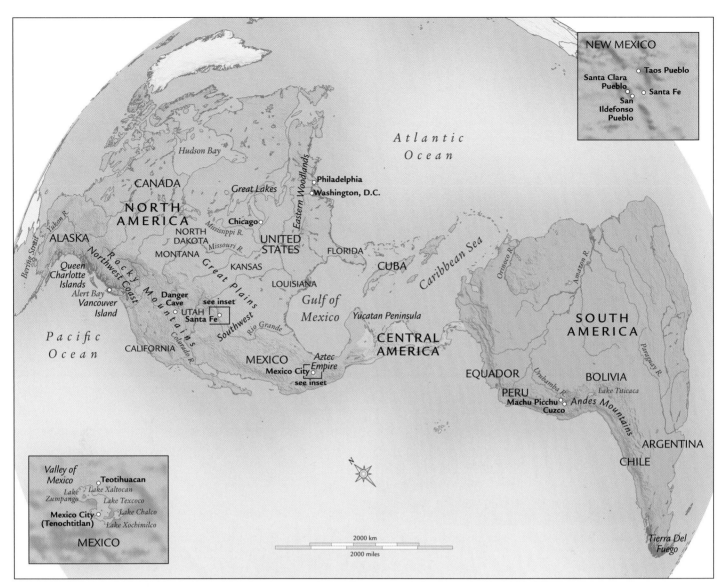

**MAP 26-1 • THE AMERICAS AFTER 1300**

Diverse cultures inhabited the Americas, each shaping a distinct artistic tradition.

back to Teotihuacan, and the one on the south dedicated to Huitzilopochtli, the solar god of the newly arrived Mexica tribe. Two steep staircases led up the west face of the pyramid from the plaza in front. Sacrificial victims climbed these stairs to the Temple of Huitzilopochtli, where priests threw them over a stone, quickly cut open their chests, and pulled out their still-throbbing hearts, a sacrifice that ensured the survival of the sun, the gods, and the Aztecs. The bodies were then rolled down the stairs and dismembered. Thousands of severed heads were said to have been kept on a skull rack in the plaza, represented in FIGURE 26–2 by the rack with a single skull to the right of the eagle.

During the winter rainy season the sun rose behind the Temple of Tlaloc, and during the dry season it rose behind the Temple of Huitzilopochtli. The double temple thus united two natural forces, sun and rain, or fire and water. During the spring and autumn equinoxes, the sun rose between the two temples.

## SCULPTURE

Aztec sculpture was monumental, powerful, and often unsettling (see "A Closer Look," page 839). A particularly striking example is an imposing statue of Coatlicue, mother of the Mexica god Huitzilopochtli (**FIG. 26–3**). Coatlicue means "she of the serpent skirt," and this broad-shouldered figure with clawed feet has a skirt of twisted snakes. The statue may allude to the moment of Huitzilopochtli's birth: when Coatlicue conceived Huitzilopochtli from a ball of down, her other children—the stars and the moon—jealously conspired to kill her. As they attacked, Huitzilopochtli emerged from his mother's body fully grown and armed, drove off his half-brothers, and destroyed his half-sister, the moon goddess Coyolxauhqui. Coatlicue, however, did not survive the encounter. In this sculpture, she has been decapitated and a pair of serpents, symbols of gushing blood, rise from her neck to form her head. Their eyes are her eyes; their fangs, her tusks. Around her stump of

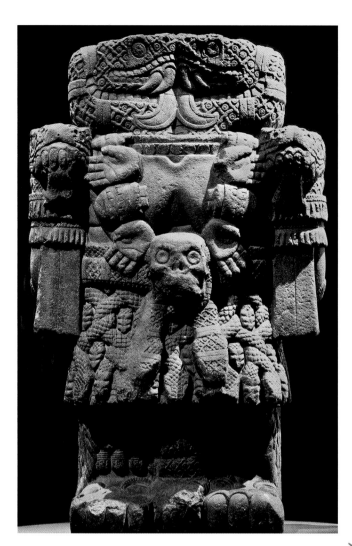

## 26-3 • THE GODDESS COATLICUE
Mexico. Aztec, c. 1500. Basalt, height 8′6″ (2.65 m).
Museo Nacional de Antropología, Mexico City.

a neck hangs a necklace of human hands, hearts, and a dangling skull. Despite the surface intricacy, the statue's massive form creates an impression of solidity, and the entire sculpture leans forward, looming over the viewer. The colors with which it was originally painted would have heightened its dramatic impact.

### FEATHERWORK

Indeed Aztec art was colorful. An idea of its iridescent splendor is captured in the feather headdress **(FIG. 26–4)** said to have been given by the Aztec emperor Moctezuma to Cortés, and thought to be the one listed in the inventory of treasures Cortés shipped to Charles V, the Habsburg emperor in Spain, in 1519. Featherwork was one of the glories of Mesoamerican art but very few of these extremely fragile artworks survive. The tropical feathers in this headdress exemplify the exotic tribute paid to the Aztecs; the long iridescent green feathers that make up most of the headdress are the exceedingly rare tail feathers of the quetzal bird—each male quetzal has only two such plumes. The feathers were gathered in small bunches, their quills reinforced with reed tubes, and then

## 26-4 • FEATHER HEADDRESS OF MOCTEZUMA
Mexico. Aztec, before 1519.
Quetzal, blue cotinga, and other feathers and gold on a fiber frame, 45⅝ × 68⅞″ (116 × 175 cm). Museum für Völkerkunde, Vienna.

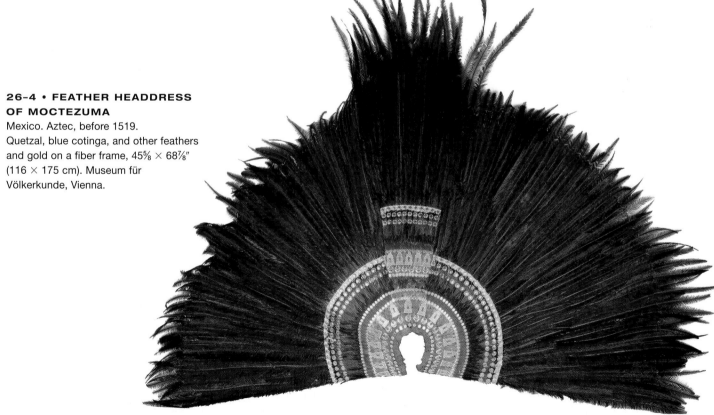

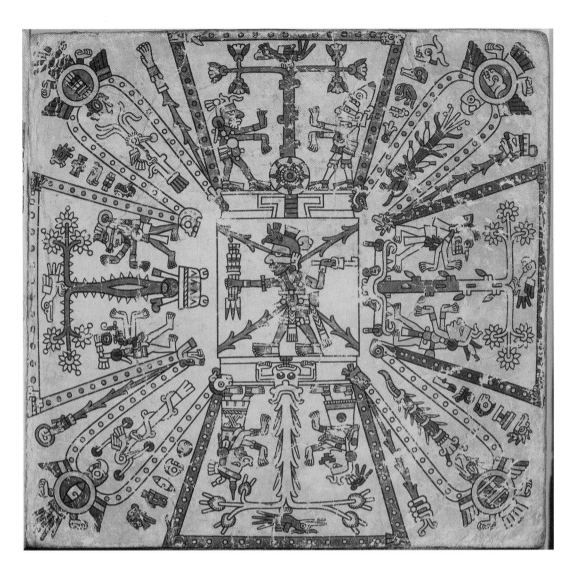

**26-5 • A VIEW OF THE WORLD**
Page from *Codex Fejervary-Mayer*. Mexico. Aztec or Mixtec, c. 1400–1519. Paint on animal hide, each page 6⅞ × 6⅞" (17.5 × 17.5 cm), total length 13'3" (4.04 m). The National Museums and Galleries on Merseyside, Liverpool, England.

sewn to the frame in overlapping layers, the joins concealed by small gold plaques. Featherworkers were esteemed craftspeople. After the Spanish invasion, they turned their exacting skills to "feather paintings" of Christian subjects.

### MANUSCRIPTS

Aztec scribes also created brilliantly colored books: histories, maps, and divinatory almanacs. Instead of being bound on one side like European books, Mesoamerican books took the form of a screenfold, accordion-pleated so that each page was connected only to the two adjacent pages. This format allowed great flexibility: a book could be opened to show two pages, or unfolded to show six or eight pages simultaneously; different sections of the book could also be juxtaposed. A rare manuscript that survived the Spanish conquest provides a concise summary of Mesoamerican cosmology (**FIG. 26–5**). Mesoamerican peoples recognized five key directions: north, south, east, west, and center. At the center of the image is Xiuhtecutli, god of fire, time, and the calendar. Radiating from him are the four cardinal directions—each associated with a specific color, a deity, and a tree with a bird in its branches. Two hundred and sixty dots trace the eight-lobed path around the central figure, referring to the 260-day Mesoamerican divinatory calendar; the 20 day signs of this calendar are also distributed throughout the image. By linking the 260-day calendar to the four directions, this image speaks eloquently of the unity of space and time in the Mesoamerican worldview.

The Aztec Empire was short-lived. Within two years of their arrival in Mexico, the Spanish conquistadors and their indigenous allies overran Tenochtitlan. They built their own capital, Mexico City, over its ruins and established their own cathedral on the site of Tenochtitlan's sacred precinct.

## THE INCA EMPIRE

At the beginning of the sixteenth century the Inca Empire was one of the largest states in the world. It extended more than 2,600 miles along western South America, encompassing most of modern Peru, Ecuador, Bolivia, and northern Chile and reaching into present-day Argentina. Like the Aztec Empire, its rise was rapid and its destruction sudden.

The Incas called their empire the "Land of the Four Quarters." At its center was their capital, Cuzco, "the navel of

## Calendar Stone ▸ Mexico. Aztec, c. 1500. Diameter 11′6¾″ (3.6 m).
Museo Nacional de Antropología, Mexico City.

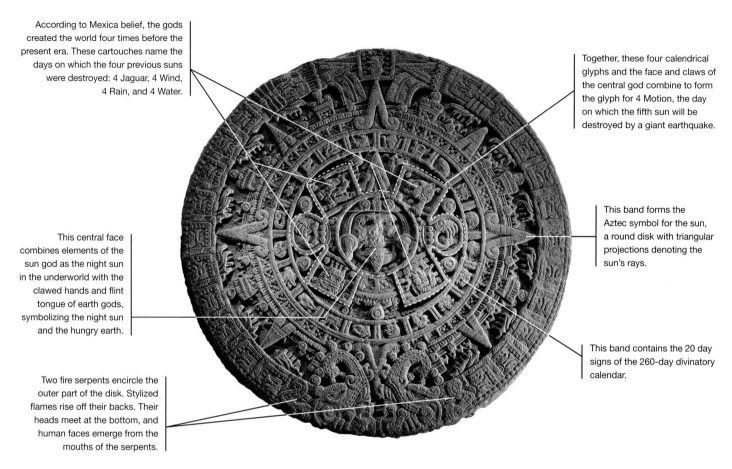

According to Mexica belief, the gods created the world four times before the present era. These cartouches name the days on which the four previous suns were destroyed: 4 Jaguar, 4 Wind, 4 Rain, and 4 Water.

Together, these four calendrical glyphs and the face and claws of the central god combine to form the glyph for 4 Motion, the day on which the fifth sun will be destroyed by a giant earthquake.

This central face combines elements of the sun god as the night sun in the underworld with the clawed hands and flint tongue of earth gods, symbolizing the night sun and the hungry earth.

This band forms the Aztec symbol for the sun, a round disk with triangular projections denoting the sun's rays.

This band contains the 20 day signs of the 260-day divinatory calendar.

Two fire serpents encircle the outer part of the disk. Stylized flames rise off their backs. Their heads meet at the bottom, and human faces emerge from the mouths of the serpents.

SEE MORE: View the Closer Look feature for the Calendar Stone **www.myartslab.com**

the world," located high in the Andes Mountains. The Inca state began as one of many small competing kingdoms that emerged in the highlands. In the fifteenth century the Incas began to expand, suddenly and rapidly, and had subdued most of their vast domain—through conquest, alliance, and intimidation—by 1500.

To hold this linguistically and ethnically diverse empire together, the Inca ("Inca" refers to both the ruler and the people) relied on religion, an efficient bureaucracy, and various forms of labor taxation, in which the payment was a set amount of time spent performing tasks for the state. In return the state provided gifts through local leaders and sponsored lavish ritual entertainments. Men might cultivate state lands, serve in the army, or work periodically on public works projects—building roads and terracing hillsides, for example—while women wove cloth as

tribute. No Andean civilization ever developed writing, but the Inca kept detailed accounts and historical records on knotted and colored cords (*quipu*).

To move their armies and speed transport and communication within the empire, the Incas built more than 23,000 miles of roads. These varied from 50-foot-wide thoroughfares to 3-foot-wide paths. Two main north–south roads, one along the coast and the other through the highlands, were linked by east–west roads. Travelers journeyed on foot, using llamas as pack animals. Stairways helped them negotiate steep mountain slopes, and rope suspension bridges allowed river gorge crossings. All along the roads, storehouses and lodgings—more than a thousand have been found—were spaced a day's journey apart. A relay system of runners could carry messages between Cuzco and the farthest reaches of the empire in about a week.

## CUZCO

Cuzco, a capital of great splendor, was home to the Inca, ruler of the empire. Its urban plan was said to have been designed by the Inca Pachacuti (r. 1438–1471) in the shape of a puma, its head the fortress of Sacsahuaman, and its belly the giant plaza at the center of town. The city was divided into upper and lower parts, reflecting the dual organization of Inca society. Cuzco was the symbolic as well as the political center of the Inca Empire: everyone had to carry a burden when entering the city, and gold, silver, or textiles brought into the city could not afterward be removed from it.

Cuzco was a showcase of the finest Inca masonry, some of which can still be seen in the present-day city (see "Inca Masonry," page 842). Architecture was a major expressive form for the Inca, the very shape of individually worked stones conveying a powerful aesthetic impact (FIG. 26–6). In contrast to the massive walls, Inca buildings had gabled, thatched roofs. Doors, windows, and niches were trapezoid-shaped, narrower at the top than the bottom.

## MACHU PICCHU

**MACHU PICCHU**, one of the most spectacular archaeological sites in the world, provides an excellent example of Inca architectural planning (FIG. 26–7). At 9,000 feet above sea level, it straddles a

**26-6 • INCA MASONRY, DETAIL OF A WALL AT MACHU PICCHU**
Peru. Inca, 1450–1530.

**26-7 • MACHU PICCHU**
Peru. Inca, 1450–1530.

SEE MORE: View a video about Machu Picchu
**www.myartslab.com**

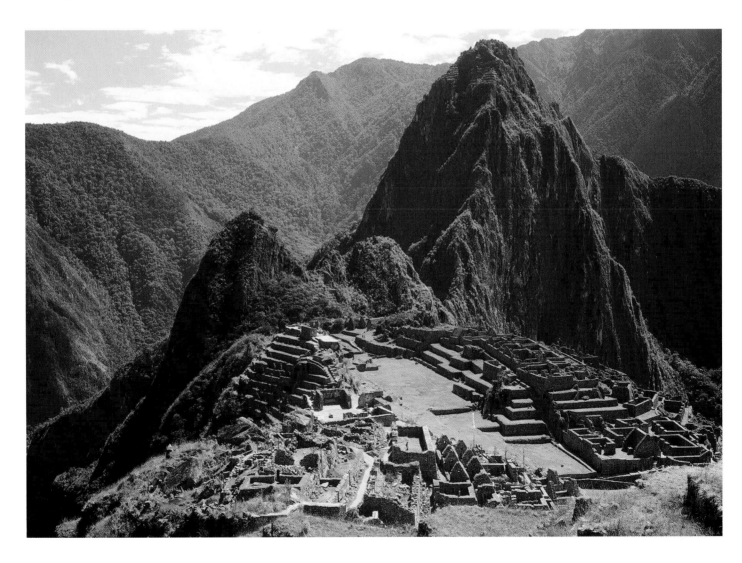

Working with the simplest of tools—mainly heavy stone hammers—and using no mortar, Inca builders created stonework of great refinement and durability: roads and bridges that linked the entire empire, terraces for growing crops, and structures both simple and elaborate. The effort expended on stone construction by the Inca was prodigious. Fine Inca masonry consisted of either rectangular blocks or irregular polygonal blocks (SEE FIG. 26–6). In both types, adjoining blocks were painstakingly shaped to fit tightly together without mortar. Their stone faces might be slightly beveled along their edges so that each block presented a "pillowed" shape expressing its identity, or walls might be smoothed into a continuous flowing surface in which the individual blocks form a seamless whole. At a few Inca sites, the stones used in construction were boulder-size: up to 27 feet tall. In Cuzco, and elsewhere in the Inca empire, Inca masonry has survived earthquakes that have destroyed later structures.

At Machu Picchu (SEE FIGS. 26–6, 26–7), all buildings and terraces within its 3-square-mile extent were made of granite, the hard stone occurring at the site. Commoners' houses and some walls were constructed of irregular stones that were carefully fitted together, while fine polygonal or smoothed masonry distinguished palaces and temples.

polygonal-stone wall                    smooth-surfaced wall

SEE MORE: View a simulation about Inca masonry www.myartslab.com

---

ridge between two high peaks in the eastern slopes of the Andes and looks down on the Urubamba River. Stone buildings, today lacking only their thatched roofs, occupy terraces around central plazas, and narrow agricultural terraces descend into the valley. The site, near the eastern limits of the empire, was the royal estate of the Inca ruler Pachacuti. The court might retire to this warmer, lower-altitude palace when the Cuzco winter became too harsh to enjoy. Important diplomatic negotiations and ceremonial feasts may also have taken place at this country retreat. The entire complex is designed with great sensitivity to its surroundings, with walls and plazas framing stupendous vistas of the surrounding landscape, and carefully selected stones echoing the shapes of the mountains beyond.

## TEXTILES

The production of fine textiles was already an important art in the Andes by the third millennium BCE (see Chapter 12). Among the

**26-8 • TUNIC**
Peru. Inca, c. 1500. Camelid fiber and cotton, 35⅞ × 30"
(91 × 76.5 cm). Dumbarton Oaks Research Library and Collections,
Pre-Columbian Collection, Washington, D.C.

Incas, textiles of cotton and camelid fibers (from llama, vicuña, and alpaca) were a primary form of wealth. One form of labor taxation required the manufacture of fibers and cloth, and textiles as well as agricultural products filled Inca storehouses. Cloth was deemed a fitting gift for the gods, so fine garments were draped around statues, and even burned as sacrificial offerings.

The patterns and designs on garments were not simply decorative but also carried symbolic messages, including indications of a person's ethnic identity and social rank. In the elaborate **TUNIC** in **FIGURE 26–8**, each square represents a miniature tunic. For example, tunics with checkerboard patterns were worn by military officers and royal escorts, and the four-part motifs may refer to the empire as the Land of the Four Quarters. The diagonal key motif is often found on tunics with horizontal border stripes but its meaning is not known. While we may not be sure what was meant in every case, patterns and colors appear to have been standardized like uniforms in order to convey information at a glance. Encompassing all these patterns associated with different ranks and statuses, this exquisitely woven tunic may have been a royal garment.

## METALWORK

When they arrived in Peru in 1532, the Spanish were far less interested in Inca cloth than in their vast quantities of gold and silver. The Inca valued objects made of gold and silver not for their precious metal, but because they saw in them symbols of the sun and the moon. They are said to have called gold the "sweat of the sun" and silver the "tears of the moon." On the other hand, the Spanish exploration of the New World was propelled by feverish tales of native treasure. Whatever gold and silver objects the Spanish could obtain were melted down to enrich their royal coffers. Only a few small figures buried as offerings, like the little **LLAMA** shown in **FIGURE 26–9**, escaped the conquerors. The llama was thought to have a special connection with the sun, with rain, and with fertility, and a llama was sacrificed to the sun every morning in Cuzco. In this small silver figurine, the essential character of a llama is rendered with a few well-chosen details, but in keeping with the value that Andeans placed on textiles the blanket on its back is carefully described.

## THE AFTERMATH OF THE SPANISH CONQUEST

Native American populations in Mexico and Peru declined sharply after the conquest because of the exploitative policies of the conquerors and the ravages of smallpox and other diseases that spread from Europe and against which the indigenous people had no immunity. This demographic collapse meant that the population of the Americas declined by as much as 90 percent in the century after contact with Europe. European missionaries suppressed local beliefs and practices and worked to spread Christianity throughout the Americas. Although increasing numbers of Europeans began to settle and dominate the land, native arts did not end with the Spanish conquest. Traditional arts,

**26–9 • LLAMA**
From Bolivia or Peru, found near Lake Titicaca, Bolivia. Inca, 15th century. Cast silver with gold and cinnabar, 9 × 8½ × 1¾" (22.9 × 21.6 × 4.4 cm). American Museum of Natural History, New York.

including fine weaving, continue to this day, transforming and remaining vital as indigenous peoples adjust to a changing world.

## NORTH AMERICA

In America north of Mexico, from the upper reaches of Canada and Alaska to the southern tip of Florida, many different peoples with widely varying cultures coexisted. Here, the Europeans came less as military men seeking riches to plunder than as families seeking land to farm. Unlike the Spaniards, they found no large cities with urban populations to resist them. However, although they imagined that the lands they settled were an untended wilderness, in fact nearly all of North America was populated and possessed by indigenous peoples. Over the next 400 years, by means of violence, bribery, and treaties, the English colonies and, in turn, the United States displaced nearly all Native Americans from their ancestral homelands. What indigenous art Euro-Americans encountered they viewed as a curiosity, not art.

Much Native American artwork was small, portable, fragile, and impermanent. In previous times these artworks were not

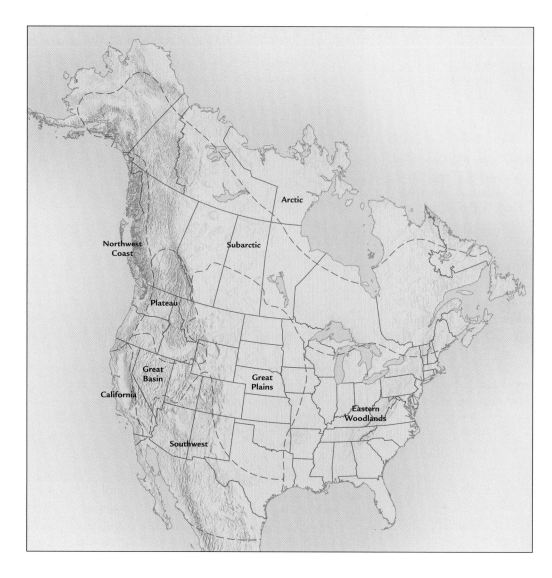

**MAP 26-2 • NORTH AMERICAN CULTURAL AREAS**

The varied geographic regions of North America supported diverse cultures adapted to their distinct environments.

appreciated for their aesthetic qualities, but were collected as anthropological artifacts or souvenirs, often under coercive conditions. Today, many Native peoples have begun to reclaim sacred objects and human remains that were forcibly taken from them, and museums are beginning to work with Native communities to present their art in respectful and culturally sensitive ways. We will look at art from only four North American cultural areas: the Eastern Woodlands, the Great Plains, the Northwest Coast, and the Southwest **(MAP 26–2)**.

### THE EASTERN WOODLANDS

In the Eastern Woodlands, after the decline of the great Mississippian centers (see Chapter 12), most tribes lived in stable villages, and they combined hunting, gathering, and agriculture for their livelihood. In the sixteenth century, the Iroquois formed a powerful confederation of five northeastern Native American nations, which played a prominent military and political role until after the American Revolution. The Huron and Illinois also formed sizable confederacies.

The arrival in the seventeenth century on the Atlantic coast of a few boatloads of Europeans seeking religious freedom, land

to farm, and a new life for themselves brought major changes. Trade with these settlers gave the Woodlands peoples access to things they valued, while on their part the colonists learned native forms of agriculture, hunting, and fishing—skills they needed in order to survive. In turn, Native Americans traded furs for such useful items as metal tools, cookware, needles, and cloth, and they especially prized European glass beads and silver. These trade items largely replaced older materials, such as crystal, copper, and shell.

**WAMPUM.** Woodlands peoples made belts and strings of cylindrical purple and white shell beads called wampum. The Iroquois and Delaware peoples used wampum to keep records (the purple and white patterns served as memory devices) and exchanged belts of wampum to conclude treaties **(FIG. 26–10)**. Few actual wampum treaty belts have survived, so this one, said to commemorate an unwritten treaty when the land now comprising the state of Pennsylvania was ceded by the Delawares in 1682, is especially prized. The belt, with two figures of equal size holding hands, suggests the mutual respect enjoyed by the Delaware and

Basketry is the weaving of reeds, grasses, and other plant materials to form containers. In North America the earliest evidence of basketwork, found in Danger Cave, Utah, dates to as early as 8400 BCE. Over the subsequent centuries, Native American women, notably in California and the American Southwest, developed basketry into an art form that combined utility with great beauty.

There are three principal basket-making techniques: coiling, twining, and plaiting. **Coiling** involves sewing together a spiraling foundation of rods with some other material. **Twining** twists multiple elements around a vertical warp of rods. Plaiting weaves strips over and under each other.

The coiled basket shown here was made by a Pomo woman in California. According to Pomo legend, the Earth was dark until their ancestral hero stole the sun and brought it to Earth in a basket. He hung the basket first just over the horizon, but, dissatisfied with the light it gave, he kept suspending it in different places across the dome of the sky. He repeats this process every day, which is why the sun moves across the sky from east to west. In the Pomo basket, the structure of coiled willow and bracken fern root produces a spiral surface into which the artist worked sparkling pieces of clam shell, trade beads, and soft tufts of woodpecker and quail feathers. The underlying basket, the glittering shells, and the soft, moving feathers make this an exquisite container. Such baskets were treasured possessions, cremated with their owners at death.

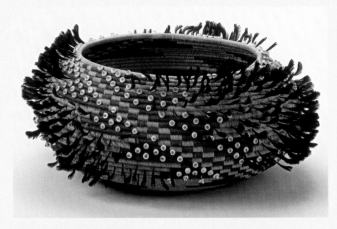

**FEATHERED BOWL**
c. 1877. Willow, bulrush, fern, feather, shells, glass beads. Height 5½″ (14 cm), diameter 12″ (36.5 cm). Philbrook Museum, Tulsa, Oklahoma. Gift of Clark Field (1948.39.37)

Penn's Society of Friends (Quakers), a respect that later collapsed into land fraud and violence. In general, wampum strings and belts had the authority of legal agreement and also symbolized a moral and political order.

QUILLWORK. Woodlands art focused on personal adornment—tattoos, body paint, elaborate dress—and fragile arts such as **quillwork**. Quillwork involved dyeing porcupine and bird quills with a variety of natural dyes, soaking the quills to soften them,

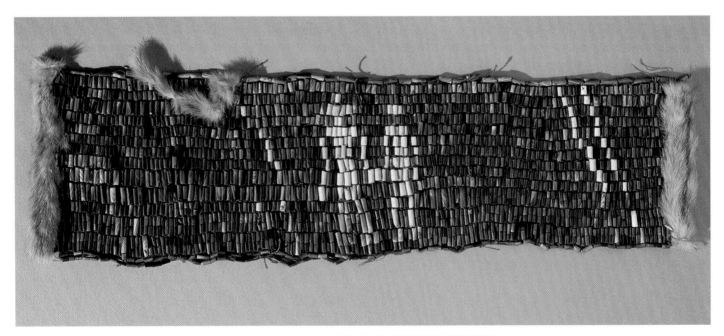

**26–10 • WAMPUM BELT, TRADITIONALLY CALLED WILLIAM PENN'S TREATY WITH THE DELAWARE**
1680s. Shell beads, 17⅜ × 6⅛″ (44 × 15.5 cm). Royal Ontario Museum, Canada. HD6364

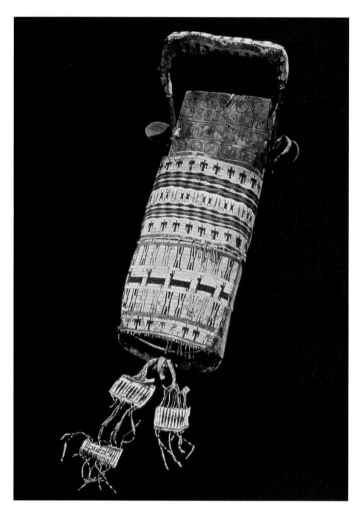

**26-11 • BABY CARRIER**
Upper Missouri River area. Eastern Sioux, 19th century. Wooden board, buckskin, porcupine quill, length 31″ (78.8 cm). Department of Anthropology, Smithsonian Institution Libraries, Washington, D.C. Catalogue No. 7311

and Bohemia. Early beadwork mimicked the patterns and colors of quillwork. In the nineteenth century it largely replaced quillwork and incorporated European designs. Among other sources of inspiration, Canadian nuns introduced the young women in their schools to embroidered European floral motifs, and Native embroiderers began to adapt these designs, as well as European needlework techniques and patterns from European garments, into their own work. Functional aspects of garments might be transformed into purely decorative motifs; for example, a pocket would be replaced by an area of beadwork shaped like a pocket. A **SHOULDER BAG** from Kansas, made by a Delaware woman (**FIG. 26–12**), is covered with curvilinear plant motifs in contrast to the rectilinear patterns of traditional quillwork. White lines outline brilliant pink and blue leaf-shaped forms, heightening the intensity of the colors, which alternate within repeated patterns. This Delaware bag exemplifies the evolution of beadwork design and its adaptation to a changing world. The very shape of this bandolier bag is adapted from European military uniforms.

## THE GREAT PLAINS

Between the Eastern Woodlands region and the Rocky Mountains to the west lay an area of prairie grasslands called the Great Plains. On the Great Plains, two differing ways of life developed, one a relatively recent and short-lived (1700–1870) nomadic lifestyle—dependent on the region's great migrating herds of buffalo for food, clothing, and shelter—and the other, a much older sedentary and agricultural lifestyle. Horses, from wild herds descended from feral horses brought to America by Spanish explorers in the sixteenth and seventeenth centuries, made travel and a nomadic life easier for the dispossessed eastern groups that moved to the plains.

European settlers on the eastern seaboard put increasing pressure on the Eastern Woodlands peoples, seizing their farmlands and forcing them westward. Both Native Americans and back-country settlers were living in loosely village-based, farming societies and thus were competing for the same resources. The resulting interaction of Eastern Woodlands artists with one another and with Plains artists led in some cases to the emergence of a new hybrid style, while other artists consciously fought to maintain their own cultures.

PORTABLE ARCHITECTURE. The nomadic Plains peoples hunted buffalo for food and hides from which they created clothing and a light, portable dwelling known as a tipi (formerly spelled teepee) (**FIG. 26–13**). The tipi was well adapted to withstand the strong and constant wind, the dust, and the violent storms of the prairies. The framework of a tipi consisted of a stable pyramidal frame of three or four long poles, filled out with about 20 additional poles, in a roughly oval plan. The framework was covered with hides (or, later, with canvas) to form a conical structure. The hides were specially prepared to make them flexible and waterproof. Between 20 and 40 hides were used to make a tipi, depending on its size. An opening at the top served as the smoke hole for a central hearth.

and then working them into rectilinear, ornamental surface patterns on deerskin clothing and on birch-bark items like baskets and boxes. A Sioux legend recounts how a mythical ancestor, Doublewoman ("double" because she was both beautiful and ugly, benign and dangerous), appeared to a woman in a dream and taught her the art of quillwork. As the legend suggests, quillwork was a woman's art form, as was basketry (see "Basketry," page 845). The Sioux **BABY CARRIER** in **FIGURE 26–11** is richly decorated with symbols of protection and well-being, including bands of antelopes in profile and thunderbirds flying with their heads turned and tails outspread. The thunderbird was an especially beneficent symbol, thought to be capable of protecting against both human and supernatural adversaries.

BEADWORK. In spite of the use of shell beads in wampum, decorative beadwork did not become commonplace until after European contact. In the late eighteenth century, Native American artists began to acquire European colored-glass beads, and in the nineteenth century they favored the tiny seed beads from Venice

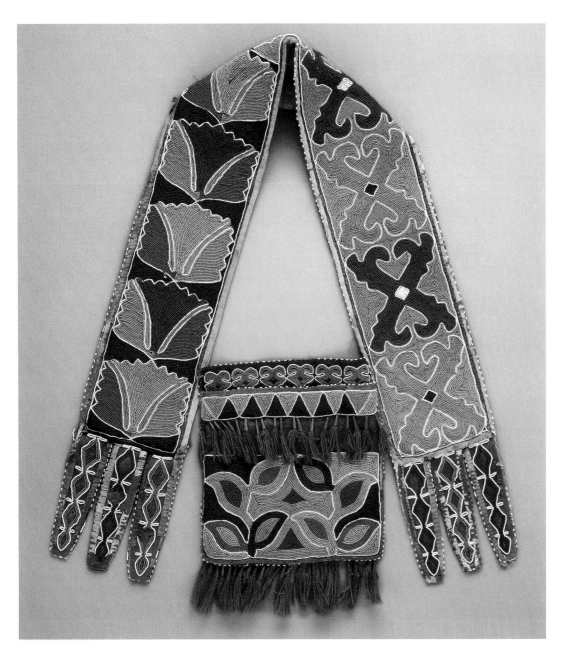

**26-12 • SHOULDER BAG**
Kansas. Delaware people, c. 1860. Wool fabric, cotton fabric and thread, silk ribbon, and glass beads, 23 × 7¾″ (58.5 × 19.8 cm). The Detroit Institute of Arts. Founders Society Purchase (81.216)

**26-13 • BLACKFOOT WOMEN RAISING A TIPI**
Photographed c. 1900. Montana Historical Society, Helena, Montana.

**26-14 • BATTLE SCENE, HIDE PAINTING**
North Dakota. Mandan, 1797–1800. Tanned buffalo hide, dyed
porcupine quills, and black, red, green, yellow, and brown pigment,
7'10" × 8'6" (2.44 × 2.65 m). Peabody Museum of Archaeology,
Harvard University, Cambridge, Massachusetts. 99-12-10/53121

This robe, collected in 1804 by Meriwether Lewis and William Clark on
their expedition into western lands acquired by the United States in
the Louisiana Purchase, is the earliest documented example of Plains
painting. It was one of a number of Native American artworks that Lewis
and Clark sent to President Thomas Jefferson. Jefferson displayed the
robe in the entrance hall of his home at Monticello, Virginia.

The tipi leaned slightly into the prevailing west wind while the
flap-covered door and smoke hole faced east, away from the wind.
An inner lining covered the lower part of the walls and the
perimeter of the floor to protect the occupants from drafts.

Tipis were the property and responsibility of women, who set
them up at new encampments and lowered them when the group
moved on. Blackfoot women could set up their huge tipis in less

than an hour. Women quilled, beaded, and embroidered tipi
linings, as well as backrests, clothing, and equipment. The patterns
with which tipis were decorated, like their proportions and colors,
varied from nation to nation, family to family, and individual to
individual. In general, the bottom was covered with traditional
motifs and the center section held personal images. When
disassembled and packed to be dragged by a horse to another
location, the tipi served as a platform for transporting other
possessions. The Sioux arranged their tipis in two half-circles—one
for the sky people and one for the earth people—divided along an
east–west axis. When the Blackfoot people gathered in the summer
for their ceremonial Sun Dance, their encampment contained
hundreds of tipis in a circle a mile in circumference.

PLAINS INDIAN PAINTING.    Plains men recorded their exploits in
paintings on tipis and on buffalo-hide robes. The earliest
documented painted buffalo-hide robe, presented to Lewis and

Clark during their transcontinental expedition, illustrates a battle fought in 1797 by the Mandan (of what is now North Dakota) and their allies against the Sioux (FIG. 26–14). The painter, trying to capture the full extent of a conflict in which five nations took part, shows a party of warriors in 22 separate episodes. The party is led by a man with a pipe and an elaborate eagle-feather headdress, and the warriors are armed with bows and arrows, lances, clubs, and flintlock rifles. Details of equipment and emblems of rank— headdresses, sashes, shields, feathered lances, powder horns for the rifles—are depicted carefully. Horses are shown in profile with stick legs, C-shaped hooves, and either clipped or flowing manes.

The figures stand out clearly against the light-colored background of the buffalo hide. The painter pressed lines into the hide, then filled in the forms with black, red, green, yellow, and brown pigments. A strip of colored porcupine quills runs down the spine of the buffalo hide. The robe would have been worn draped over the shoulders of the powerful warrior whose deeds it commemorates. As the wearer moved, the painted horses and warriors would seem to come alive, transforming the warrior into a living representation of his exploits.

Life on the Great Plains changed abruptly in 1869, when the transcontinental railway linking the east and west coasts of the United States was completed, providing easy access to Native American lands. Between 1871 and 1890, Euro-American hunters killed off most of the buffalo, and soon ranchers and then farmers moved into the Great Plains. The U.S. government forcibly moved the outnumbered and outgunned Native Americans to reservations, land considered worthless until the later discovery of oil and, in the case of the Black Hills, gold.

## THE NORTHWEST COAST

From southern Alaska to northern California, the Pacific coast of North America is a region of unusually abundant resources. Its many rivers fill each year with salmon returning to spawn. Harvested and dried, the fish could sustain large populations throughout the year. The peoples of the Northwest Coast— among them the Tlingit, the Haida, and the Kwakwaka'wakw (formerly spelled Kwakiutl)—exploited this abundance to develop a complex and distinctive way of life in which the arts played a central role.

ANIMAL IMAGERY. Animals feature prominently in Northwest Coast art because each extended family group (clan) claimed descent from a mythic animal or animal-human ancestor, from whom the family derived its name and the right to use certain animals and spirits as totemic emblems, or crests. These emblems appear frequently in Northwest Coast art, notably in carved cedar house poles and the tall, free-standing poles (mortuary poles) erected to memorialize dead chiefs. Chiefs, who were males in the most direct line of

descent from the mythic ancestor, validated their status and garnered prestige for themselves and their families by holding ritual feasts known as potlatches, during which they gave valuable gifts to the invited guests. Shamans, who were sometimes also chiefs, mediated between the human and spirit worlds. Some shamans were female, giving them unique access to certain aspects of the spiritual world.

Northwest Coast peoples lived in large, elaborately decorated communal houses made of massive timbers and thick planks. Carved and painted partition screens separated the chief's quarters from the rest of the house. The Tlingit screen illustrated in FIGURE 26–15 came from the house of Chief Shakes of Wrangell (d. 1916), whose family crest was the grizzly bear. The image of a rearing

**26–15 • GRIZZLY BEAR HOUSE-PARTITION SCREEN**
The house of Chief Shakes of Wrangell, Canada. Tlingit people, c. 1840. Cedar, paint, and human hair, 15 × 8′ (4.57 × 2.74 m). Denver Art Museum, Denver, Colorado.

## Hamatsa Masks

During the harsh winter season, when spirits are thought to be most powerful, many Northwest Coast peoples seek spiritual renewal through their ancient rituals—including the potlatch, or ceremonial gift giving, and the initiation of new members into the prestigious Hamatsa society. With snapping beaks and cries of "Hap! Hap! Hap!" ("Eat! Eat! Eat!"), Hamatsa, the people-eating spirit of the north, and his three assistants—horrible masked monster birds—begin their wild, ritual dance. The dancing birds threaten and even attack the Kwakwaka'wakw people who gather for the Winter Ceremony.

In the Winter Ceremony, youths are captured, taught the Hamatsa lore and rituals, and then in a spectacular theater-dance performance are "tamed" and brought back into civilized life. All the members of the community, including singers, gather in the main room of the great house, which is divided by a painted screen (SEE FIG. 26–15). The audience members fully participate in the performance; in early times, they brought containers of blood so that when

the bird-dancers attacked them, they could appear to bleed and have flesh torn away.

Whistles from behind the screen announce the arrival of the Hamatsa (danced by an initiate), who enters through the central hole in the screen in a flesh-craving frenzy. Wearing hemlock, a symbol of the spirit world, he crouches and dances wildly with outstretched arms as attendants try to control him. He disappears but returns again, now wearing red cedar and dancing upright. Finally tamed, a full member of society, he even dances with the women.

Then the masked bird-dancers appear—first Raven-of-the-North-End-of-the-World, then Crooked-Beak-of-the-End-of-the-World, and finally the untranslatable Huxshukw, who cracks open skulls with his beak and eats the brains of his victims. Snapping their beaks, these masters of illusion enter the room backward, their masks pointed up as though the birds are looking skyward. They move slowly counterclockwise around the floor. At each change in the music they crouch, snap their beaks, and let out their wild cries of "Hap!

Hap! Hap!" Essential to the ritual dances are the huge carved and painted wooden masks, articulated and operated by strings worked by the dancers. Among the finest masks are those by Willie Seaweed (1873–1967), a Kwakwaka'wakw chief, whose brilliant colors and exuberantly decorative carving style determined the direction of twentieth-century Kwakwaka'wakw sculpture.

The Canadian government, abetted by missionaries, outlawed the Winter Ceremony and potlatches in 1885, claiming the event was injurious to health, encouraged prostitution, endangered children's education, damaged the economy, and was cannibalistic. But the Kwakwaka'wakw refused to give up their "oldest and best" festival—one that spoke powerfully to them in many ways, establishing social rank and playing an important role in arranging marriages. By 1936, the government and the missionaries, who called the Kwakwaka'wakw "incorrigible," gave up. But not until 1951 could the Kwakwaka'wakw people gather openly for winter ceremonies, including the initiation rites of the Hamatsa society.

**Edward S. Curtis HAMATSA DANCERS, KWAKWAKA'WAKW**
Canada. Photographed 1914. Smithsonian Institution Libraries, Washington, D.C.

The photographer Edward S. Curtis (1868–1952) devoted 30 years to documenting the lives of Native Americans. This photograph shows participants in a film he made about the Kwakwaka'wakw. For the film, his Native American assistant, Richard Hunt, borrowed family heirlooms and commissioned many new pieces from the finest Kwakwaka'wakw artists. Most of the pieces are now in museum collections. The photograph shows carved and painted posts, masked dancers (including those representing people-eating birds), a chief at the left (holding a speaker's staff and wearing a cedar neck ring), and spectators at the right.

**Attributed to Willie Seaweed KWAKWAKA'WAKW BIRD MASK**
Alert Bay, Vancouver Island, Canada. Prior to 1951. Cedar wood, cedar bark, feathers, and fiber, 10 × 72 × 15″ (25.4 × 183 × 38.1 cm). Collection of the Museum of Anthropology, Vancouver, Canada. (A6120)

The name "Seaweed" is an anglicization of the Kwakwaka'wakw name *Siwid*, meaning "Paddling Canoe," "Recipient of Paddling," or "Paddled To"—referring to a great chief to whose potlatches guests paddled from afar. Willie Seaweed was not only the chief of his clan, but a great orator, singer, and tribal historian who kept the tradition of the potlatch alive during years of government repression.

grizzly painted on the screen is itself made up of smaller bears and bear heads that appear in its ears, eyes, nostrils, joints, paws, and body. The oval door opening is a symbolic vagina; passing through it re-enacts the birth of the family from its ancestral spirit.

TEXTILES. Blankets and other textiles produced by the Chilkat Tlingit had great prestige among Northwest Coast peoples (FIG. 26–16). Both men and women worked on the blankets. Men drew the patterns on boards, and women wove the patterns into the blankets, using shredded cedar bark and mountain-goat wool. The weavers did not use looms; instead, they hung cedar warp threads from a rod and twined colored goat wool back and forth through them to make the pattern. The ends of the warp form the fringe at the bottom of the blanket.

The small face in the center of the blanket shown here represents the body of a large stylized creature, perhaps a sea bear (a fur seal) or a standing eagle. Above the body are the creature's large eyes; below it and to the sides are its legs and claws. Characteristic of Northwest painting and weaving, the images are composed of two basic elements: the ovoid, a slightly bent rectangle with rounded corners, and the formline, a continuous, shape-defining line. Here, subtly swelling black formlines define shapes with

gentle curves, ovoids, and rectangular C shapes. When the blanket was worn, its two-dimensional shapes would have become three-dimensional, with the dramatic central figure curving over the wearer's back and the intricate side panels crossing over his shoulders and chest.

MASKS. Many Native American cultures stage ritual dance ceremonies to call upon guardian spirits. The participants in Northwest Coast dance ceremonies wore elaborate costumes and striking carved and painted wooden masks. Among the most elaborate masks were those used by the Kwakwaka'wakw in their Winter Ceremony, in which they initiated members into the shamanistic Hamatsa society (see "Hamatsa Masks," opposite). The dance re-enacted the taming of Hamatsa, a cannibal spirit, and his three attendant bird spirits. Magnificent carved and painted masks transformed the dancers into Hamatsa and the bird attendants, who searched for victims to eat. Strings allowed the dancers to manipulate the masks so that the beaks opened and snapped shut with spectacular effect. Isolated in museums as "art," the masks doubtless lose some of the shocking vivacity they have in performance; nevertheless their bold forms and color schemes retain power and meaning that can be activated by the viewer's imagination.

**26–16 • CHILKAT BLANKET**
Tlingit people, before 1928. Mountain-goat wool and shredded cedar bark, 55⅛ × 63¾″ (140 × 162 cm). American Museum of Natural History, New York.

## THE SOUTHWEST

The Native American peoples of the southwestern United States include, among others, the Pueblo (sedentary village-dwelling groups) and the Navajo. The Pueblo groups are heirs of the Ancestral Puebloans (Anasazi) and Hohokam cultures (see Chapter 12). The Ancestral Puebloans built apartmentlike villages and cliff dwellings whose ruins are found throughout the Four Corners region of New Mexico, Colorado, Arizona, and Utah in the American Southwest. The Navajo, who arrived in the region sometime between 1100 and 1500 CE, developed a semisedentary way of life based on agriculture and (after the introduction of sheep by the Spaniards) shepherding. Being among the very few Native American tribal groups whose reservations are located on their actual ancestral homelands, both groups have succeeded in maintaining the continuity of their traditions despite Euro-American pressure. Today, their arts reflect the adaptation of traditional forms to new technologies, new mediums, and the influences of the dominant American culture that surrounds them.

THE PUEBLOS.    Some Pueblo villages, like those of their ancient ancestors, consist of multi-storied dwellings made of adobe. One of these, **TAOS PUEBLO**, shown in **FIGURE 26–17** in a photograph taken in 1947 by the American photographer of the Southwest, Laura Gilpin (1891–1979), is located in north-central New Mexico. Continually occupied and modified for over 500 years, the up to five-story house blocks of Taos Pueblo provide flexible, communal dwellings. Ladders provide access to the upper stories and to insulated inner rooms, entered through holes in the ceiling. Two large house blocks are arrayed around a central plaza that opens toward the neighboring mountains, rising in a stepped fashion to provide a series of roof terraces that can serve as viewing platforms. The plaza and roof terraces are centers of communal life and ceremony, as can be seen in Pablita Velarde's painting of the winter solstice celebrations (SEE FIG. 26–19).

CERAMICS.    Pottery traditionally was a woman's art among Pueblo peoples. Wares were made by coiling and other hand-building techniques, and then fired at low temperature in wood bonfires. The best-known twentieth-century Pueblo potter was

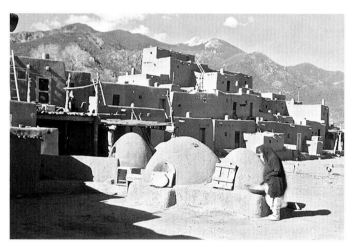

**26-17 • Laura Gilpin  TAOS PUEBLO**
Taos, New Mexico. Photographed 1947. Amon Carter Museum, Fort Worth, Texas.

Laura Gilpin, photographer of the landscape, architecture, and people of the American Southwest, began her series on the Pueblos and Navajos in the 1930s. She published her work in four volumes of photographs between 1941 and 1968.

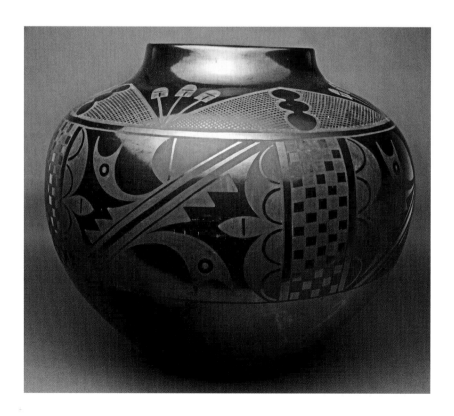

**26-18 • Maria Montoya Martinez and Julian Martinez  BLACKWARE STORAGE JAR**
New Mexico. c. 1942. Ceramic, height 18¾″ (47.6 cm), diameter 22½″ (57.1 cm). Museum of Indian Arts and Culture/Laboratory of Anthropology, Museum of New Mexico, Santa Fe.

Maria Montoya Martinez (1887–1980) of San Ildefonso Pueblo in New Mexico. Inspired by prehistoric pottery that was unearthed at nearby archaeological excavations and by the then fashionable Art Deco style, she and her husband, Julian Martinez (1885–1943), developed a distinctive **blackware** ceramic style notable for its elegant forms and subtle textures (**FIG. 26–18**). Maria Martinez made pots covered with a slip that was then burnished. Using additional slip, Julian Martinez painted the pots with designs that interpreted traditional Pueblo and Ancestral Puebloan imagery. After firing, the burnished ground became a lustrous black and the slip painting retained a matte surface. By the 1930s, production of blackware in San Ildefonso had become a communal enterprise. Family members and friends all worked making pots, and Maria Martinez signed all the pieces so that, in typical Pueblo communal solidarity, everyone profited from the art market.

THE SANTA FE INDIAN SCHOOL. In the 1930s Anglo-American art teachers and dealers worked with Native Americans of the Southwest to create a distinctive, stereotypical "Indian" style in several mediums—including jewelry, pottery, weaving, and painting—to appeal to tourists and collectors. A leader in this effort was Dorothy Dunn (1903–1991), who taught painting in the Santa Fe Indian School, an off-reservation government boarding school in New Mexico, from 1932 to 1937. Dunn inspired her

students to create a painting style that combined the outline drawing and flat colors of folk art, the decorative qualities of Art Deco, and "Indian" subject matter. She and her students formed the Studio School. Restrictive as the school was, Dunn's success made painting a viable occupation for young Native American artists.

Pablita Velarde (1918–2006), from Santa Clara Pueblo in New Mexico and a 1936 graduate of Dorothy Dunn's school, was only a teenager when one of her paintings was selected for exhibition at the Chicago World's Fair in 1933. Thereafter, Velarde documented Pueblo ways of life in a large series of murals for Bandelier National Monument, launching a long and successful career. In smaller works on paper, such as the one illustrated here, she continued this focus on Pueblo life. **KOSHARES OF TAOS** (**FIG. 26–19**) illustrates a moment during a ceremony celebrating the winter solstice when koshares, or clowns, take over the plaza from the Katsinas. Katsinas—the supernatural counterparts of animals, natural phenomena like clouds, and geological features like mountains—are central to traditional Pueblo religion. They manifest themselves in the human dancers who impersonate them during the winter solstice ceremony, as well as in the small figures known as Katsina dolls that are given to children as educational aids in learning to identify the masks. Velarde's painting combines bold, flat colors and a simplified decorative line with European perspective. Her paintings, with their Art Deco abstraction, influenced the popular idea of the "Indian" style in art.

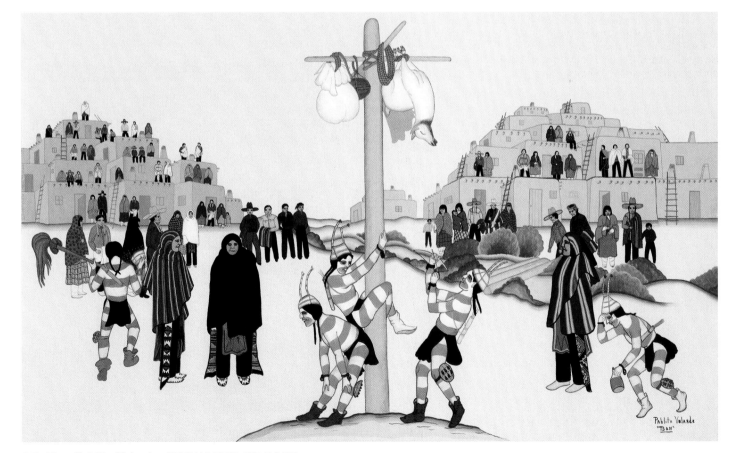

**26–19 • Pablita Velarde KOSHARES OF TAOS**
New Mexico. 1940s. Watercolor on paper, 13⅞ × 22⅜" (35.3 × 56.9 cm). Philbrook Museum of Art, Tulsa, Oklahoma.
Museum Purchase (1947.37)

## Navajo Night Chant

This chant accompanies the creation of a sand painting during a Navajo curing ceremony. It is sung toward the end of the ceremony and indicates the restoration of inner harmony and balance.

In beauty (happily) I walk.
With beauty before me I walk.
With beauty behind me I walk.
With beauty below me I walk.
With beauty above me I walk.
With beauty all around me I walk.
It is finished (again) in beauty.
It is finished in beauty.

(Cited in Washington Matthews, "The Night Chant: A Navaho Ceremony," in *Memoirs of the American Museum of Natural History*, Vol. 6. New York, 1902, p. 145.)

---

THE NAVAJOS. While some Navajo arts, like sand painting, have deep traditional roots, others have developed over the centuries of European contact. Navajo weaving (SEE FIG. 26–1) depends on the wool of sheep introduced by the Spaniards, and the designs and colors of Navajo blankets continue to evolve today in response to tourism and changing aesthetics. Similarly, jewelry made of turquoise and silver did not become an important Navajo art form until the mid nineteenth century. Traditionally, Navajo arts had strict gender divisions: women wove cloth, and men worked metal.

Sand painting, a traditional Navajo art, is the exclusive province of men. Sand paintings are made to the accompaniment of chants by shaman-singers in the course of healing and blessing ceremonies, and they have great sacred significance (see "Navajo Night Chant," above). The paintings depict mythic heroes and events; and as ritual art, they follow prescribed rules and patterns that ensure their power. To make them, the singer dribbles pulverized colored stones, pollen, flowers, and other natural colors over a hide or sand ground. The rituals are intended to cure by restoring harmony to the world. The paintings are not meant to be seen by the public and certainly not to be displayed in museums. They are meant to be destroyed by nightfall of the day on which they are made.

In 1919 a respected shaman-singer named Hosteen Klah (1867–1937) began to incorporate sand-painting images into weaving, breaking with the traditional prohibitions. Many Navajos took offense at Klah both for recording the sacred images and for doing so in what was traditionally a woman's art form. Klah had learned to weave from his mother and sister. The Navajo traditionally recognize at least three genders; Hosteen Klah was a *nadle*, or Navajo third-gender. Hence, he could learn both female and male arts; that is, he was trained both to weave and to heal. Hosteen Klah was not breaking artistic barriers in a conventional sense, but rather exemplifying the complexities of the traditional

Navajo gender system. Klah's work was ultimately accepted because of his great skill and prestige.

The **WHIRLING LOG CEREMONY** sand painting, woven into tapestry **(FIG. 26–20)**, depicts part of the Navajo creation myth. The Holy People create the earth's surface and divide it into four parts. They create humans, and bring forth corn, beans, squash, and tobacco—the four sacred plants. A male-female pair of humans and

**26-20 • Hosteen Klah WHIRLING LOG CEREMONY**
Sand painting; tapestry by Mrs. Sam Manuelito. Navajo, c. 1925. Wool, 5′5″ × 5′10″ (1.69 × 1.82 m). Heard Museum, Phoenix, Arizona.

## A NEW BEGINNING

While Native American art has long been displayed in anthropology and natural history museums, today the art of indigenous peoples is finally achieving full recognition by the art establishment (see "Craft or Art?," page 856). The Institute of American Indian Arts (IAIA), founded in 1962 in Santa Fe and attended by Native American students from all over North America, supports Native American aspirations in the arts today just as Dorothy Dunn's Studio School did in the 1930s. Staffed by Native American artists, the school encourages the incorporation of indigenous ideals in the arts without creating an official "style." As alumni achieved distinction and the IAIA museum in Santa Fe established a reputation for excellence, the institute has led Native American art into the mainstream of contemporary art (see Chapter 31).

To cite just one example, contemporary Native American artist Jaune Quick-to-See Smith (b. 1940) borrowed a well-known image by Leonardo da Vinci for her **THE RED MEAN** (FIG. 26–21). She describes the work as a self-portrait, and indeed the center of the work has a bumper sticker that reads "Made in the U.S.A." above an identification number. The central figure quotes Leonardo's Vitruvian Man (see "The Vitruvian Man," page 637), but the message here is autobiographical. Leonardo inscribed the human form within perfect geometric shapes to emphasize the perfection of the human body, while Smith put her silhouette inside the red X that signifies nuclear radiation. This image alludes both to the uranium mines found on some Indian reservations and to the fact that many have become temporary repositories for nuclear waste. The image's background is a collage of Native American tribal newspapers. Her self-portrait thus includes her ethnic identity and life on the reservation as well as the history of Western art.

**26-21 • Jaune Quick-to-See Smith THE RED MEAN: SELF PORTRAIT** 1992. Acrylic, newspaper collage, and mixed media on canvas, 90 × 60″ (228.6 × 154.4 cm). Smith College Museum of Art, Northampton, Massachusetts. Part gift from Janet Wright Ketcham, class of 1953, and part purchase from the Janet Wright Ketcham, class of 1953, Fund © Jaune Quick-to-See Smith

one of the sacred plants stand in each of the four quarters, defined by the central cross. The four Holy People (the elongated figures) surround the image, and the guardian figure of Rainbow Maiden frames the scene on three sides. Like all Navajo artists, Hosteen Klah hoped that the excellence of the work would make it pleasing to the spirits. Recently, shaman-singers have made permanent sand paintings on boards for sale, but they usually introduce slight errors in them to render the paintings ceremonially harmless.

Other artists, such as the Canadian Haida artist Bill Reid (1920–1998), have sought to sustain and revitalize traditional art in their work. Trained as a woodcarver, painter, and jeweler, Reid revived the art of carving totem poles and dugout canoes in the Haida homeland of Haida Gwaii—"Islands of the People"— known on maps today as the Queen Charlotte Islands. Late in life he began to create large-scale sculptures in bronze. With their

## Craft or Art?

In many world cultures, the distinction between "fine art" and "craft" does not exist. The traditional Western academic hierarchy of materials —in which marble, bronze, oil, and fresco are valued more than terra cotta and watercolor—and the equally artificial hierarchy of subjects— in which history painting, including religious history, stands supreme— are irrelevant to non-Western art, and to much art produced in the West before the modern era.

The indigenous peoples of the Americas did not produce objects as works of art to be displayed in museums. In their eyes all pieces were utilitarian objects, adorned in ways necessary for their intended purposes. A work was valued for its effectiveness and for the role it played in society. Some, like a Sioux baby carrier (SEE FIG. 26–11), enrich mundane life with their aesthetic qualities. Others, such as Pomo baskets (see "Basketry," page 845), commemorate important events. The function of an Inca tunic may have been to identify or confer status on its owner or user through its material value or symbolic associations. And as with art in all cultures, many pieces had great spiritual or magical power. Such works of art cannot be fully comprehended or appreciated when they are seen only on pedestals or encased in glass boxes in museums or galleries. They must be imagined, or better yet seen, as acting in their societies. How powerfully might our minds and emotions be engaged if we saw Kwakwaka'wakw masks functioning in religious drama, changing not only the outward appearance, but also the very essence of the individual.

At the beginning of the twentieth century, European and American artists broke away from the academic bias that extolled the Classical heritage of Greece and Rome. They found new inspiration in the art— or craft, if you will—of many different non-European cultures. Artists explored a new freedom to use absolutely any material or technique that effectively challenged outmoded assumptions and opened the way for a free and unfettered delight in, and an interest in understanding, Native American art as well as the art of other non-Western cultures. The more recent twentieth- and twenty-first-century conception of art as a multimedia adventure has helped validate works of art once seen only in ethnographic collections. Today objects once called "primitive" are recognized as great works of art and acknowledged to be an essential dimension of a twenty-first-century worldview. The line between "art" and "craft" seems more artificial and less relevant than ever before.

**26-22 • Bill Reid THE SPIRIT OF HAIDA GWAII**
Haida, 1991. Bronze, approx. 13 × 20′ (4 × 6 m). Canadian Embassy, Washington, D.C.

black patina, these works recall traditional Haida carvings in shiny black argillite.

Reid's imposing **THE SPIRIT OF HAIDA GWAII** now stands outside the Canadian Embassy in Washington, D.C. **(FIG. 26–22)**. This sculpture, which Reid viewed as a metaphor for modern Canada's multicultural society, depicts a boatload of figures from the natural and mythic worlds struggling to paddle forward. The dominant figure is a shaman in a spruce-root basket hat and Chilkat blanket holding a speaker's pole. On the prow, the place reserved for the chief in a war canoe, sits the Bear. He faces backward rather than forward, and is bitten by an Eagle, with formline-patterned wings. The Eagle, in turn, is bitten by the Seawolf. The Eagle and the Seawolf, together with the man behind them, nevertheless continue paddling. At the stern, steering the canoe, is the Raven, the trickster in Haida mythology. The Raven is assisted by Mousewoman, the traditional guide and escort of humans in the spirit realms. According to Reid, the work represents a "mythological and environmen-

**26-23 • NATIONAL MUSEUM OF THE AMERICAN INDIAN**
The Smithsonian Institution, Washington, D.C. Opened September, 2004. Architectural design: GBQC in association with Douglas Cardinal (Blackfoot). Architectural consultants: Johnpaul Jones (Cherokee-Choctaw) and Ramona Sakiestewa (Hopi). Landscape consultant: Donna House (Navajo-Oneida), ethno-botanist.

tal lifeboat," where "the entire family of living things … whatever their differences, … are paddling together in one boat, headed in one direction." (Bringhurst, 1991.)

THE NATIONAL MUSEUM OF THE AMERICAN INDIAN. In September 2004 the National Museum of the American Indian finally opened on the Mall in Washington, D.C., directly below Capitol Hill and across from the National Gallery of Art. Inspired by the colors, textures, and forms of the American Southwest, the museum building establishes a new presence for Native Americans on the Mall **(FIG. 26–23)**. Symbolizing the Native relationship to the environment, the museum is surrounded by boulders ("Grandfather Rocks"), water, and plantings that recall the varied landscapes of North America, including wetlands, meadows, forest, and traditional cropland with corn, squash, and tomatoes. The entrance to the museum on the east side faces the morning sun and recalls the orientation of prairie tipis. Inside the building a Sun Marker of stained glass in the south wall throws its dagger of light across the vast atrium as the day progresses. Once again the great spirits of earth and sky take form in a creation of the art of the Americas.

**THINK ABOUT IT**

**26.1** Distinguish characteristic styles and techniques developed by three Native American cultures, and discuss their application in one work from each of these three cultures considered in the chapter.

**26.2** Discuss Aztec and Inca achievements in the area of architecture and urbanism. Identify and analyze the function of one achievement of each culture and explain its importance.

**26.3** Explain the idea of portable architecture, citing at least one specific example discussed in the chapter. Discuss the unique advantages of portable architecture.

**26.4** Explore two examples of work from the chapter that exhibit influence from other cultures.

**26.5** Discuss the gender system in Navajo society, and explain the roles for making art assigned to different genders.

**PRACTICE MORE:** Compose answers to these questions, get flashcards for images and terms, and review chapter material with quizzes
**www.myartslab.com**

**27-1 • THE BARUNGA STATEMENT**    Various artists from Arnhem Land and central Australia. 1988.
Ochers on composition board with collage of printed text on paper, 48 × 47¼″ (122 × 120 cm). Parliament House Art Collection,
Parliament House, Canberra.

# ART OF PACIFIC CULTURES

In 1788, when Captain James Cook arrived in Australia, at least 300,000 Indigenous Australians, whose ancestors had arrived 50,000 years earlier, and who spoke over 250 languages, were living there. For 40,000 years these Aboriginal Australians had been creating rock art—the oldest continuous culture in the world. Nevertheless, Cook claimed Australia for Britain as a *terra nullius*, a land that belonged to no one. Within a few decades, European diseases had killed 50 percent of Indigenous Australians. Colonization and the advent of missionaries would change their lives forever.

Two hundred years later, Indigenous Australians presented what is now known as **THE BARUNGA STATEMENT (FIG. 27–1)** to the then prime minister Bob Hawke. It was inspired by the Yirrkala Bark Petitions, which 25 years earlier had gained national attention when indigenous land rights claims were presented to the government on traditional bark paintings from Arnhem Land in the Northern Territory. The Barunga Statement placed its call for broader Aboriginal rights in text on paper collaged onto composition board decorated with two different styles of indigenous painting: one from Arnhem Land (on the left; SEE ALSO FIG. 27–3) and the other from Australia's central desert area (on the right; see also "A Closer Look," page 876).

Painted in natural ochers, the cross hatching (*rarrk*) and zigzag patterns from the north contrast with the more fluid curved lines and dots that fill the central desert painting. In both, the artists use symbols to retell stories about the adventures of ancestral beings while dazzling the eye.

In 1992, the Australian High Court rejected Cook's *terra nullius* argument and granted land rights to Indigenous Australians. When no treaty between the national government and Indigenous Australians followed, Galarrwuy Yunupingu, an indigenous leader, asked for the Barunga Statement back so that he could bury it. Today, however, it still hangs in Parliament and the struggle for full rights for Indigenous Australians continues.

Throughout the Pacific, indigenous cultures have been impacted by contact with the West, though to different degrees. In New Zealand, for example, the Treaty of Waitangi (1840) recognized Maori ownership of land and gave Maori the rights of British subjects, establishing a different political dynamic. Nonetheless, numerous issues remain there, as in other parts of the region. Pacific islanders today use the arts to express and preserve their own rich and distinctive cultural identities.

## LEARN ABOUT IT

**27.1** Recognize how the availability of raw materials affects artistic choices and styles throughout the Pacific.

**27.2** Investigate ways that ancestor rituals influence the art in different Pacific cultures.

**27.3** Examine the role the human body plays as a subject in Pacific art.

**27.4** Compare the differences between ephemeral and enduring materials in different societies across the Pacific.

**27.5** Assess the impact of Western contact on art in the Pacific.

**HEAR MORE:** Listen to an audio file of your chapter www.myartslab.com

# THE PEOPLING OF THE PACIFIC

On a map with the Pacific Ocean as its center, only the peripheries of the great landmasses of Asia and the Americas appear. Nearly one-third of the earth's surface is taken up by this vast expanse. Europeans arriving in Oceania in the late eighteenth and early nineteenth centuries noted four distinct but connected cultural-geographic areas: Australia, Melanesia, Micronesia, and Polynesia (**MAP 27–1**). Australia includes the continent, as well as the island of Tasmania to the southeast. Melanesia ("black islands," a reference to the dark skin color of its inhabitants) includes New Guinea and the string of islands that extend eastward from it as far as Fiji and New Caledonia. Micronesia ("small islands"), to the north of Melanesia, is a region of small islands and coral atolls. Polynesia ("many islands") is scattered over a huge, triangular region defined by New Zealand in the south, Rapa Nui (Easter Island) in the east, and the Hawaiian Islands to the north. The last region on earth to be inhabited by humans, Polynesia covers some 7.7 million square miles, of which fewer than 130,000 square miles are dry land—and most of that is New Zealand. With the exception of temperate New Zealand, with its marked seasons and snowcapped mountains, Oceania is in the tropics, that is, between the tropic of Cancer in the north and the tropic of Capricorn to the south.

Australia, Tasmania, and New Guinea formed a single continent during the last Ice Age, which began some 2.5 million years ago. About 50,000 years ago, when the sea level was some 330 feet lower than it is today, people moved to this continent from Southeast Asia, making at least part of the journey over open water.

Some 27,000 years ago humans were settled on the large islands north and east of New Guinea as far south as San Cristobal, but they ventured no farther for another 25,000 years. By about 4000 BCE—possibly as early as 7000 BCE—the people of Melanesia were raising pigs and cultivating taro, a plant with edible rootstocks. As the glaciers melted, the sea level rose, flooding low-lying coastal land. By around 4000 BCE a 70-mile-wide waterway, now called the Torres Strait, separated New Guinea from Australia, whose indigenous people continued their hunting and gathering way of life into the twentieth century.

The settling of the rest of the islands of Melanesia and the westernmost islands of Polynesia—Samoa and Tonga—coincided with the spread of the Lapita culture, named for a site in New Caledonia. The Lapita people were Austronesian speakers who probably migrated from Taiwan to Melanesia about 6,000 years ago. They spread throughout the islands of Melanesia beginning around 1500 BCE. They were farmers and fisherfolk who cultivated taro and yams, and brought with them dogs, pigs, and chickens, animals that these colonizers needed for food. They also carried with them the distinctive ceramics whose remnants today enable us to trace the extent of their travels. Lapita potters produced dishes, platters, bowls, and jars. Sometimes they covered their wares with a red slip, and they often decorated them with bands of incised and stamped patterns—dots, lines, and hatching—that may also have been used to decorate bark cloth and for tattooing. Most of the decoration was geometric, but some was figurative. The human face that appears in the example in **FIGURE 27–2** is among the earliest representations of a human being, one of the most important subjects in Oceanic art. The Lapita people were skilled shipbuilders and navigators and engaged in inter-island trade. Over time the Lapita culture lost its widespread cohesion and evolved into various local forms. Its end is generally dated to the early centuries of the Common Era.

Polynesian culture emerged in the eastern Lapita region on the islands forming Tonga and Samoa. Just prior to the beginning of the first millennium CE, daring Polynesian seafarers, probably in double-hulled sailing canoes, began settling the scattered islands of Far Oceania and eastern Micronesia. Voyaging over open water, sometimes for thousands of miles, they reached Hawaii and Rapa Nui after about 500 CE and settled New Zealand around 800/900–1200 CE.

While this history of migrations across Melanesia to Polynesia and Micronesia allowed for cross-cultural borrowings, there are distinctions between these areas and within the regions as well. The islands that make up Micronesia, Melanesia, and Polynesia include both low-lying coral atolls and the tall tops of volcanic mountains that rise from the ocean floor. Raw materials available to residents of these islands vary greatly, and islander art and architecture utilize these materials in different ways. The soil of volcanic islands can be very rich and thus can support densely populated settlements with a local diversity of plants and animals. On the other hand, coral atolls do not generally have very good soil and thus cannot support

**27-2 • FRAGMENTS OF A LARGE LAPITA JAR**
Venumbo Reef, Santa Cruz Island, Solomon Islands. c. 1200–1100 BCE. Clay, height of human face motif approx. 1½″ (4 cm).

**MAP 27–1 • PACIFIC CULTURAL-GEOGRAPHIC REGIONS**

The Pacific cultures are found in four vast areas: Australia, Melanesia, Micronesia, and Polynesia.

large populations. In a like manner, volcanic islands can provide good stone for tools and building (as at Nan Madol, SEE FIG. 27–10), while coral is sharp but not particularly hard, and the strongest tools on a coral atoll are often those made from giant clam shells. Generally, the diversity of both plants and animals decreases from west to east among the Pacific islands.

The arts of this vast and diverse region display an enormous variety that is closely linked to each community's ritual and religious life. In this context, the visual arts were often just one strand in a rich weave that also included music, dance, and oral literature.

# AUSTRALIA

The hunter-gatherers of Australia were closely attuned to the environments in which they lived until European settlers disrupted their way of life. Their only modification of the landscape was regular controlled burning of the underbrush, which encouraged new plant life and attracted animals. Their intimate knowledge of plants, animals, and water sources enabled them to survive and thrive in a wide range of challenging environments.

Indigenous Australian life is intimately connected with the concept of the Dreamtime, or the Dreaming. Not to be confused with our notions of sleep and dreams, the Dreaming refers to the period before humans existed. (The term, a translation from Arrente, one of the more than 250 languages spoken in Australia when Europeans arrived, was first used in the late nineteenth century to try to understand the indigenous worldview.) According to this complex belief system, the world began as a flat, featureless place. Ancestral Spirit Beings emerged from the earth or arrived from the sea, taking many different forms. The Spirit Beings had many adventures, and in crossing the continent they created all of its physical features: mountains, sand hills, creeks, and water holes. They also brought about the existence of animals, plants, and humans and created the ceremonies and sacred objects needed to ensure that they themselves were remembered, a system sometimes referred to as Aboriginal Laws. The Spirit Beings eventually returned to the earth or became literally one of its features. Thus, they are identified with specific places, which are honored as sacred sites. Indigenous Australians who practice this traditional religion believe that they are descended from the Spirit

Beings and associate themselves with particular places related to the ancestors' stories and transformations.

Knowledge of the Dreaming stories, and of the objects related to them, is sacred and secret. Multiple levels of meaning are learned over a lifetime and restricted to those properly trained and initiated to know each level. As a result, an outsider's understanding of the stories and related art (objects and motifs) is strictly limited to what is allowed to be public. Some stories are shared by many tribes across great distances, while others are specific to an area. Men and women have their own stories, women's often associated with food and food gathering.

Since the Dreaming has never ceased, the power of the ancestral Spirit Beings still exists. Indigenous Australians have developed a rich artistic life to relive the stories of the ancestors and transmit knowledge about them to subsequent generations. Ceremonial art forms include paintings on rock and bark, sand drawings, and ground sculptures. Sacred objects, songs, and dances are used to renew the supernatural powers of the ancestors in ceremonial meetings, called corroborees. In **FIGURE 27–3**, Western Arnhem Land artist Jimmy Midjaw Midjaw depicts such a meeting held by a group of Mimi, spirits who live in the narrow spaces between rocks by day and come out at night. Specific to this area, they taught humans how to hunt and cook animals, and to dance, sing, and play instruments in ceremonies. Tall, thin, human-like figures, often in motion, they were painted in ancient rock shelters, and since at least the late nineteenth century, on eucalyptus bark.

Bark paintings are found throughout northern Australia, where numerous regional styles exist. In Western Arnhem Land, the background is usually a monochromatic red ocher wash, with figures in white, black, and red pigments. In the 1950s and 1960s, Midjaw Midjaw was part of a prolific group of artists on Minjilang (Croker Island) that became well known through the anthropologists and collectors working in the area.

## MELANESIA

In Melanesia the people usually rely at least partially on agriculture, and as a result they live in permanent settlements, many of which feature spaces set aside for ritual use. Position and status in society are not inherited or determined by birth, but are achieved by the accumulation of wealth (often in the form of pigs), prestige through leadership, and, often, participation in men's societies. Much ceremony is related to rituals associated with these societies, such as initiation into different levels or grades. Other important rituals facilitate relationships with the deceased and with supernatural forces. Melanesian art is often bold and dazzling. Masking and body decoration, often as part of ceremonial performances, are important, though often ephemeral, aspects of Melanesian art. Although men are prominent in the sculptural and masking traditions, women play significant roles as audience and are known for their skill in making bark cloth, woven baskets, pottery, and other aesthetically pleasing objects.

**27-3 • Jimmy Midjaw Midjaw  THREE DANCERS AND TWO MUSICIANS: CORROBOREE OF MIMI, SPIRITS OF THE ROCKS**
Minjilang (Croker Island), West Arnhem Land, Australia. Mid 20th century. Natural pigments on eucalyptus bark, 23 × 35″ (59 × 89 cm). Musée du Quai Branly, Paris, France. MNAO 64.9.103

## NEW GUINEA

New Guinea, the largest island in the Pacific (and, at 1,500 miles long and 1,000 miles wide, the second-largest island in the world), is today divided between two countries. Its eastern half is part of the modern nation of Papua New Guinea; the western half is West Papua, a province of present-day Indonesia. Located near the equator and with mountains that rise to 16,000 feet, the island inhabitants utilize a variety of environments, from coastal mangrove marshes to grasslands, from dense rainforests to swampy river valleys. The population is equally diverse, with coastal fishermen, riverine hunters, slash-and-burn agriculturalists, and more stable farmers in the highlands. Between New Guinea itself and the smaller neighboring islands more than 700 languages have been identified.

THE *KORAMBO* OR CEREMONIAL HOUSE OF THE ABELAM OF PAPUA NEW GUINEA. The Abelam, who live in the foothills of

**27-4 • EXTERIOR OF *KORAMBO* (*HAUS TAMBARAN*)**
Kinbangwa village, Sepik River, Papua New Guinea. Abelam, 20th century.

the mountains on the north side of the Sepik River in Papua New Guinea, raise pigs and cultivate yams, taro, bananas, and sago palms. In traditional Abelam society, people live in extended families or clans in hamlets. Wealth among the Abelam is measured in pigs, but men gain status from participation in a yam cult that has a central place in Abelam society. The yams that are the focus of this cult—some of which reach an extraordinary 12 feet in length—are associated with clan ancestors and the potency of their growers. Village leaders renew their relationship with the forces of nature that yams represent during the Long Yam Festival, which is held at harvest time and involves processions, masked figures, singing, and the ritual exchange of the finest yams.

An Abelam hamlet includes sleeping houses, cooking houses, storehouses for yams, a central space for rituals, and a ceremonial or spirit house, the **korambo** (*haus tambaran* in Pidgin). In this ceremonial structure reserved for the men of the village, the objects associated with the yam cult and with clan identity are kept hidden from women and uninitiated boys. Men of the clan gather in the *korambo* to organize rituals, especially initiation rites, and conduct community business. The prestige of a hamlet is linked to the quality of its *korambo* and the size of its yams. Constructed on a frame of poles and rafters and roofed with split cane and thatch, *korambo* are built with a triangular floor plan, the side walls meeting at the back of the building. The elaborately decorated façade consists of three parts, beginning at the bottom: a woven mat, a painted and carved wooden lintel, and painted sago bark panels (FIG. 27-4). In this example, built about 1961, red, white, and black faces of spirits (*nggwal*) appear on the façade's bark panels, and the figure at the top is said to represent a female flying witch. This last figure is associated with the feminine power of the house itself. The projecting pole at the top of the *korambo* is the only male element of the architecture, and is said to be the penis of the house. The small door at the lower right is a female element, a womb; entering and exiting the house is the symbolic equivalent to death and rebirth. The Abelam believe the paint itself has magical qualities. Regular, ritual repainting revitalizes the images and ensures their continued potency.

Every stage in the construction of a *korambo* is accompanied by ceremonies, which are held in the early morning while women and boys are still asleep. The completion of the façade of a house is celebrated with a ceremony called *mindja*, which includes all-night dancing, and which may continue for six months, until the roof is completely thatched. Women participate in these inaugural ceremonies and are allowed to enter the new house, which afterward is ritually cleansed and closed to them.

*BILUM*—CONTEMPORARY NET BAGS OF HIGHLAND NEW GUINEA. Women's arts in Papua New Guinea tend to be less spectacular and more subtle than men's, but nonetheless significant. Both functionally and symbolically, they contribute to a balance between male and female roles in society. **Bilum**, for example, are netted bags made mainly by women throughout the central

**27-5 • WOMEN WEARING NET BAGS (*BILUM*)**
Wahgi valley, Western Highlands Province, Papua New Guinea. 1990.

highlands of New Guinea (FIG. 27–5). Looped from a single long thread spun on the thigh, *bilum* are very strong and, as loosely woven work bags, are used to carry items from vegetables to beer. The bones of a deceased man may be stored in a special *bilum* in a village's men's house (which is similar in function to the Abelam *korambo* in FIGURE 27–4), while his widow wears his personal bag as a sign of mourning. Women wear decorative *bilum*, into which marsupial fur is often incorporated, as adornment, exchange them as gifts, and use them to carry babies.

*Bilum* are rich metaphorical symbols. Among the women of the Wahgi tribe, who live in the Wahgi valley of the central highlands, seen in FIGURE 27–5, the term *bilum* may be used as a synonym for womb and bride, and they are also associated with ideas of female attractiveness; depending on how they are worn, they can indicate whether a girl is eligible for marriage.

In the past, *bilum* were made from natural fibers, most commonly the inner bark of a ficus plant. Today, while the technique for making them remains unchanged, a wide array of colorful, contemporary fibers, including nylon and acrylic yarn, are used, and new designs incorporating complicated patterns and

words are constantly appearing. *Bilum* are now made by women throughout Papua New Guinea, not just in the highlands. They are sold commercially in markets and towns, and have become one of the country's national symbols.

SPIRIT POLES OF THE ASMAT OF WEST PAPUA. The Asmat, who live along rivers in the coastal swamp forests on the southwest coast, were known in the past as warriors and headhunters (head-hunting was generally believed to maintain balance between hostile groups). In their culture, they identified trees with human beings, their fruit with human heads. Fruit-eating birds were thus the equivalent of headhunters, and were often represented in war and mortuary arts, along with the praying mantis, whose female bites off the head of the male during mating. In the past, the Asmat believed that death was always caused by an enemy, either by direct killing or through magic, and that it required revenge, usually in the form of taking an enemy's head, to appease the spirit of the person who had died.

Believing that the spirit of the dead person remained in the village, the Asmat erected elaborately sculpted memorial poles

(**FIG. 27–6**), known as *bisj* (pronounced bish), which embodied the spirits of the ancestors and paid tribute to them. *Bisj* poles are generally carved from mangrove trees, although some in a museum in Leiden recently have been found to be from the wild nutmeg. The felling of a tree is a ritual act in which a group of men attack the tree as if it were an enemy. The figures on the poles represent the dead individuals who are to be avenged; small figures represent dead children. The bent pose of the figures associates them with the praying mantis. The large, lacy phalluses emerging from the figures at the top of the poles are carved from the projecting roots of the tree and symbolize male fertility, while the surface decoration suggests body ornamentation. The *bisj* were placed in front of special houses belonging to the village's men's society. The poles faced the river to ensure that the spirits of the dead would travel to the realm of the ancestors (*safan*), which lay beyond the sea. The *bisj* pole also served symbolically as the dugout canoe that would take the spirit of the deceased down the river to *safan*.

By carving *bisj* poles (usually for several deceased at the same time) and organizing a *bisj* feast, relatives publicly indicated their responsibility to avenge their dead in a headhunting raid. As part of the ceremonies, mock battles were held, the men boasting of their bravery, the women cheering them on. After the ceremonies, the poles were left in the swamp to deteriorate and transfer their supernatural power back to nature. Today, Asmat continue to carve *bisj* poles and use them in funerary ceremonies, although they stopped headhunting in the 1970s. Poles are also made to sell to outsiders.

## NEW IRELAND

**MALAGAN DISPLAY OF NEW IRELAND.** New Ireland is one of the large eastern islands of the nation of Papua New Guinea. The northern people on the island still practice a complex set of death and commemorative rites known as *malagan* (pronounced malanggan), which could take place as much as two years after a person's death. In the past, clan leaders rose to prominence primarily through *malagan* ceremonies that honored their wives' recently deceased family members. The greater the *malagan* ceremony, the greater prominence the clan leader had achieved.

**27-6 • ASMAT ANCESTRAL SPIRIT POLES (*BISJ*)**
Buepis village, Fajit River, West Papua Province, Indonesia. c. 1960. Wood, paint, palm leaves, and fiber, height approx. 18′ (5.48 m).

*Malagan* also included rites to initiate young men and women into adulthood. After several months' training in seclusion in a ritual enclosure, they were presented to the public and carved and painted figures were given to them. The combined funerary and initiation ceremonies included feasts, masked dances, and the creation of a special house to display elaborately carved and painted sculptures (FIG. 27–7) that honored the dead. The display house illustrated, which dates to the early 1930s, is more than 14 feet wide and 12 deceased individuals are being honored. The carvings are large (the first on the left is nearly 6 feet in height) and take the form of horizontal friezes, standing figures, and poles containing several figures. They are visually complex, with tensions created between solid and pierced void, and between the two-dimensional painted patterns on three-dimensional sculptural forms. Kept secret until the final phase of the ceremonies, their unveiling was the climax of the festivities. After the ceremonies they were no longer considered ritually "active" and were destroyed or, since the late nineteenth century, sold to outsiders. *Malagan* figures are still being carved and ceremonies are held today.

### NEW BRITAIN

TUBUAN MASK OF NEW BRITAIN. In the Papua New Guinea province of New Britain, which includes the Duke of York Islands, Tubuan masks represent the Tolai male secret society. This has different levels or grades of increasing knowledge and power, and wields both spiritual and social control, especially during the three months of ceremonies known as the "Time of the Tubuan."

Though initiation to the society is the main purpose of the ceremonies, the men of the village, who have achieved power through the accumulation of wealth, and in the past through bravery in war, use this period to call up the spirits represented by the masks, who have the authority to settle disputes, stop fights, punish lawbreakers, and force the payment of debts. Political power and authority are underscored and enhanced by their appearance, and in the past they had the power of life and death.

The masks represent both female and male spirits, though all the masks are danced by men. Local stories say women originally owned the masks and that they were stolen from them by men. The **TUBUAN MASK** (FIG. 27–8) represents the Mother, who gives birth to her children, the Duk Duk masks, which represent the new initiates into the society. With the appearance, first of the Mother masks, then of the Duk Duk masks, the initiates return to the village from the bush, where they have undergone intensive preparation to enter the society. The Tubuan mask has a distinctive, tall conical shape and prominent eyes formed by concentric white circles. The green leaf skirt is a very sacred part of the mask, which is made from painted bark cloth, various fibers, and feathers: Black feathers on top indicate a more powerful spirit than white feathers.

## MICRONESIA

The majority of Micronesia's islands are small, low-lying coral atolls, but in the western region several are volcanic in origin. The eastern islands are more closely related culturally to Polynesia,

**27-7 • *MALAGAN* DISPLAY**
Medina village, New Ireland, Papua New Guinea. c. 1930. Height 82⅝″ (210 cm), width 137¾″ (350 cm). Museum für Völkerkunde, Basel, Switzerland.

while those in the west show connections to Melanesia, especially in the men's houses found on Palau and Yap. The atolls—circular coral reefs surrounding lagoons where islands once stood—have a limited range of materials for creating objects of any kind. Micronesians are known especially for their navigational skills and their fine canoes. They also create textiles from banana and coconut fibers, bowls from turtle shells, and abstract human figures from wood, which is scarce. As in other parts of the Pacific, tattooing and the performative arts remain central to life.

*WAPEPE* NAVIGATION CHART. Sailors from the Marshall Islands relied on celestial navigation (navigating by the sun and moon and stars) as well as a detailed understanding of the ocean currents and trade winds to travel from one island to another. To teach navigation to younger generations, elders traditionally used stick charts (*wapepe* or *mattang*)—maps that showed land, but also the path from one island to the next, the water a sailor would cross during his voyage.

In common use until the 1950s, the stick chart (FIG. 27–9) was a schematic diagram of the prevailing ocean currents and the characteristic wave patterns encountered between islands. The currents are represented by sticks held together by coconut fibers; the shells mark islands on the route. The arrangement of sticks around a shell indicates a zone of distinctive waves shaped by the effect of an island deflecting the prevailing wind. Such refracted waves enable a

27-9 • *WAPEPE* NAVIGATION CHART
Marshall Islands. 19th century. Sticks, coconut fiber, shells, 29½ × 29½″ (75 × 75 cm). Peabody Essex Museum, Salem.

navigator to sense the proximity of land without being able to see it, and to discern the least difficult course for making landfall. Although the *wapepe* is primarily functional, its combination of clarity, simplicity, and abstraction has an aesthetic impact.

NAN MADOL. The basalt cliffs of the island of Pohnpei provided the building material for one of the largest and most remarkable stone architectural complexes in Oceania. Nan Madol, on its southeast coast, consists of 92 artificial islands set within a network of canals covering about 170 acres (MAP 27–2). Seawalls and breakwaters 15 feet high and 35 feet thick protect the area from the ocean. When it was populated, openings in the breakwaters gave canoes access to the ocean and allowed seawater to flow in and out with the tides, flushing clean the canals. While other similar complexes have been identified in Micronesia, Nan Madol is the largest and most impressive, reflecting the importance of the kings who ruled from the site. The artificial islands and the buildings atop them were built between the early thirteenth and seventeenth centuries, until the dynasty's political decline. The site had been abandoned by the time Europeans discovered it in the nineteenth century.

Nan Madol was an administrative and ceremonial center as well as, at one time, a home for as many as 1,000 people. The powerful kings drew upon this labor force to construct a monumental city. Both the buildings and the underlying islands are built of massive pieces of stone set in alternating layers of log-shaped stones and boulders of prismatic basalt. The largest of the

27-8 • TUBUAN MASK BEING DANCED
Tolai people, Duke of York Islands, New Britain, Papua New Guinea. c. 1990. Cloth, paint, fiber, feathers.

TEMWEN

Reef

Reef

Peiniot

Nakapw
Harbor

NAKAPW

Karian

NAN
MADOL

Pahnwi

Reef

MADOLENIHMW
(POHNPEI)

NAHNNINGI

Pacific
Ocean

N

500 m
500 yards

MAP 27–2 • THE
COMPLEX OF NAN
MADOL

Pohnpei, Federated
States of Micronesia.
c. 1200/1300–
c. 1500/1600.

artificial islets is more than 100 yards long, and one basalt corner-stone alone is estimated to weigh about 50 tons. The stone logs were split from the cliffs by alternately heating the stone and dousing it with water. Most of the islands are oriented northeast–southwest, receiving the benefit of the cooling prevailing winds.

The royal mortuary compound, which once dominated the southeast side of Nan Madol (**FIG. 27–10**), has walls rising in subtle upward and outward curves to a height of 25 feet. To achieve the sweeping, rising lines, the builders increased the number of stones in the header courses (those with the ends of the stones laid facing out along the wall) relative to the stretcher courses (those with the lengths of the stones laid parallel to the wall) as they came to the corners and entryways. The plan of the structure consists simply of progressively higher rectangles within rectangles—the outer walls leading by steps up to interior walls that lead up to a central courtyard with a small, cubical tomb.

# POLYNESIA

The settlers of the far-flung islands of Polynesia developed distinctive cultural traditions but also retained linguistic and cultural affinities that reflect their common origin. Traditional Polynesian

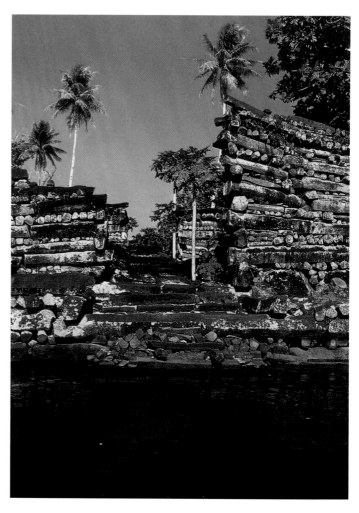

**27–10 • ROYAL MORTUARY COMPOUND, NAN MADOL**
Pohnpei, Federated States of Micronesia. Basalt blocks,
wall height up to 25′ (7.62 m).

society was generally far more stratified than Melanesian society: A person's genealogy, tracing his or her descent from an ancestral god, determined his or her place in society. First-born children of the hereditary elite were considered the most sacred because they inherited more spiritual power (*mana*) at their birth. *Mana* could be gained through leadership, courage, or skill or lost due to failure in warfare. It was protected by strict laws of conduct called *tapu*, a word that came into the English language as taboo.

All of the arts in Polynesia were sacred, and their creation was a sacred act: Master artists were also ritual specialists. Objects were crafted from a variety of materials, some of which, like jadite in New Zealand, were considered spiritually powerful. Some objects were useful ones, such as canoes, fishhooks, and weapons; others indicated the status and rank of the society's elite. The objects had their own *mana* that could increase or decrease depending on how successful they were in performing their functions. Their quality and beauty were important: Objects were made to endure and many were handed down as heirlooms from generation to generation. In addition, the human body itself was the canvas for the art of tattoo (*tatau* in several Polynesian languages).

Polynesian religions included many levels of gods, from creator gods and semidivine hero-gods (such as Maui, who appears in the stories of many of the Polynesian cultures) to natural forces, but the most important were one's ancestors, who became gods at their death. They remained influential in daily life, so needed to be honored and placated, and their help was sought for important projects and in times of trouble. Throughout much of Polynesia, figures in human form, often generically called *tiki*, were carved in stone, wood, and in some places, such as the Marquesas Islands, human bone. These statues represented the ancestors and were often placed on sacred ritual sites attended by ritual specialists (SEE FIG. 27–13) or, as in New Zealand, incorporated into meeting houses (see "Te-Hau-ki-Turanga," pages 870–871).

## MARQUESAS ISLANDS

TATTOO IN THE MARQUESAS ISLANDS. The art of tattoo was widespread and ancient in Oceania. Tattoo chisels made of bone have been found in Lapita sites. They are quite similar to the tools used to create the decorated Lapita pottery, suggesting some symbolic connection between the marking of the pottery and of human skin. The Polynesians, descendants of the Lapita people, brought tattooing with them as they migrated throughout the Pacific. As they became isolated from each other over time, distinctive styles evolved: Spirals became a hallmark of the Maori facial tattoo (*moko*), and rows of triangles became prominent in Hawaiian designs.

The people of the Marquesas Islands, an archipelago about 900 miles northeast of Tahiti, were the most extensively tattooed of all Polynesians. The process of tattooing involves shedding blood, the most *tapu* (sacred), substance in Polynesia. In the Marquesas, the process for a young man of high social rank began around age 18; by age 30 he would be fully tattooed. Because of the sacredness

and prestige of the process, some men continued to be tattooed until their skin was completely covered and the designs disappeared. Marquesan women were also tattooed, usually on the hands, ankles, lips, and behind the ears.

The process was painful and expensive. Though women could be tattooed with little ceremony in their own homes, in the case of both high-ranking men and women, special houses were built for the occasion. The master tattooer and his assistants had to be fed and paid. At the end of the session a special feast was held to display the new tattoos. Each design had a name and a meaning: Tattooing was done to mark passages in people's lives and their social positions, and to commemorate special events or accomplishments. Some tattoos denoted particular men's societies or eating groups. Especially for men, tattoos showed their courage and were essential to their sexual attractiveness to women.

Tattooing was forbidden in the nineteenth century by French colonial administrators and Catholic missionaries, and died out in the Marquesas. Beginning in the 1970s, tattooing underwent a resurgence throughout the Pacific and in 1980 **TEVE TUPUHIA** became the first Marquesan in modern times to be fully tattooed **(FIG. 27–11)**. He went to Samoa, the only place in Polynesia where the traditional art form continued, to be tattooed by master

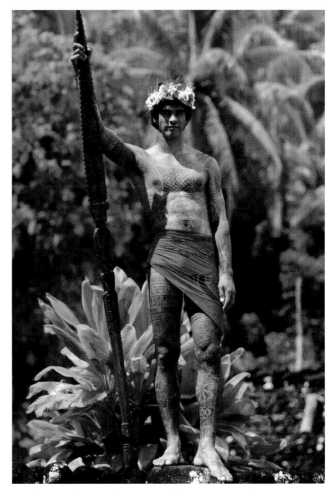

**27-11 • TEVE TUPUHIA**
Marquesan man tattooed in 1980 by Samoan Lese li'o.

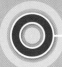
## Te-Hau-ki-Turanga

New Zealand was settled sometime after 800 CE by intrepid seafaring Polynesians now known as the Maori. As part of the process of adapting their Polynesian culture to the temperate New Zealand environment, they began to build wooden-frame homes, the largest of which, the chief's house, evolved after Western contact into the meeting house (*whare nui*). The meeting house stands on an open plaza (*marae*) a sacred place where a Maori tribe (*iwi*) or subtribe (*hapu*) still today greets visitors, discusses important issues, and mourns the dead. In it, tribal history and genealogy are recorded and preserved. Carved by the master carver Raharuhi Rukupo in the early

1840s, Te-Hau-ki-Turanga is the oldest existing, fully decorated meeting house in New Zealand (FIG. A). Built by Rukupo as a memorial to his elder brother, its name refers to the region of New Zealand where it was made—Turanga, today Gisborne, on the northeast coast of North Island—and can be translated as the Breezes of Turanga.

In this area of New Zealand, the meeting house symbolizes the tribe's founding ancestor, for whom it is often named. The ridgepole is the backbone, the rafters are the ribs, and the slanting **bargeboards**—the boards attached to the projecting end of the gable—are the outstretched enfolding arms. The face appears in the gable mask. Relief

figures of ancestors cover the support poles, wall planks, and the lower ends of the rafters. The ancestors, in effect, support the house. They were thought to take an active interest in community affairs and to participate in the discussions held in the meeting house. Rukupo, an important political and religious leader as well as a master carver, included an unusual naturalistic portrait of himself among them.

Painted curvilinear patterns (**kowhaiwhai**) decorate the rafters in red and black on a white background. The **koru** pattern, a curling stalk with a bulb at the end that resembles the young tree fern, dominates the design system. Lattice panels

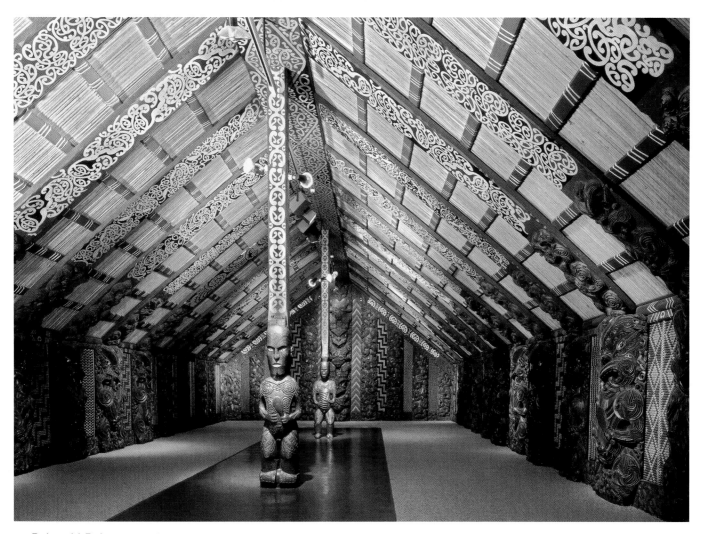

**A.** Raharuhi Rukupo, master carver  **TE-HAU-KI-TURANGA (MAORI MEETING HOUSE)**
Gisborne/Turanga, New Zealand; built and owned by the Rongowhakaata people of Turanga. 1842–1843, restored in 1935.
Wood, shell, grass, flax, and pigments. Museum of New Zealand/Te Papa Tongarewa, Wellington. Neg. B18358

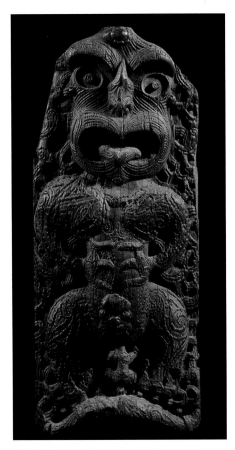

(**tukutuku**) made by women fill the spaces between the wall planks. Because ritual prohibitions, or taboos, prevented women from entering the meeting house, they worked from the outside and wove the panels from the back. They created the black, white, and orange patterns from grass, flax, and flat slats. Each pattern has a symbolic meaning: chevrons represent the teeth of the sea monster Taniwha; steps represent the stairs of heaven climbed by the hero-god Tawhaki; and diamonds represent the flounder.

When Captain Cook arrived in New Zealand in the second half of the eighteenth century, each tribe and geographical region had its own style. A storehouse doorway from the Ngati Paoa tribe (FIG. B), who lived in the Hauraki Gulf area to the west of Turanga, dates to this period of time (or earlier) and shows the soft, shallow surface carving resulting from the use of stone tools. In comparison, a house panel (**poupou**) from Te-Hau-ki-Turanga, carved with steel tools, is much more fully three-dimensional, with the deeply cut, very precisely detailed surface carving characteristic of that time.

As is typical throughout Polynesia (SEE FIG. 27–13), the figures face frontally and have large heads with open eyes. Their hands are placed on the stomach and their tongues stick out in defiance from their figure-eight-shaped mouths. The Hauraki Gulf figure represents a male ancestor, while the Te-Hau-ki-Turanga figure (FIG. C) is a female ancestor nursing a child. Both have a small figure, representing their descendants, between their legs.

Considered a national treasure by the Maori, this meeting house was restored in 1935 by Maori artists who knew the old, traditional methods; it is now preserved at the Museum of New Zealand/Te Papa Tongarewa in Wellington and considered *taonga* (cultural treasure).

**B. CARVED FIGURE FROM STOREHOUSE DOORWAY**
Ngäti Päoa, Hauraki Gulf, New Zealand. 1500–1800. Wood, height 33⅞″ (86 cm). Museum of New Zealand/Te Papa Tongarewa, Wellington.

**C. POUPOU**
(panel) from Te-Hau-ki-Turanga. Wood and red pigment, height 4′7″ (140 cm). Museum of New Zealand/Te Papa Tongarewa, Wellington.

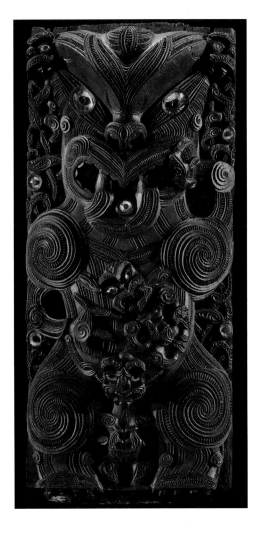

Interior side wall

**Parts of the meeting house**

Front

Interior rear wall

**SEE MORE:** View a simulation explaining the construction of the meeting house **www.myartslab.com**

**27-12 • FEATHER CLOAK, KNOWN AS THE KEARNY CLOAK**
Hawaii. c. 1843. Red, yellow, and black feathers, olona cordage, and netting, length 55¾″ (143 cm). Bishop Museum, Honolulu.

King Kamehameha III (r. 1825–1854) presented this cloak to Commodore Lawrence Kearny, commander of the frigate
USS *Constellation*.

Samoan artist Lese I'io. The process took six weeks and cost $35,000. Teve based his tattoo designs on drawings made by George Langsdorff, a German naturalist who visited the Marquesas in 1804 as part of a Russian scientific expedition. Today, Marquesan-style tattoo designs are seen throughout French Polynesia.

## HAWAII

FEATHER CLOAK FROM HAWAII.   The Hawaiian islanders had one of the most highly stratified of all Polynesian societies, with valleys and whole islands ruled by high chiefs. Soon after contact with the West, the entire archipelago was unified for the first time under the rule of Kamehameha I (r. 1810–1819), who assumed the title of king in the European manner.

Among the members of the Hawaiian elite, feathered capes and cloaks were emblems of their high social status. The most valuable were full-length and made with thousands of red and yellow feathers. A full-length cloak, like the one in **FIGURE 27–12**, was reserved for the highest ranks of the elite men. It was called an *'ahu 'ula* ("red cloak"); the color red is associated with high status and rank throughout Polynesia. Often given as gifts to important visitors to Hawaii, this particular cloak was presented in 1843 to Commodore Lawrence Kearny, commander of the USS *Constellation*, by King Kamehameha III (r. 1825–1854).

Draped over the wearer's shoulders, such a cloak creates a sensuously textured and colored abstract design, which in this example joins to create matching patterns of paired crescents on front and back. The cloak's foundation consisted of coconut fiber netting onto which bundles of feathers were tied. The feathers were part of an annual tribute paid to the king by his subjects. The red, and especially the yellow feathers, were highly prized and came from several species of birds including the *i'iwi, apapane, 'o'o,* and *mamo* (which is now extinct). In some cases, each bird yielded only seven or eight feathers, making the collecting of feathers very labor-intensive and increasing the value of the cloaks.

The cloaks were so closely associated with the spiritual power (*mana*) of the elite person that they could be made only by specialists trained in both the complicated technique of manufacture and the rituals attending their fabrication. Surrounded by protective objects, they created the cloak while reciting the chief's genealogy and imbuing it with the power of his ancestors. As a result, the cloaks were seen as protective of the wearer, while also proclaiming his elite status, and political and economic power.

Feathers were used for decorating not just cloaks, but also helmets, capes, blankets, and garlands (*leis*), all of which conferred status and prestige. The annual tribute paid to the king by his subjects included feathers, and tall feather pompons (*kahili*)

mounted on long slender sticks were symbols of royalty. Even the effigies of gods that Hawaiian warriors carried into battle were made of light, basketlike structures covered with feathers.

## MONUMENTAL MOAI ON RAPA NUI

Rapa Nui (Easter Island) is the most isolated inhabited locale in Oceania, some 2,300 miles west of the coast of South America and 1,200 miles from Pitcairn Island, the nearest Polynesian outpost. Three volcanoes, one at each corner, make up the small triangular island. Originally known to its native inhabitants as Te Pito o te Henúa (Navel of the World) and now known as Rapa Nui, it was named Easter Island by Captain Jacob Roggeveen, the Dutch explorer who first landed there on Easter Sunday in 1722. Rapa Nui became part of Chile in 1888.

MONUMENTAL MOAI.   Rapa Nui is the site of Polynesia's most impressive stone sculpture. Though many imaginative theories have been posited regarding the origins of its statues, from space aliens to Native Americans, they are most definitely part of an established Polynesian tradition. Sacred religious sites (*marae*) with stone altar platforms (*ahu*) are common throughout Polynesia. On Rapa Nui, most of the *ahu* are near the coast, parallel to the shore. About 900 CE, the islanders began to erect stone figures on the *ahu*, perhaps as memorials to deceased chiefs. Nearly 1,000 of the figures, called **moai**, have been found on the island, including some 400 unfinished ones in the quarry at Rano Raraku where they were being carved. The statues themselves are made from tufa, a yellowish-brown volcanic stone. On their heads, *pukao* (topknots of hair) were rendered in red scoria. When the statues were in place, the insertion of white coral and stone "opened" the eyes. In 1978 several figures on Ahu Nau Nau (**FIG. 27–13**) were restored to their original condition. They are about 36 feet tall, but *moai* range in size from much smaller to a 65-foot statue that is still in the quarry. Like other Polynesian statues, the figures here face frontally. Their large heads have deep-set eyes under a prominent brow ridge; a long, concave, pointed nose; a small mouth with pursed lips; and an angular chin. The extremely elongated earlobes have parallel engraved lines that suggest ear ornaments. The figures have schematically indicated breastbones and pectorals, and small arms with hands pressed close to the sides. Their bodies emerge from the site at just below waist level, so they have no legs.

The islanders stopped erecting *moai* around 1500 and entered a period of warfare among themselves, apparently because overpopulation was straining the island's available resources. Most of the *moai* were knocked down and destroyed during this period, which marked the emergence of a new religious focus on what is usually termed the bird-man cult. The island's indigenous population, which may at one time have consisted of as many as 10,000 people, was

**27–13 • *MOAI* ANCESTOR FIGURES**
Ahu Nau Nau, Rapa Nui (Easter Island). c. ?1000–1500 CE, restored 1978. Volcanic stone (tufa), average height approx. 36′ (11 m).

**SEE MORE:** View the podcast on the *Moai* Ancestor Figures
**www.myartslab.com**

nearly eradicated in 1877 when Peruvian slave traders precipitated an epidemic of smallpox and tuberculosis that left only 110 inhabitants alive. Today, a vibrant population of some 4,000 people is known especially for its energetic and athletic dance performances.

## SAMOA

*TAPA (SIAPO)* IN SAMOA. As they migrated across the Pacific, Polynesians brought with them the production of bark cloth. Known by various names throughout the Pacific, most commonly as **tapa**, in Samoa it is called **siapo**. Bark cloth is usually made by women, although sometimes men help to obtain the bark or decorate the completed cloth. In Samoa, *siapo* is made by stripping the inner bark from branches of the paper mulberry tree, although banyan and breadfruit are sometimes used in other archipelagoes. The bark is beaten with a wooden mallet, then folded over and beaten again, to various degrees of softness. Larger pieces can be made by building up the cloth in a process of felting or using natural pastes as glue. The heavy wooden mallets used for beating the cloth are often incised with complex patterns, which leave impressions like watermarks in the cloth, viewable when the cloth is held up to the light.

Plain and decorated *tapa* of various thicknesses and qualities was used throughout Polynesia for clothing, sails, mats, and ceremonial purposes, including wrapping the dead. *Tapa* was also used to wrap wooden or wicker frames to make human effigies in the Marquesas and Rapa Nui, serving a purpose we still do not completely understand. In western Polynesia (Samoa and Tonga) very large pieces, 7–10 feet across and hundreds of feet long, were traditionally given in ceremonial exchanges of valuables and as

**27–14 • TAPA (SIAPO VALA)**
Samoa. 20th century. 58⅝ × 57" (149 × 145 cm).
Auckland Museum, New Zealand. AM 46892

gifts. Along with fine mats, *siapo* is still sometimes given as gifts on important ceremonial occasions.

A widespread use of *tapa* was for clothing. For example, Samoan men and women wore large pieces of *siapo* as wraparound skirts (*lavalava*) (SEE FIG. 27–16). Special chiefs, called talking chiefs, who spoke on behalf of the highest-ranking chief in the village council, wore special *tapa* skirts called *siapo vala* (FIG. 27–14).

Distinctive design styles for *tapa* cloth evolved across the Pacific, even when the material used was essentially the same from one island to the next. It could be dyed bright yellow with turmeric or brown with dyes made from nuts. It could also be exposed to smoke to turn it black or darker brown. Today, contemporary fabric paint is often used. Decorative designs were made through a variety of means from freehand painting to impressing on the coloring with tiny bamboo stamps, or using stencils, as is done in Fiji. This Samoan *siapo vala* has designs that are produced by first placing the cloth over a wooden design tablet, an **upeti**, and then rubbing pigment over the cloth to pick up the carved pattern. The second stage is to overpaint this lighter rubbed pattern by hand. The result is a boldly patterned, symmetrical design.

# RECENT ART IN OCEANIA

In the late 1960s and early 1970s, a cultural resurgence swept across the Pacific. Growing independence and autonomy throughout the region, the model of civil rights and other movements in the United States, and dramatic increases in tourism, among other factors, brought a new awareness of the importance of indigenous cultures. Many of them had been fundamentally changed, if not nearly destroyed, by colonial rule and missionary efforts to eradicate local customs and beliefs.

## PACIFIC ARTS FESTIVAL

In the early 1970s, the South Pacific Commission conceived the idea of an arts festival that would promote traditional song and dance. The first Festival of Pacific Arts was held in 1972 in Fiji; subsequent festivals, held every four years, have been hosted by New Zealand, Papua New Guinea, Tahiti, Australia, Cook Islands, Samoa, New Caledonia, Palau, and American Samoa.

Musicians from the highlands of Papua New Guinea (FIG. 27–15) were among the more than 2,000 participants from 27 countries at the tenth festival at Pago Pago, American Samoa, in 2008. Carrying traditional drums, they wore elaborate headdresses topped with bird of paradise feathers, and neck ornaments made from kina shells, a once valuable medium of exchange in New Guinea.

In the 36 years since their founding, the festivals have had an enormous impact on the arts. Many Pacific cultures now have their own festivals, such as in the Marquesas Islands where they are held every four years. In an age of globalization and the Internet, festivals are one of the main ways in which young people become involved in, and learn about, their cultures. However, the festivals

**27-15 • MUSICIANS FROM PAPUA NEW GUINEA AT THE PACIFIC ARTS FESTIVAL**
Pago Pago, American Samoa, 2008.

are not without controversy: Some people are critical of an increasing level of professionalism and commercialism.

CENTRAL DESERT PAINTING. In Australia, indigenous artists have adopted canvas and acrylic paint for rendering imagery traditionally associated with more ephemeral media like body and sand drawing. Sand drawing is an ancient ritual art form that involves creating large colored designs on bare earth. Made with red and yellow ochers, seeds, and feathers arranged on the ground in symbolic patterns, they are used to convey tribal knowledge to initiates. In 1971, several indigenous Pintubi men who were trained and initiated to know the sacred knowledge, and were living in government-controlled Papunya Tula in the central desert of Australia, were encouraged by nonindigenous art teacher Geoffrey Bardon to transform their ephemeral art into a painted mural on the school wall. The success of the public mural encouraged community elders to allow others to try their hand at painting. In Utopia, a neighboring community, it was the women who began painting in 1988 after success in tie-dyeing with fabrics. Art galleries, originally located in Alice Springs, spread the art form, and "dot paintings" were a worldwide phenomenon by the late 1980s. Paintings also became an economic mainstay for many Aboriginal groups in the central and western Australia desert.

Although they are creating work for sale, the artists can paint only stories to which they have rights, and must be careful to depict only what a noninitiated person is allowed to know.

Clifford Possum Tjapaltjarri (c. 1932–2002), a founder of the Papunya Tula Artists Cooperative (1972), gained an international reputation after an exhibition of his paintings in 1988. He worked with his canvases on the floor, as in traditional sand painting, using ancient patterns and colors, principally red and yellow, as well as touches of blue. The superimposed layers of concentric circles and undulating lines and dots in a painting like *Man's Love Story* (see "A Closer Look," page 876) create an effect of shifting colors and lights.

The painting seems entirely abstract, but it actually conveys a narrative involving two mythical ancestors: one of these ancestors came to Papunya in search of honey ants; the white U shape on the left represents him seated in front of a water hole with an ants' nest, represented by the concentric circles. His digging stick lies to his right, and white sugary leaves lie to his left. The straight white "journey line" represents his trek from the west. The second ancestor, represented by the brown-and-white U-shaped form, came from the east, leaving footprints, and sat down by another water hole nearby. He began to spin a hair string on a spindle (the form leaning toward the upper right of the painting) but was

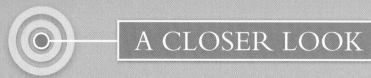
*Man's Love Story* ▶ by Clifford Possum Tjapaltjarri, 1978. Synthetic polymer paint on canvas.
6'11¾" × 8'4¼" (2.15 × 2.57 m). Art Gallery of South Australia, Adelaide.
Visual Arts Board of the Australia Council Contemporary Art Purchase Grant, 1980

Designs may have multiple meanings. A circle can represent a water hole or ant hole, as here, but also a hole where the ancestral spirit beings exited and entered the earth, a person as viewed from above, or a campfire.

Honey ants are sweet and are a delicacy. A digging stick is used to open up the nest, exposing the ant colony so that the ants can be removed and eaten.

Hair is spun into string using a spindle that is rotated across the thigh. The string is surprisingly strong and was used for utilitarian and ceremonial purposes, depending on the region.

Synthetic polymer, or acrylic, paint replaces the earth-toned ochers used in the original sand paintings that provide the model for these.

Women are important figures in the Dreaming stories and are represented in several places in this painting. Indigenous women are artists and paint their own stories, too, which usually center on food and food gathering.

The dots are made using a stick with a round, flat end that is dipped into the paint. Several people can work at the same time to fill in dotted areas.

SEE MORE View the Closer Look feature for Clifford Possum Tjapaltjarri's *Man's Love Story* www.myartslab.com

distracted by thoughts of the woman he loved, who belonged to a kinship group into which he could not marry. When she approached, he let his hair string blow away (represented by the brown flecks below him) and lost all his work. Four women (the dotted U shapes) came at night and surrounded the camp to guard the lovers. Rich symbolism also fills other areas of the painting: the white footprints are those of another ancestral figure following a woman, and the wavy line at the top is the path of yet

another ancestor. The black, dotted oval area indicates the site where young men were taught this story. The long horizontal bars are mirages, while the wiggly shapes represent caterpillars, a source of food. Possum Tjapaltjarri painted numerous variations of this Dreaming story.

The painting is effectively a map showing the ancestors' journeys. To begin the work Possum Tjapaltjarri first painted the landscape features and the impressions left on the earth by the

figures—their tracks, direction lines, and the U-shaped marks they left when sitting. Then, working carefully, dot by dot, he captured the vast expanse and shimmering light of the arid landscape. The painting's resemblance to modern Western painting styles such as Abstract Expressionism, gestural painting, pointillism, or color field painting (see Chapter 32) is accidental. Possum Tjapaltjarri's work is rooted in the mythic, narratives of the Dreaming. He and other contemporary artists working in both age-old and new media continue to create arts that express the deepest meanings of their culture.

*ULUGALI'I SAMOA: SAMOAN COUPLE.* Many contemporary Pacific artists live in urban settings, were trained at colleges and universities, and create artworks in modern media that deal with a range of political issues. These include the colonial legacy, discrimination, misappropriation, cultural identity, land rights, and many others. Shigeyuki Kihara is a multimedia and performance artist of Samoan and Japanese descent who lives in New Zealand. In **ULUGALI'I SAMOA: SAMOAN COUPLE (FIG. 27–16)**, she explores issues of culture, identity, stereotypes, authenticity, representation, and gender roles through a reappropriation of nineteenth- and early twentieth-century colonial photographs. Made in studio settings,

those photographs were often turned into postcards depicting Pacific Island men and women, both alone and in couples, the women as bare-breasted and sexualized "dusky maidens" and the men as emasculated "noble savages." Kihara confronts these stereotyped images of the South Seas in carefully restaged, sepia-toned photographs that, through ironic twists, also directly challenge the viewer's understanding of gender and gender roles.

In this photograph of a male and female couple both figures are clothed as they might have been in the nineteenth century, wearing large pieces of Samoan bark cloth (SEE FIG. 27–14), and holding traditional Samoan status objects, a plaited fan and a flywhisk. Kihara herself poses as the native woman, but has also superimposed her own face, with wig and mustache, onto the body of the male figure. *Ulugali'i Samoa: Samoan Couple* is part of a series of photographs called "Fa'a fafine: In a Manner of a Woman." *Fa'a fafine* is the Samoan word for a biological male who lives as a woman, the "third gender" socially accepted historically throughout much of Polynesia (and also in the Americas, SEE FIG. 26–20). Kihara is, herself, *fa'a fafine*, a transgender woman who lives and identifies in that gender role. In this photograph and the others in the series, she blurs stereotyped notions of who or what is male or female, original or copy, reality or perception. This work was part of the exhibition "Shigeyuki Kihara: Living Photographs," the first solo exhibition by a Samoan in the Metropolitan Museum of Art in New York. Her work and that of other urban artists draws on the richness of Pacific cultures while addressing the issues of the twenty-first century.

**27-16 • Shigeyuki Kihara *ULUGALI'I SAMOA*: SAMOAN COUPLE**
2004–2005. C-type photograph, edition 5, 31½ × 23⅗″ (80 × 60 cm). Metropolitan Museum of Art, New York. Gift of Shigeyuki Kihara, 2009

## THINK ABOUT IT

**27.1** Discuss how differences in environment, affecting available resources, impact the visual arts, including architectural forms and body adornment.

**27.2** Assess the importance of ancestors in Pacific art and the different ways in which ancestors are engaged, honored, or invoked through various art forms.

**27.3** Discuss the ways in which the human body is adorned and/or depicted in art across the Pacific, and how these define or enhance status, authority, and gender roles.

**27.4** Discuss the variety of materials used in ceremonies and adornment throughout the Pacific and explain how their permanence or impermanence reflects cultural difference.

**27.5** Examine the impact of contact with Western society on the arts and cultures of the peoples of the Pacific. Discuss the different ways in which contemporary indigenous artists throughout the Pacific are addressing issues that remain today.

**PRACTICE MORE:** Compose answers to these questions, get flashcards for images and terms, and review chapter material with quizzes **www.myartslab.com**

**28–1** • Attributed to Kojo Bonsu  **FINIAL OF A SPOKESPERSON'S STAFF (*OKYEAME POMA*)**
From Ghana. Ashanti culture, 1960s–1970s. Wood and gold, height 11¼″ (28.57 cm).
Sarah Da Vanzo Collection, Johannesburg, South Africa.

# ART OF AFRICA IN THE MODERN ERA

Political power is like an egg, says an Ashanti proverb. Grasp it too tightly and it will shatter in your hand; hold it too loosely and it will slip from your fingers. Whenever the *okyeame* (spokesman) for one twentieth-century Ashanti ruler was conferring with that ruler or communicating the ruler's words to others, he held a staff with this symbolic caution on the use and abuse of power prominently displayed on the gold-leaf-covered finial (FIG. 28–1). Since about 1900 these advisors have carried staffs of office such as the one pictured here. The carved figure at the top illustrates a story that may have multiple meanings when told by a witty owner. This staff was probably carved in the 1960s or 1970s by Kojo Bonsu. The son of Osei Bonsu (1900–1976), a famous carver, Kojo Bonsu lives in the Ashanti city of Kumasi and continues to carve prolifically.

A staff or scepter is a nearly universal symbol of authority and leadership. Today in many colleges and universities a ceremonial mace is still carried by the leader of an academic procession, and it is often placed in front of the speaker's lectern, as a symbol of the speaker's authority. The Ashanti spokesmen who carry their image-topped staffs are part of this widespread tradition.

Since the fifteenth century, when the first Europeans explored Africa, objects such as this staff have been shipped back to Western museums of natural history or ethnography, where they were catalogued as curious artifacts of "primitive cultures." Toward the end of the nineteenth century, however, changes in Western thinking about African culture gradually led more and more people to appreciate the inherent aesthetic qualities of these unfamiliar objects and at last to embrace them fully as art. In recent years the appreciation of traditional African arts have been further enhanced through the exploration of their meaning from the point of view of the people who made them.

If we are to understand African art such as this staff on its own terms, we must take it out of the glass case of the museum where we usually encounter it and imagine the artwork playing its vital role in a human community. Indeed, this is true of any work of art produced anywhere in the world. When we recognize in an artwork the true expression of values and beliefs, our imaginations cross a bridge to understanding.

28.1 Examine the role of the visual arts in the expression of power and authority by modern African leaders.

28.2 Summarize the role of the arts in divination to disclose the cause of misfortune in several African cultures.

28.3 Examine the role of African arts in its reaction to the colonial experience.

28.4 Contrast the ways in which African contemporary artists explore their search for an identity through their art.

28.5 Evaluate the role of masquerade in African rites of passage such as initiation and funeral rituals.

**HEAR MORE:** Listen to an audio file of your chapter **www.myartslab.com**

# TRADITIONAL AND CONTEMPORARY AFRICA

The second-largest continent in the world, Africa is a land of enormous diversity (MAP 28–1). Geographically, it ranges from vast deserts to tropical rainforest, from flat grasslands to spectacular mountains and dramatic rift valleys. Cultural diversity in Africa is equally impressive. More than 1,000 African languages have been identified and grouped into five major linguistic families. Various languages represent unique cultures, with their own history, customs, and art forms.

Before the nineteenth century, the most important outside influence to pervade Africa had been the religious culture of Islam, which spread gradually and largely peacefully through much of west Africa and along the east African coast (see "Foundations of African Cultures," page 883). The modern era, in contrast, begins with the European exploration during the nineteenth century and subsequent colonization of the African continent, developments that brought traditional African societies into sudden and traumatic contact with the "modern" world that Europe had largely created.

European ships first visited sub-Saharan Africa in the fifteenth century. For the next several hundred years, however, European contact with Africa was almost entirely limited to coastal areas, where trade, including the tragic slave trade, was carried out. Between the sixteenth and nineteenth centuries, over 10 million slaves were taken from Africa to colonies in North and South America and the Caribbean islands. Countries that participated in the Atlantic slave trade included Great Britain, Portugal, France, Spain, Denmark, Holland, and the United States.

During the nineteenth century, as the slave trade was gradually eliminated, European explorers began to investigate the unmapped African interior in earnest. They were soon followed by Christian missionaries, whose reports excited popular interest in the continent. Drawn by the potential wealth of Africa's natural resources, European governments began to seek territorial concessions from African rulers. Diplomacy soon gave way to force, and toward the end of the century competition among rival European powers fueled the so-called Scramble for Africa, during which England, France, Germany, Belgium, Italy, Spain, and Portugal raced to lay claim to whatever part of the continent they could. By 1914 virtually all of Africa had fallen under colonial rule.

Public and private collections of African art grew rapidly in size during this period. This was due not only to geographic exploration and colonial expansion, but also to the development of anthropology as a field of study. Artifacts from various African cultures became instruments through which university professors and museum curators could explain human development in purely evolutionary terms. Museums and collectors competed with one another to collect everywhere and as quickly as possible, believing that "traditional" African cultures were being quickly altered by the colonial experience. As territory was subsumed under European control, vast quantities of art objects flowed into European city, state, and national collections.

Objects also entered Western collections through conflict. For example, when a British expedition headed by the newly appointed Acting Council-General, James Phillips, embarked on a mission to discuss the trade agreement with the *oba* of Benin, he was told he could not meet with the king because he was engaged in an important annual ceremony honoring his ancestors. Phillips refused to postpone his visit and the expedition was

**28-2 • MEMBERS OF THE BRITISH PUNITIVE EXPEDITION IN THE BENIN PALACE IN 1897 WITH OBJECTS FROM THE ROYAL TREASURY**

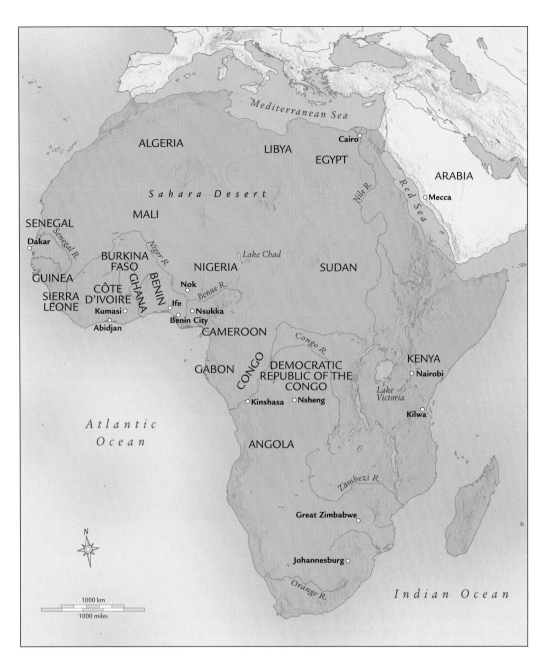

**MAP 28–1 •**
**PRESENT-DAY AFRICA**

The vast continent of Africa is home to over fifty countries and innumerable cultures.

attacked by a group headed by two chiefs, without the king's knowledge, killing all but two expedition members. A punitive expedition was launched in 1897 by the British **(FIG. 28–2)** which resulted in much of the town, including the palace, being destroyed and over 2,000 antiquities—nearly the entire store of artifacts from the royal palace—being seized. The king was deposed and sent into exile. His successor assumed the throne in 1914. The antiquities were taken to Europe and auctioned to defray the costs of the expedition and provide pensions for those who had been ambushed or their survivors. These objects are now dispersed in museums and private collections throughout the world.

Changes in Western thinking about art gradually led people to appreciate the aesthetic qualities of tradition-based African "artifacts" and finally to embrace them fully as art. As noted earlier, the earliest collections of African art were, for the most part, acquired by museums of natural history or ethnography, which exhibited the works as curious artifacts of "primitive" cultures. By the latter half of the twentieth century, art museums, both in Africa and in the West, began to collect African art seriously and methodically. Today, these collections afford us a rich sampling of African art created for the most part in the nineteenth and twentieth centuries.

In the years following World War I, nationalistic movements resisting European incursion arose across Africa. Their leaders generally did not advocate a return to earlier forms of political organization but rather demanded the transformation of colonial divisions into modern nation-states governed by Africans. From the 1950s through the mid 1970s, one colony after another gained its independence, and the present-day map of Africa took shape. Today, the continent is composed of over 50 independent countries.

**28-3 • NANKANI COMPOUND**
Sirigu, Ghana. 1972.

Among the Nankani people, creating living areas is a cooperative but gender-specific project. Men build the structures, women decorate the surfaces. The structures are also gendered. The round dwellings shown here are women's houses located in an interior courtyard; men occupy rectangular flat-roofed houses. The bisected lozenge design on the dwelling to the left is called *zalanga*, the name for the braided sling that holds a woman's gourds and most treasured possessions.

While African societies were profoundly disrupted during the colonial period, numerous tradition-based societies persist, both within and across contemporary political borders, and art continues to play a vital role in the spiritual and social life of the community. This chapter explores African art in light of how it addresses some of the fundamental concerns of human existence. Works of art are often directly related to the commemoration of significant rites of passage such as procreation and birth, initiation to adulthood, socialization in adult life, and death. While political leaders throughout the world use art to express their authority and status, in Africa community leaders are thought to connect the living community with the spirit world. In this regard, African art often especially idealizes the spirits of community leaders and deceased persons, who are expected to mediate between the temporal and supernatural worlds to help achieve well-being both for themselves and for the entire community. In these contexts, art is often intended to help mediate aid and support from a supernatural world of ancestors and other spirit forces. These concerns—rather than geographical region or time frame—form the backdrop against which we look at artworks in this chapter, as African art can be more fully understood within contexts of production and use.

Generally, the full meaning of a tradition-based work of art can only be realized in the context of its use. For instance, when masked dancers perform within a specific ceremonial event, the mask itself (which we may later see as an artwork in a museum) is only a part of a process that most fully reveals its meaning in performance.

## DOMESTIC ARCHITECTURE

Shelter is a basic human concern, yet each culture approaches it in a unique way that helps define that culture. The farming communities of the Nankani people in the border area between Burkina Faso and Ghana, in west Africa, have developed a distinctive painted architecture. The earthen buildings of their walled compounds are low and single-storied with either flat roofs that form terraces or conical roofs. Each compound is surrounded by a defensive wall with a single entrance on the west side. Each building inside the enclosure is arranged so that it has a direct view of the entrance. Some buildings are used only by men, others only by women. For example, Nankani men are in charge of the ancestral shrine near the entrance of the compound, the corral for cattle, and the granary; they have rectangular houses. The inner courtyards, outdoor kitchen, and round houses are

## Foundations of African Cultures

Africa was the site of one of the great civilizations of the ancient world—that of Egypt, which arose along the fertile banks of the Nile River over the course of the fourth millennium BCE and lasted for some 3,000 years. Egypt's rise coincided with the emergence of the Sahara—now the largest desert in the world—from the formerly lush grasslands of northern Africa. Some of the oldest-known African art, images inscribed and painted in the mountains of the central Sahara beginning around 8000 BCE, bear witness to this gradual transformation as well as to the lives of the pastoral peoples who once lived in the region.

As the grassland dried, its populations migrated in search of pasture and arable land. Many probably made their way to the Sudan, the broad band of savanna south of the Sahara. During the sixth century BCE, knowledge of iron smelting spread across the Sudan, enabling larger and more complex societies to emerge. One such society was the ironworking Nok culture, which arose in present-day Nigeria around 500 BCE and lasted until about 200 CE. Terra-cotta figures created by Nok artists are the earliest known sculpture from sub-Saharan Africa.

Farther south in present-day Nigeria, a remarkable culture developed in the city of Ife, which rose to prominence around 800 CE. There, from roughly 1000 to 1400, a tradition of naturalistic sculpture in bronze and terra cotta flourished. Ife was, and remains, the sacred city of the Yoruba people. According to legend, Ife artists brought the techniques of bronze casting to the kingdom of Benin to the west. From 1170 to the present century, Benin artists in the service of the court created numerous works in bronze, at first in the naturalistic style of Ife, then in an increasingly stylized and elaborate manner.

With the Arab conquest of North Africa during the seventh and eighth centuries, Islamic travelers and merchants became regular visitors to the Sudan. Largely through their writings, we know of the powerful west African empires of Ghana and Mali, which flourished successively from the fourth through the sixteenth centuries along the great bend in the Niger River. Both grew wealthy by controlling the flow of African gold and forest products into the lucrative trans-Sahara trade. The city of Jenné, in Mali, served not only as a commercial hub but also as a prominent center of Islam.

Meanwhile, since before the Common Era, peoples along the coast of east Africa had participated in a maritime trade network that ringed the Indian Ocean and extended east to the islands of Indonesia. Over time, trading settlements arose along the coastline, peopled by Arab, Persian, and Indian merchants as well as Africans. By the thirteenth century these settlements were important port cities, and a new language, Swahili, had developed from the longtime mingling of Arabic with local African languages. Peoples of the interior organized extensive trade networks to funnel goods to these ports. From 1000 to 1500 many of these interior routes were controlled by the Shona people from the site called Great Zimbabwe. The extensive stone palace compound there stood in the center of a city of some 10,000 people at its height. Numerous cities and kingdoms, often of great wealth and opulence, greeted the astonished eyes of the first European visitors to Africa at the end of the fifteenth century.

---

women's areas (FIG. 28–3). Men build the compound; women paint the buildings inside and out.

The women decorate the walls with horizontal molded ridges called *yidoor* ("rows in a cultivated field") and long eye ("long life"), to express good wishes for the family. They paint the walls with rectangles and squares divided diagonally to create triangular patterns that contrast with the curvature of the walls. The painted patterns are called braided sling, broken pottery, broken gourd, and sometimes, since the triangular motifs can be seen as pointing up or down, they are sometimes called filed teeth. The same geometric motifs are used on pottery and baskets, and for scarification of the skin. When people decorate themselves, their homes, and their possessions with the same patterns, art serves to enhance cultural identity.

### CHILDREN AND THE CONTINUITY OF LIFE

Among the most fundamental of human concerns is the continuation of life from one generation to the next. In tradition-based societies children are especially important: Not only do they represent the future of the family and the community, but they also provide a form of "social security," guaranteeing that parents will have someone to care for them when they are old.

In the often harsh and unpredictable climates of Africa, human life can be fragile. In some areas half of all infants die before the age of 5, and the average life expectancy may be as low as 40 years. In these areas women bear many children in hopes that at least a few will survive into adulthood, and failure to have children is a disaster for a wife, her husband, and her husband's lineage. Women who have had difficulty bearing children appeal for help with special offerings or prayers, often involving the use of art.

YORUBA TWIN FIGURES. The Yoruba people of Nigeria have one of the highest rates of twin births in the world. The birth of twins is a joyful occasion, yet it is troubling as well, for twins are more delicate than single babies, and one or both may well die. Many African peoples believe that a dead child continues its life in a spirit world and that the parents' care and affection may reach it there, often through the medium of art. When a Yoruba twin dies, the parents often consult a diviner, a specialist in ritual and spiritual practices, who may tell them that an image of a twin (*ere ibeji*) must

**CHILDREN, ART, AND PERFORMANCE.** In sub-Saharan Africa, as elsewhere, children from an early age are intensely interested in adult roles and activities including art making and the performative arts. In many societies a child's link to a particular artistic or craft activity is fixed. For example, in Africa, wood carving is universally a male-dominated activity, while women are most often involved in pottery production, and individual children may be apprenticed to a wood carver or potter according to their gender. But, even beyond such formal apprenticeships, children are especially interested in the festive activities of community life, such as masquerade. While mask making and masquerade performance are usually controlled by adult associations, children are given space at the edges of events to experiment with their homemade masks and costumes. Yoruba masquerades such as Gelede or Egungun are often organized so that children perform first **(FIG. 28–5)**. Some families even purchase or make elaborate costuming for their children in a similar style to that worn by adults. Adults view these early forays into masquerade as a

**28-4 • TWIN FIGURES (*ERE IBEJI*)**
From Nigeria. Yoruba culture, 20th century. Wood, height 7⅞″ (20 cm). The University of Iowa Museum of Art, Iowa City.
The Stanley Collection (x1986.489 and x1986.488)

As with other African sculpture, patterns of use result in particular signs of wear. The facial features of *ere ibeji* are often worn down or even obliterated by repeated feedings and washings. Camwood powder applied as a cosmetic builds to a thick crust in areas that are rarely handled, and the blue indigo dye regularly applied to the hair eventually builds to a thin layer of color.

be carved to serve as a dwelling place for the deceased twin's spirit **(FIG. 28–4)**.

When the image is finished, the mother brings the artist gifts. Then, carrying the figure as she would a living child, she dances home accompanied by the singing of neighborhood women. She places the figure in a shrine in her bedroom and lavishes care upon it, feeding it, dressing it with beautiful textiles and jewelry, anointing it with cosmetic oils. The Yoruba believe that the spirit of a dead twin, thus honored, is appeased and will look with favor on the surviving family members.

The twins here are female. They may be the work of the Yoruba artist Akiode, who died in 1936. Like most objects that Africans produce to encourage the birth and growth of children, the figures emphasize health and well-being. They have beautiful, glossy surfaces to suggest that they are well fed, as well as marks of adulthood, such as elaborate hairstyles and scarification patterns, that will one day be achieved. They represent hope for the future, for survival, and for prosperity.

**28-5 • ELDER GUIDING SMALL BOY IN EGUNGUN PERFORMANCE WHILE ADULT EGUNGUN PERFORMER LOOKS ON**
Nigeria. Yoruba culture. National Museum of African Art, Smithsonian Institution, Washington, D.C. Eliot Elisofon Photographic Archive (EEPA 1992-028-02691)

training ground. As children perform, they are encouraged and gently corrected from the sidelines by family members. The Yoruba of Nigeria, especially, place a significant value on the training of children in adult performance and aesthetic forms, and children are encouraged to perform from an early age.

## INITIATION

In contemporary Western societies, initiation into the adult world is extended over several years and punctuated by numerous rites, such as being confirmed in a religion, earning a driver's license, graduating from high school, and reaching the age of majority. All of these steps involve acquiring the knowledge society deems appropriate and accepting the corresponding responsibilities. In other societies, initiation can take other forms, and the acquisition of knowledge is usually supplemented by trials of endurance to prove that the candidate is equal to the responsibilities of adult life.

MASKS OF BWA INITIATION.    The Bwa people of central Burkina Faso initiate young men and women into adulthood following the onset of puberty. The initiates are first separated from younger playmates by being "kidnapped" by older relatives, though their disappearance is explained in the community by saying that they have been devoured by wild beasts. The initiates remove their clothing and sleep on the ground without blankets. Isolated from the community, they are instructed about the world of nature spirits and about the masks that represent them. They learn of the spirit each mask represents, and they memorize the story of each spirit's encounter with the founding ancestors of the clan. They learn how to construct costumes from hemp to be worn with the masks, and they learn the songs and instruments that accompany the masks in performance. Only boys wear each mask in turn and learn the dance steps that express the character and personality each mask represents. Returning to the community, the initiates display their new knowledge in a public ceremony. Each boy performs with one of the masks, while the girls sing the accompanying songs. At the end of the mask ceremony the young men and young women rejoin their families as adults, ready to marry, to start farms, and to begin families of their own.

Most Bwa masks depict spirits that have taken an animal form, such as crocodile, hyena, hawk, or serpent. Others represent spirits in human form. Among the most spectacular masks, however, are those that represent spirits that have taken neither human nor animal form. Crowned with tall, narrow planks (FIG. 28–6), these masks are covered in abstract patterns that are easily recognized by

**28-6 • FIVE MASKS IN PERFORMANCE**
Dossi, Burkina Faso. Bwa culture, 1984. Wood, mineral pigments, and fiber, height approx. 7' (2.13 m).

The Bwa have been making and using such masks since well before Burkina Faso achieved its independence in 1960. We might assume their use is centuries old, but in this case, the masks are a comparatively recent innovation. The elders of the Bwa family who own these masks state that they, like all Bwa, once followed the cult of the spirit of Do, who is represented by masks made of leaves. In the last quarter of the nineteenth century, the Bwa were the targets of slave raiders from the north and east. Their response to this new danger was to acquire wooden masks from their neighbors, for such masks seemed a more effective and powerful way of communicating with spirits who could help them. Thus, faced with a new form of adversity, the Bwa sought a new tradition to cope with it.

SEE MORE: View a video of the Bwa masks in a performance **www.myartslab.com**

28-7 • TEMNE *NOWO* MASQUERADE
WITH ATTENDANTS
Sierra Leone. 1980.

the initiated. The white crescent at the top represents the quarter moon, under which the initiation is held. The white triangles below represent bull roarers—sacred sound-makers that are swung around the head on a long cord to recreate spirit voices. The large central X represents the scar that every initiated Bwa bears as a mark of devotion. The horizontal zigzags at the bottom represent the path of the ancestors and symbolize adherence to ancestral ways. That the path is difficult to follow is clearly conveyed. The curving red hook that projects in front of the face is said to represent the beak of the hornbill, a bird associated with the supernatural world and believed to be an intermediary between the living and the dead. The mask thus proudly announces the initiate's passage to adulthood while encoding secrets of initiation in abstract symbols of proper moral conduct.

INITIATION TO WOMANHOOD IN WEST AFRICA. Among the Mende, Temne, Vai, and Kpelle peoples of Sierra Leone, the initiation of girls into adulthood is organized by a society of older women called Sande or Bondo. The initiation culminates with a ritual bath in a river, after which the initiated return to the village.

At the ceremony, the Sande women wear black gloves and stockings, black costumes of shredded raffia fibers that cover the entire body, and black masks called *nowo* or *sowei* (FIG. 28–7).

With its glossy black surface, high forehead, elaborately plaited hairstyle decorated with combs, and refined facial features, the mask represents ideal female beauty. The mask is worn by a senior member of the women's Sande society whose responsibility it is to prepare Sande girls for their adult roles in society, including marriage and child rearing. The meanings of the mask are complex. It has been shown that the mask can be compared with the chrysalis of a certain African butterfly, with the creases at the base of the mask representing the segments of the chrysalis. Thus, the young woman entering adulthood is like a butterfly emerging from its cocoon. The comparison extends even further, for just as the butterfly feeds on the toxic sap of the milkweed to make itself poisonous to predatory birds, so the medicinal powers of the Sande society is believed to protect the young women from danger. The creases may additionally refer to the concentric waves that radiate outward as the initiate emerges from the river to take her place as a member of the adult community.

**BWAMI ASSOCIATION AMONG THE LEGA.** A ceremony of initiation may also accompany the achievement of other types of membership. Among the Lega people, who live in the dense forests between the headwaters of the Congo River and the great lakes of east Africa, the political system is based on a voluntary association called *bwami*, which comprises six levels or grades. Some 80 percent of all male Lega belong to *bwami*, and all aspire to the highest grade. Women can belong to *bwami* as well, although not at a higher grade than their husbands.

Promotion from one grade of *bwami* to the next takes many years. It is based not only on a candidate's character but also on his or her ability to pay the initiation fees, which increase dramatically with each grade. No candidate for any level of *bwami* can pay the fees without assistance: All must enlist the help of relatives to provide the necessary payment, which may include cowrie shells, goats, wild game, palm oil, clothing, and trade goods. Thus, the ambition to move from one level of *bwami* to the next encourages a harmonious community, for all must stay on good terms with other members of the community if they are to advance **(FIG. 28–8)**.

*Bwami* initiations into advanced grades are held in the plaza at the center of the community in the presence of all members.

**28-8 • LEGA TITLED-ELDER WEARING PRESTIGE HAT**
From Democratic Republic of Congo, 1967. National Museum of African Art, Smithsonian Institution, Washington, D.C.
Eliot Elisofon Photographic Archive (EEPA EECL 2238)

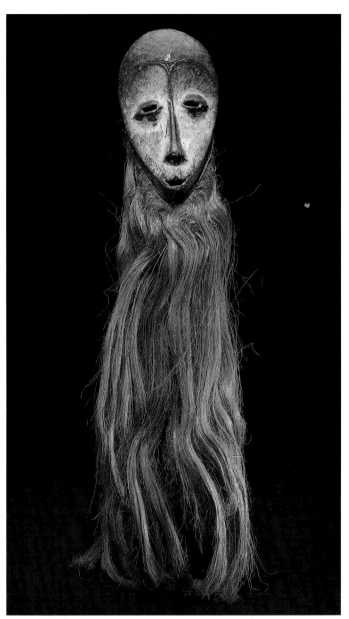

**28-9 • *BWAMI* MASK (*LUKWAKONGO*)**
From Democratic Republic of Congo. 20th century. Wood, plant fiber, and pigment, height 22¾" (57.5 cm). UCLA Fowler Museum of Cultural History, Los Angeles.

Dances and songs are performed, and the values and ideals of the appropriate grade are explained through proverbs and sayings. These standards are illustrated by natural or crafted objects, which are presented to the initiate as signs of membership. At the highest two levels of *bwami*, such objects include exquisitely made small masks and sculpted figures.

The mask in **FIGURE 28–9** is associated with *yananio*, the second-highest grade of *bwami*. Typical of Lega masks, the head is fashioned as an oval into which is carved a concave, heart-shaped face with narrow, raised features. The masks are often colored white with clay and fitted with a long beard made of plant fibers. Too small to cover the face, they are displayed in other ways—held in the palm of a hand, for example, or attached to a thigh. Each

means of display recalls a different value or saying, so that one mask may convey a variety of meanings. Generally, the masks symbolize continuity between the ancestors and the living community and are thought to be direct links to deceased relatives and past members of *bwami*.

**AFRICAN ART CONFRONTING THE WEST.** During the late nineteenth and early twentieth century, Nkanu peoples residing in the Democratic Republic of the Congo and Angola created brightly painted figurative sculpture and decorated wall panels adorned with human and animal figures to celebrate the completion of initiation rites (*nkanda*). These artworks were displayed in a three-sided roofed enclosure, a *kikaku*, which was built at a crossroads near the initiation campground. These displays were made to reinforce the values taught during *nkanda* and to announce to the community that initiation was coming to a close and that their children would soon be home.

The *kikaku* resembled a stage. Wall panels were carved, painted, and attached to its back and sides, and sculpted figures were placed in front of the wall panels on the floor of the structure. The *kikaku* wall panels were accentuated with brightly colored and symbolically charged patterns that conveyed specific meanings

associated with the coming-of-age ritual. European colonial officials were a favorite subject in *kikaku* (**FIG. 28–10**). Their depictions were considered "portraits" of specific individuals, and included distinguishing characteristics such as costume and hairstyle. Nkanu artists seem to have singled out specific colonial officials whom they especially despised for their cruelty or whom they wanted to ridicule because of their dalliances with Nkanu women. These caricatures became a means of confronting colonial domination without openly attacking colonial officials, which would have undoubtedly led to severe repercussions.

In the wall panels here, the central figure represents a colonial administrator. He is flanked by two figures representing Congolese men who are members of the Force Publique, the Belgian colonial military force. One soldier is depicted wearing an ammunition belt, while the other assumes the awkward stance of an initiate who must balance on one leg. Both the stance and the painted patterns on the panels symbolically relate to the virility and procreative capacity of the initiate upon the successful completion of *nkanda*. After the initiation sequence, the *kikaku* and its contents were left to decay. Only a few individual pieces have been acquired by Western museums—there is no extant example of an entire *kikaku* in any museum collection.

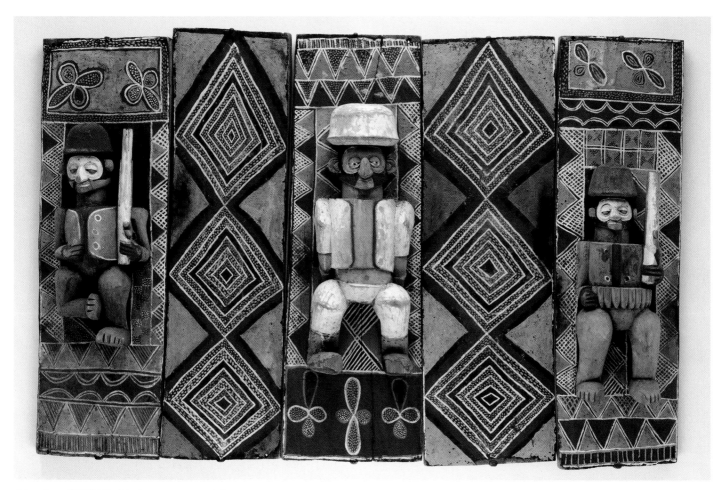

**28-10 • INITIATION WALL PANELS**
From Democratic Republic of the Congo. Nkanu, early 20th century. Wood, pigment, height 33⅜" (84.8 cm).
National Museum of African Art, Smithsonian Institution, Washington, D.C. Museum purchase (99-2-1)

## THE SPIRIT WORLD

While African religious beliefs have been influenced by Christianity and Islam for hundreds of years, many African peoples still rely on traditional customs and belief systems to find the answers to universal human problems. Why does one child fall ill and die while another remains healthy? Why does one year bring rain and a bountiful crop, while the next brings drought and famine? People everywhere confront these fundamental and troubling questions. In many African belief systems it is usually thought that a supreme creator god is not fundamentally involved in the daily lives of humans. Instead, numerous subordinate spirit forces are said to be ever-present and involved in human affairs. For instance, such spirits may inhabit agricultural fields, the river that provides fish, the forest that is home to game, or the land that must be cleared in order to build a new village. Families, too, may acknowledge the existence of ancestral spirits. These spirits control success and failure in life, and if a proper relationship is not maintained with them, harm in the form of illness or misfortune can befall an individual, his family, or the entire community.

To communicate with these all-important spirits, many African societies rely on a specialist, such as a diviner who serves as a link between the supernatural and human worlds, opening the lines of communication through such techniques as prayer, sacrifice, offerings, ritual performance, and divination. Sometimes art plays a role in the diviner's dealings with the spirit world, giving visible identity and personality to what is imaginary and intangible (see "Divination Among the Chokwe," page 892). *Nkisi* are objects that harness spirit forces or powers and are made by the Kongo and Songye peoples of the Democratic Republic of Congo to alleviate illness, protect vulnerable individuals such as children, provide success in hunting, trade, and other endeavors, and serve a divinatory function to seek out wrongdoers and punish them for their misdeeds (see "A Closer Look," page 890). A *nkisi nkonde* is a specific type of *nkisi* and begins its life as an unadorned wooden figure, often in human form, that is purchased from a carver at a market or commissioned by a diviner on behalf of a client who has encountered some adversity. The diviner prescribes medicinal ingredients (*bilongo*), which are taken from the plant, animal, and mineral worlds, and are specific to a client's problem. Each ingredient has a unique role. When *bilongo* are added to the *nkonde* they infuse it with a spirit force and focus the power in a particular direction. The word *nkonde* shares a stem with *konda* ("to hunt") for the figure is quick to hunt down a client's enemies and destroy them. A *nkisi nkonde* may serve many private and public functions. Two warring communities might agree to end their conflict by swearing an oath of peace and then driving a nail into the *nkonde* to seal the agreement, or a mother might invoke the power of the *nkonde* to heal her sick child.

SPIRIT SPOUSE OF THE BAULE. Some African peoples conceive of the spirit world as a parallel realm in which spirits may have families, live in villages, attend markets, and possess personalities complete with faults and virtues. The Baule people in Côte d'Ivoire believe that each of us lived in the spirit world before we were born. While there, we had a spirit spouse, whom we left behind when we entered this life. A person who has difficulty assuming his or her gender-specific role as an adult Baule—a man who has not married or achieved his expected status in life, for example, or a woman who has not borne children—may dream of his or her spirit spouse.

For such a person, the diviner may prescribe the carving of an image of the **SPIRIT SPOUSE** (**FIG. 28–11**). A man has a *blolo bla* (otherworld wife) and a woman has a *blolo bian* (otherworld husband) carved. The figures display the most admired and

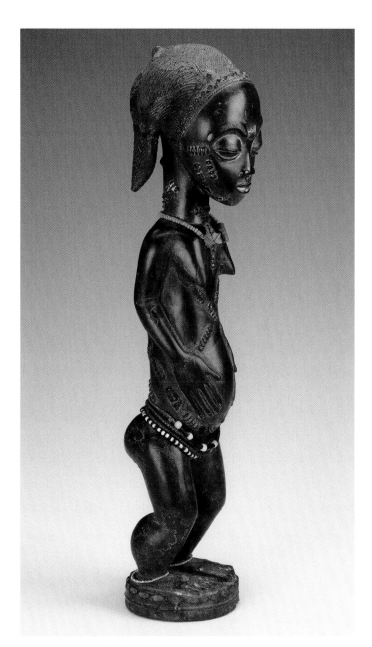

**28-11 • SPIRIT SPOUSE (*BLOLO BLA*)**
From Côte d'Ivoire. Baule culture, early–mid 20th century. Wood, glass beads, gold hollow beads, plant fiber, white pigment, encrustation, height 19¼" (48.9 cm). National Museum of African Art, Smithsonian Institution Washington, D.C. (85-15-2)

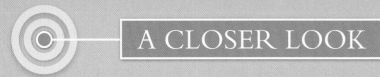
## Kongo *Nkisi Nkonde* ➤

**Power Figure (*Nkisi Nkonde*).**
From the Democratic Republic of Congo. Kongo culture, 19th century. Wood, nails, pins, blades, and other materials, height 44″ (111.7 cm). The Field Museum, Chicago.

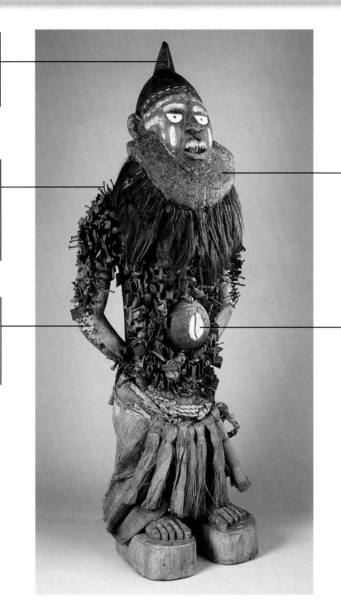

The *bilongo* may be placed on the head of the figure, thought to be an especially appropriate site to communicate with spirit forces.

Clients drive a nail, blade, or other pointed object into the figure to get the *nkonde*'s attention and prick it into action. The large number of objects driven into this *nkonde* suggests that its powers were both formidable and efficacious.

This *nkonde* stands in a pose called *pakalala*, a stance of alertness like that of a wrestler challenging an opponent. Other *nkonde* figures hold a knife or spear in an upraised hand, ready to strike or attack.

*Bilongo* may also be suspended in a packet from the figure's neck or waist or even placed into the figure's beard. The beard is associated with the powers that come with age and seniority.

Additonal *bilongo* are inserted into a body cavity such as the figure's belly, as this is thought to be the seat of a person's life or soul. The term *mooyo* means both "belly" and "life."

SEE MORE: View the Closer Look feature for Kongo *Nkisi Nkonde* **www.myartslab.com**

desirable marks of beauty so that the spirit spouses may be encouraged to enter and inhabit them. Spirit spouse figures are broadly naturalistic, with swelling, fully rounded musculature and careful attention to details of hairstyle, jewelry, and scarification patterns. They may be carved standing in a quiet, dignified pose or seated on a stool. The owner keeps the figure in his or her room, dressing it in beautiful textiles and jewelry, washing it, anointing it with oil, feeding it, and caressing it. Over time, the surface of the figure softens as it takes on a glossy sheen indicating the attention it has been given. The Baule hope that by caring for and pleasing his or her spirit spouse a balance may be restored that will free the individual's human life to unfold smoothly.

**YORUBA DIVINATION.**   While spirit beings are often portrayed in African art, major deities are generally considered to be far removed from the everyday lives of humans and are thus rarely

depicted. Such is the case with Olodumare, the creator god of the Yoruba people of southwestern Nigeria.

The Yoruba have a sizable pantheon of lesser, but still important, gods (*orisha*). Two *orisha* are principal mediators: Orunmila who represents certainty, fate, order, and equilibrium; and his counterpart Eshu who represents uncertainty, disorder, and chance. Commonly represented in art, Eshu is a capricious and mischievous trickster who loves nothing better than to disrupt things that appear to be going well. The opposing forces of order and disorder are mediated through the agency of a diviner (*babalawo*) who employs a divination board (*opon ifa*) and its paraphernalia to reveal the causes of a client's problems **(FIG. 28–12)**. The divination board is sprinkled with a white wood dust

and the *orisha* Orunmila and Eshu are called to the divination by tapping the board with a special tapper. The *babalawo* throws 16 palm nuts and after each toss records the way the palm nuts have landed in the white wood dust on the divination board. Each configuration of the palm nuts relates to particular verses from a complex oral tradition also known as Ifa. As the selected verses are recited by the diviner, the client relates the verses to his or her own particular problems or concerns.

Eshu's image often appears on divination objects and in shrines employed by his worshipers. His image always appears at the top of the divination board, while other images along the edge of the board relate symbolically to the world of Ifa divination. Eshu is associated with two eternal sources of human conflict—sex and money—and is usually portrayed with a long hairstyle: The Yoruba consider long hair to represent excess libidinous energy and unrestrained sexuality. Figures of Eshu are usually adorned with long strands of cowrie shells, a traditional African currency. Shrines to him are erected wherever there is the potential for encounters that lead to conflict, especially at crossroads, in markets, or in front of banks. Eshu's followers hope that their offerings will persuade the god to spare them the pitfalls he places in front of others.

## LEADERSHIP

As in societies throughout the world, art in Africa is used to identify those who hold power, to validate their right to their authority as representatives of the family or community, and to communicate the rules for moral behavior that must be obeyed by all members of the society. The gold-and-wood spokesman's staff shown in FIGURE 28–1 with which this chapter opened is an example of the art of leadership. It belongs to the culture of the Ashanti peoples of Ghana, in west Africa. The Ashanti greatly admire fine language—one of their adages is, "We speak to the wise man in proverbs, not in plain speech"— and consequently their governing system includes the special post of spokesman to the ruler.

The Ashanti use gold not only for objects, such as the staff, that are reserved for the use of rulers, but also for jewelry, as do other peoples of the region. But for the Ashanti, who live in the middle of the richest goldfields of west Africa, gold was long a major source of power; for centuries they traded it, first via intermediaries across the Sahara to the Mediterranean world, then later directly to Europeans on the west African coast.

**28–12 • *IFA* DIVINATION SESSION**
Yoruba culture, Nigeria. National Museum of African Art, Smithsonian Institution, Washington, D.C. Eliot Elisofon Photographic Archives (EEPA 1992-028-02016)

## Divination among the Chokwe

Chokwe peoples of the Democratic Republic of the Congo and Angola consult diviners (*nganga*) about problems such as death, illness, impotence, sterility, and theft. As the mediator between this world and the supernatural, the diviner's role is to ascertain the true meaning and underlying cause of an affliction or misfortune, and whether it is due to a conflict with human protagonists or with spirit forces. The diviner's ability to uncover the cause of a client's problems comes through the agency of powerful spirit forces and the efficacy of divinatory paraphernalia. A Chokwe *nganga*, utilizing a rattle to call the spirits to the divination, begins to shake a shallow covered basket (*ngombo ya kusekula*) containing a variety of natural objects including small antelope horns, seeds, and minerals. The basket also contains a number of carved wooden objects representing humans (in various symbolic poses), animals, and other objects such as small models of masks and masked figures. The objects in the basket are tossed about as the basket is shaken and when finished the cover is removed to reveal the arrangement of the objects as they came to rest inside. The *nganga* interprets the results of multiple tosses to disclose the underlying cause of the client's problem and suggests what steps need to be taken to remedy the situation.

**DIVINATION BASKET (*NGOMBO*)**
Democratic Republic of the Congo and Angola. Chokwe peoples, mid 19th–early 20th century. Plant fiber, seed, stone, horn, shell, bone, metal, feather, camwood, depth 12⅟₁₆″ (30.7 cm). National Museum of African Art, Smithsonian Institution, Washington, D.C. (86-12-17.1)

---

*KENTE* CLOTH.　The Ashanti are also renowned for the beauty of their woven textiles (**kente**) (FIG. 28–13). Weaving was introduced in Ghana sometime during the seventeenth century from neighboring regions of west Africa. The weavers were, traditionally, men. Ashanti weavers work on small, light, horizontal looms that produce long, narrow strips of cloth. They begin by laying out the long warp threads in brightly colored stripes. Today the threads are likely to be rayon. Formerly, however, they were cotton and later silk, which the Ashanti first procured in the seventeenth century by unraveling silk cloth obtained through European trade. Weft threads are woven through the warp to produce complex patterns that are named after the warp-faced patterns or weft designs. The long strips produced by the loom are then cut to size and sewn together to form large rectangles of finished *kente* cloth.

　*Kente* cloth was originally reserved for state regalia. A man wore a single piece, about 6–7 feet by 12–13 feet, wrapped like a toga, with no belt and the right shoulder bare. Women wore two pieces—a skirt and a shawl. The *kente* cloth shown here began with a warp pattern that alternates red, green, and yellow. The pattern is known as *oyokoman ogya da mu* ("there is a fire between two factions of the Oyoko clan") and refers to the civil war that followed the death of the Ashanti king Osei Tutu in about 1730. Traditionally, only the king of the Ashanti was allowed to wear this pattern. Other complex patterns were reserved for the royal family or members of the court.

THE KUBA *NYIM*.　The Kuba people of the Democratic Republic of Congo produce elaborate and sophisticated arts tied to leadership. At the pinnacle of the hierarchy sits the Kuba paramount ruler (*nyim*) whose residence was located approximately in the center of the Kuba region. The current *nyim* can trace his predecessors back to the founding of the kingdom in the seventeenth century. At the installation of a new monarch, a new capital city (*Nsheng*) is built that includes the residence of the *nyim*, his wives, and children, as well as areas for other governmental functions, all surrounded by a high palisade.

**28-13 • *KENTE* CLOTH**
From Ghana. Ashanti culture, 20th century. Silk, 6'10⁹⁄₁₆″ × 4'3⁹⁄₁₆″ (2.09 × 130 m). National Museum of African Art and National Museum of Natural History, Smithsonian Institution, Washington, D.C. Purchased with funds provided by the Smithsonian Collections Acquisition Program, 1983–85 (EJ 10583)

Titled individuals will often lavish elaborate surface decoration on objects that belong to them to indicate their rank and prestige within the political and social hierarchy. This is exemplified in the geometric woven decoration on the walls of royal buildings **(FIG. 28–14)** and decorated mats, and on the intricate carved decoration of wooden drums, boxes, and other objects. It is also seen on the variety of embroidered textiles for men and women and on regalia such as headdresses and jewelry that serve as prestige and festive attire for celebratory occasions. An eagle feather chief (*kum*

**28-14 • DECORATED BUILDING (SLEEPING ROOM FOR *NYIM*) IN THE ROYAL COMPOUND OF THE KUBA *NYIM***
Nsheng, Democratic Republic of the Congo. 1980.

**SEE MORE:** View a simulation of woven decoration on walls **www.myartslab.com**

*apoong*) displays sumptuous adornment at his investiture. Each element of regalia signifies a prerogative of an individual's titled position relative to the position of others within a complicated system of titleholding. Naturally the most extravagant adornment is worn by the paramount ruler, as can be seen in the photograph taken by Eliot Elisofon of the Kuba *nyim* in 1971 **(FIG. 28–15)**. Textile display is also an essential aspect of funeral rituals where textiles are worn at celebratory dances and displayed on the body of the deceased. The textiles are subsequently buried with the deceased, where the Kuba believe an individual remains for a period of time before being reborn.

YORUBA PALACE ART.    The kings of the Yoruba people of Nigeria also manifested their authority and power through the large palaces in which they lived. In a typical palace plan, the principal rooms opened onto a veranda with elaborately carved posts facing a courtyard **(FIG. 28–16)**. Elaborate carving also covered the palace doors. Among the most important Yoruba artists of the early twentieth century was Olowe of Ise (d. 1938), who

28-16 • **VERANDA POSTS BY OLOWE OF ISE INSTALLED IN THE COURTYARD OF THE PALACE OF THE *OGAGA* OF IKERE**
Nigeria, c. 1910–1914. Wood and pigment. Photograph taken in 1964.

**EXPLORE MORE:** Gain insight from a primary source related to Olowe of Ise's veranda posts
**www.myartslab.com**

**28-17 • PALACE DOOR BY OLOWE OF ISE**
From Ise Palace, Nigeria, Yoruba peoples. c. 1904–1910. Wood, pigment, height 81½″ × width 34⅝″ × depth 6¼″ (207 × 88 × 15.9 cm). National Museum of African Art, Smithsonian Institution, Washington, D.C. (88-13-1)

carved doors and veranda posts for the rulers of the Ekiti-Yoruba kingdoms in southwestern Nigeria.

The door panel from the royal palace at Ise (FIG. 28–17) illustrates Olowe's artistry. Its asymmetrical composition combines narrative and symbolic scenes in horizontal rectangular panels. Tall figures carved in profile end in heads facing out to confront the viewer. Their long necks and elaborate hairstyles make them appear even taller, unlike typical Yoruba sculpture which uses short, static figures. The figures are in such high relief that the upper portions are actually carved in the round. The figures move energetically against an underlying decorative pattern, and the entire surface of the doors was painted; only traces of the original colors remain.

This door panel commemorates the *arinjale* (king) of Ise receiving Major W.R. Reeve-Tucker, the first British traveling commissioner for the province, and his entourage. A separate door panel, in a private collection, presents the European entourage. In the second register of this panel, the *arinjale* is portrayed on horseback wearing a conical crown and accompanied by court messengers. A variety of other members of the court, including royal wives who are lifting their breasts (a gesture of generosity and affection performed by elder women), bearers carrying kegs of gunpowder, royal guards, and priests appear in other registers. The bottom register portrays a human sacrifice, with birds pecking at the corpse. Human sacrifice occurred rarely and was usually undertaken to ensure community survival. The two rows of heads on the left side of the panel may represent either ancestors of the *arinjale* or enemies taken in battle.

Olowe seems to have worked from the early 1900s until his death in 1938. Although he was famous throughout Yorubaland and called upon by patrons as distant as 60 miles from his home, few records of his activities remain, and only one European, Philip Allison, wrote of meeting him and watching him work. Allison described Olowe carving the iron-hard African oak "as easily as [he would] a calabash [gourd]."

## DEATH AND ANCESTORS

In the view of many African peoples, death is not an end but a transition—the leaving behind of one phase of life and the beginning of another. Just as ceremonies mark the initiation of young men and women into the community of adults, so too they mark the initiation of the newly dead into the community of spirits. Like the rites of initiation into adulthood, death begins with a separation from the community, in this case the community of the living. A period of isolation and trial follows, during which the newly dead spirit may, for example, journey to the land of ancestors. Finally, the deceased is reintegrated into a community, this time the community of ancestral spirits. The living who preserve the memory of the deceased may appeal to his or her spirit to intercede on their behalf with nature spirits or to prevent the spirits of the dead from using their powers to harm (see "Kuba Funerary Mask," pages 896–897).

# THE OBJECT SPEAKS

## Kuba Funerary Mask

The Kuba people of the Democratic Republic of Congo perform funerary masquerades to honor deceased members of the men's initiation society and high-ranking individuals who belonged to the community council of elders.

In the southern Kuba region, funeral rites for initiated men are often accompanied by the appearance of one or more masquerade figures on the day of interment of the deceased. On these occasions initiation society members, family, and friends of the deceased celebrate the departed's life while mourning his death. In part, funeral rites are elaborate because of the belief that the spirit of the recently deceased (*mwendu*) may bring harm to his family or community if his achievements and status in life are not acknowledged at the funeral. The *mwendu* may be angered for a variety of reasons. Perhaps outstanding debts were not paid and the money or other goods were kept by a family member. Or the deceased had asked for something to be buried with him and this request was not honored. Disrespect is most often shown if the deceased is not given a proper burial, one equal to his rank in life. For an initiated man, a funeral masquerade is mandatory in this region, and members of the community-based men's initiation society show their solidarity with the deceased and his spirit by performing a masquerade at his funeral.

Among the most spectacular masquerades performed in the Kuba region is that of *Ngady mwaash*—the name means literally "female mask." The mask is carved from wood, and attached to a framework covered with cloth and decorated with beads and shells that forms the top, sides, and back of the head. Wooden ears, carved separately, are attached to the sides of the head. The face of the mask presents an exuberant blend of bold geometric patterns composed of contrasting areas of triangles and parallel lines. A triangular-shaped hat, identical to that worn by female diviners, is attached to the mask. The hat signifies that *Ngady mwaash* is invested with the power of nature spirits (*ngesh*) to whom Kuba diviners attribute their extraordinary powers.

The costume for *Ngady mwaash* is composed of a shirt and leggings made from animal hide or cloth, often extensively decorated with painted black-and-white triangles. Small wooden dowels attached to the front of the shirt represent breasts. Although wearing a woman's long embroidered skirt under a short decorated skirt affixed with a belt, *Ngady mwaash* is always performed by a man. Costume accessories include strands of beaded and shell-laden bandoliers that crisscross the

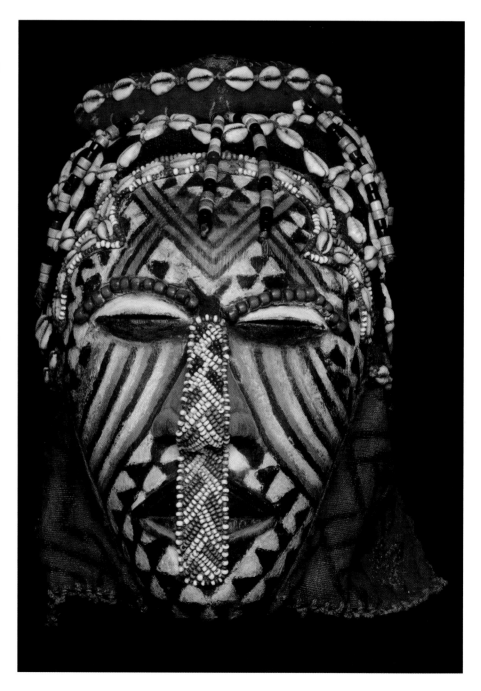

*Ngady mwaash* mask. Democratic Republic of Congo, Kuba peoples. Late 19th–mid 20th century. Wood, pigment glass beads, cowrie shells, fabric, thread, height 12½″ (31.8 cm). The Art Institute of Chicago. (1982.1505)

*Bwoom* masked dancer at the funeral of an initiated man. Democratic Republic of the Congo, Southern Kuba peoples. 1982.

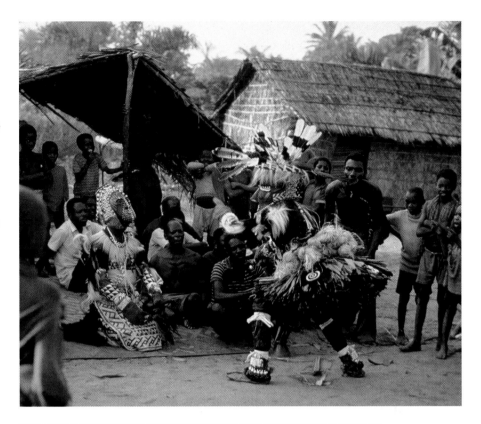

chest and decorated arm- and legbands. The mask, costume, and accessories, as well as the fly whisk that *Ngady mwaash* carries, represent wealth and high status.

The funeral masquerade performance is held near the residence of the man who has died, just prior to burial. The perimeter of the dance ground is lined with family, friends, and onlookers who have come to bid a final farewell to the deceased and witness the performance. *Ngady mwaash* takes turns performing with another masked figure designated as male, such as the masked figure *Bwoom*.

The individual character or persona of male and female masked figures is fully realized during performance. *Bwoom*, who carries a short sword, exudes power and restrained aggression. The dancer employs lunging movements and quick short jabs with his sword, causing onlookers to suspect that he may suddenly lose control and harm someone. This feeling of apprehension is a constituent part of the performance style of *Bwoom*, and is a principal reason why community members look forward to masquerade with such anticipation. In contrast, the performance style of *Ngady mwaash* is decidedly nonthreatening, with graceful movements as the dancer's body, legs, arms, and hands move in fluid gestures. The differences in the performance styles of male and female masquerade figures parallel the difference in the dance styles of men and women in Kuba culture. The men's initiation society, which organizes funeral masquerades, expresses its control and dominance of ritual affairs in part through the contrasting performance styles of *Bwoom* and *Ngady mwaash*.

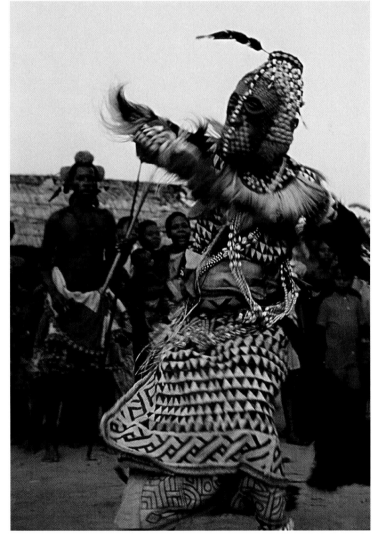

*Ngady mwaash* masked dancer at the funeral of an initiated man. Democratic Republic of the Congo, Southern Kuba peoples. 1982.

**DOGON FUNERARY *DAMA*.** Among the Dogon people of Mali, in west Africa, a collective funeral rite called *dama*, is held every 12 to 13 years **(FIG. 28–18)**. During *dama*, a variety of different masks perform to the sound of gunfire to drive the souls of the deceased from the village. Among the most common masks to perform is the *kanaga*, whose rectangular face supports a superstructure of planks that depict a woman, bird, or lizard with splayed legs.

For a deceased man, men from the community later engage in a mock battle on the roof of his home and participate in ritual hunts; for a deceased woman, the women of the community smash her cooking vessels on the threshold of her home. These portions of *dama* are reminders of human activities the deceased will no longer engage in. The *dama* may last as long as six days and include the performance of hundreds of masks. Because a *dama* is so costly, it is performed for several deceased elders at the same time. However, in certain Dogon communities frequented by tourists, *dama* performances have become more frequent as new masked characters are invented, including masks representing tourists holding wooden cameras or anthropologists holding notebooks in their hands. In response to tourists, Dogon mask-makers produce additional masks that are offered for sale at the conclusion of the performance.

**FANG ANCESTOR GUARDIAN.** The Fang, along with other peoples who live near the Atlantic coast from southern Cameroon through Rio Muni and into Gabon, shared a number of similar institutions and beliefs in which the skulls, bones, and relics of ancestors who had performed great deeds during their lifetimes were collected after burial and placed in a cylindrical bark container (*nsek-bieri*), which was preserved by the family. Deeds thus honored included being victorious in warfare, killing an elephant, being the first to trade with Europeans, bearing an especially large number of children, or founding a particular lineage or community. The bones and relics of deceased family members were thought to have special powers that could be drawn upon to aid the living with problems that confronted or threatened the family. Before colonial officials banned many ritual practices, ancestral spirits represented by the reliquaries were regularly consulted on problems with fertility—failure in conceiving and bringing to term children—or with hunting and farming, or before embarking on a commercial venture.

As a point of focus for mediation between the ancestors and the living, the Fang placed a wooden sculpture called a *bieri* on top of the container holding the relics. These sculptures functioned as

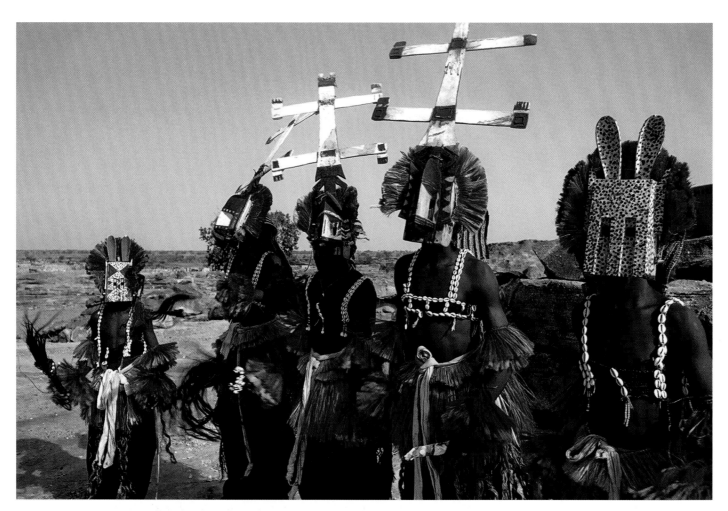

**28–18 • *KANAGA* AND RABBIT MASQUERADE FIGURES AT *DAMA***
Mali. Dogon culture, 1959. National Museum of African Art, Smithsonian Institution, Washington, D.C. Eliot
Elisofon Photographic Archives (EEPA 3502)

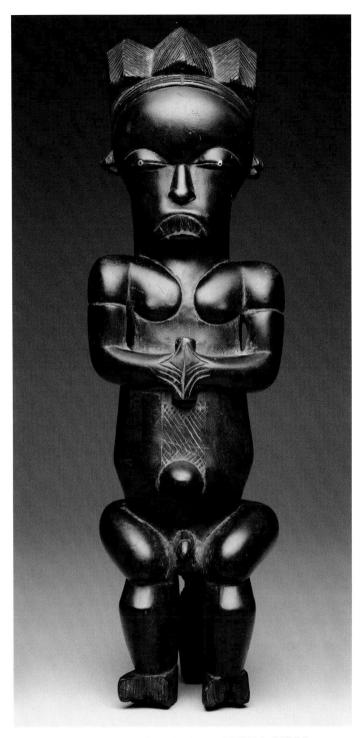

**28–19 • RELIQUARY GUARDIAN (*EYEMA BIERI*)**
From Gabon. Fang people, Mvai group, mid–late 19th century. Wood, metal, and shell, height 21¼″ (53.97 cm). Dallas Museum of Art. The Eugene and Margaret McDermott Art Fund, Inc. (2000.3.MCD)

points of contact for ancestral support and veneration and also as guardians to protect the relics from malevolent spirit forces **(FIG. 28–19)**.

*Bieri* were carved in a number of different forms and styles, including large heads with long necks which were secured into the lid of the container; the container thus represents the body of the ancestors. Other *bieri* were created as full figures in a relatively naturalistic style, with carefully arranged hairstyles, fully rounded torsos, and heavily muscled legs and arms. Both forms are today considered among the great masterpieces of African sculpture. Here, the figure's firmly set jaw and powerfully built, muscular body exudes a sense of authority and confidence. These powerfully realized sculptures were often enhanced by the frequent application of cleansing and purifying palm oil over an extended period of time. This has produced a rich, glossy black surface that may literally excrete oil.

An authority on Fang culture suggests that the Fang strive to achieve a balance between the opposing forces of chaos and order, male and female, pure and impure, powerful and weak. They value an attitude of quiet composure, of reflection and tranquility. These qualities are embodied in the symmetry of the *bieri*, which communicates the calm and wisdom of the ancestor while also instilling awe and fear in those not initiated into the Fang religion.

## CONTEMPORARY ART

The photographs of rituals and ceremonies in this chapter show ways in which African traditional arts have continued during the modern era. All of the photographs are somewhat dated, yet even today performances are staged in which the traditional types of masks appear. Many African communities continue to recreate art forms according to their traditions. But Africa is ever-changing and, as new experiences pose new challenges and offer new opportunities, African art changes over time.

Perhaps the most obvious development in African art has been the adaptation of modern materials to traditional forms. Some Yoruba, for example, have used photographs and children's brightly colored, imported plastic dolls in place of the traditional *ere ibeji*, images of twins, shown in FIGURE 28–4. The Guro people of Côte d'Ivoire continue to commission delicate masks dressed with costly textiles and other materials, but they paint them with brilliantly colored oil-based enamel paints. The Baule create brightly painted versions of spirit-spouse figures dressed as businessmen or soccer players.

Throughout the colonial period and especially during the years following World War II, many African artists trained in the techniques of European art. In the postcolonial era, numerous African artists have studied in Europe and the United States, and many have become known internationally through exhibitions of their work in galleries and museums. Yet the diversity of influences on contemporary Africa makes it impossible to render a homogeneous view of what constitutes contemporary African art. As the art historian and curator Salah Hassan writes: "The development of a modern idiom in African art is closely linked to modern Africa's search for identity. Most contemporary works have apparent ties to traditional African folklore, belief systems and imagery. The only way to interpret or understand these works is in the light of the dual experience of colonialism and assimilation into Western culture in Africa. They reflect the search for a new identity."

**EL ANATSUI OF GHANA.** This search for identity inspired a desire to affirm Africa's rich legacy of tradition-based art in the work of El Anatsui. Born in Ghana in 1944, Anatsui studied art in Kumasi where he took course work he describes as predominantly Western in orientation. He found the emphasis on Western traditions irrelevant, while Ghana's own rich legacy was ignored and, following his own inclinations, he began to study Ghanaian surface design traditions as produced by Ewe and Asante textile artists. In 1975, Anatsui took a position in the Fine Arts Department of the University of Nigeria at Nsukka. There he found a like-minded spirit in Uche Okeke, who was intensely interested in revitalizing *uli*, an important Igbo surface design system. Anatsui began to create what would become a large body of work inspired by *uli* and other graphic systems using tools such as chain saws and blowtorches. More recently, while still concerned with the survival and transmission of inherited traditions, Anatsui began to appropriate cast-off objects he found in and around Nsukka, including broken and discarded mortars, large coconut graters, and liquor-bottle caps, to create revelatory art forms in a variety of media. These include visually stunning, immense wall sculptures that fold and undulate like textiles but are made from metal bottle caps sewn together with copper wire **(FIG. 28–20)**.

Although he lives in Nigeria, El Anatsui, like many contemporary African artists, also participates in international art events—including workshops, symposia, biennial exhibitions, and art festivals that dramatically invigorate our global visual culture. On the other hand, many other African artists have moved permanently to major European and American cities, which offer them increased opportunities for exposure to art dealers, museum curators, art critics, and the expanding base of public and private collectors of African contemporary art.

**AFRICAN ARTISTS IN DIASPORA.** While many African artists are primarily influenced by their own culture and traditions, others—especially some who no longer live on the continent—seem entirely removed from African stylistic influences and yet still express the search for a new African identity in revelatory ways. Their experiences of movement, accommodation, and change often become important elements in their art making and form an additional basis for the interpretation of their work.

Julie Mehretu **(FIG. 28–21)** is an eminent example of this kind of artist. Born in Ethiopia in 1970, but having lived as well in Senegal and the United States, and now in New York City, Mehretu makes large-scale paintings and wall drawings that exude intense

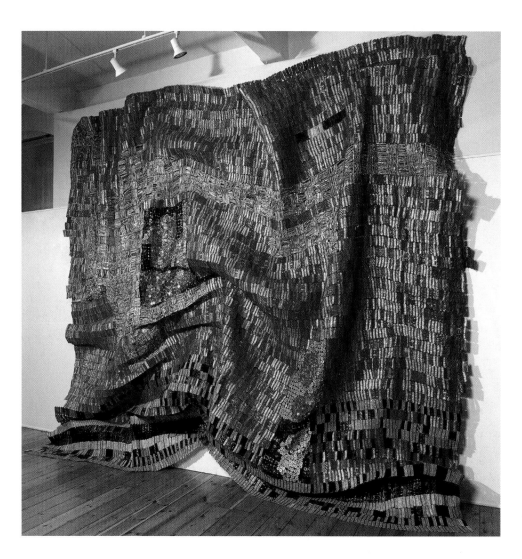

**28-20 • El Anatsui**
**FLAG FOR A NEW WORLD POWER**
2004. Aluminum bottle tops, copper wire, 196 × 177″ (500 × 450 cm). October Gallery, London.

**28–21 • Julie Mehretu DISPERSION**

2002. Ink and acrylic on canvas, 90 × 144″ (228.6 × 365.8 cm). Collection of Nicolas and Jeanne Greenberg Rohatyn, New York

**EXPLORE MORE:** Gain insight from a primary source related to *Dispersion* **www.myartslab.com**

energy. Her works speak not only to her own history of movement and change, but also to the transnational movement of myriad others uprooted by choice or by force as they create new identities in this increasingly turbulent period of globalization and change.

The underpinnings of her intricately layered canvases are architectural plans of airports, passenger terminals, and other places where people congregate and pass through during their lives. Layered and at times obscuring these architectural elements is an immense inventory of signs and markings influenced by cartography, weather maps, Japanese and Chinese calligraphy, tattooing, graffiti, and various stylized forms suggesting smoke and explosions borrowed from cartoons, comic books, and anime. Occasionally architectural details such as arches, stairways, and columns reminiscent of Dürer or Piranesi can also be discerned. The ambiguous reading of the paintings as either implosion and chaos or explosion and regeneration gives the works visual and conceptual complexity. Mehretu explains that she is not interested in describing or mapping specific locations but "in the multi-faceted layers of place, space, and time that impact the formation of personal and communal identity." Mehretu's concerns echo those of other contemporary African artists whose identification with the continent becomes increasingly complex as they move from Africa and enter a global arena.

## THINK ABOUT IT

**28.1** Compare and contrast the ways two African leaders express their power and authority through the visual arts.

**28.2** Explain the use of art during divination rituals and discuss one artwork from the chapter that is used in the practice.

**28.3** Analyze the initiation wall panels shown in FIGURE 28–10 and discuss how the artist addresses the experience of colonialism in the work.

**28.4** Compare and contrast the works of two African-born contemporary artists, El Anatsui's *Flag for a New World Power* and Julie Mehretu's *Dispersion*. Assess what, if anything, about these works ties them to long-standing African traditions, and what, if anything, about them demonstrates influence from external sources, particularly Western sources, including works treated in Chapters 31 and 32.

**28.5** Explain the role of masquerade in African art by analyzing a rite-of-passage ceremony such as the Bwa culture's performance in Burkina Faso or the Kuba funeral ceremony in the Democratic Republic of Congo.

**PRACTICE MORE:** Compose answers to these questions, get flashcards for images and terms, and review chapter material with quizzes **www.myartslab.com**

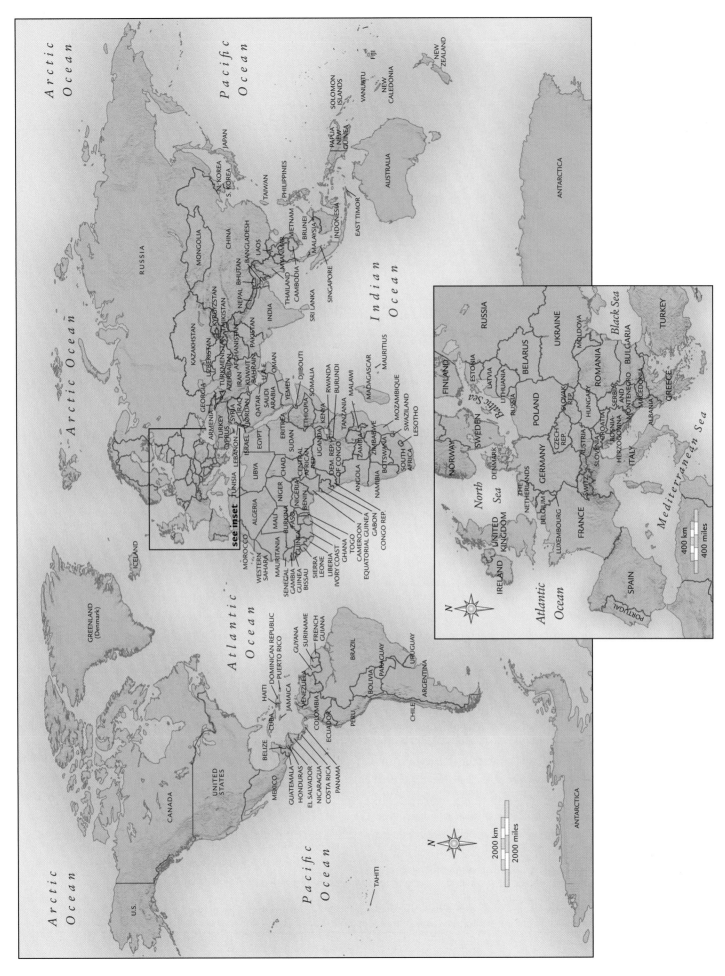

Arctic Ocean

Pacific Ocean

NEW ZEALAND

FIJI

SOLOMON ISLANDS

VANUATU

NEW CALEDONIA

PAPUA NEW GUINEA

AUSTRALIA

N. KOREA
S. KOREA
JAPAN
TAIWAN
PHILIPPINES

EAST TIMOR

VIETNAM
BRUNEI
MALAYSIA
INDONESIA

RUSSIA

MONGOLIA
CHINA

BANGLADESH
BHUTAN
NEPAL
MYANMAR
LAOS
THAILAND
CAMBODIA
SINGAPORE

Indian Ocean

KAZAKHSTAN
UZBEKISTAN
KYRGYZSTAN
TURKMENISTAN
TAJIKISTAN
AZERBAIJAN
AFGHANISTAN
IRAN
PAKISTAN

INDIA
SRI LANKA

GEORGIA
ARMENIA
TURKEY
CYPRUS
SYRIA
LEBANON
ISRAEL
JORDAN
KUWAIT
BAHRAIN
QATAR
SAUDI ARABIA
U.A.E.
OMAN
YEMEN
DJIBOUTI
SOMALIA

EGYPT
LIBYA
SUDAN
ERITREA
ETHIOPIA
UGANDA
KENYA
RWANDA
BURUNDI
TANZANIA
MALAWI
MADAGASCAR
MAURITIUS
MOZAMBIQUE
SWAZILAND
LESOTHO
ZAMBIA
ZIMBABWE
BOTSWANA
SOUTH AFRICA
NAMIBIA
ANGOLA
DEM. REP. OF CONGO
CONGO REP.
GABON
CAMEROON
EQUATORIAL GUINEA
CENTRAL AFRICAN REP.
CHAD
NIGER
NIGERIA
BENIN
TOGO
GHANA
IVORY COAST
LIBERIA
SIERRA LEONE
GUINEA
BISSAU
GUINEA
GAMBIA
SENEGAL
BURKINA FASO
MALI
MAURITANIA
WESTERN SAHARA
MOROCCO
ALGERIA
TUNISIA

see inset

Arctic Ocean

Atlantic Ocean

ICELAND

GREENLAND (Denmark)

CANADA

UNITED STATES

U.S.

MEXICO
BELIZE
GUATEMALA
HONDURAS
EL SALVADOR
NICARAGUA
COSTA RICA
PANAMA

CUBA
JAMAICA
HAITI
DOMINICAN REPUBLIC
PUERTO RICO

COLOMBIA
ECUADOR
VENEZUELA
GUYANA
SURINAME
FRENCH GUIANA

PERU
BRAZIL
BOLIVIA
PARAGUAY
CHILE
ARGENTINA
URUGUAY

TAHITI

Pacific Ocean

ANTARCTICA

ANTARCTICA

N

2000 km
2000 miles

**Inset:**

RUSSIA
FINLAND
NORWAY
SWEDEN
ESTONIA
LATVIA
LITHUANIA
RUSSIA
BELARUS
UKRAINE
MOLDOVA
ROMANIA
BULGARIA
Black Sea
TURKEY
GREECE
MACEDONIA
ALBANIA
SERBIA
MONTENEGRO
BOSNIA-HERZEGOVINA
CROATIA
SLOVENIA
HUNGARY
SLOVAK REP.
AUSTRIA
CZECH REP.
POLAND
Baltic Sea
DENMARK
GERMANY
SWITZ.
ITALY
FRANCE
LUXEMBOURG
BELGIUM
THE NETHERLANDS
UNITED KINGDOM
IRELAND
North Sea
SPAIN
PORTUGAL
Mediterranean Sea
Atlantic Ocean

N

400 km
400 miles

**abacus** (p. 108)   The flat slab at the top of a **capital**, directly under the **entablature**.

**abbey church** (p. 239)   An abbey is a religious community headed by an abbot or abbess. An abbey church often has an especially large choir to provide space for the monks or nuns.

**absolute dating** (p. 12)   A method of assigning a precise historical date to periods and objects, based on known and recorded events in the region, as well as technically extracted physical evidence (such as carbon-14 disintegration). See also **radiometric dating**, **relative dating**.

**abstract, abstraction** (p. 8)   Any art that does not represent observed aspects of nature or transforms visible forms into a stylized image. Also: the **formal** qualities of this process.

**academy** (p. 924)   A place of study, the word coming from the Greek name of a garden near Athens where Plato and, later, Platonic philosophers held discussions. Academies of fine arts, such as the Academy of Drawing or the Royal Academy of Painting, were created to foster the arts by teaching, by discussion, by exhibitions, and occasionally by financial aid.

**acanthus** (p. 110)   A Mediterranean plant whose leaves are reproduced in architectural ornament used on **moldings**, **friezes**, and **Corinthian capitals**.

**acropolis** (p. 129)   The citadel of an ancient Greek city, located at its highest point and housing temples, a treasury, and sometimes a royal palace. The most famous is the Acropolis in Athens.

**acroterion (acroteria)** (p. 110)   An ornament at the corner or peak of a roof.

**adobe** (p. 393)   Sun-baked blocks made of clay mixed with straw. Also: the buildings made with this material.

**aedicula** (p. 609)   A decorative architectural frame, usually found around a niche, door, or window. An aedicula is made up of a **pediment** and **entablature** supported by **columns** or **pilasters**.

**agora** (p. 138)   An open space in a Greek town used as a central gathering place or market. See also **forum**.

**aisle** (p. 228)   Passage or open corridor of a church, hall, or other building that parallels the main space, usually on both sides, and is delineated by a row, or **arcade**, of **columns** or **piers**. Called side aisles when they flank the **nave** of a church.

**album** (p. 795)   A book consisting of a series of painting or prints (album leaves) mounted into book form.

**allegory** (p. 625)   In a work of art, an image (or images) that symbolizes an idea, concept, or principle, often moral or religious.

**alloy** (p. 23)   A mixture of metals; different metals melted together.

**amalaka** (p. 301)   In Hindu architecture, the circular or square-shaped element on top of a spire (**shikhara**), often crowned with a **finial**, symbolizing the cosmos.

**ambulatory** (p. 228)   The passage (walkway) around the **apse** in a **basilican** church or around the central space in a **central-plan building**.

**amphora** (p. 101)   An ancient Greek jar for storing oil or wine, with an egg-shaped body and two curved handles.

**aniconic** (p. 262)   A symbolic representation without images of human figures, very often found in Islamic art.

**animal interlace or style** (p. 427)   Decoration made of interwoven animals or serpents, often found in Celtic and early medieval Northern European art.

**ankh** (p. 51)   A looped cross signifying life, used by ancient Egyptians.

**appropriation** (p. 1102)   Term used to describe the practice of some postmodern artists of adopting images in their entirety from other works of art or from visual culture for use in their own art. The act of recontextualizing the appropriated image allows the artist to critique both it and the time and place in which it was created.

**apse, apsidal** (p. 192)   A large semicircular or polygonal (and usually **vaulted**) niche protruding from the end wall of a building. In the Christian church, it contains the altar. Apsidal is an adjective describing the condition of having such a space.

**arabesque** (p. 263)   A type of linear surface decoration based on foliage and **calligraphic** forms, usually characterized by flowing lines and swirling shapes.

**arcade** (p. 172)   A series of **arches**, carried by **columns** or **piers** and supporting a common wall or **lintel**. In a **blind arcade**, the arches and supports are **engaged** (attached to the wall) and have a decorative function.

**arch** (p. 271)   In architecture, a curved structural element that spans an open space. Built from wedge-shaped stone blocks called **voussoirs**, which, when placed together and held at the top by a trapezoidal **keystone**, form an effective space-spanning and weight-bearing unit. Requires **buttresses** at each side to contain the outward **thrust** caused by the weight of the structure. **Corbel arch** (p. 16): an arch or **vault** formed by **courses** of stones, each of which projects beyond the lower course until the space is enclosed; usually finished with a **capstone**. **Horseshoe arch** (p. 268): an arch of more than a half-circle; typical of western Islamic architecture. **Round arch** (p. 271): arch that displaces most of its weight, or downward thrust along its curving sides, transmitting that weight to adjacent supporting uprights (door or window jambs, columns, or piers). Ogival arch: a pointed arch created by S-curves. Relieving arch: an arch built into a heavy wall just above a **post-and-lintel** structure (such as a gate, door, or window) to help support the wall above by transferring the load to the side walls. **Transverse arch** (p. 457): an arch that connects the wall **piers** on both sides of an interior space, up and over a stone vault.

**Archaic smile** (p. 114)   The curved lips of an ancient Greek statue, usually interpreted as a way of animating facial features.

**architrave** (p. 108)   The bottom element in an **entablature**, beneath the **frieze** and the **cornice**.

**archivolt** (p. 473)   A molded band framing an **arch**, or a series of stone blocks that rest directly on the **columns**.

**ashlar** (p. 99)   Highly finished, precisely cut block of stone. When laid in even courses, ashlar masonry creates a uniform face with fine joints. Often used as a facing on the visible exterior of a building, especially as a veneer for the **façade**. Also called **dressed stone**.

**assemblage** (p. 1026)   Artwork created by gathering and manipulating two- and/or three-dimensional found objects.

**astragal** (p. 110)   A thin convex decorative **molding**, often found on Classical **entablatures**, and usually decorated with a continuous row of beadlike circles.

**atelier** (p. 944)   The studio or workshop of a master artist or craftsperson, often including junior associates and apprentices.

**atmospheric perspective** (p. 562)   See **perspective**.

**atrial cross** (p. 941)   The cross placed in the **atrium** of a church. In Colonial America, used to mark a gathering and teaching place.

**atrium** (p. 160)   An unroofed interior courtyard or room in a Roman house, sometimes having a pool or garden, sometimes surrounded by **columns**. Also: the open courtyard in front of a Christian church; or an entrance area in modern architecture.

**automatism** (p. 1056)   A technique whereby the usual intellectual control of the artist over his or her brush or pencil is foregone. The artist's aim is to allow the subconscious to create the artwork without rational interference.

**avant-garde** (p. 971)   Term derived from the French military word meaning "before the group," or "vanguard." Avant-garde denotes those artists or concepts of a strikingly new, experimental, or radical nature for their time.

**axis** (p. xxxii)   An implied line around which the elements of a picture are organized.

**axis-mundi** (p. 297)   A concept of an "axis of the world," which marks sacred sites and denotes a link between the human and celestial realms. For example, in Buddhist art, the *axis mundi* can be marked by monumental freestanding decorative **pillars**.

**bailey** (p. 473)   The outermost walled courtyard of a castle.

**baldachin** (p. 467)   A canopy (whether suspended from the ceiling, projecting from a wall, or supported by **columns**) placed over an honorific or sacred space such as a throne or church altar.

**bar tracery** (p. 507)   See **tracery**.

**barbarian** (p. 151)   A term used by the ancient Greeks and Romans to label all foreigners outside their cultural orbit (e.g., Celts, Goths, Vikings). The word derives from an imitation of what the "barblings" of their language sounded like to those who could not understand it.

**bargeboards** (p. 870)   Boards covering the rafters at the gable end of a building; bargeboards are often carved or painted.

**barrel vault** (p. 188)   See **vault**.

**base** (p. 110)   Any support. Also: masonry supporting a statue or the shaft of a **column**.

**basilica** (p. 192)   A large rectangular building. Often built with a **clerestory**, side **aisles** separated from the center **nave** by **colonnades**, and an **apse** at one or both ends. Roman centers for administration, later adapted to Christian church use.

**battered** (p. 418)   An architectural design whereby walls are sloped inward toward the top to increase stability.

**bay** (p. 172)   A unit of space defined by architectural elements such as **columns, piers**, and walls.

**beehive tomb** (p. 98)   A **corbel-vaulted** tomb, conical in shape like a beehive, and covered by an earthen mound.

**Benday dots** (p. 1093)   In modern printing and typesetting, the individual dots that, together with many others, make up lettering and images. Often machine- or computer-generated, the dots are very small and closely spaced to give the effect of density and richness of tone.

**bi** (p. 333)   A jade disk with a hole in the center.

**bilum** (p. 863)   Netted bags made mainly by women throughout the central highlands of New Guinea. The bags can be used for everyday purposes or even to carry the bones of the recently deceased as a sign of mourning.

**biomorphic** (p. 1057)   A term used in the early twentieth century to denote the biologically or organically inspired shapes and forms that were routinely included in abstracted Modern art.

**black-figure** (p. 105)   A style or technique of ancient Greek pottery in which black figures are painted on a red clay ground. See also **red-figure**.

**blackware** (p. 853)   A **ceramic** technique that produces pottery with a primarily black surface with **matte** and glossy patterns on the surface.

**blind arcade** (p. 780)   See **arcade**.

**bodhisattva** (p. 297)   In Buddhism, a being who has attained enlightenment but chooses to remain in this world in order to help others advance spiritually. Also defined as a potential Buddha.

**Book of Hours** (p. 547)   A private prayer book, containing a calendar, services for the canonical hours, and sometimes special prayers.

**boss** (p. 554)   A decorative knoblike element that can be found in many places, such as at the intersection of a Gothic **rib vault** or in the buttonlike projections of metalwork.

**bracket, bracketing** (p. 335)   An architectural element that projects from a wall to support a horizontal part of a building, such as beams or the eaves of a roof.

**buon fresco** (p. 87)   See **fresco**.

**burin** (p. 590)   A metal instrument used in **engraving** to cut lines into the metal plate. The sharp end of the burin is trimmed to give a diamond-shaped cutting point, while the other end is finished with a wooden handle that fits into the engraver's palm.

**buttress, buttressing** p. 172)   A projecting support built against an external wall, usually to counteract the lateral **thrust** of a **vault** or **arch** within. In Gothic architecture, a **flying buttress** is an arched bridge above the **aisle** roof that extends from the upper **nave** wall, where the lateral thrust of the main vault is greatest, down to a solid **pier**.

**cairn** (p.17)   A pile of stones or earth and stones that served both as a prehistoric burial site and as a marker of underground tombs.

**calligraphy** (p. 279)   Handwriting as an art form.

**calotype** (p. 968)   The first photographic process utilizing negatives and paper positives. It was invented by William Henry Fox Talbot in the late 1830s.

**calyx krater** (p. 118)   See **krater**.

**came (cames)** (p. 497)   A lead strip used in the making of leaded or **stained-glass windows**. Cames have an indented groove on the sides into which the separate pieces of glass are fitted to hold the composition together.

**cameo** (p. 178)   Gemstone, clay, glass, or shell having layers of color, carved in **low relief** to create an image and ground of different colors.

**camera obscura** (p. 967)   An early cameralike device used in the Renaissance and later for recording images of nature. Made from a dark box (or room) with a hole in one side (sometimes fitted with a lens), the camera obscura operates when bright light shines through the hole, casting an upside-down image of an object outside onto the inside wall of the box.

**canon of proportions** (p. 65)   A set of ideal mathematical ratios in art based on measurements, as in the proportional relationships among the basic elements of the human body.

**canopic jar** (p. 56)   Special jars used to store the major organs of a body before embalming, found in ancient Egyptian culture.

**capital** (p. 110)   The sculpted block that tops a **column**. According to the **conventions** of the **orders**, capitals include different decorative elements. See **order**. A **historiated capital** is one displaying a figural composition of a **narrative** scene.

**capriccio** (p. 912)   A painting or print of a fantastic, imaginary landscape, usually with architecture.

**capstone** (p. 99)   The final, topmost stone in a **corbel arch** or **vault**, which joins the sides and completes the structure.

**cartoon** (p. 497)   A full-scale drawing used to transfer or guide a design onto a surface (such as a wall, canvas, panel, or **tapestry**) to be painted, carved, or woven.

**cartouche** (p. 189)   A frame for a **hieroglyphic** inscription formed by a rope design surrounding an oval space. Used to signify a sacred or honored name. Also: in architecture, a decorative device or plaque, usually with a plain center used for inscriptions or epitaphs.

**caryatid** (p. 107)   A sculpture of a draped female figure acting as a **column** supporting an **entablature**.

**cassone (cassoni)** (p. 616)   An Italian dowry chest often highly decorated with carvings, paintings, **inlaid** designs, and gilt embellishments.

**catacomb** (p. 219)   A subterranean burial ground consisting of tunnels on different levels, having niches for urns and **sarcophagi** and often incorporating rooms (**cubiculae**).

**cathedral** (p. 222)   The principal Christian church in a diocese, the bishop's administrative center and housing his throne (*cathedra*).

**celadon** (p. 352)   A high-fired, transparent glaze of pale bluish-green hue whose principal coloring agent is an oxide of iron. In China and Korea, such glazes typically were applied over a pale gray **stoneware** body, though Chinese potters sometimes applied them over **porcelain** bodies during the Ming (1368–1644) and Qing (1644–1911) dynasties. Chinese potters invented celadon glazes and initiated the continuous production of celadon-glazed wares as early as the third century CE.

**cella** (p. 108)   The principal interior room at the center of a Greek or Roman temple within which the cult statue was usually housed. Also called the **naos**.

**celt** (p. 377)   A smooth, oblong stone or metal object, shaped like an axe-head.

**cenotaph** (p. 771)   A funerary monument commemorating an individual or group buried elsewhere.

**centering** (p. 172)   A temporary structure that supports a masonry **arch** and **vault** or **dome** during construction until the mortar is fully dried and the masonry is self-sustaining.

**central-plan building** (p. 228)   Any structure designed with a primary central space surrounded by symmetrical areas on each side. For example, a **rotunda** or a Greek-cross plan (equal-armed cross).

**ceramics** (p. 22)   A general term covering all types of wares made from fired clay, including **porcelain** and **terra cotta**.

**chacmool** (p. 390)   In Mayan sculpture, a half-reclining figure probably representing an offering bearer.

**chaitya** (p. 302)   A type of Buddhist temple found in India. Built in the form of a hall or **basilica**, a *chaitya* hall is highly decorated with sculpture and usually is carved from a cave or natural rock location. It houses a sacred shrine or **stupa** for worship.

**chamfer** (p. 780)   The slanted surface produced when an angle is trimmed or beveled, common in building and metalwork.

**chasing** (p. 776)   Ornamentation made on metal by **incising** or hammering the surface.

**château (châteaux)** (p. 691)   A French country house or residential castle. A *château fort*, is a military castle incorporating defensive works such as towers and battlements.

**chattri (chattris)** (p. 779)   A decorative pavilion with an umbrella-shaped **dome** in Indian architecture.

**chevron** (p. 350)   A decorative or heraldic motif of repeated Vs; a zigzag pattern.

**chiaroscuro** (p. 634)   An Italian word designating the contrast of dark and light in a painting, drawing, or print. *Chiaroscuro* creates spatial depth and volumetric forms through gradations in the intensity of light and shadow.

**cista (cistae)** (p. 166)   **Cylindrical** containers used by wealthy women as a case for toiletry articles such as a mirror.

**clerestory** (p. 58)   The topmost zone of a wall with windows in a **basilica** extending above the aisle roofs. Provides direct light into the central interior space (the **nave**).

**cloister** (p. 442)   An open space within a monastery, surrounded by an **arcaded** or colonnaded walkway, often having a fountain and garden. The most important monastic buildings (e.g., dormitory, refectory) open off of it. Since members of a cloistered order do not leave the monastery or interact with outsiders, the cloister represents the center of their enclosed world.

**codex (codices)** (p. 243)   A book, or a group of **manuscript** pages (folios), held together by stitching or other binding on one side.

**coffer** (p. 197)   A recessed decorative panel that is used to reduce the weight of and to decorate ceilings or **vaults**. The use of coffers is called coffering.

**coiling** (p. 845)   A technique in basketry. In coiled baskets a spiraling structure is held in place by another material.

**collage** (p. 1026)   A composition made of cut and pasted scraps of materials, sometimes with lines or forms added by the artist.

**colonnade** (p. 69)   A row of **columns**, supporting a straight **lintel** (as in a **porch** or **portico**) or a series of **arches** (an **arcade**).

**colophon** (p. 432)   The data placed at the end of a book listing the book's author, publisher, **illuminator**, and other information related to its production. In East Asian **handscrolls**, the inscriptions which follow the painting are also called colophons.

**column** (p. 110)   An architectural element used for support and/or decoration. Consists of a rounded or polygonal vertical **shaft** placed on a **base** and topped by a decorative **capital**. In Classical architecture, built in accordance with the rules of one of the architectural **orders**. Columns can be free-standing or attached to a background wall (**engaged**).

**combine** (p. 1085)   Combinations of painting and sculpture using nontraditional art materials.

**complementary color** (p. 993)   The primary and secondary colors across from each other on the color wheel (red and green, blue and orange, yellow and purple). When juxtaposed, the intensity of both colors increases. When mixed together, they negate each other to make a neutral gray-brown.

**composite order** (p. 163)   See **order**.

**composite pose** or **image** (p. 9)   Combining different viewpoints within a single representation of a subject.

**composition** (p. xxix)   The overall arrangement, organizing design, or structure of a work of art.

**conch** (p. 234)   A half-**dome**.

**cong** (p. 328)   A square or octagonal jade tube with a cylindrical hole in the center. A symbol of the earth, it was used for ritual worship and astronomical observations in ancient China.

**connoisseurship** (p. 741)   A term derived from the French word connoisseur, meaning "an expert," and signifying the study and evaluation of art based primarily on **formal**, visual, and stylistic analysis. A connoisseur studies the style and technique of an object to assess its relative quality and identify its maker through visual comparison with other works of secure authorship. See also **contextualism**; **formalism**.

**contrapposto** (p. 121)   An Italian term meaning "set against," used to describe the pose that results from setting parts of the body in opposition to each other around a central **axis**.

**convention** (p. 51)   A traditional way of representing forms.

**corbel, corbeling** (p. 16)   An early roofing and arching technique in which each **course** of stone projects slightly beyond the previous layer (a corbel) until the

uppermost corbels meet. Results in a high, almost pointed **arch** or **vault**.

**corbeled vault** (p. 99)   See **vault**.

**Corinthian order** (p. 108)   See **order**.

**cornice** (p. 110)   The uppermost section of a Classical **entablature**. More generally, a horizontally projecting element found at the top of a building wall or **pedestal**. A raking cornice is formed by the junction of two slanted cornices, most often found in **pediments**.

**course** (p. 99)   A horizontal layer of stone used in building.

**crenellation** (p. 44)   Alternating higher and lower sections along the top of a defensive wall, giving a stepped appearance and forming a permanent shield for defenders on top of a fortified building.

**crocket** (p. 585)   A stylized leaf used as decoration along the outer angle of spires, pinnacles, gables, and around **capitals** in Gothic architecture.

**cruciform** (p. 232)   A term describing anything that is cross-shaped, as in the cruciform plan of a church.

**cubiculum (cubicula)** (p. 224)   A small private room for burials in the **catacombs**.

**cuneiform** (p. 28)   An early form of writing with wedge-shaped marks impressed into wet clay with a **stylus**, primarily used by ancient Mesopotamians.

**curtain wall** (p. 1045)   A wall in a building that does not support any of the weight of the structure.

**cyclopean construction** (p. 93)   A method of building using huge blocks of rough-hewn stone. Any large-scale, monumental building project that impresses by sheer size. Named after the Cyclopes (sing. Cyclops) one-eyed giants of legendary strength in Greek myths.

**cylinder seal** (p. 32)   A small cylindrical stone decorated with **incised** patterns. When rolled across soft clay or wax, the resulting raised pattern or design (**relief**) served in Mesopotamian and Indus Valley cultures as an identifying signature.

**dado (dadoes)** (p. 163)   The lower part of a wall, differentiated in some way (by a molding or different coloring or paneling) from the upper section.

**daguerreotype** (p. 967)   An early photographic process that makes a positive print on a light-sensitized copperplate; invented and marketed in 1839 by Louis-Jacques-Mandé Daguerre.

**demotic writing** (p. 77)   The simplified form of ancient Egyptian **hieratic writing**, used primarily for administrative and private texts.

**dendrochronology** (p. xxxvi)   The dating of wood based on the patterns of the growth rings.

**desert varnish** (p. 400)   In southwestern North America, a substance that turned cliff faces into dark surfaces. Neolithic artists would draw images by scraping through the dark surface.

**diptych** (p. 215)   Two panels of equal size (usually decorated with paintings or **reliefs**) hinged together.

**dogu** (p. 356)   Small human figurines made in Japan during the Jomon period. Shaped from clay, the figures have exaggerated expressions and are in contorted poses. They were probably used in religious rituals.

**dolmen** (p. 17)   A prehistoric structure made up of two or more large upright stones supporting a large, flat, horizontal slab or slabs.

**dome** (p. 188)   A rounded **vault**, usually over a circular space. Consists of curved masonry and can vary in shape from hemispherical to bulbous to ovoidal. May use a supporting vertical wall (**drum**), from which the vault springs, and may be crowned by an open space (**oculus**) and/or an exterior **lantern**. When a dome is built over a square space, an intermediate element is required to make the transition to a circular drum. There are two systems: A dome on **pendentives** (spherical triangles) incorporates **arched**, sloping intermediate sections of wall that carry the weight and **thrust** of the dome to

heavily **buttressed** supporting **piers**. A dome on **squinches** uses an arch built into the wall (squinch) in the upper corners of the space to carry the weight of the dome across the corners of the square space below. A half-dome or **conch** may cover a semicircular space.

**domino construction** (p. 1045)   System of building construction introduced by the architect Le Corbusier in which reinforced concrete floor slabs are floated on six free-standing posts placed as if at the positions of the six dots on a domino playing piece.

**Doric order** (p. 108)   See **order**.

**dressed stone** (p. 85)   See **ashlar**.

**drillwork** (p. 190)   The technique of using a drill for the creation of certain effects in sculpture.

**drum** (p. 110)   The wall that supports a **dome**. Also: a segment of the circular **shaft** of a column.

**drypoint** (p. 748)   An **intaglio** printmaking process by which a metal (usually copper) plate is directly inscribed with a pointed instrument (**stylus**). The resulting design of scratched lines is inked, wiped, and printed. Also: the print made by this process.

**earthenware** (p. 22)   A low-fired, opaque **ceramic** ware that is fired in the range of 800 to 900 degrees Celsius. Earthenware employs humble clays that are naturally heat resistant; the finished wares remain porous after firing unless glazed. Earthenware occurs in a range of earth-toned colors, from white and tan to gray and black, with tan predominating.

**earthwork** (p. 1102)   Usually very large scale, outdoor artwork that is produced by altering the natural environment.

**echinus** (p. 110)   A cushionlike circular element found below the **abacus** of a **Doric capital**. Also: a similarly shaped molding (usually with egg-and-dart motifs) underneath the **volutes** of an **Ionic** capital.

**electronic spin resonance** (p. 12)   Method that uses magnetic field and microwave irradiation to date material such as tooth enamel and its surrounding soil.

**elevation** (p. 108)   The arrangement, proportions, and details of any vertical side or face of a building. Also: an architectural drawing showing an exterior or interior wall of a building.

**emblema (emblemata)** (p. 202)   In a **mosaic**, the elaborate central motif on a floor, usually a self-contained unit done in a more refined manner, with smaller **tesserae** of both marble and semiprecious stones.

**embroidery** (p. 484)   Stitches applied on top of an already-woven fabric ground.

**encaustic** (p. 79)   A painting medium using pigments mixed with hot wax.

**engaged column** (p. 173)   A column attached to a wall. See also **column**.

**engraving** (p. 590)   An **intaglio** printmaking process of inscribing an image, design, or letters onto a metal or wood surface from which a print is made. An engraving is usually drawn with a sharp implement (**burin**) directly onto the surface of the plate. Also: the print made from this process.

**entablature** (p. 108)   In the Classical **orders**, the horizontal elements above the **columns** and **capitals**. The entablature consists of, from bottom to top, an **architrave**, a **frieze**, and a **cornice**.

**entasis** (p. 108)   A slight swelling of the **shaft** of a Greek **column**. The optical illusion of entasis makes the column appear from afar to be straight.

**etching** (p. 748)   An **intaglio** printmaking process in which a metal plate is coated with acid-resistant resin and then inscribed with a **stylus** in a design, revealing the plate below. The plate is then immersed in acid, and the design of exposed metal is eaten away by the acid. The resin is removed, leaving the design etched permanently into the metal and the plate ready to be inked, wiped, and printed.

**Eucharist** (p. 222)   The central rite of the Christian Church, from the Greek word "thanksgiving." Also known as the Mass or Holy Communion, it is based on the Last Supper. According to traditional Catholic Christian belief, consecrated bread and wine become the body and blood of Christ; in Protestant belief, bread and wine symbolize the body and blood.

**exedra (exedrae)** (p. 199)   In architecture, a semicircular niche. On a small scale, often used as decoration, whereas larger exedrae can form interior spaces (such as an **apse**).

**expressionism** (p. 151)   Terms describing a work of art in which forms are created primarily to evoke subjective emotions rather than a rational response.

**façade** (p. 52)   The face or front wall of a building.

**faience** (p. 87)   Type of **ceramic** covered with colorful, opaque glazes that form a smooth, impermeable surface. First developed in ancient Egypt.

**fang ding** (p. 328)   A square or rectangular bronze vessel with four legs. The *fang ding* was used for ritual offerings in ancient China during the Shang dynasty.

**femmage** (p. 1101)   From "female" and "**collage**," the incorporation of fabric into painting.

**fête galante** (p. 908)   A subject in painting depicting well-dressed people at leisure in a park or country setting. It is most often associated with eighteenth-century French Rococo painting.

**filigree** (p. 87)   Delicate, lacelike ornamental work.

**fillet** (p. 110)   The flat ridge between the carved out **flutes** of a **column shaft**. See also fluting.

**finial** (p. 308)   A knoblike architectural decoration usually found at the top point of a spire, pinnacle, canopy, or gable. Also found on furniture; also the ornamental top of a staff.

**flutes, fluted** (p. 110)   In architecture, evenly spaced, rounded parallel vertical grooves incised on **shafts** of **columns** or columnar elements (such as **pilasters**).

**flying buttress** (p. 496)   See **buttress**.

**flying gallop** (p. 87)   Animals posed off the ground with legs fully extended backwards and forwards to signify that they are running.

**foreshortening** (p. 119)   The illusion created on a flat surface in which figures and objects appear to recede or project sharply into space. Accomplished according to the rules of perspective.

**formal analysis** (p. xxix)   An exploration of the visual character that artists bring to their works through the expressive use of elements such as line, form, color, and light, and through its overall structure or composition.

**Formalism, formalist** (p. 1073)   An approach to the understanding, appreciation, and valuation of art based almost solely on considerations of form. This approach tends to regard an artwork as independent of its time and place of making. In the 1940s, Formalism was most ardently proposed by critic Clement Greenberg. See also **connoisseurship**.

**forum** (p. 178)   A Roman town center; site of temples and administrative buildings and used as a market or gathering area for the citizens.

**four-iwan mosque** (p. 271)   See **iwan** and **mosque**.

**fresco** (p. 87)   A painting technique in which water-based pigments are applied to a surface of wet plaster (called **buon fresco**). The color is absorbed by the plaster, becoming a permanent part of the wall. **Fresco secco** is created by painting on dried plaster, and the color may flake off. Murals made by both these techniques are called frescoes.

**fresco secco** (p. 87)   See **fresco**.

**frieze** (p. 108)   The middle element of an **entablature**, between the **architrave** and the cornice. Usually decorated with sculpture, painting, or moldings. Also: any continuous flat band with **relief sculpture** or painted decorations.

**frottage** (p. 1056)   A design produced by laying a piece of paper over a textured surface and rubbing with charcoal or other soft medium.

**fusuma** (p. 818)   Sliding doors covered with paper, used in traditional Japanese construction. *Fusuma* are often highly decorated with paintings and colored backgrounds.

**gallery** (p. 236)   In church architecture, the story found above the side **aisles** of a church, usually open to and overlooking the **nave**. Also: in secular architecture, a long room, usually above the ground floor in a private house or a public building used for entertaining, exhibiting pictures, or promenading. Also: a building or hall in which art is displayed or sold. Also: *galleria*.

**garbhagriha** (p. 301)   From the Sanskrit word meaning "womb chamber," a small room or shrine in a Hindu temple containing a holy image.

**genre painting** (p. 712)   A term used to loosely categorize paintings depicting scenes of everyday life, including (among others) domestic interiors, parties, inn scenes, and street scenes.

**geoglyphs** (p. 392)   Earthen designs on a colossal scale, often created in a landscape as if to be seen from an aerial viewpoint.

**gesso** (p. 544)   A ground made from glue, gypsum, and/or chalk forming the ground of a wood panel or the priming layer of a canvas. Provides a smooth surface for painting.

**gilding** (p. 87)   The application of paper-thin **gold leaf** or gold pigment to an object made from another medium (for example, a sculpture or painting). Usually used as a decorative finishing detail.

**giornata (giornate)** (p. 537)   Adopted from the Italian term meaning "a day's work," a giornata is the section of a **fresco** plastered and painted in a single day.

**gold leaf** (p. 47)   Paper-thin sheets of hammered gold that are used in **gilding**. In some cases (such as Byzantine **icons**), also used as a ground for paintings.

**gold foil** (p. 87)   A thin sheet of gold.

**gopura** (p. 775)   The towering gateway to an Indian Hindu temple complex. A temple complex can have several different *gopuras*.

**Grand Manner** (p. 922)   An elevated style of painting popular in the eighteenth century in which the artist looked to the ancients and to the Renaissance for inspiration; for portraits as well as history painting, the artist would adopt the poses, compositions, and attitudes of Renaissance and antique models.

**Grand Tour** (p. 911)   Popular during the eighteenth and nineteenth centuries, an extended tour of cultural sites in France and Italy intended to finish the education of a young upper-class person primarily from Britain or North America.

**granulation** (p. 87)   A technique of decoration in which metal granules, or tiny metal balls, are fused onto a metal surface.

**graphic arts** (p. xxiv)   A term referring to those arts that are drawn or printed and that utilize paper as primary support.

**grattage** (p. 1056)   A pattern created by scraping off layers of paint from a canvas laid over a textured surface. See also **frottage**.

**grid** (p. 64)   A system of regularly spaced horizontally and vertically crossed lines that gives regularity to an architectural plan or in the composition of a work of art. Also: in painting, a grid is used to allow designs to be enlarged or transferred easily.

**grisaille** (p. 538)   A style of monochromatic painting in shades of gray. Also: a painting made in this style.

**groin vault** (p. 188)   See **vault**.

**grozing** (p. 497)   In **stained-glass** windows, chipping away at the edges of a piece of glass to achieve the precise shape needed for inclusion in the composition.

**hall church** (p. 518)   A church with a **nave** and **aisles** of the same height, giving the impression of a large, open hall.

**handscroll** (p. 337)   A long, narrow, horizontal painting or text (or combination thereof) common in Chinese and Japanese art and of a size intended for individual use. A handscroll is stored wrapped tightly around a wooden pin and is unrolled for viewing or reading.

**hanging scroll** (p. 795)   In Chinese and Japanese art, a vertical painting or text mounted within sections of silk. At the top is a semicircular rod; at the bottom is a round dowel. Hanging scrolls are kept rolled and tied except for special occasions, when they are hung for display, contemplation, or commemoration.

**haniwa** (p. 356)   Pottery forms, including cylinders, buildings, and human figures, that were placed on top of Japanese tombs or burial mounds.

**Happening** (p. 1085)   An art form developed by Allan Kaprow in the 1960s incorporating performance, theater, and visual images. A Happening was organized without a specific narrative or intent; with audience participation, the event proceeded according to chance and individual improvisation.

**hemicycle** (p. 508)   A semicircular interior space or structure.

**henge** (p. 18)   A circular area enclosed by stones or wood posts set up by Neolithic peoples. It is usually bounded by a ditch and raised embankment.

**hieratic scale** (p. 27)   The use of different sizes for powerful or holy figures and for ordinary people to indicate relative importance. The larger the figure, the greater the importance.

**hieroglyph** (p. 52)   Picture writing; words and ideas rendered in the form of pictorial symbols.

**high relief** (p. 304)   See **relief sculpture**.

**historiated capital** (p. 479)   See **capital**.

**historicism** (p. 963)   The strong consciousness of and attention to the institutions, themes, styles, and forms of the past, made accessible by historical research, textual study, and archaeology.

**history paintings** (p. 924)   Paintings based on historical, mythological, or biblical narratives. Once considered the noblest form of art, history paintings generally convey a high moral or intellectual idea and are often painted in a grand pictorial style.

**horizon line**   A horizontal "line" formed by the implied meeting point of earth and sky. In **linear perspective**, the **vanishing point** or points are located on this "line."

**horseshoe arch** (p. 268)   See **arch**.

**hue** (p. xxii)   Pure color. The saturation or intensity of the hue depends on the purity of the color. Its value depends on its lightness or darkness.

**hydria** (p. 139)   A large ancient Greek and Roman jar with three handles (horizontal ones at both sides and one vertical at the back), used for storing water.

**hypostyle hall** (p. 66)   A large interior room characterized by many closely spaced columns that support its roof.

**icon** (p. 237)   An image representing a sacred figure or event in the Byzantine, and later in the Orthodox, Church. Icons were venerated by the faithful, who believed them to have miraculous powers to transmit messages to God.

**iconic image** (p. 224)   A picture that expresses or embodies an intangible concept or idea.

**iconoclasm** (p. 245)   The banning or destruction of images, especially **icons** and religious art. Iconoclasm in eighth- and ninth-century Byzantium and sixteenth- and seventeenth-century Protestant territories arose from differing beliefs about the power, meaning, function, and purpose of imagery in religion.

**iconography** (p. xxxiii)   Identifying and studying the subject matter and conventional motifs or symbols in works of art.

**iconology** (p. xxxv)   Interpreting works of art as embodiments of cultural situation by placing them within broad social, political, religious, and intellectual contexts.

**iconophile** (p. 246)   From the Greek for "lovers of images." In Byzantine art, iconophiles advocated for the continued use of **iconic images** in art.

**iconostasis** (p. 245)   The partition screen in a Byzantine or Orthodox church between the **sanctuary** (where the Mass is performed) and the body of the church (where the congregation assembles). The iconostasis displays **icons**.

**idealization** (p. xxiv)   A process in art through which artists strive to make their forms and figures attain perfection, based on pervading cultural values and/or their own personal ideals.

**ideograph** (p. 331)   A written character or symbol representing an idea or object. Many Chinese characters are ideographs.

**ignudi** (p. 645)   Heroic figures of nude young men.

**illumination** (p. 425)   A painting on paper or parchment used as an illustration and/or decoration in **manuscripts** or **albums**. Usually richly colored, often supplemented by gold and other precious materials. The artists are referred to as illuminators. Also: the technique of decorating manuscripts with such paintings.

**impasto** (p. 748)   Thick applications of pigment that give a painting a palpable surface texture.

**impost block** (p. 600)   A block, serving to concentrate the weight above, imposed between the **capital** of a **column** and the springing of an **arch** above.

**incising** (p. 32)   A technique in which a design or inscription is cut into a hard surface with a sharp instrument. Such a surface is said to be incised.

**ink painting** (p. 810)   A monochromatic style of painting developed in China using black ink with gray washes.

**inlay** (p. 30)   To set pieces of a material or materials into a surface to form a design. Also: material used in or decoration formed by this technique.

**installation** (p. 1087)   Contemporary art created for a specific site, especially a gallery or outdoor area, that creates a complete and controlled environment.

**intaglio** (p. 590)   Term used for a technique in which the design is carved out of the surface of an object, such as an **engraved seal** stone. In the **graphic arts**, intaglio includes **engraving**, **etching**, and **drypoint**—all processes in which ink transfers to paper from **incised**, ink-filled lines cut into a metal plate.

**intarsia** (p. 617)   Decoration formed through wood **inlay**.

**intuitive perspective** (p. 184)   See **perspective**.

**Ionic order** (p. 108)   See **order**.

**iwan** (p. 71)   A large, **vaulted** chamber in a **mosque** with a monumental **arched** opening on one side.

**jamb** (p. 473)   In architecture, the vertical element found on both sides of an opening in a wall, and supporting an **arch** or **lintel**.

**japonisme** (p. 994)   A style in French and American nineteenth-century art that was highly influenced by Japanese art, especially prints.

**jasperware** (p. 917)   A fine-grained, unglazed, white **ceramic** developed by Josiah Wedgwood, often colored by metallic oxides with the raised designs remaining white.

**jataka tales** (p. 300)   In Buddhism, stories associated with the previous lives of Shakyamuni, the historical Buddha.

**joggled voussoirs** (p. 272)   Interlocking **voussoirs** in an **arch** or **lintel**, often of contrasting materials for colorful effect.

**joined-block sculpture** (p. 367)   A method of constructing large-scale wooden sculpture developed in

Japan. The entire work is constructed from smaller hollow blocks, each individually carved, and assembled when complete. The joined-block technique allowed the production of larger sculpture, as the multiple joints alleviate the problems of drying and cracking found with sculpture carved from a single block.

**kantharos (p. 117)**   A type of Greek vase or goblet with two large handles and a wide mouth.

**keep (p. 473)**   The innermost and strongest structure or central tower of a medieval castle, sometimes used as living quarters, as well as for defense. Also called a donjon.

**kente (p. 892)**   A woven cloth made by the Ashanti peoples of Africa. Kente cloth is woven in long, narrow pieces in complex and colorful patterns, which are then sewn together.

**key block (p. 826)**   A key block is the master block in the production of a colored **woodblock print**, which requires different blocks for each color. The key block is a flat piece of wood upon which the outlines for the entire design of the print were first drawn on its surface and then all but these outlines were carved away with a knife. These outlines serve as a guide for the accurate **registration** or alignment of the other blocks needed to add colors to specific parts of a print.

**keystone (p. 172)**   The topmost **voussoir** at the center of an **arch**, and the last block to be placed. The pressure of this block holds the arch together. Often of a larger size and/or decorated.

**kiln (p. 22)**   An oven designed to produce enough heat for the baking, or firing, of clay.

**kiva (p. 398)**   A ceremonial enclosure, usually wholly or partly underground, used for ritual purposes by modern Pueblo peoples and Ancestral Puebloans. *Kivas* may be round or square, made of **adobe** or stone, and they usually feature a hearth and a small indentation in the floor behind it.

**kondo (p. 360)**   The main hall inside a Japanese Buddhist temple where the images of Buddha are housed.

**korambo (p. 863)**   A ceremonial or spirit house in Pacific cultures, reserved for the men of a village and used as a meeting place as well as to hide religious artifacts from the uninitiated.

**kore (kourai) (p. 114)**   An Archaic Greek statue of a young woman.

**koru (p. 870)**   A design depicting a curling stalk with a bulb at the end that resembles a young tree fern, and often found in Maori art.

**kouros (kouroi) (p. 114)**   An Archaic Greek statue of a young man or boy.

**kowhaiwhai (p. 870)**   Painted curvilinear patterns often found in Maori art.

**krater (p. 99)**   An ancient Greek vessel for mixing wine and water, with many subtypes that each have a distinctive shape. **Calyx krater**: a bell-shaped vessel with handles near the base that resemble a flower calyx. **Volute krater**: a type of krater with handles shaped like scrolls.

**Kufic (p. 272)**   An ornamental, angular Arabic script.

**kylix (p. 124)**   A shallow Greek cup, used for drinking, with a wide mouth and small handles near the rim.

**lacquer (p. 22)**   A type of hard, glossy surface varnish used on objects in East Asian cultures, made from the sap of the Asian sumac or from shellac, a resinous secretion from the lac insect. Lacquer can be layered and manipulated or combined with pigments and other materials for various decorative effects.

**lakshana (p. 303)**   Term used to designate the thirty-two marks of the historical Buddha. The *lakshana* include, among others, the Buddha's golden body, his long arms, the wheel impressed on his palms and the soles of his feet, and his elongated earlobes.

**lamassu (p. 42)**   Supernatural guardian-protector of ancient Near Eastern palaces and throne rooms, often represented sculpturally as a combination of the bearded head of a man, powerful body of a lion or bull, wings of an eagle, and the horned headdress of a god, usually possessing five legs.

**lancet (p. 502)**   A tall, narrow window crowned by a sharply pointed **arch**, typically found in Gothic architecture.

**lantern (p. 458)**   A turretlike structure situated on a roof, **vault**, or **dome**, with windows that allow light into the space below.

**leythos (lekythoi) (p. 141)**   A slim Greek oil vase with one handle and a narrow mouth.

**linear perspective (p. 593)**   See **perspective**.

**linga shrine (p. 310)**   A place of worship centered on an object or representation in the form of a phallus (the lingam), which symbolizes the power of the Hindu god Shiva.

**lintel (p. 473)**   A horizontal element of any material carried by two or more vertical supports to form an opening.

**literati (p. 337)**   The English word used for the Chinese *wenren* or the Japanese *bunjin*, referring to well educated artists who enjoyed literature, **calligraphy**, and painting as a pastime. Their paintings are termed **literati painting**.

**literati painting (p. 791)**   A style of painting that reflects the taste of the educated class of East Asian intellectuals and scholars. Aspects include an appreciation for the antique, small scale, and an intimate connection between maker and audience.

**lithography (p. 951)**   Process of making a print (lithograph) from a design drawn on a flat stone block with greasy crayon. Ink is applied to the wet stone and adheres only to the greasy areas of the design.

**loggia (p. 532)**   Italian term for a covered open-air **gallery**. Often used as a corridor between buildings or around a courtyard, loggias usually have **arcades** or **colonnades**.

**logosyllabic (p. 385)**   A writing system consisting of both logograms (symbols that represent words) and phonetic signs (symbols that represent sounds, in this case syllables). Cuneiform, Maya, and Japanese are examples of logosyllabic scripts.

**longitudinal-plan building (p. 228)**   Any structure designed with a rectangular shape. If a cross-shaped building, the main arm of the building would be longer then any arms that cross it. For example, **basilicas** or Latin-cross plan churches.

**lost-wax casting (p. 413)**   A method of casting metal, such as bronze, by a process in which a wax mold is covered with clay and plaster, then fired, melting the wax and leaving a hollow form. Molten metal is then poured into the hollow space and slowly cooled. When the hardened clay and plaster exterior shell is removed, a solid metal form remains to be smoothed and polished.

**low relief (p. 39)**   See **relief sculpture**.

**lunette (p. 223)**   A semicircular wall area, framed by an **arch** over a door or window. Can be either plain or decorated.

**lusterware (p. 277)**   **Ceramic** pottery decorated with metallic glazes.

**madrasa (p. 271)**   An Islamic institution of higher learning, where teaching is focused on theology and law.

**maenad (p. 104)**   In ancient Greece, a female devotee of the wine god Dionysos who participated in orgiastic rituals. She is often depicted with swirling drapery to indicate wild movement or dance. (Also called a Bacchante, after Bacchus, the Roman name of Dionysos.)

**majolica (p. 571)**   Pottery painted with a tin glaze that, when fired, gives a lustrous and colorful surface.

**mandala (p. 299)**   An image of the cosmos represented by an arrangement of circles or concentric geometric shapes containing diagrams or images. Used for meditation and contemplation by Buddhists.

**mandapa (p. 301)**   In a Hindu temple, an open hall dedicated to ritual worship.

**mandorla (p. 474)**   Light encircling, or emanating from, the entire figure of a sacred person.

**manuscript (p. 242)**   A handwritten book or document.

**maqsura (p. 268)**   An enclosure in a Muslim **mosque**, near the **mihrab**, designated for dignitaries.

**martyrium (martyria) (p. 237)**   In Christian architecture, a church, chapel, or shrine built over the grave of a martyr or the site of a great miracle.

**mastaba (p. 53)**   A flat-topped, one-story structure with slanted walls over an ancient Egyptian underground tomb.

**matte (p. 571)**   Term describing a smooth surface that is without shine or luster.

**mausoleum (p. 177)**   A monumental building used as a tomb. Named after the tomb of Mausolos erected at Halikarnassos around 350 BCE.

**medallion (p. 225)**   Any round ornament or decoration. Also: a large medal.

**megalith (p. 17)**   A large stone used in prehistoric building. Megalithic architecture employs such stones.

**megaron (p. 93)**   The main hall of a Mycenaean palace or grand house, having a columnar **porch** and a room with central fireplace surrounded by four **columns**.

**memento mori (p. 907)**   From Latin for "remember that you must die." An object, such as a skull or extinguished candle, typically found in a **vanitas** image, symbolizing the transience of life.

**memory image (p. 8)**   An image that relies on the generic shapes and relationships that readily spring to mind at the mention of an object.

**menorah (p. 219)**   A Jewish lamp-stand with seven or nine branches; the nine-branched menorah is used during the celebration of Hanukkah. Representations of the seven-branched menorah, once used in the Temple of Jerusalem, became a symbol of Judaism.

**metope (p. 110)**   The carved or painted rectangular panel between the **triglyphs** of a **Doric frieze**.

**mihrab (p. 261)**   A recess or niche that distinguishes the wall oriented toward Mecca (**qibla**) in a **mosque**.

**millefiori (p. 428)**   A term derived from the Italian for "a thousand flowers" that refers to a glass-making technique in which rods of differently-colored glass are fused in a long bundle that is subsequently sliced to produce disks or beads with small-scale, multicolor patterns.

**minaret (p. 267)**   A tower on or near a **mosque**, varying extensively in form throughout the Islamic world, from which the faithful are called to prayer five times a day.

**minbar (p. 261)**   A high platform or pulpit in a **mosque**.

**miniature (p. 243)**   Anything small. In painting, miniatures may be illustrations within **albums** or **manuscripts** or intimate portraits.

**mirador (p. 275)**   In Spanish and Islamic palace architecture, a very large window or room with windows, and sometimes balconies, providing views to interior courtyards or the exterior landscape.

**mithuna (p. 302)**   The amorous male and female couples in Buddhist sculpture, usually found at the entrance to a sacred building. The *mithuna* symbolize the harmony and fertility of life.

**moai (p. 859)**   Statues found in Polynesia, carved from tufa, a yellowish brown volcanic stone, and depicting the human form. Nearly 1,000 of these statues have been found on the island of Rapa Nui but their significance has been a matter of speculation.

**mobile (p. 1059)**   A sculpture made with parts suspended in such a way that they move in a current of air.

**modeling (p. xxix)** In painting, the process of creating the illusion of three-dimensionality on a two-dimensional surface by use of light and shade. In sculpture, the process of molding a three-dimensional form out of a malleable substance.

**module (p. 341)** A segment or portion of a repeated design. Also: a basic building block.

**molding (p. 315)** A shaped or sculpted strip with varying contours and patterns. Used as decoration on architecture, furniture, frames, and other objects.

**mortise-and-tenon (p. 19)** A method of joining two elements. A projecting pin (tenon) on one element fits snugly into a hole designed for it (mortise) on the other. Such joints are very strong and flexible.

**mosaic (p. 146)** Images formed by small colored stone or glass pieces (**tesserae**), affixed to a hard, stable surface.

**mosque (p. 261)** An edifice used for communal Islamic worship.

**Mozarabic (p. 433)** An eclectic style practiced in Christian medieval Spain while much of the Iberian peninsula was ruled by Muslim dynasties.

**mudra (p. 304)** A symbolic hand gesture in Buddhist art that denotes certain behaviors, actions, or feelings.

**mullion (p. 507)** A slender vertical element or colonnette that divides a window into subsidiary sections.

**muqarna (p. 275)** Small nichelike components stacked in tiers to fill the transition between differing vertical and horizontal planes.

**naos (p. 236)** The principal room in a temple or church. In ancient architecture, the **cella**. In a Byzantine church, the **nave** and **sanctuary**.

**narrative image (p. 224)** A picture that recounts an event drawn from a story, either factual (e.g., biographical) or fictional.

**narthex (p. 222)** The vestibule or entrance **porch** of a church.

**nave (p. 192)** The central space of a **basilica**, two or three stories high and usually flanked by aisles.

**necking (p. 110)** The molding at the top of the **shaft** of the **column**.

**necropolis (p. 53)** A large cemetery or burial area; literally a "city of the dead."

**negative space (p. 120)** Empty space, surrounded and shaped so that it acquires a sense of form or volume.

**nemes headdress (p. 51)** The royal headdress of Egypt.

**niello (p. 87)** A metal technique in which a black sulfur alloy is rubbed into fine lines **engraved** into metal (usually gold or silver). When heated, the **alloy** becomes fused with the surrounding metal and provides contrasting detail.

**nishiki-e (p. 813)** A multicolored and ornate Japanese print.

**oculus (p. 188)** In architecture, a circular opening. Oculi are usually found either as windows or at the apex of a **dome**. When at the top of a dome, an oculus is either open to the sky or covered by a decorative exterior **lantern**.

**odalisque (p. 950)** Turkish word for "harem slave girl" or "concubine."

**ogee (p. 551)** An S-shaped curve. See **arch**.

**oinochoe (p. 128)** A Greek jug used for wine.

**olpe (p. 105)** Any Greek vase or jug without a spout.

**one-point perspective** See **perspective**.

**orant (p. 222)** The representation of a standing figure praying with outstretched and upraised arms.

**oratory (p. 232)** A small chapel.

**order (p. 110)** A system of proportions in Classical architecture that includes every aspect of the building's plan, elevation, and decorative system. **Composite**: a combination of the **Ionic** and the **Corinthian** orders.

The **capital** combines **acanthus** leaves with **volute** scrolls. **Corinthian**: the most ornate of the orders, the Corinthian includes a **base**, a **fluted column shaft** with a capital elaborately decorated with acanthus leaf carvings. Its **entablature** consists of an **architrave** decorated with **moldings**, a **frieze** often containing sculptured **reliefs**, and a **cornice** with dentils. **Doric**: the column shaft of the Doric order can be fluted or smooth-surfaced and has no base. The Doric capital consists of an undecorated **echinus** and **abacus**. The Doric entablature has a plain architrave, a frieze with **metopes** and **triglyphs**, and a simple cornice. **Ionic**: the column of the Ionic order has a base, a fluted shaft, and a capital decorated with volutes. The Ionic entablature consists of an architrave of three panels and moldings, a frieze usually containing sculpted relief ornament, and a cornice with dentils. **Tuscan**: a variation of Doric characterized by a smooth-surfaced column shaft with a base, a plain architrave, and an undecorated frieze. A colossal order is any of the above built on a large scale, rising through several stories in height and often raised from the ground by a **pedestal**.

**orientalism (p. 966)** The fascination with Middle Eastern cultures.

**orthogonal (p. 140)** Any line running back into the represented space of a picture perpendicular to the imagined picture plane. In **linear perspective**, all orthogonals converge at a single **vanishing point** in the picture and are the basis for a **grid** that maps out the internal space of the image. An orthogonal plan is any plan for a building or city that is based exclusively on right angles, such as the grid plan of many major cities.

**pagoda (p. 341)** An East Asian **reliquary** tower built with successively smaller, repeated stories. Each story is usually marked by an elaborate projecting roof.

**painterly (p. xxiv)** A style of painting which emphasizes the techniques and surface effects of brushwork (also color, light, and shade).

**palace complex (p. 41)** A group of buildings used for living and governing by a ruler and his or her supporters, usually fortified.

**palazzo (p. 600)** Italian term for palace, used for any large urban dwelling.

**palmette (p. 139)** A fan-shaped ornament with radiating leaves.

**panel painting** Any painting executed on a wood support. The wood is usually planed to provide a smooth surface. A panel can consist of several boards joined together.

**parapet (p. 138)** A low wall at the edge of a balcony, bridge, roof, or other place from which there is a steep drop, built for safety. A parapet walk is the passageway, usually open, immediately behind the uppermost exterior wall or battlement of a fortified building.

**parchment (p. 243)** A writing surface made from treated skins of animals. Very fine parchment is known as **vellum**.

**parish church (p. 239)** Church where local residents attend regular services.

**parterre (p. 760)** An ornamental, highly regimented flowerbed. An element of the ornate gardens of seventeenth-century palaces and **châteaux**.

**passage grave (p. 17)** A prehistoric tomb under a **cairn**, reached by a long, narrow, slab-lined access passageway or passageways.

**pastel (p. 912)** Dry pigment, chalk, and gum in stick or crayon form. Also: a work of art made with pastels.

**pedestal (p. 107)** A platform or **base** supporting a sculpture or other monument. Also: the block found below the base of a Classical **column** (or **colonnade**), serving to raise the entire element off the ground.

**pediment (p. 108)** A triangular gable found over major architectural elements such as Classical Greek **porticoes**, windows, or doors. Formed by an **entablature** and the ends of a sloping roof or a raking **cornice**. A similar architectural element is often used decoratively above a door or window, sometimes with a curved upper **molding**. A broken pediment is a variation on the traditional pediment, with an open space at the center of the topmost angle and/or the horizontal cornice.

**pendentive (p. 236)** The concave triangular section of a **vault** that forms the transition between a square or polygonal space and the circular **base** of a **dome**.

**peplos (p. 115)** A loose outer garment worn by women of ancient Greece. A cloth rectangle fastened on the shoulders and belted below the bust or at the waist.

**Performance art (p. 1085)** An artwork based on a live, sometimes theatrical performance by the artist.

**peristyle (p. 66)** A surrounding **colonnade** in Greek architecture. A peristyle building is surrounded on the exterior by a colonnade. Also: a peristyle court is an open colonnaded courtyard, often having a pool and garden.

**perspective (p. 184)** A system for representing three-dimensional space on a two-dimensional surface. **Atmospheric perspective**: A method of rendering the effect of spatial distance by subtle variations in color and clarity of representation. **Intuitive perspective**: A method of giving the impression of recession by visual instinct, not by the use of an overall system or program. **Oblique perspective**: An intuitive spatial system in which a building or room is placed with one corner in the picture plane, and the other parts of the structure recede to an imaginary vanishing point on its other side. Oblique perspective is not a comprehensive, mathematical system. **One-point** and multiple-point perspective (also called **linear**, scientific or mathematical perspective): A method of creating the illusion of three-dimensional space on a two-dimensional surface by delineating a horizon line and multiple **orthogonal** lines. These recede to meet at one or more points on the horizon (called **vanishing points**), giving the appearance of spatial depth. Called scientific or mathematical because its use requires some knowledge of geometry and mathematics, as well as optics. **Reverse perspective**: A Byzantine perspective theory in which the orthogonals or rays of sight do not converge on a vanishing point in the picture, but are thought to originate in the viewer's eye in front of the picture. Thus, in reverse perspective the image is constructed with orthogonals that diverge, giving a slightly tipped aspect to objects.

**photomontage (p. 1039)** A photographic work created from many smaller photographs arranged (and often overlapping) in a composition, which is then rephotographed.

**pictograph (p. 331)** A highly stylized depiction serving as a symbol for a person or object. Also: a type of writing utilizing such symbols.

**picture plane (p. 573)** The theoretical plane corresponding with the actual surface of a painting, separating the spatial world evoked in the painting from the spatial world occupied by the viewer.

**picture stone (p. 436)** A medieval northern European memorial stone covered with figural decoration. See also **rune stone**.

**picturesque (p. 917)** A term describing the taste for the familiar, the pleasant, and the agreeable, popular in the eighteenth and nineteenth centuries in Europe. Originally used to describe the "picture like" qualities of some landscape scenes. When contrasted with the **sublime**, the picturesque stood for the interesting but ordinary domestic landscape.

**piece-mold casting (p. 328)** A casting technique in which the mold consists of several sections that are connected during the pouring of molten metal, usually bronze. After the cast form has hardened, the pieces of the mold are disassembled, leaving the completed object.

**pier (p. 266)** A masonry support made up of many stones, or rubble and concrete (in contrast to a column **shaft** which is formed from a single stone or a series of **drums**), often square or rectangular in plan, and capable of carrying very heavy architectural loads.

**pietà** (p. 231)   A devotional subject in Christian religious art. After the Crucifixion the body of Jesus was laid across the lap of his grieving mother, Mary. When others are present the subject is called the Lamentation.

**pietra dura** (p. 781)   Italian for "hard stone." Semiprecious stones selected for color, variation, and cut in shapes to form ornamental designs such as flowers or fruit.

**pietra serena** (p. 600)   A gray Tuscan limestone used in Florence.

**pilaster** (p. 160)   An **engaged column**-like element that is rectangular in format and used for decoration in architecture.

**pilgrimage church** (p. 239)   A site that attracts visitors wishing to venerate **relics** as well as attend services.

**pillar** (p. 219)   In architecture, any large, free-standing vertical element. Usually functions as an important weight-bearing unit in buildings.

**pilotis** (p. 1045)   Free-standing posts.

**pinnacle** (p. 499)   In Gothic architecture, a steep pyramid decorating the top of another element such as a **buttress**. Also: the highest point.

**plate tracery** (p. 502)   See **tracery**.

**plinth** (p. 163)   The slablike base or **pedestal** of a **column**, statue, wall, building, or piece of furniture.

**pluralism** (p. 1106)   A social structure or goal that allows members of diverse ethnic, racial, or other groups to exist peacefully within the society while continuing to practice the customs of their own divergent cultures, thus providing to artists a variety of valid contemporary styles.

**podium** (p. 138)   A raised platform that acts as the foundation for a building, or as a platform for a speaker.

**polychrome, polychromy** (p. 521)   The multicolored painting decoration applied to any part of a building, sculpture, or piece of furniture.

**polyptych** (p. 564)   An altarpiece constructed from multiple panels, sometimes with hinges to allow for movable wings.

**porcelain** (p. 22)   A high-fired, vitrified, translucent, white **ceramic** ware that employs two specific clays—kaolin and petuntse—and is fired in the range of 1,300 to 1,400 degrees Celsius. The relatively high proportion of silica in the body clays renders the finished porcelains translucent. Like **stonewares**, porcelains are glazed to enhance their aesthetic appeal and to aid in keeping them clean. By definition, porcelain is white, though it may be covered with a glaze of bright color or subtle hue. Chinese potters were the first in the world to produce porcelain, which they were able to make as early as the eighth century.

**porch** (p. 108)   The covered entrance on the exterior of a building. With a row of **columns** or **colonnade**, also called a **portico**.

**portal** (p. 39)   A grand entrance, door, or gate, usually to an important public building, and often decorated with sculpture.

**portico** (p. 62)   In architecture, a projecting roof or porch supported by **columns**, often marking an entrance. See also **porch**.

**post-and-lintel** (p. 16)   An architectural system of construction with two or more vertical elements (posts) supporting a horizontal element (**lintel**).

**potassium-argon dating** (p. 12)   Technique used to measure the decay of a radioactive potassium isotope into a stable isotope of argon, and inert gas.

**potsherd** (p. 22)   A broken piece of **ceramic** ware.

**poupou** (p. 871)   A house panel, often carved with designs and found in Pacific cultures.

**Prairie Style** (p. 1046)   Style developed by a group of midwestern architects who worked together using the aesthetic of the Prairie and indigenous prairie plants for landscape design to design mostly domestic homes and small public buildings mostly in the midwest.

**predella** (p. 548)   The base of an altarpiece, often decorated with small scenes that are related in subject to that of the main panel or panels.

**primitivism** (p. 1022)   The borrowing of subjects or forms usually from non-European or prehistoric sources by Western artists. Originally practiced by Western artists as an attempt to infuse their work with the naturalistic and expressive qualities attributed to other cultures, especially colonized cultures.

**pronaos** (p. 108)   The enclosed vestibule of a Greek or Roman temple, found in front of the **cella** and marked by a row of **columns** at the entrance.

**proscenium** (p. 150)   The stage of an ancient Greek or Roman theater. In modern theater, the area of the stage in front of the curtain. Also: the framing **arch** that separates a stage from the audience.

**psalter** (p. 253)   In Jewish and Christian scripture, a book containing the psalms, or songs, attributed to King David.

**psykter** (p. 127)   A Greek vessel with an extended bottom allowing it to float in a larger krater; used to chill wine.

**putto (putti)** (p. 229)   A plump, naked little boy, often winged. In Classical art, called a cupid; in Christian art, a cherub.

**pylon** (p. 66)   A massive gateway formed by a pair of tapering walls of oblong shape. Erected by ancient Egyptians to mark the entrance to a temple complex.

**qibla** (p. 267)   The **mosque** wall oriented toward Mecca indicated by the **mihrab**.

**quatrefoil** (p. 503)   A four-lobed decorative pattern common in Gothic art and architecture.

**quillwork** (p. 845)   A Native American decorative craft technique. The quills of porcupines and bird feathers are dyed and attached to materials in patterns.

**radiometric dating** (p. 12)   A method of dating prehistoric works of art made from organic materials, based on the rate of degeneration of radiocarbons in these materials. See also **relative dating**, **absolute dating**.

**raigo** (p. 372)   A painted image that depicts the Amida Buddha and other Buddhist deities welcoming the soul of a dying worshiper to paradise.

**raku** (p. 821)   A type of **ceramic** pottery made by hand, coated with a thick, dark glaze, and fired at a low heat. The resulting vessels are irregularly shaped and glazed, and are highly prized for use in the Japanese tea ceremony.

**readymade** (p. 1037)   An object from popular or material culture presented without further manipulation as an artwork by the artist.

**red-figure** (p. 118)   A style and technique of ancient Greek vase painting characterized by red clay-colored figures on a black background. (The figures are reserved against a painted ground and details are drawn, not engraved, as in **black-figure style**.)

**register** (p. 30)   A device used in systems of spatial definition. In painting, a register indicates the use of differing groundlines to differentiate layers of space within an image. In sculpture, the placement of self-contained bands of **reliefs** in a vertical arrangement. See **registration marks**.

**registration marks** (p. 826)   In Japanese **woodblock printing**, these were two marks carved on the blocks to indicate proper alignment of the paper during the printing process. In multicolor printing, which used a separate block for each color, these marks were essential for achieving the proper position or registration of the colors.

**relative dating** (p. 12)   See **radiometric dating**.

**relic** (p. 239)   A venerated object associated with a saint or martyr.

**relief sculpture** (p. 5)   A three-dimensional image or design whose flat background surface is carved away to a

certain depth, setting off the figure. Called **high** or **low (bas) relief** depending upon the extent of projection of the image from the background. Called **sunken relief** when the image is carved below the original surface of the background, which is not cut away.

**reliquary** (p. 299)   A container, often made of precious materials, used as a repository to protect and display sacred **relics**.

**repoussé** (p. 87)   A technique of hammering metal from the back to create a protruding image. Elaborate **reliefs** are created with wooden armatures against which the metal sheets are pressed and hammered.

**rhyton** (p. 88)   A vessel in the shape of a figure or an animal, used for drinking or pouring liquids on special occasions.

**rib vault** (p. 495)   See **vault**.

**ridgepole** (p. 16)   A longitudinal timber at the apex of a roof that supports the upper ends of the rafters.

**roof comb** (p. 386)   In a Mayan building, a masonry wall along the apex of a roof that is built above the level of the roof proper. Roof combs support the highly decorated false façades that rise above the height of the building at the front.

**rosettes** (p. 105)   A round or oval ornament resembling a rose.

**rotunda** (p. 197)   Any building (or part thereof) constructed in a circular (or sometimes polygonal) shape, usually producing a large open space crowned by a **dome**.

**round arch** (p. 172)   See **arch**.

**roundel** (p. 160)   Any element with a circular format, often placed as a decoration on the exterior of architecture.

**rune stone** (p. 436)   A stone used in early medieval northern Europe as a commemorative monument, which is carved or inscribed with runes, a writing system used by early Germanic peoples.

**rustication** (p. 600)   In building, the rough, irregular, and unfinished effect deliberately given to the exterior facing of a stone edifice. Rusticated stones are often large and used for decorative emphasis around doors or windows, or across the entire lower floors of a building. Also, masonry construction with conspicuous, often beveled joints.

**salon** (p. 905)   A large room for entertaining guests; a periodic social or intellectual gathering, often of prominent people; a hall or **gallery** for exhibiting works of art.

**sanctuary** (p. 102)   A sacred or holy enclosure used for worship. In ancient Greece and Rome, consisted of one or more temples and an altar. In Christian architecture, the space around the altar in a church called the chancel or presbytery.

**sarcophagus** (p. 49)   A stone coffin. Often rectangular and decorated with **relief sculpture**.

**scarab** (p. 51)   In Egypt, a stylized dung beetle associated with the sun and the god Amun.

**scarification** (p. 403)   Ornamental decoration applied to the surface of the body by cutting the skin for cultural and/or aesthetic reasons.

**school of artists** (p. 281)   An art historical term describing a group of artists, usually working at the same time and sharing similar styles, influences, and ideals. The artists in a particular school may not necessarily be directly associated with one another, unlike those in a workshop or **atelier**.

**scribe** (p. 242)   A writer; a person who copies texts.

**scriptorium (scriptoria)** (p. 242)   A room in a monastery for writing or copying **manuscripts**.

**scroll painting** (p. 243)   A painting executed on a rolled support. Rollers at each end permit the horizontal scroll to be unrolled as it is studied or the vertical scroll to be hung for contemplation or decoration.

**sculpture in the round** (p. 5)   Three-dimensional sculpture that is carved free of any background or block.

**seals** (p. 338)   Personal emblems usually carved of stone in **intaglio** or **relief** and used to stamp a name or legend onto paper or silk. In China, they traditionally employ the archaic characters appropriately known as "seal script," of the Zhou or Qin. Cut in stone, a seal may state a formal given name, or it may state any of the numerous personal names that China's painters and writers adopted throughout their lives. A treasured work of art often bears not only the seal of its maker but also those of collectors and admirers through the centuries. In the Chinese view, these do not disfigure the work but add another layer of interest.

**serdab** (p. 53)   In Egyptian tombs, the small room in which the *ka* statue was placed.

**sfumato** (p. 634)   Italian term meaning "smoky," soft, and mellow. In painting, the effect of haze in an image. Resembling the color of the atmosphere at dusk, *sfumato* gives a smoky effect.

**sgraffito** (p. 602)   Decoration made by **incising** or cutting away a surface layer of material to reveal a different color beneath.

**shaft** (p. 110)   The main vertical section of a **column** between the **capital** and the **base**, usually circular in cross section.

**shaft grave** (p. 98)   A deep pit used for burial.

**shikhara** (p. 301)   In the architecture of northern India, a conical (or pyramidal) spire found atop a Hindu temple and often crowned with an **amalaka**.

**shoin** (p. 819)   A term used to describe the various features found in the most formal room of upper-class Japanese residential architecture.

**shoji** (p. 819)   A standing Japanese screen covered in translucent rice paper and used in interiors.

**siapo** (p. 874)   A type of **tapa** cloth found in Samoa and still used as an important gift for ceremonial occasions.

**silkscreen printing** (p. 1091)   A technique of printing in which paint or ink is pressed through a stencil and specially prepared cloth to produce a previously designed image. Also called serigraphy.

**sinopia (sinopie)** (p. 537)   Italian word taken from "Sinope," the ancient city in Asia Minor that was famous for its red-brick pigment. In **fresco** paintings, a full-sized, preliminary sketch done in this color on the first rough coat of plaster or *arriccio*.

**site-specific sculpture** (p. 1102)   A sculpture commissioned and/or designed for a particular location.

**slip** (p. 120)   A mixture of clay and water applied to a ceramic object as a final decorative coat. Also: a solution that binds different parts of a vessel together, such as the handle and the main body.

**spandrel** (p. 172)   The area of wall adjoining the exterior curve of an **arch** between its springing and the **keystone**, or the area between two arches, as in an **arcade**.

**spolia** (p. 465)   Latin for "hide stripped from an animal." Term used for fragments of older architecture or sculpture reused in a secondary context.

**springing** (p. 172)   The point at which the curve of an **arch** or **vault** meets with and rises from its support.

**squinch** (p. 236)   An **arch** or **lintel** built across the upper corners of a square space, allowing a circular or polygonal dome to be more securely set above the walls.

**stained glass** (p. 464)   Molten glass stained with color using metallic oxides. Stained glass is most often used in windows, for which small pieces of different colors are precisely cut and assembled into a design, held together by lead **cames**. Additional details may be added with vitreous paint.

**stave church** (p. 436)   A Scandinavian wooden structure with four huge timbers (staves) at its core.

**stele (stelae)** (p. 27)   A stone slab placed vertically and decorated with inscriptions or reliefs. Used as a grave marker or memorial.

**stereobate** (p. 110)   A foundation upon which a Classical temple stands.

**still life** (p. xxxv)   A type of painting that has as its subject inanimate objects (such as food, dishes, fruit, or flowers).

**stoa** (p. 107)   In Greek architecture, a long roofed walk-way, usually having **columns** on one long side and a wall on the other.

**stoneware** (p. 22)   A high-fired, vitrified, but opaque **ceramic** ware that is fired in the range of 1,100 to 1,200 degrees Celsius. At that temperature, particles of silica in the clay bodies fuse together so that the finished vessels are impervious to liquids, even without glaze. Stoneware pieces are glazed to enhance their aesthetic appeal and to aid in keeping them clean (since unglazed ceramics are easily soiled). Stoneware occurs in a range of earth-toned colors, from white and tan to gray and black, with light gray predominating. Chinese potters were the first in the world to produce stoneware, which they were able to make as early as the Shang dynasty.

**stringcourse** (p. 499)   A continuous horizontal band, such as a **molding**, decorating the face of a wall.

**studiolo** (p. 617)   A room for private conversation and the collection of fine books and art objects. Also known as a study.

**stupa** (p. 298)   In Buddhist architecture, a bell-shaped or pyramidal religious monument, made of piled earth or stone, and containing sacred **relics**.

**stylobate** (p. 110)   In Classical architecture, the stone foundation on which a temple **colonnade** stands.

**stylus** (p. 28)   An instrument with a pointed end (used for writing and printmaking), which makes a delicate line or scratch. Also: a special writing tool for **cuneiform** writing with one pointed end and one triangular.

**sublime** (p. 955)   djective describing a concept, thing, or state of greatness or vastness with high spiritual, moral, intellectual or emotional value; or something awe-inspiring. The sublime was a goal to which many nineteenth-century artists aspired in their artworks.

**sunken relief** (p. 71)   See **relief sculpture**.

**symposium** (p. 118)   An elite gathering of wealthy and powerful men in ancient Greece that focused principally on wine, music, poetry, conversation, games, and love making.

**syncretism** (p. 222)   A process whereby artists assimilate images and ideas from other traditions or cultures and give them new meanings.

**taotie** (p. 328)   A mask with a dragon or animal-like face common as a decorative motif in Chinese art.

**tapa** (p. 874)   A type of cloth used for various purposes in Pacific cultures, made from tree bark stripped and beaten, and often bearing subtle designs from the mallets used to work the bark.

**tapestry** (p. 484)   Multicolored pictorial or decorative weaving meant to be hung on a wall or placed on furniture. Pictorial or decorative motifs are woven directly into the fabric of the cloth itself.

**tatami** (p. 819)   Mats of woven straw used in Japanese houses as a floor covering.

**tempera** (p. 141)   A painting medium made by blending egg yolks with water, pigments, and occasionally other materials, such as glue.

**tenebrism** (p. 724)   The use of strong **chiaroscuro** and artificially illuminated areas to create a dramatic contrast of light and dark in a painting.

**terra cotta** (p. 114)   A medium made from clay fired over a low heat and sometimes left unglazed. Also: the orange-brown color typical of this medium.

**tessera (tesserae)** (p. 146)   The small piece of stone, glass, or other object that is pieced together with many others to create a **mosaic**.

**tetrarchy** (p. 204)   Four-man rule, as in the late Roman Empire, when four emperors shared power.

**thatch** (p. 17)   Plant material such as reeds or straw tied over a framework of poles.

**thermo-luminescence dating** (p. 12)   A technique that measures the irradiation of the crystal structure of material such as flint or pottery and the soil in which it is found, determined by luminescence produced when a sample is heated.

**tholos** (p. 138)   A small, round building. Sometimes built underground, as in a Mycenaean tomb.

**tholos tomb** (p. 98)   See **tholos**.

**thrust** (p. 172)   The outward pressure caused by the weight of a **vault** and supported by **buttressing**. See **arch**.

**tierceron** (p. 554)   In vault construction, a secondary rib that arcs from a **springing** point to the rib that runs lengthwise through the **vault**, called the ridge rib.

**tondo** (p. 128)   A painting or **relief sculpture** of circular shape.

**torana** (p. 300)   In Indian architecture, an ornamented gateway **arch** in a temple, usually leading to the **stupa**.

**torc** (p. 151)   A circular neck ring worn by Celtic warriors.

**toron** (p. 417)   In West African **mosque** architecture, the wooden beams that project from the walls. Torons are used as support for the scaffolding erected annually for the replastering of the building.

**tracery** (p. 502)   Stonework or woodwork applied to wall surfaces or filling the open space of windows. In **plate tracery**, openings are cut through the wall. In **bar tracery**, **mullions** divide the space into vertical segments and form decorative patterns at the top of the opening or panel.

**transept** (p. 228)   The arm of a **cruciform** church, perpendicular to the **nave**. The point where the nave and transept cross is called the crossing. Beyond the crossing lies the **sanctuary**, whether **apse**, choir, or chevet.

**transverse arch** (p. 457)   An **arch** that connects the wall **piers** on both sides of an interior space, up and over a stone **vault**.

**trefoil** (p. 294)   An ornamental design made up of three rounded lobes placed adjacent to one another.

**triforium** (p. 502)   The element of the interior elevation of a church, found directly below the **clerestory** and consisting of a series of **arched** openings. The triforium can be made up of openings from a narrow wall passageway, or it can be attached directly to the wall.

**triglyph** (p. 110)   Rectangular block between the **metopes** of a **Doric frieze**. Identified by the three carved vertical grooves, which approximate the appearance of the end of a wooden beam.

**triptych** (p. 564)   An artwork made up of three panels. The panels may be hinged together so the side segments (wings) fold over the central area.

**trompe l'oeil** (p. 617)   A manner of representation in which the appearance of natural space and objects is re-created with the express intention of fooling the eye of the viewer, who may be convinced that the subject actually exists as three-dimensional reality.

**trumeau** (p. 473)   A **column**, **pier**, or post found at the center of a large **portal** or doorway, supporting the **lintel**.

**tugra** (p. 284)   A **calligraphic** imperial monogram used in Ottoman courts.

**tukutuku** (p. 871)   Lattice panels created by women from the Maori culture and used in architecture.

**Tuscan order** (p. 161)   See **order**.

**twining** (p. 845)   A basketry technique in which short rods are sewn together vertically. The panels are then joined together to form a vessel.

**tympanum (p. 473)** In Classical architecture, the vertical panel of the **pediment**. In medieval and later architecture, the area over a door enclosed by an **arch** and a **lintel**, often decorated with sculpture or **mosaic**.

**ukiyo-e (p. 994)** A Japanese term for a type of popular art that was favored from the sixteenth century, particularly in the form of color **woodblock prints**. *Ukiyo-e* prints often depicted the world of the common people in Japan, such as courtesans and actors, as well as landscapes and myths.

**undercutting (p. 214)** A technique in sculpture by which the material is cut back under the edges so that the remaining form projects strongly forward, casting deep shadows.

**underglaze (p. 799)** Color or decoration applied to a ceramic piece before glazing.

**upeti (p. 874)** A carved wooden design tablet, used to create patterns in cloth by dragging the fabric across it, and found in Pacific cultures.

**urna (p. 303)** In Buddhist art, the curl of hair on the forehead that is a characteristic mark of a buddha. The *urna* is a symbol of divine wisdom.

**ushnisha (p. 303)** In Asian art, a round turban or tiara symbolizing royalty and, when worn by a buddha, enlightenment.

**vanishing point (p. 608)** In a **perspective** system, the point on the **horizon line** at which orthogonals meet. A complex system can have multiple vanishing points.

**vanitas (p. 751)** An image, especially popular in Europe during the seventeenth century, in which all the objects symbolize the transience of life. *Vanitas* paintings are usually of still lifes or genre subjects.

**vault (p. 17)** An arched masonry structure that spans an interior space. **Barrel** or tunnel vault: an elongated or continuous semicircular vault, shaped like a half-cylinder.

**Corbeled vault**: a vault made by projecting **courses** of stone. **Groin** or cross vault: a vault created by the intersection of two barrel vaults of equal size which creates four side compartments of identical size and shape. Quadrant or half-barrel vault: as the name suggests a half-barrel vault. **Rib vault**: ribs (extra masonry) demarcate the junctions of a groin vault. Ribs may function to reinforce the groins or may be purely decorative. See also **corbeling**.

**veduta (p. 913)** Italian for "vista" or "view." Paintings, drawings, or prints often of expansive city scenes or of harbors.

**vellum (p. 243)** A fine animal skin prepared for writing and painting. See also **parchment**.

**verism (p. 170)** style in which artists concern themselves with describing the exterior likeness of an object or person, usually by rendering its visible details in a finely executed, meticulous manner.

**vihara (p. 301)** From the Sanskrit term meaning "for wanderers." A *vihara* is, in general, a Buddhist monastery in India. It also signifies monks' cells and gathering places in such a monastery.

**volute (p. 110)** A spiral scroll, as seen on an **Ionic capital**.

**votive figure (p. 31)** An image created as a devotional offering to a god or other deity.

**voussoir (p. 172)** The oblong, wedge-shaped stone blocks used to build an arch. The topmost voussoir is called a **keystone**.

**warp (p. 286)** The vertical threads in a weaver's loom. Warp threads make up a fixed framework that provides the structure for the entire piece of cloth, and are thus often thicker than weft threads. See also **weft**.

**wattle and daub (p. 17)** A wall construction method combining upright branches, woven with twigs (wattles) and plastered or filled with clay or mud (daub).

**weft (p. 286)** The horizontal threads in a woven piece of cloth. Weft threads are woven at right angles to and through the warp threads to make up the bulk of the decorative pattern. In carpets, the weft is often completely covered or formed by the rows of trimmed knots that form the carpet's soft surface. See also **warp**.

**westwork (p. 439)** The monumental, west-facing entrance section of a Carolignian, Ottonian, or Romanesque church. The exterior consists of multiple stories between two towers; the interior includes an entrance vestibule, a chapel, and a series of **galleries** overlooking the nave.

**white-ground (p. 141)** A type of ancient Greek pottery in which the background color of the object was painted with a **slip** that turns white in the firing process. Figures and details were added by painting on or **incising** into this slip. White-ground wares were popular in the Classical period as funerary objects.

**woodblock print (p. 589)** A print made from one or more carved wooden blocks. In Japan, woodblock prints were made using multiple blocks carved in **relief**, usually with a block for each color in the finished print. See also **woodcut**.

**woodcut (p. 590)** A type of print made by carving a design into a wooden block. The ink is applied to the block with a roller. As the ink remains only on the raised areas between the carved-away lines, these carved-away areas and lines provide the white areas of the print. Also: the process by which the woodcut is made.

**yaksha, yakshi (p. 296)** The male (*yaksha*) and female (*yakshi*) nature spirits that act as agents of the Hindu gods. Their sculpted images are often found on Hindu temples and other sacred places, particularly at the entrances.

**ziggurat (p. 28)** In Mesopotamia, a tall stepped tower of earthen materials, often supporting a shrine.

Susan V. Craig, updated by Carrie L. McDade

This bibliography is composed of books in English that are appropriate "further reading" titles. Most items on this list are available in good libraries, whether college, university, or public institutions. Recently published works have been emphasized so that the research information would be current. There are three classifications of listings: general surveys and art history reference tools, including journals and Internet directories; surveys of large periods that encompass multiple chapters (ancient art in the Western tradition, European medieval art, European Renaissance through eighteenth-century art, modern art in the West, Asian art, and African and Oceanic art, and art of the Americas); and books for individual Chapters 1 through 32.

## General Art History Surveys and Reference Tools

Adams, Laurie Schneider. *Art across Time.* 4th ed. New York: McGraw-Hill, 2011.

Barnet, Sylvan. *A Short Guide to Writing about Art.* 10th ed. Upper Saddle River, NJ: Pearson/Prentice Hall, 2010.

Bony, Anne. *Design: History, Main Trends, Main Figures.* Edinburgh: Chambers, 2005.

Boström, Antonia. *Encyclopedia of Sculpture.* 3 vols. New York: Fitzroy Dearborn, 2004.

Broude, Norma, and Mary D. Garrard, eds. *Feminism and Art History: Questioning the Litany.* Icon Editions. New York: Harper & Row, 1982.

Chadwick, Whitney. *Women, Art, and Society.* 4th ed. New York: Thames & Hudson, 2007.

Chilvers, Ian, ed. *The Oxford Dictionary of Art.* 4th ed. New York: Oxford Univ. Press, 2009.

Curl, James Stevens. *A Dictionary of Architecture and Landscape Architecture.* 2nd ed. Oxford: Oxford Univ. Press, 2006.

Davies, Penelope J. E., et al. *Janson's History of Art: The Western Tradition.* 8th ed. Upper Saddle River, NJ: Prentice Hall, 2010.

*The Dictionary of Art.* Ed. Jane Turner. 34 vols. New York: Grove's Dictionaries, 1996.

*Encyclopedia of World Art.* 17 vols. New York: McGraw-Hill, 1959–84.

Frank, Patrick, Duane Preble, and Sarah Preble. *Prebles' Artforms.* 10th ed. Upper Saddle River, NJ: Pearson/Prentice Hall, 2008.

Gaze, Delia, ed. *Dictionary of Women Artists.* 2 vols. London: Fitzroy Dearborn, 1997.

Griffiths, Antony. *Prints and Printmaking: An Introduction to the History and Techniques.* 2nd ed. London: British Museum Press, 1996.

Hadden, Peggy. *The Quotable Artist.* New York: Allworth Press, 2002.

Hall, James. *Dictionary of Subjects and Symbols in Art.* 2nd ed. Boulder, CO: Westview Press, 2008.

Holt, Elizabeth Gilmore, ed. *A Documentary History of Art.* 3 vols. New Haven: Yale Univ. Press, 1986.

Honour, Hugh, and John Fleming. *The Visual Arts: A History.* 7th ed. rev. Upper Saddle River, NJ: Pearson/Prentice Hall, 2010.

Johnson, Paul. *Art: A New History.* New York: HarperCollins, 2003.

Kemp, Martin, ed. *The Oxford History of Western Art.* Oxford: Oxford Univ. Press, 2000.

Kleiner, Fred S. *Gardner's Art through the Ages.* Enhanced 13th ed. Belmont, CA: Thomson/Wadsworth, 2011.

Kostof, Spiro. *A History of Architecture: Settings and Rituals.* 2nd ed. Revised. Greg Castillo. New York: Oxford Univ. Press, 1995.

Mackenzie, Lynn. *Non-Western Art: A Brief Guide.* 2nd ed. Upper Saddle River, NJ: Pearson/Prentice Hall, 2001.

Marmor, Max, and Alex Ross, eds. *Guide to the Literature of Art History 2.* Chicago: American Library Association, 2005.

Onians, John, ed. *Atlas of World Art.* New York: Oxford Univ. Press, 2004.

Sayre, Henry M. *Writing about Art.* 6th ed. Upper Saddle River, NJ: Pearson/Prentice Hall, 2009.

Sed-Rajna, Gabrielle. *Jewish Art.* Trans. Sara Friedman and Mira Reich. New York: Abrams, 1997.

Slatkin, Wendy. *Women Artists in History: From Antiquity to the Present.* 4th ed. Upper Saddle River, NJ: Pearson/Prentice Hall, 2001.

Sutton, Ian. *Western Architecture: From Ancient Greece to the Present. World of Art.* New York: Thames & Hudson, 1999.

Trachtenberg, Marvin, and Isabelle Hyman. *Architecture, from Prehistory to Postmodernity.* 2nd ed. Upper Saddle River, NJ: Pearson/Prentice Hall, 2002.

Watkin, David. *A History of Western Architecture.* 4th ed. New York: Watson-Guptill, 2005.

## Art History Journals: A Select List of Current Titles

*African Arts.* Quarterly. Los Angeles: Univ. of California at Los Angeles, James S. Coleman African Studies Center, 1967–.

*American Art: The Journal of the Smithsonian American Art Museum.* 3/year. Chicago: Univ. of Chicago Press, 1987–.

*American Indian Art Magazine.* Quarterly. Scottsdale, AZ: American Indian Art Inc., 1975–.

*American Journal of Archaeology.* Quarterly. Boston: Archaeological Institute of America, 1885–.

*Antiquity: A Periodical of Archaeology.* Quarterly. Cambridge: Antiquity Publications Ltd., 1927–.

*Apollo: The International Magazine of the Arts.* Monthly. London: Apollo Magazine Ltd., 1925–.

*Architectural History.* Annually. Farnham, UK: Society of Architectural Historians of Great Britain, 1958–.

*Archives of American Art Journal.* Quarterly. Washington, DC: Archives of American Art, Smithsonian Institution, 1960–.

*Archives of Asian Art.* Annually. New York: Asia Society, 1945–.

*Ars Orientalis: The Arts of Asia, Southeast Asia, and Islam.* Annually. Ann Arbor: Univ. of Michigan Dept. of Art History, 1954–.

*Art Bulletin.* Quarterly. New York: College Art Association, 1913–.

*Art History: Journal of the Association of Art Historians.* 5/year. Oxford: Blackwell Publishing Ltd., 1978–.

*Art in America.* Monthly. New York: Brant Publications Inc., 1913–.

*Art Journal.* Quarterly. New York: College Art Association, 1960–.

*Art Nexus.* Quarterly. Bogata, Colombia: Arte en Colombia Ltda, 1976–.

*Art Papers Magazine.* Bimonthly. Atlanta: Atlanta Art Papers Inc., 1976–.

*Artforum International.* 10/year. New York: Artforum International Magazine Inc., 1962–.

*Artnews.* 11/year. New York: Artnews LLC, 1902–.

*Bulletin of the Metropolitan Museum of Art.* Quarterly. New York: Metropolitan Museum of Art, 1905–.

*Burlington Magazine.* Monthly. London: Burlington Magazine Publications Ltd., 1903–.

*Dumbarton Oaks Papers.* Annually. Locust Valley, NY: J. J. Augustin Inc., 1940–.

*Flash Art International.* Bimonthly. Trevi, Italy: Giancarlo Politi Editore, 1980–.

*Gesta.* Semiannually. New York: International Center of Medieval Art, 1963–.

*History of Photography.* Quarterly. Abingdon, UK: Taylor & Francis Ltd., 1976–.

*International Review of African American Art.* Quarterly. Hampton, VA: International Review of African American Art, 1976–.

*Journal of Design History.* Quarterly. Oxford: Oxford Univ. Press, 1988–.

*Journal of Egyptian Archaeology.* Annually. London: Egypt Exploration Society, 1914–.

*Journal of Hellenic Studies.* Annually. London: Society for the Promotion of Hellenic Studies, 1880–.

*Journal of Roman Archaeology.* Annually. Portsmouth, RI: Journal of Roman Archaeology LLC, 1988–.

*Journal of the Society of Architectural Historians.* Quarterly. Chicago: Society of Architectural Historians, 1940–.

*Journal of the Warburg and Courtauld Institutes.* Annually. London: Warburg Institute, 1937–.

*Leonardo: Art, Science and Technology.* 6/year. Cambridge, MA: MIT Press, 1968–.

*Marg.* Quarterly. Mumbai, India: Scientific Publishers, 1946–.

*Master Drawings.* Quarterly. New York: Master Drawings Association, 1963–.

*October.* Cambridge, MA: MIT Press, 1976–.

*Oxford Art Journal.* 3/year. Oxford: Oxford Univ. Press, 1978–.

*Parkett.* 3/year. Zürich, Switzerland: Parkett Verlag AG, 1984–.

*Print Quarterly.* Quarterly. London: Print Quarterly Publications, 1984–.

*Simiolus: Netherlands Quarterly for the History of Art.* Quarterly. Apeldoorn, Netherlands: Stichting voor Nederlandse Kunsthistorische Publicaties, 1966–.

*Woman's Art Journal.* Semiannually. Philadelphia: Old City Publishing Inc., 1980–.

## Internet Directories for Art History Information: A Selected List

ARCHITECTURE AND BUILDING,
http://www.library.unlv.edu/arch/rsrce/webresources/
A directory of architecture websites collected by Jeanne Brown at the Univ. of Nevada at Las Vegas. Topical lists include architecture, building and construction, design, history, housing, planning, preservation, and landscape architecture. Most entries include a brief annotation and the last date the link was accessed by the compiler.

ART HISTORY RESOURCES ON THE WEB,
http://witcombe.sbc.edu/ARTHLinks.html
Authored by Professor Christopher L. C. E. Witcombe of Sweet Briar College in Virginia, since 1995, the site includes an impressive number of links for various art historical eras as well as links to research resources, museums, and galleries. The content is frequently updated.

ART IN FLUX: A DIRECTORY OF RESOURCES FOR RESEARCH IN CONTEMPORARY ART,
http://www.boisestate.edu/art/artinflux/intro.html
Cheryl K. Shurtleff of Boise State Univ. in Idaho, has authored this directory, which includes sites selected according to their relevance to the study of national or international contemporary art and artists. The subsections include artists, museums, theory, reference, and links.

ARTCYCLOPEDIA: THE GUIDE TO GREAT ART ON THE INTERNET
http://www.artcyclopedia.com
With more than 2,100 art sites and 75,000 links, this is one of the most comprehensive web directories for artists and art topics. The primary search is by artist's name but access is also available by title of artwork, artistic movement, museums and galleries, nationality, period, and medium.

MOTHER OF ALL ART AND ART HISTORY LINKS PAGES
http://umich.edu/~motherha
Maintained by the Dept. of the History of Art at the Univ. of Michigan, this directory covers art history departments, art museums, fine arts schools and departments as well as links to research resources. Each entry includes annotations.

VOICE OF THE SHUTTLE,
http://vos.ucsb.edu
Sponsored by Univ. of California, Santa Barbara, this directory includes more than 70 pages of links to humanities and humanities-related resources on the Internet. The structured guide includes specific subsections on architecture, on art (modern and contemporary), and on art history. Links usually include a one-sentence explanation and the resource is frequently updated with new information.

ARTBABBLE
http://www.artbabble.org/
An online community created by staff at the Indianapolis Museum of Art to showcase art-based video content, including interviews with artists and curators, original documentaries, and art installation videos. Partners and contributors to the project include Art21, Los Angeles County Museum of Art, The Museum of Modern Art, The New York Public Library, San Francisco Museum of Modern Art, and Smithsonian American Art Museum.

YAHOO! ARTS>ART HISTORY,
http://dir.yahoo.com/Arts/Art_History/
Another extensive directory of art links organized into subdivisions with one of the most extensive being "Periods and

Movements." Links include the name of the site as well as a few words of explanation.

## Asian Art, General

Addiss, Stephen, Gerald Groemer, and J. Thomas Rimer, eds. *Traditional Japanese Arts and Culture: An Illustrated Sourcebook*. Honolulu: Univ. of Hawai'i Press, 2006.

Barnhart, Richard M. *Three Thousand Years of Chinese Painting*. New Haven: Yale Univ. Press, 1997.

Blunden, Caroline, and Mark Elvin. *Cultural Atlas of China*. 2nd ed. New York: Checkmark Books, 1998.

Brown, Kerry, ed. *Sikh Art and Literature*. New York: Routledge in collaboration with the Sikh Foundation, 1999.

Chang, Léon Long-Yien, and Peter Miller. *Four Thousand Years of Chinese Calligraphy*. Chicago: Univ. of Chicago Press, 1990.

Chang, Yang-mo. *Arts of Korea*. Ed. Judith G. Smith. New York: Metropolitan Museum of Art, 1998.

Clark, John. *Modern Asian Art*. Honolulu: Univ. of Hawai'i Press, 1998.

Clunas, Craig. *Art in China*. 2nd ed. Oxford History of Art. Oxford: Oxford Univ. Press, 2009.

Coaldrake, William H. *Architecture and Authority in Japan*. London: Routledge, 1996.

Cohen, Warren I. *East Asian Art and American Culture: A Study in International Relations*. New York: Columbia Univ. Press, 1992.

Collcutt, Martin, Marius Jansen, and Isao Kumakura. *Cultural Atlas of Japan*. New York: Facts on File, 1988.

Craven, Roy C. *Indian Art: A Concise History*. Rev. ed. World of Art. New York: Thames & Hudson, 1997.

Dehejia, Vidya. *Indian Art*. Art & Ideas. London: Phaidon Press, 1997.

Fisher, Robert E. *Buddhist Art and Architecture*. World of Art. New York: Thames & Hudson, 1993.

Fu, Xinian. *Chinese Architecture*. Ed. & exp., Nancy S. Steinhardt. New Haven: Yale Univ. Press, 2002.

Hearn, Maxwell K., and Judith G. Smith, eds. *Arts of the Sung and Yüan: Papers Prepared for an International Symposium*. New York: Dept. of Asian Art, Metropolitan Museum of Art, 1996.

*Heibonsha Survey of Japanese Art*. 31 vols. New York: Weatherhill, 1972–80.

Hertz, Betti-Sue. *Past in Reverse: Contemporary Art of East Asia*. San Diego: San Diego Museum of Art, 2004.

*Japanese Arts Library*. 15 vols. New York: Kodansha International, 1977–87.

Kerlogue, Fiona. *Arts of Southeast Asia*. World of Art. New York: Thames & Hudson, 2004.

Khanna, Balraj, and George Michell. *Human and Divine: 2000 Years of Indian Sculpture*. London: Hayward Gallery, 2000.

Lee, Sherman E. *A History of Far Eastern Art*. 5th ed. Ed. Naomi Noble Richards. New York: Abrams, 1994.

———. *China, 5000 Years: Innovation and Transformation in the Arts*. New York: Solomon R. Guggenheim Museum, 1998.

Liu, Cary Y., and Dora C.Y. Ching, eds. *Arts of the Sung and Yüan: Ritual, Ethnicity, and Style in Painting*. Princeton: Art Museum, Princeton Univ., 1999.

McArthur, Meher. *The Arts of Asia: Materials, Techniques, Styles*. New York: Thames & Hudson, 2005.

———. *Reading Buddhist Art: An Illustrated Guide to Buddhist Signs and Symbols*. New York: Thames & Hudson, 2002.

Mason, Penelope. *History of Japanese Art*. 2nd ed. Upper Saddle River, NJ: Pearson/Prentice Hall, 2005.

Michell, George. *Hindu Art and Architecture*. World of Art. London: Thames & Hudson, 2000.

———. *The Penguin Guide to the Monuments of India*. 2 vols. New York: Viking, 1989.

Mitter, Partha. *Indian Art*. Oxford History of Art. Oxford: Oxford Univ. Press, 2001.

Murase, Miyeko. *Bridge of Dreams: The Mary Griggs Burke Collection of Japanese Art*. New York: Metropolitan Museum of Art, 2000.

Nickel, Lukas, ed. *Return of the Buddha: The Qingzhou Discoveries*. London: Royal Academy of Arts, 2002.

Pak, Youngsook, and Roderick Whitfield. *Buddhist Sculpture*. Handbook of Korean Art. London: Laurence King, 2003.

Sullivan, Michael. *The Arts of China*. 5th ed., rev. & exp. Berkeley: Univ. of California Press, 2008.

Thorp, Robert L., and Richard Ellis Vinograd. *Chinese Art & Culture*. New York: Abrams, 2001.

Topsfield, Andrew, ed. *In the Realm of Gods and Kings: Arts of India*. London: Philip Wilson, 2004.

Tucker, Jonathan. *The Silk Road: Art and History*. Chicago: Art Media Resources, 2003.

Tregear, Mary. *Chinese Art*. Rev. ed. World of Art. New York: Thames & Hudson, 1997.

Vainker S. J. *Chinese Pottery and Porcelain: From Prehistory to the Present*. New York: Braziller, 1991.

## African and Oceanic Art and Art of the Americas, General

Anderson, Richard L., and Karen L. Field, eds. *Art in Small-Scale Societies: Contemporary Readings*. Upper Saddle River, NJ: Pearson/Prentice Hall, 1993.

Bacquart, Jean-Baptiste. *The Tribal Arts of Africa*. New York: Thames & Hudson, 1998.

Bassani, Ezio, ed. *Arts of Africa: 7000 Years of African Art*. Milan: Skira, 2005.

Benson, Elizabeth P. *Retratos: 2,000 Years of Latin American Portraits*. San Antonio, TX: San Antonio Museum of Art, 2004.

Berlo, Janet Catherine, and Lee Anne Wilson. *Arts of Africa, Oceania, and the Americas: Selected Readings*. Upper Saddle River, NJ: Prentice Hall, 1993.

Calloway, Colin G. *First Peoples: A Documentary Survey of American Indian History*. 3rd ed. Boston: Bedford/St. Martin's, 2008.

Coote, Jeremy, and Anthony Shelton, eds. *Anthropology, Art, and Aesthetics*. New York: Oxford Univ. Press, 1992.

Drewal, Henry, and John Pemberton III. *Yoruba: Nine Centuries of African Art and Thought*. New York: Center for African Art, 1989.

Evans, Susan Toby. *Ancient Mexico & Central America: Archaeology and Culture History*. 2nd ed. New York: Thames & Hudson, 2008.

———, and David L. Webster, eds. *Archaeology of Ancient Mexico and Central America: An Encyclopedia*. New York: Garland, 2001.

———, and Joanne Pillsbury, eds. *Palaces of the Ancient New World: A Symposium at Dumbarton Oaks, 10th and 11th October, 1998*. Washington, DC: Dumbarton Oaks Research Library and Collection, 2004.

Geoffroy-Schneiter, Bérénice. *Tribal Arts*. New York: Vendome Press, 2000.

Hiller, Susan, ed. & compiled. *The Myth of Primitivism: Perspectives on Art*. London: Routledge, 1991.

Mack, John, ed. *Africa, Arts and Cultures*. London: British Museum Press, 2000.

*Mexico: Splendors of Thirty Centuries*. New York: Metropolitan Museum of Art, 1990.

Nunley, John W., and Cara McCarty. *Masks: Faces of Culture*. New York: Abrams in assoc. with the Saint Louis Art Museum, 1999.

Perani, Judith, and Fred T. Smith. *The Visual Arts of Africa: Gender, Power, and Life Cycle Rituals*. Upper Saddle River, NJ: Pearson/Prentice Hall, 1998.

Phillips, Tom, ed. *Africa: The Art of a Continent*. New York: Prestel, 1995.

Price, Sally. *Primitive Art in Civilized Places*. 2nd ed. Chicago: Univ. of Chicago Press, 2001.

Rabineau, Phyllis. *Feather Arts: Beauty, Wealth, and Spirit from Five Continents*. Chicago: Field Museum of Natural History, 1979.

Schuster, Carl, and Edmund Carpenter. *Patterns that Connect: Social Symbolism in Ancient & Tribal Art*. New York: Abrams, 1996.

Scott, John F. *Latin American Art: Ancient to Modern*. Gainesville: Univ. Press of Florida, 1999.

Stepan, Peter. *Africa*. Trans. John Gabriel and Elizabeth Schwaiger. London: Prestel, 2001.

Visonà, Monica Blackmun, et al. *A History of Art in Africa*. 2nd ed. Upper Saddle River, NJ: Pearson/Prentice Hall, 2008.

## Chapter 23 Art of South and Southeast Asia after 1200

Asher, Catherine B. *Architecture of Mughal India*. New York: Cambridge Univ. Press, 1992.

Beach, Milo Cleveland. *Mughal and Rajput Painting*. New York: Cambridge Univ. Press, 1992.

Guy, John, and Deborah Swallow, eds. *Arts of India, 1550–1900*. London: V&A Publications, 1990.

Khanna, Balraj, and Aziz Kurtha. *Art of Modern India*. London: Thames & Hudson, 1998.

Koch, Ebba. *Mughal Art and Imperial Ideology: Collected Essays*. New Delhi: Oxford Univ. Press, 2001.

Michell, George. *Hindu Art and Architecture*. World of Art. London: Thames & Hudson, 2000.

Miller, Barbara Stoler (trans.). *Love Song of the Dark Lord: Jayadeva's Gitagovinda*. New York: Columbia Univ. Press, 1977.

Moynihan, Elizabeth B., ed. *The Moonlight Garden: New Discoveries at the Taj Mahal*. Asian Art & Culture. Washington, DC: Arthur M. Sackler Gallery, Smithsonian Institution Press, 2000.

Nou, Jean-Louis. *Taj Mahal*. Text by Amina Okada and M. C. Joshi. New York: Abbeville Press, 1993.

Pal, Pratapaditya. *Court Paintings of India, 16th–19th Centuries*. New York: Navin Kumar, 1983.

———. *The Peaceful Liberators: Jain Art from India*. New York: Thames & Hudson, 1994.

Rossi, Barbara. *From the Ocean of Painting: India's Popular Paintings, 1589 to the Present*. New York: Oxford Univ. Press, 1998.

Schimmel, Annemarie. *The Empire of the Great Mughals: History, Art and Culture*. Ed. Burzine K. Waghmar. Trans. Corinne Attwood. London: Reaktion Books, 2004.

Stronge, Susan. *Painting for the Mughal Emperor: The Art of the Book, 1560–1660*. London: V&A Publications, 2002.

Tillotson, G. H. R. *Mughal India*. Architectural Guides for Travelers. San Francisco: Chronicle Books, 1990.

———. *The Tradition of Indian Architecture: Continuity, Controversy and Change since 1850*. New Haven: Yale Univ. Press, 1989.

Verma, Som Prakash. *Painting the Mughal Experience*. New York: Oxford Univ. Press, 2005.

Welch, Stuart Cary. *The Emperors' Album: Images of Mughal India*. New York: Metropolitan Museum of Art, 1987.

———. *India: Art and Culture 1300–1900*. New York: Metropolitan Museum of Art, 1985.

## Chapter 24 Chinese and Korean Art after 1279

Andrews, Julia Frances, and Kuiyi Shen. *A Century in Crisis: Modernity and Tradition in the Art of Twentieth-Century China*. New York: Solomon R. Guggenheim Museum, 1998.

Barnhart, Richard M. *Painters of the Great Ming: The Imperial Court and the Zhe School*. Dallas: Dallas Museum of Art, 1993.

Barrass, Gordon S. *The Art of Calligraphy in Modern China*. London: British Museum Press, 2002.

Berger, Patricia Ann. *Empire of Emptiness: Buddhist Art and Political Authority in Qing China*. Honolulu: Univ. of Hawai'i Press, 2003.

Bickford, Maggie. *Ink Plum: The Making of a Chinese Scholar-Painting*. New York: Cambridge Univ. Press, 1996.

Billeter, Jean François. *The Chinese Art of Writing*. New York: Skira/Rizzoli, 1990.

Bush, Susan, and Hsio-yen Shih, eds. *Early Chinese Texts on Painting*. Cambridge, MA: Harvard Univ. Press, 1985.

Cahill, James. *The Distant Mountains: Chinese Painting in the Late Ming Dynasty, 1580–1644*. New York: Weatherhill, 1982.

———. *Hills beyond a River: Chinese Painting of the Yuan Dynasty, 1279–1368*. New York: Weatherhill, 1976.

———. *Parting at the Shore: Chinese Painting of the Early and Middle Ming Dynasty 1368–1580*. New York: Weatherhill, 1978.

Chaves, Jonathan (trans.). *The Chinese Painter as Poet*. New York: Art Media Resources, 2000.

Chung, Anita. *Drawing Boundaries: Architectural Images in Qing China*. Honolulu: Univ. of Hawai'i Press, 2004.

Clunas, Craig. *Pictures and Visuality in Early Modern China*. Princeton: Princeton Univ. Press, 1997.

Fang, Jing Pei. *Treasures of the Chinese Scholar: Form, Function and Symbolism*. Ed. J. May Lee Barrett. New York: Weatherhill, 1997.

Fong, Wen C. *Between Two Cultures: Late-Nineteenth- and Twentieth-Century Chinese Paintings from the Robert H. Ellsworth Collection in the Metropolitan Museum of Art*. New York: Metropolitan Museum of Art, 2001.

Hearn, Maxwell K., and Judith G. Smith, eds. *Chinese Art: Modern Expressions*. New York: Dept. of Asian Art, Metropolitan Museum of Art, 2001.

Ho, Chuimei, and Bennet Bronson. *Splendors of China's Forbidden City: The Glorious Reign of Emperor Qianlong*. Chicago: Field Museum, 2004.

Ho, Wai-kam, ed.. *The Century of Tung Ch'i-ch'ang, 1555–1636*. 2 vols. Kansas City: Nelson-Atkins Museum of Art, 1992.

Kim, Hongnam. *The Life of a Patron: Zhou Lianggong (1612–1672) and the Painters of Seventeenth-Century China*. New York: China Institute in America, 1996.

Knapp, Ronald G. *China's Vernacular Architecture: House Form and Culture*. Honolulu: Univ. of Hawai'i Press, 1989.

Lee, Sherman, and Wai-Kam Ho. *Chinese Art under the Mongols: The Yüan Dynasty, 1279–1368*. Cleveland: Cleveland Museum of Art, 1968.

Lim, Lucy. ed. *Wu Guanzhong: A Contemporary Chinese Artist*. San Francisco: Chinese Culture Foundation, 1989.

Moss, Paul. *Escape from the Dusty World: Chinese Paintings and Literati Works of Art*. London: Sydney L. Moss, 1999.

Ng, So Kam. *Brushstrokes: Styles and Techniques of Chinese Painting*. San Francisco: Asian Art Museum of San Francisco, 1993.

*The Poetry [of] Ink: The Korean Literati Tradition, 1392–1910*. Paris: Réunion des Musées Nationaux: Musée National des Arts Asiatiques Guimet, 2005.

Smith, Karen. *Nine Lives: The Birth of Avant-Garde Art in New China*. Zurich: Scalo, 2006.

Till, Barry. *The Manchu Era (1644–1912), Arts of China's Last Imperial Dynasty*. Victoria, BC: Art Gallery of Greater Victoria, 2004.

Vainker, S. J. *Chinese Pottery and Porcelain: From Prehistory to the Present*. London: British Museum Press, 1991.

Watson, William. *The Arts of China 900–1620*. Pelican History of Art. New Haven: Yale Univ. Press, 2000.

Weidner, Marsha Smith. *Views from Jade Terrace: Chinese Women Artists, 1300–1912*. Indianapolis, IN: Indianapolis Museum of Art, 1988.

Xinian, Fu, et al. *Chinese Architecture*. Ed. Nancy S. Steinhardt. New Haven: Yale Univ. Press, 2002.

## Chapter 25 Japanese Art after 1333

Addiss, Stephen. *The Art of Zen: Painting and Calligraphy by Japanese Monks, 1600–1925*. New York: Abrams, 1989.

Berthier, François. *Reading Zen in the Rocks: The Japanese Dry Landscape Garden*. Trans. & essay, Graham Parkes. Chicago: Univ. of Chicago Press, 2000.

Calza, Gian Carlo. *Ukiyo-e*. New York: Phaidon Press, 2005.

Graham, Patricia J. *Faith and Power in Japanese Buddhist Art, 1600–2005*. Honolulu: Univ. of Hawai'i, 2007.

———. *Tea of the Sages: The Art of Sencha*. Honolulu: Univ. of Hawai'i, 1998.

Guth, Christine. *Art of Edo Japan: The Artist and the City 1615–1868*. Perspectives. New York: Abrams, 1996.

Hickman, Money L. *Japan's Golden Age: Momoyama*. New Haven: Yale Univ. Press, 1996.

Kobayashi, Tadashi, and Lisa Rotondo-McCord. *An Enduring Vision: 17th to 20th Century Japanese Painting from the Gitter-Yelen Collection*. New Orleans: New Orleans Museum of Art, 2003.

Lillehoji, Elizabeth, ed. *Critical Perspectives on Classicism in Japanese Painting, 1600–1700*. Honolulu: Univ. of Hawai'i Press, 2004.

McKelway, Matthew P. *Traditions Unbound: Groundbreaking Painters of Eighteenth-Century Kyoto*. San Francisco: Asian Art Museum – Chong-Moon Lee Center, 2005.

Meech, Julia, and Jane Oliver. *Designed for Pleasure: The World of Edo Japan in Prints and Paintings, 1680–1860*. Seattle: Univ. of Washington Press in association with the Asia Society and Japanese Art Society of America, New York, 2008.

Miyajima, Shin'ichi and Sato Yasuhiro. *Japanese Ink Painting*. Ed. George Kuwayama. Los Angeles: Los Angeles County Museum of Art, 1985.

Munroe, Alexandra. *Japanese Art after 1945: Scream Against the Sky*. New York: Abrams, 1994.

Murase, Miyeko, ed. *Turning Point: Oribe and the Arts of Sixteenth-Century Japan*. New York: Metropolitan Museum of Art, 2003.

Newland, Amy Reigle, ed. *The Hotei Encyclopedia of Japanese Woodblock Prints*. 2 vols. Amsterdam: Hotei Publishing, 2005.

Ohki, Sadako. *Tea Culture of Japan*. New Haven: Yale Univ. Press, 2009.

Rousmaniere, Nicole, ed. *Crafting Beauty in Modern Japan: Celebrating Fifty Years of the Japan Traditional Art Crafts Exhibition*. Seattle: Univ. of Washington Press, 2007.

Screech, Timon. *The Lens Within the Heart: The Western Scientific Gaze and Popular Imagery in Later Edo Japan*. 2nd ed. Honolulu: Univ. of Hawai'i Press, 2002.

Singer, Robert T., and John T. Carpenter. *Edo, Art in Japan 1615–1868*. Washington, DC: National Gallery of Art, 1998.

## Chapter 26 Art of the Americas after 1300

Bauer, Brian S. *Ancient Cuzco: Heartland of the Inca*. Joe R. and Teresa Lozano Long Series in Latin American and Latino Art and Culture. Austin: Univ. of Texas Press, 2004.

Berlo, Janet Catherine, and Ruth B. Phillips. *Native North American Art*. Oxford History of Art. Oxford: Oxford Univ. Press, 1998.

Bringhurst, Robert. *The Black Canoe: Bill Reid and the Spirit of Haida Gwaii*. Seattle: Univ. of Washington Press, l991.

Burger, Richard L., and Lucy C. Salazar, eds. *Machu Picchu: Unveiling the Mystery of the Incas*. New Haven: Yale Univ. Press, 2004.

Fields, Virginia M., and Victor Zamudio-Taylor. *The Road to Aztlan: Art from a Mythic Homeland*. Los Angeles: Los Angeles County Museum of Art, 2001.

Griffin-Pierce, Trudy. *Earth is my Mother, Sky is my Father: Space, Time, and Astronomy in Navajo Sandpainting*. Albuquerque: Univ. of New Mexico Press, 1992.

Jonaitis, Aldona. *Art of the Northwest Coast*. Seattle: Univ. of Washington Press, 2006.

Kaufman, Alice, and Christopher Selser. *The Navajo Weaving Tradition: 1650 to the Present*. New York: Dutton, 1985.

Macnair, Peter L., Robert Joseph, and Bruce Grenville. *Down from the Shimmering Sky: Masks of the Northwest Coast*. Vancouver: Douglas & McIntyre, 1998.

Matos Moctezuma, Eduardo, and Felipe R. Solís Olguín. *Aztecs*. London: Royal Academy of Arts, 2002.

Matthews, Washington. *The Night Chant: A Navaho Ceremony* in Memoirs of the American Museum of Natural History, vol. 6. New York, 1902.

Moseley, Michael E. *The Incas and Their Ancestors: The Archaeology of Peru*. Rev. ed. London: Thames & Hudson, 2001.

Nabokov, Peter, and Robert Easton. *Native American Architecture*. New York: Oxford Univ. Press, 1989.

Pasztory, Esther. *Aztec Art*. Norman: Univ. of Oklahoma Press, 2000.

Rushing III, W. Jackson, ed. *Native American Art in the Twentieth Century: Makers, Meanings, Histories*. New York: Routledge, 1999.

Shaw, George Everett. *Art of the Ancestors: Antique North American Indian Art*. Aspen, CO: Aspen Art Museum, 2004.

Taylor, Colin F. *Buckskin & Buffalo: The Artistry of the Plains Indians*. New York: Rizzoli, 1998.

Townsend, Richard F., ed. *The Aztecs*. 2nd rev. ed. Ancient Peoples and Places. London: Thames & Hudson, 2000.

Trimble, Stephen. *Talking with the Clay: The Art of Pueblo Pottery in the 21st Century*. 20th anniversary. rev ed. Santa Fe, NM: School for Advanced Research Press, 2007.

Wood, Nancy C. *Taos Pueblo*. New York: Knopf, 1989.

## Chapter 27 Art of Pacific Cultures

Caruana, Wally. *Aboriginal Art*. 2nd ed. World of Art. New York: Thames & Hudson, 2003.

Craig, Barry, Bernie Kernot, and Christopher Anderson, eds. *Art and Performance in Oceania*. Honolulu: Univ. of Hawai'i Press, 1999.

D'Alleva, Anne. *Arts of the Pacific Islands*. Perspectives. New York: Abrams, 1998.

Herle, Anita, et al. *Pacific Art: Persistence, Change, and Meaning*. Honolulu: Univ. of Hawai'i Press, 2002.

Kaeppler, Adrienne Lois, Christian Kaufmann, and Douglas Newton. *Oceanic Art*. Trans. Nora Scott and Sabine Bouladon. New York: Abrams, 1997.

Kirch, Patrick Vinton. *The Lapita Peoples: Ancestors of the Oceanic World*. The Peoples of South-East Asia and the Pacific. Cambridge, MA: Blackwell, 1997.

Kjellgren, Eric. *Splendid Isolation: Art of Easter Island*. New York: Metropolitan Museum of Art, 2001.

———, and Carol Ivory. *Adorning the World: Art of the Marquesas Islands*. New Haven: Yale Univ. Press in association with the Metropolitan Museum of Art, 2005.

Küchler, Susanne, and Graeme Were. *Pacific Pattern*. London: Thames & Hudson, 2005.

Lilley, Ian, ed. *Archaeology of Oceania: Australia and the Pacific Islands*. Malden, MA: Blackwell, 2006.

McCulloch, Susan. *Contemporary Aboriginal Art: A Guide to the Rebirth of an Ancient Culture*. Rev. ed. Crows Nest, NSW, Australia: Allen & Unwin, 2001.

Moore, Albert C. *Arts in the Religions of the Pacific: Symbols of Life*. Religion and the Arts Series. New York: Pinter, 1995.

Morphy, Howard. *Aboriginal Art*. London: Phaidon Press, 1998.

Morwood, M. J. *Visions from the Past: The Archaeology of Australian Aboriginal Art*. Washington, DC: Smithsonian Institution Press, 2002.

Neich, Roger, and Mick Pendergrast. *Traditional Tapa Textiles of the Pacific*. London: Thames & Hudson, 1997.

Newton, Douglas, ed. *Arts of the South Seas: Island Southeast Asia, Melanesia, Polynesia, Micronesia; The Collections of the Musée Barbier-Mueller*. Trans. David Radzinowicz Howell. New York: Prestel, 1999.

Rainbird, Paul. *The Archaeology of Micronesia*. Cambridge World Archaeology. New York: Cambridge Univ. Press, 2004.

Smidt, Dirk, ed. *Asmat Art: Woodcarvings of Southwest New Guinea*. New York: George Braziller in assoc. with Rijksmuseum voor Volkenkunde, Leiden, 1993.

Starzecka, D. C., ed. *Maori Art and Culture*. London: British Museum Press, 1996.

Taylor, Luke. *Seeing the Inside: Bark Painting in Western Arnhem Land*. Oxford Studies in Social and Cultural Anthropology. New York: Oxford Univ. Press, 1996.

Thomas, Nicholas. *Oceanic Art*. World of Art. New York: Thames & Hudson, 1995.

———, Anna Cole and Bronwen Douglas, eds. *Tattoo: Bodies, Art, and Exchange in the Pacific and the West*. Durham, NC: Duke Univ. Press, 2005.

## Chapter 28 Art of Africa in the Modern Era

Anatsui, El. *El Anatsui Gawu*. Llandudno, Wales, UK: Oriel Mostyn Gallery, 2003.

*Astonishment and Power*. Washington, DC: National Museum of African Art, Smithsonian Institution Press, 1993.

Beckwith, Carol, and Angela Fisher. *African Ceremonies*. 2 vols. New York: Abrams, 1999.

Binkley, David A. *"Avatar of Power: Southern Kuba Masquerade Figures in a Funerary Context"* in *Africa-Journal of the International African Institute*, 57/1 (1987): 75–97.

Cameron, Elisabeth L. *Art of the Lega*. Los Angeles: UCLA Fowler Museum of Cultural History, 2001.

Cole, Herbert M., ed. *I Am Not Myself: The Art of African Masquerade*. Los Angeles: Fowler Museum of Cultural History, Univ. of California, 1985.

———. *Icons: Ideals and Power in the Art of Africa*. Washington, DC: National Museum of African Art, Smithsonian Institution Press, 1989.

*A Fiction of Authenticity: Contemporary Africa Abroad*. St. Louis, MO: Contemporary Art Museum St. Louis, 2003.

Fogle, Douglas, and Olukemi Ilesanmi. *Julie Mehretu: Drawing into Painting*. Minneapolis, MN: Walker Art Center, 2003.

Gillow, John. *African Textiles*. San Francisco: Chronicle Books, 2003.

Graham, Gilbert. *Dogon Sculpture: Symbols of a Mythical Universe*. Brookville, NY: Hillwood Art Museum, Long Island Univ., C. W. Post Campus, 1997.

Hess, Janet Berry. *Art and Architecture in Postcolonial Africa*. Jefferson, NC: McFarland, 2006.

Jordán, Manuel, ed. *Chokwe! Art and Initiation Among the Chokwe and Related Peoples*. Munich: Prestel, 1998.

Kasfir, Sidney Littlefield. *Contemporary African Art*. World of Art. London: Thames & Hudson, 2000.

Morris, James, and Suzanne Preston Blier. *Butabu: Adobe Architecture of West Africa*. New York: Princeton Architectural Press, 2004.

Oguibe, Olu, and Okwui Enwezor. *Reading the Contemporary: African Art from Theory to the Marketplace*. Cambridge, MA: MIT Press, 1999.

Pemberton III, John, ed. *Insight and Artistry in African Divination*. Washington, DC: Smithsonian Institution Press, 2000.

Perrois, Louis, and Marta Sierra Delage. *The Art of Equatorial Guinea: The Fang Tribes*. New York: Rizzoli, 1990.

Picton, John, et al. *El Anatsui: A Sculpted History of Africa*. London: Saffron Books in conjunction with the October Gallery, 1998.

Roberts, Mary Nooter, and Allen F. Roberts, eds. *Memory: Luba Art and the Making of History*. New York: Museum for African Art, 1996.

Roy, Christopher D. *Art of the Upper Volta Rivers*. Meudon, France: Chaffin, 1987.

Stepan, Peter. *Spirits Speak: A Celebration of African Masks*. Munich: Prestel, 2005.

Van Damme, Annemieke. *Spectacular Display: The Art of Nkanu Initiation Rituals*. Washington, DC: National Museum of African Art, Smithsonian Institution Press, 2001.

Vogel, Susan Mullin. *Baule: African Art, Western Eyes*. New Haven: Yale Univ. Press, 1997.

## Chapter 23

23.1 © Peter Adams/Corbis; 23.2 © Dirk Bakker; 23.3 Prince of Wales Museum of Western India; 23.4 Courtesy of Marilyn Stokstad, Private Collection; Art and its Contexts a Thierry Ollivier. Musée des Arts Asiatiques-Guimet, Paris, France. Réunion des Musées Nationaux/Art Resource, NY; Art and its Contexts b Rene-Gabriel Ojeda/RMN/Art Resource, NY; 23.6 The Walters Art Museum, Baltimore; 23.7 Collection of Phoenix Art Museum. Photographed by Craig Smith; 23.8 Bernard O'Kane/Alamy; Closer Look © Sheldan Collins/Corbis; 23.10, 23.12 V&A Images; 23.11 Freer Gallery of Art, Smithsonian Institution, Washington, D.C.; Object Speaks Katherine Wetzel/Virginia Museum of Fine Arts; 23.13 B.P. Mathur/Pierre/Dinodia Picture Agency; 23.14 Photograph © 2008 Museum of Fine Arts, Boston.; 23.15 David Ball/Alamy Images; 23.16 Courtesy of Marilyn Stokstad, Private Collection; 23.17 Rick Asher; 23.18 Photograph courtesy Peabody Essex Museum. Photo: Sexton/Dykes; 23.19 © Tate, London 2010/ © Anish Kapoor

## Chapter 24

24.1, 24.2, 24.3 National Palace Museum Taiwan, Republic of China; 24.4 The Cleveland Museum of Art; 24.5, 24.6 National Palace Museum, Taipei, Republic of China; Closer Look National Palace Museum Taipei, Republic of China; 24.7 Palace Museum, Beijing; 24.8 PanoramaStock/Robert Harding World Imagery; 24.9 The Nelson-Atkins Museum of Art, Kansas City, Missouri. Photograph by Jamison Miller; 24.10 © Wolfgang Kaehler 2007 www.wkaehlerphoto.com; Object Speaks The Nelson-Atkins Museum of Art, Kansas City, Missouri. Photograph Robert Newcombe; 24.11 The Cleveland Museum of Art; 24.12 Collection of Phoenix Art Museum; 24.13 Collection C. C. Wang family; 24.14 Spencer Museum of Art, The University of Kansas; 24.15 Museum of Oriental Ceramics, Osaka. Gift of the Sumitomo Group [20773]; 24.16 Ewha Woman's University Museum, Seoul, Korea; 24.17 Photo Courtesy of Central Library, Tenri University, Tenri, Japan; 24.18 National Treasure # 217. Samsung Museum, Lee'um, Seoul, Republic of Korea; 24.19 National Museum of Korea; 24.20 Whanki Foundation/Whanki Museum

## Chapter 25

25.1 Photograph © The Art Institute of Chicago; 25.2 Reproduced with permission. © 2005 Museum of Fine Arts, Boston. All Rights Reserved; 25.3 TNM Image Archives/DNP; 25.4 Michael S. Yamashita, Inc.; 25.5 Steve Vidler/SuperStock, Inc.; 25.6 Sakamoto Manschichi Photo Research Library, Tokyo; 25.7 Myoki-an/Pacific Press Service; 25.8 Sakai Collection, Tokyo. Photo: Stephen Addiss; Object Speaks a, b TNM Image Archives/DNP; 25.9a, b Smithsonian Institution; 25.10 Los Angeles County Museum of Art. Photograph © 2003 Museum Associates/LACMA; 25.11 Hosomi Museum; Technique © The Trustees of the British Museum; 25.12 Honolulu Academy of Arts; 25.13 Gitter-Yelen Foundation; 25.14 The Nelson-Atkins Museum of Art, Kansas City, Missouri. Photograph by John Lamberton; Closer Look The Nelson-Atkins Museum of Art, Kansas City, Missouri; 25.15 © Shokodo, Ltd. & Japan Artists Association, Inc. 2006; 25.16 Courtesy Hiroshima Peace Memorial Museum; Recovering the Past Courtesy Koukei Eri; 25.17 Toyobi Far Eastern Art

## Chapter 26

26.2 Bodleian Library, University of Oxford; 26.3 Werner Forman/ Art Resource, NY; 26.4 © Michel Zabe; Closer Look Museo Nacional de Arqueologia, Mexico City, Mexico/Photo © AISA/ The Bridgeman Art Library; 26.5 World Museum Liverpool, National Museums Liverpool; 26.6 Chris Rennie/Robert Harding World Imagery; 26.7 © Art Archive/Dagli Orti; 26.8 Justin Kerr/ Dumbarton Oaks, Byzantine Photograph and Fieldwork Archives, Washington, D.C.; 26.9 Photo by John Bigelow Taylor, NY. Courtesy Dept. of Library Services, American Museum of Natural History; Technique Philbrook Museum, Tulsa, Oklahoma; 26.10 With permission of the Royal Ontario Museum © ROM; 26.11 Catalogue No. 73311, Department of Anthropology, Smithsonian Institution; 26.12 The Detroit Institute of Arts; 26.13 Montana Historical Society, Helena; 26.14 © President and Fellows of Harvard College, Peabody Museum of Archaeology; 26.15 Denver Art Museum Collection, Photograph © Denver Art Museum 2009. All rights reserved; Object Speaks a Courtesy of Curtis Library, Northwestern University Library, IL; Object Speaks b Courtesy of the University of British Columbia Museum of Anthropology; 26.16 Neg./Transparency no. 3804. Photo by Stephen S. Meyers, NY. Courtesy Dept. of Library Services, American Museum of Natural History; 26.17 © 1979 Amon Carter Museum, Fort Worth, Texas. Bequest of the artist, P1979.208.698 (neg. 2528.1); 26.18 Museum of Indian Arts and Culture/Laboratory of Anthropology, Museum of New Mexico, Santa Fe; 26.19 © The Estate of Pablita Velarde © 2010 Philbrook Museum of Art, Inc., Tulsa, Oklahoma; 26.20 The Heard Museum; 26.21 Smith College Museum of Art, Northampton, Massachusetts; 26.22 Embassy of Canada; 26.23 J. Scott Applewhite/AP Photos

## Chapter 27

27.1 Courtesy of Parliament House Art Collection, Department of Parliamentary Services, Canberra A.C.T.; 27.2 Anthropology Photographic Archive, the Department of Anthropology, The University of Auckland; 27.3 © RMN/Jean-Gilles Berizzi; 27.4 Photo Courtesy of Anthony Forge, 1962. From George A. Corgin, *Native Arts of North America, Africa and the South Pacific: An Introduction*. New York. Harper & Row, Publishers, Inc., 1988; 27.5 Michael O'Hanlon; 27.6 Tobias Schneebaum; 27.7 © Museum der Kulturen Basel, Switzerland. Photograph: Peter Horner; 27.8, 27.15 Caroline Yacoe; 27.9 Photograph Courtesy Peabody Essex Museum. Photograph by Jeffrey Dykes; 27.10 Federated States of Micronesia; 27.11 Postcard produced by Pacific Promotion, Tahiti; Photo by Teva Sylvain; Object Speaks a, b, c Museum of New Zealand Te Papa Tongarewa; 27.12 Bishop Museum; 27.13 James Balog/Black Star; 27.14 Photo by Krzysztof Pfeiffer, Auckland Museum; Closer Look Art Gallery of South Australia, Adelaide. Visual Arts Board of the Australia Council Contemporary Art Purchase Grant, 1980. © Estate of the artist, licensed by Aboriginal Artists Agency 2009; 27.16 © The Metropolitan Museum of Art/ Art Resource/Scala, Florence

## Chapter 28

28.1 Sarah Da Vanzo Collection, Johannesburg, Africa; 28.2 British Museum, number 191; 28.3 © Margaret Courtney-Clarke/Corbis; 28.4 The University of Iowa Museum of Art; 28.5 Margaret Thompson Drewal/Eliot Elisofon Photographic Archives/ Smithsonian Institution; 28.6 © Charles & Josette Lenars/Corbis; 28.7 Frederick John Lamp; 28.8, 28.11, 28.15, 28.17, 28.18 Elisofon Archives, National Museum of African Art, Smithsonian Institution; 28.9 Don Cole/UCLA Fowler Museum of Cultural History; 28.10 Frank Khoury/National Museum of African Art/Smithsonian Institution; Closer Look The Field Museum, Neg#A109979c, Chicago; 28.12 Photograph by Margaret Drewa. National Museum of African Art, Smithsonian Institution, Washington, D.C. Eliot Elisofon Photographic Archives; Art and its Context Franko Khoury/National Museum of African Art/ Smithsonian Institution; 28.13 Franko Khoury/National Museum of African Art/Smithsonian Institution. Museum purchase; 28.14 Photograph by Angelo Turconi; 28.16 John Picton; Object Speaks a Photography © The Art Institute of Chicago; Object Speaks b, c Photograph by David A. Binkley & Patricia J. Darish, 1981, 1982; 28.19 Dallas Museum of Art; 28.20 Courtesy October Gallery, London; 28.21 The Project Gallery - New York and Los Angeles

Page numbers in *italics* refer to illustrations and maps

Ivory: Indian (Mughal), 782, *782*
Iwans, 780

## J

Jahangir, Mughal emperor, 779, 781, 783, *783*
*Jahangir and Shah Abbas* (Zaman), 783, *783*
Jain art, *773*, 773–774
Jainism, 772, 773, 774
Jaipur, India: Jawalhar Kala Kendra (Correa), 787–788, *788*
Japan
  agriculture, 817
  Asuka period, 817
  Buddhism, 817
  Buddhism (Zen), 814, 817, 820, 828
  Confucianism, 825
  culture, 817
  Daoism, 825
  Edo period, 813, 821–830
  foreign influences, 813
  Heian period, 817
  Jomon period, 817
  Kamakura period, 817
  Kofun period, 817
  literature, 817, 822
  map, *814*
  Meiji period, 831
  modern period, 830–833
  Momoyama period, 817–821
  Muromachi (Ashikaga) period, 814–816, 817
  Nara period, 817
  Neo-Confucianism, 821
  religious beliefs, 817
  Shinto, 817
  tea ceremonies, 819, 820–821, 825
  writing implements, *822*, 824, *824*
Japanese art after 1333
  architecture (modern), *831*, 831–832
  architecture (Momoyama period), 818, *818*
  Buddhist (Zen), 814–816, *815*, 828, *828*
  calligraphy, 817, 824
  ceramics (Momoyama period), 821, *821*
  crafts, 828, 832
  garden design, 816, *816*
  ink painting, 814–816, *815*, 824, 826
  painting (Edo period), *812*, 813, 821–828, *822–825*, *827–828*
  painting (literati), *825*, 825–826
  painting (Meiji period), *830*, 831
  painting (modern), *830*, 831, 832, *832*
  painting (Momoyama period), 818–820, *820*
  painting (Muromachi period), 814–816, *815*
  painting (Zen), 814–816, *815*, 828, *828*
  porcelain (Edo period), 830, *830*
  porcelain (modern), 832–833, *833*
  printmaking, 825, 826, *826*, 827–828, *828*
  shoin design, 818, 819, *819*, *820*
  tea ceremony rooms and equipment, *820*, 820–821, *821*
  textiles, 829, *829*
  wall paintings, 818–820, *820*
Japanese art before 1333
  architecture (Asuka period), 817
  Buddhist art (Asuka period), 817
  pottery (Jomon period), 817
  tombs, 817
Japonisme, 828
Jars
  Korean (Joseon dynasty), 808, *808*

Pacific cultures (Lapita), 860, *860*
Java, Indonesia: Minaret mosque, 778, *779*
Jawalhar Kala Kendra, Jaipur, India (Correa), 787–788, *788*
Jenné, Mali, 883
Jeong Seon, 809
  *Panoramic View of the Diamond Mountains (Geumgang-San)*, 809, *809*
Jomon period, 817
Joseon dynasty, 807–810
Jukoin fusuma panels, Daitokuji monastery, Kyoto, Japan, 819–820, *820*
Jumbo, Julia, 835
  tapestry weaving, *834*

## K

Kabuki theater, 826
Kakuzo, Okakura, 831
*Kalpa Sutra* illuminated manuscript, *773*, 773–774
Kamakura period, 817
Kamehameha I, king of Hawaiian Islands, 872
Kamehameha III, king of Hawaiian Islands, 872
Kanaga and rabbit dama masks, Dogon, Mali, *898*
Kangra School paintings, 784, *785*, 786
Kanishka, king of India, 774
Kano Eitoku, 819, 820
  fusuma panels, Jukoin, Daitokuji monastery, Kyoto, 819–820, *820*
Kano school, 819
Kapoor, Anish, 788
  *As If to Celebrate, I Discovered a Mountain Blooming with Red Flowers*, 788, *789*
Katsinas, 853
Katsushika Hokusai. *See* Hokusai
Kearny, Lawrence, 872
Kearny Cloak, Hawaii, 872, *872*
Kente cloth, Ashanti, Ghana, 892, *893*
Kenzo, Tange, 831
  Hiroshima Peace Memorial Museum and Park, *831*, 831–832
Key block, 826
Kihara, Shigeyuki, 877
  *Ulugali'i Samoa: Samoan Couple*, 877, *877*
Kimonos, 829
Kirikane, 832
Klah, Hosteen, 854
  *Whirling Log Ceremony* tapestry, *854*, 854–855
Kofun period, 817
Kojoin guest house, Onjoji temple, Kyoto, Japan, 819, *819*
Konarak, India: Sun Temple, 774
Kongo, Democratic Republic of the Congo: sculpture, 889, *890*
Korambo (ceremonial house), Abelam, Papua New Guinea, 863, *863*
Korea
  Buddhism, 807
  Goryeo dynasty, 807
  Joseon dynasty, 807–810
  map, *792*
  modern period, 810–811
  Neo-Confucianism, 807
  Yi dynasty, 807
Korean art after 1279
  ceramics and porcelain, *807*, 807–808, *808*
  ink painting, 810
  painting (Joseon dynasty), *808*, 808–810, *809*, *810*
  painting (modern), 810–811, *811*

*Koshares of Taos* (Velarde), 853, *853*
Kosode robes, 829, *829*
*Krishna and the Gopis* from *Gita Govinda* illuminated manuscript, 784, *785*
Kuba, Democratic Republic of the Congo
  architecture, 892–893, *893*
  funerary customs, 896–897, *897*
  masks, *896*, 896–897, *897*
  textiles, 893–894, *894*
Kublai Khan, 792, 794
Kushans dynasty, 774
Kwakwaka'wakw, 849, 850, 851
Kyoto, Japan, 821, 825
  Daitokuji monastery, 819–820, *820*
  Kojoin guest house, Onjoji temple, 819, *819*
  Ryoanji temple garden, 816, *816*
  Taian tearoom (Sen no Rikyu), 820–821, *821*

## L

Lacquer, 822
Lacquer box for writing implements (Ogata Korin), 822, *822*
*Landscape* (Bunsei), 814, *815*
*Landscape* (Shitao), *805*, 805–806
Landscape painting
  Chinese (Ming dynasty), *796*, 796–797
  Chinese (modern), 806, *806*
  Chinese (Qing dynasty), *790*, 791, *805*, 805–806
  Japanese, 814–816, *815*, 826
  Korean, 808, 809, *809*
Langsdorff, George, 872
Laozi, 793
Lapita people, 860, 869
Latin America. *See* Mesoamerica; Mexico
Leadership symbols in African art, *878*, 879, 891–895
Lega, Democratic Republic of the Congo: masks, 887–888
Literati painting
  Chinese, 791, 793, 794–795, 800, *802*, *803*, 803–804, 805
  Japanese, *825*, 825–826
Literature
  Chinese, 802
  Indian, 784
  Japanese, 817, 822
Living National Treasure system (Japan), 832
Llama, Inca, *843*
Lutyens, Sir Edwin
  India Gate, New Delhi, 786, *786*
  New Delhi, 786

## M

Machu Picchu, Peru, *841*, 841–842
Madurai, India: Minakshi-Sundareshvara temple, 775, *775*
Mahavira, 774
Mahayana Buddhism, 772
Malagan carvings, New Ireland, Papua New Guinea, 865–866, *866*
Mali, 883
  Dogon, 898
  Jenné, 883
Manchus, 791, 804–805
*Man's Love Story* (Possum Tjapaltjarri), 875–877, *876*

# Z

# NOTES